THE BROTHERS DUCHAMP

THE BROTHERS DUCHAMP

Jacques Villon
Raymond Duchamp-Villon
Marcel Duchamp

Text by Pierre Cabanne

NEW YORK GRAPHIC SOCIETY • BOSTON

Translated from the French by Helga and Dinah Harrison

Copyright © 1975 by Editions Ides et Calendes, Neuchâtel, Switzerland
English translation copyright © 1976 by New York Graphic Society

International Standard Book Number: 0-8212-0666-4
Library of Congress Catalog Card Number: 75-37285

First published in Switzerland by Editions Ides et Calendes

First United States edition

New York Graphic Society books are published by Little, Brown and
Company.
Published simultaneously in Canada by Little, Brown and Company
(Canada) Limited.

Printed in Switzerland

TABLE OF CONTENTS

7 Three young provincials in Paris

29 The Puteaux conspiracy

67 Light and movement

87 The golden section

91 The Virgin, the Bride, and the Bachelors

107 The Armory Show scandal

109 The horse and the machine

139 America! America!

155 Villon between the schematic and the lyrical

175 The Duchamp myth and the Large Glass

185 A solitary painter and a diligent engineer

203 Jacques Villon's fame

219 The first painter to speak the language of the air

249 Marcel Duchamp: protest and fame

257 Notes

259 The brothers Duchamp: Chronology

265 Main Exhibitions

266 Bibliography

267 List of Illustrations

ACKNOWLEDGMENTS

The publishers express their gratitude, for the generous loan of photographs and other documents, to Madame Marcel Duchamp, and to Galerie Bonnier, Geneva, Louis Carré & Cie, Paris, Monsieur Camille Renault, Paris, Galerie Sagot-Le Garrec, Paris, Galleria Arturo Schwarz, Milan.

THREE YOUNG PROVINCIALS IN PARIS

The names of the three Duchamp brothers—Jacques Villon, Raymond Duchamp-Villon, and Marcel Duchamp—evoke an overgrown suburban garden at 7 Rue Lemaître, on the slopes of Puteaux, the hamlet that was alive with artists at the beginning of this century; here, on a wicker chair near the stove, under the grey glass-roof of his studio, gentle, learned Jacques Villon used to paint.

They also recall memories of Marcel Duchamp crossing Broadway at a rapid pace, his cap pulled down over his eyes as if to avoid seeing the crowds and the huge cinema posters, or hearing the surrounding din. And of the New York apartment, 28 West 10th Street, with its succession of young painters, journalists, and their various hangers-on; and then the flat at 5 Rue Parmentier in Neuilly, where Marcel Duchamp never received visitors, and where he kept his Readymades and Miró's *La Fermière* hung above the fireplace. Duchamp is at a crazy "happening" at the American Cultural Centre in Paris, or at the showing of Raymond Duchamp-Villon's *Large Horse* at the Louis Carré gallery, looking slightly self-conscious with his idiosyncratic way of slipping in among the onlookers with a rather awkward modesty.

Rue Lemaître has been swept away by bulldozers, and the Paris of the future is building its towers on the site of the rural district where Villon used to live. Nearby was Duchamp-Villon's studio, which has remained more or less unchanged since his death. One day in the late fifties his brother took me there, and another time I went along with Marcel Duchamp, who had returned from New York on the previous day. He looked like a sly cleric: lean-faced, thin-lipped, smoking Havana cigars which he allowed to go out seemingly for the pleasure of relighting them with the help of about a dozen matches. He had a penetrating gaze but a soft voice, and his whole bearing suggested a rather disconcerting serenity. He had revolutionized first America and then the art of his time without noise or fuss.

There was a great contrast between the two men. Duchamp was often called the Great Disturber, and he was, with Picasso, the most controversial artist of the twentieth century. His older brother, Villon, was a lightweight, almost immaterial, in the world of painting. But there was an affectionate closeness between the two brothers, revealed in the way they would look at each other and converse in low, almost confidential voices.

In fact, they were both very unassuming. Villon had welcomed his unsought-for fame just as Duchamp had welcomed controversy, with a slight smile, absent-mindedly. Neither of them was unaware of his impact, or indifferent to it, yet they remained detached and self-sufficient. Villon had quietly and painstakingly given depths to the traditional elements of graphic art in order to create a visual language of interpretation and reflection, based on minute examination of colours and forms in space. Duchamp, after repudiating the concept of purely "retinal" art, stopped working, and remained virtually inactive for over forty years.

Duchamp was one of those rare mortals who could tell people that he did nothing, and evoke neither shock nor surprise. On the contrary: his friend Pierre-Henri Roché said that Duchamp's timetable constituted his best work of art. To this Duchamp replied, "That's as may be. But what does it really mean, and will anything come of it?"

Villon spoke of colour as if he were discussing an old friend and collaborator. He began his paintings by dividing his canvas geometrically, and on this plan built up his delicate structures of transparent yet strong light, and his visions of love and glory. In a neighbouring studio, Duchamp-Villon's sculptures were a reminder of his pre-war Cubist experiments undertaken before he died, in October 1918, of typhoid fever which he had contracted at the front in Champagne. On the other side of the Atlantic, Marcel Duchamp had already galvanized New York with the aggressivity of his challenge. Villon, who had been through the whole of the war, first in the Territorial Infantry, then in Camouflage, returned to his Puteaux studio as soon as he was demobilized, and did not leave it until his death in 1963.

Villon was born Gaston Duchamp on 31 July 1875, at Damville in Eure, where his father was a notary. Raymond was born on 5 November 1876, and Marcel on 28 July 1887.

Three sisters followed, of whom the eldest, Suzanne, was also to become a painter; her second husband was Jean Crotti. Between the births of Raymond and Marcel, the Duchamp family moved to Blainville, on the other side of the Seine loop, near Ry, where the original of Madame Bovary had lived and fallen in love with the district notary's clerk. But that young woman's tragedy did not seem to bother the calm Duchamps, who spent their evenings playing chess and making music.

Their maternal grandfather, Emile-Frédéric Nicolle, was the "family artist". He had given up his job as a shipping agent in order to devote himself entirely to painting and engraving. He lived in Rouen, and corresponded with Gaston, who was not yet known as Jacques Villon, when he was at the Lycée, and later at Law School. Gaston was beginning to draw, and he spent his Sundays at his grandfather's house, where the walls were lined with paintings and etchings of Rouen.

Art was not frowned upon in the Duchamp family. Madame Duchamp had inherited some talent from her father and painted dinner-sets. "She did Strasbourgs on paper," said Marcel, "and that's as far as it went."

Raymond and Marcel also went to the Lycée Corneille in Rouen; the former went on to Paris to study medicine, but had to give it up in 1900 after spending months in bed with rheumatic fever. He then became interested in sculpture, as he had learned to model several years before. He was very much influenced by Rodin.

One day, at a fair in Rouen, Gaston Duchamp saw that the booths of La Goulue were hung with big posters by Toulouse-Lautrec. He also went to an exhibition of Impressionists, at which, he said later, he was particularly struck by "the aura of the paintings". "I had no idea that there was such a thing as a science of painting or colour." The future Jacques Villon read Leonardo da Vinci's Treatise on Painting, which was to influence him later. In 1891, when he was sixteen, he did his first engraving, a *Profile of his Father*, without either varnish or mordant. As he knew nothing at all about how to prepare a plate, he used candle grease and plunged the copper into pure pharmaceutical acid. The result was awful. His *Portrait of my Grandfather*, done shortly afterwards, was more successful. Why didn't he consult his grandfather? "He was an onlooker," Villon said, "he didn't give advice." Villon therefore had to manage by himself.

He did no more engraving until 1899.

In 1894, Gaston joined Raymond in Paris. He enrolled in Corman's studio; Corman was not yet teaching at the École des Beaux-Arts but in the Boulevard de Clichy.

Rouen was the centre of a school of painters who were very stirred by Impressionism. From 1872 on, Sisley and

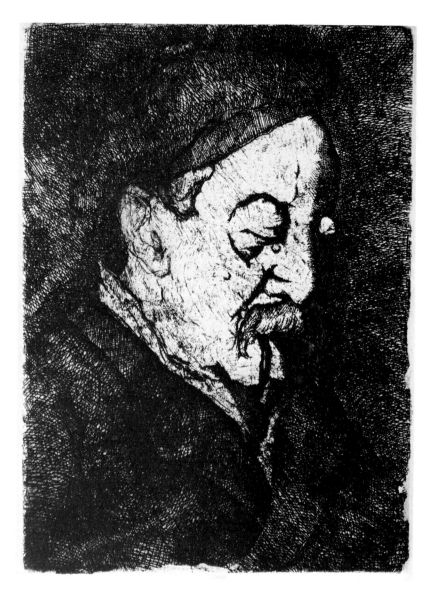

Jacques Villon *Portrait of Emile Nicolle*, 1891. (Villon's maternal grandfather). Etching.

Pissarro had given exhibitions at a local gallery, and Monet came to live at Giverny in 1883. Whenever they were in town, all three stayed at the Hôtel d'Espagne et du Dauphin, whose owner was none other than the pastry-cook Murer, one of the first collectors of Impressionist paintings. He had given up his cakeshop and restaurant in the Boulevard Voltaire in Paris to keep a hotel in Rouen. His friends' paintings consoled him for his failure as a novelist.

The Rouen painters frequented the Hôtel d'Espagne, and Eugène Murer showed them his Cézannes, Renoirs, Sisleys, Manets and Van Goghs.

Another patron and art collector was Félix-François Depeaux, a businessman and friend of Nicolle, who owned

a lot of Impressionist paintings and liked Sisley's work so much that he ended up with about fifty of his pictures.

It was Depeaux who was mainly responsible, by kindling competition and enthusiasm, for the formation of the Rouen school, a provincial branch of Paris Impressionism. Naturally, Emile-Frédéric Nicolle did not join this group of local innovators, but its influence was apparent in Gaston's early paintings, and, a few years later, in Marcel's work.

Of the future Villon's work, the landscapes and portraits of 1897-1898 are typical examples of the place and period; he continued this inspiration in Paris, where he did his military service in the 24th Infantry Regiment in 1897. The *Manor at Blainville* (Manoir de Blainville) dates from 1898, and his portraits of Edouard Lempereur, the painter, and of a cabaret singer—obviously from Montmartre—from 1899, preceding the portrait of Raymond Duchamp-Villon by a year. These rather laborious pictures are contemporary with bold, fresh and luminous watercolours which show Villon's grasp of the sketch and of his ability to define attitudes and social types.

After 1899, he took up engraving again, under the aegis of his next-door neighbour in Rue Caulaincourt, a young painter called François Jourdain, a friend of Lautrec, Bonnard and Vuillard among others. Jourdain's memoirs mention Villon as "as hospitable as one could possibly be"; he "welcomed a motley crew of painters without easels, gossip columnists without gossip, a former butcher's boy, a composer who later won the Prix de Rome, and Bibi la Purée.[1]" The future Prix de Rome was Aymé Kunc from Toulouse; when the friends next met, at the Albi Museum in 1955, Kunc was just ending his career as a boisterous orchestra conductor in

Drawing by Grass-Mick, 1902. In the centre, Jacques Villon.

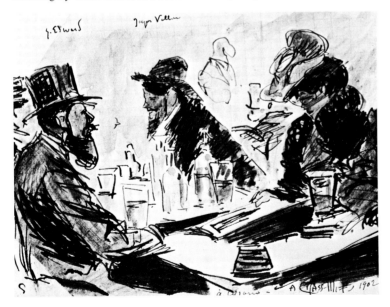

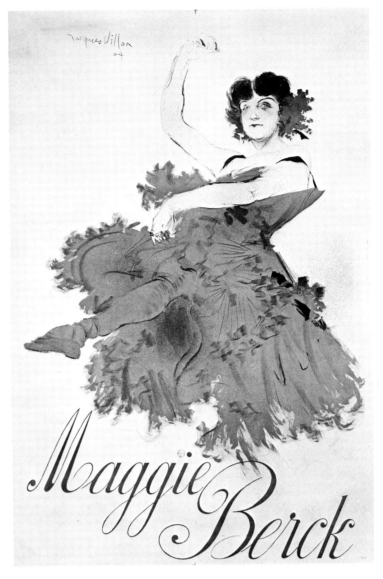

Jacques Villon *Maggie Berck Poster*, 1904.

his native town. As for Bibi la Purée, his real name was André Joseph Salis de Saglia, and he introduced himself as an "ex-student and friend of Verlaine". François Jourdain described him as "foul, dirty, thieving, ugly, and loyal", and Villon often used him as a model.

Villon now had his engravings printed by Eugène Delâtre, in Rue Tourlaque, and later by Edmond Sagot, in Rue de Châteaudun. His first copperplates were aquatints: *Le Nègre en Bonne Fortune*, which was exhibited at Sagot's and sold well, and *Spanish Dancer* (Danseuse Espagnole) and *Bernadette*, for which Villon used one of his favourite models. The lithograph *Dancer at the Moulin Rouge* (Danseuse au Moulin Rouge) was published in a supplement to the magazine 9

Jacques Villon *La Boudeuse*, 1900. (Sulking). Etching and colour aquatint.

L'Estampe et l'Affiche. The painter returned to aquatints with a portrait of his friend Supervielle, a Toulouse violinist. He also did posters, which were displayed on Paris hoardings along with those of Lautrec, Chéret and Mucha.

He earned a living by publishing cartoons in the small magazines and newspapers of the day. It was then that he became Jacques Villon, a pseudonym chosen at random, but also in homage to the author of the *Ballade des Pendus*. He did not want his own surname to be bandied about in rather controversial publications which often poked fun at morality, religion and the army. It was quite a Duchamp family tradition to change one's name: the notary called himself Eugène rather than by his given name, Justin-Isidore.

Jacques Villon's first cartoon appeared on 24 April 1897, in *Le Rire*, which had a wide circulation. His colleagues were the most popular humorists of the day: Georges Huard,

Abel Faivre, Ferdinand Fau, Burret, etc. Villon first contributed to the *Courrier Français* on 3 October 1897, and continued to do so until the paper, founded by Jules Roques as an organ of publicity for Géraudel pastilles, folded up thirteen years later.

Villon was doing so much work for *Le Rire*, *Le Courrier Français*, *Cocorico*, *L'Assiette au Beurre*, *Le Frou-Frou*, *Le Gil Blas*, etc. that he could not keep up with his painting and engraving as he wished. These two art forms presented no problems for him. "Until 1910 I painted as naturally as a

Jacques Villon

Portrait of Raymond Duchamp, 1900. Oil on canvas. p.11

La Cigarette, 1901. Etching and colour aquatint. p.12

Illustration for *L'Assiette au Beurre* No.1, 1901. p.13

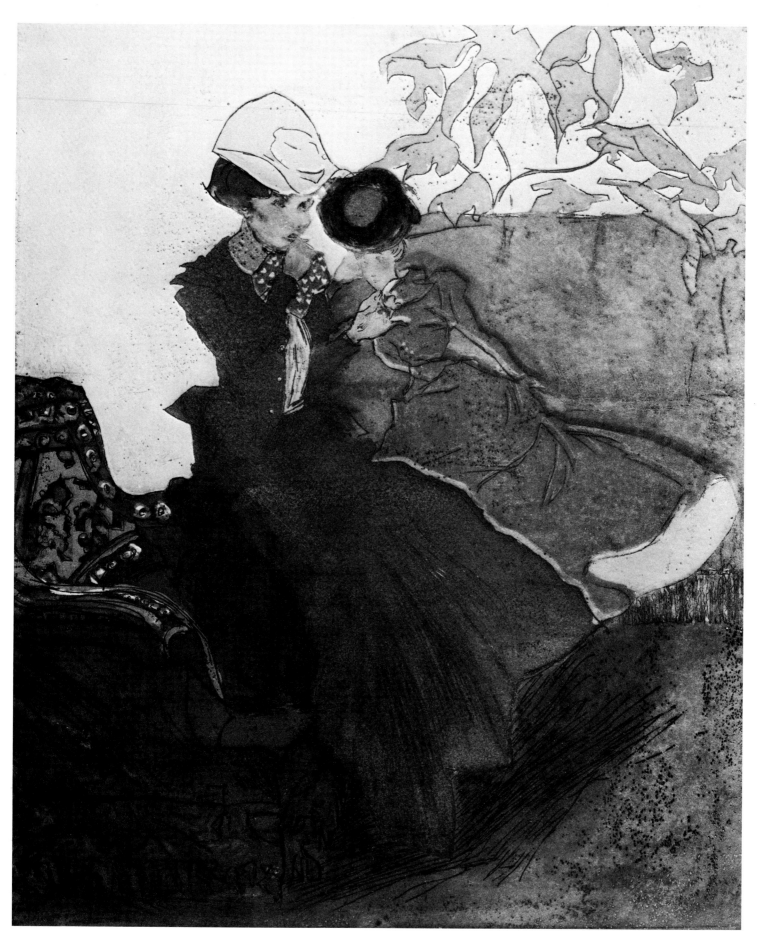

12

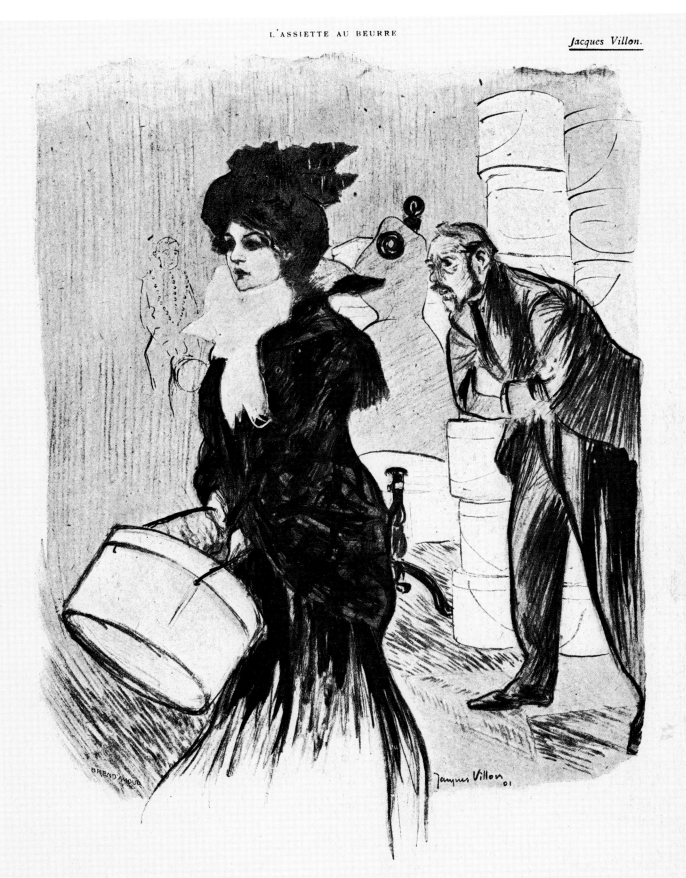

LE TRAVAIL DES FEMMES
— TOUJOURS DES AUGMENTATIONS! MAIS A QUOI PASSEZ-VOUS DONC LES NUITS, SACREBLEU!

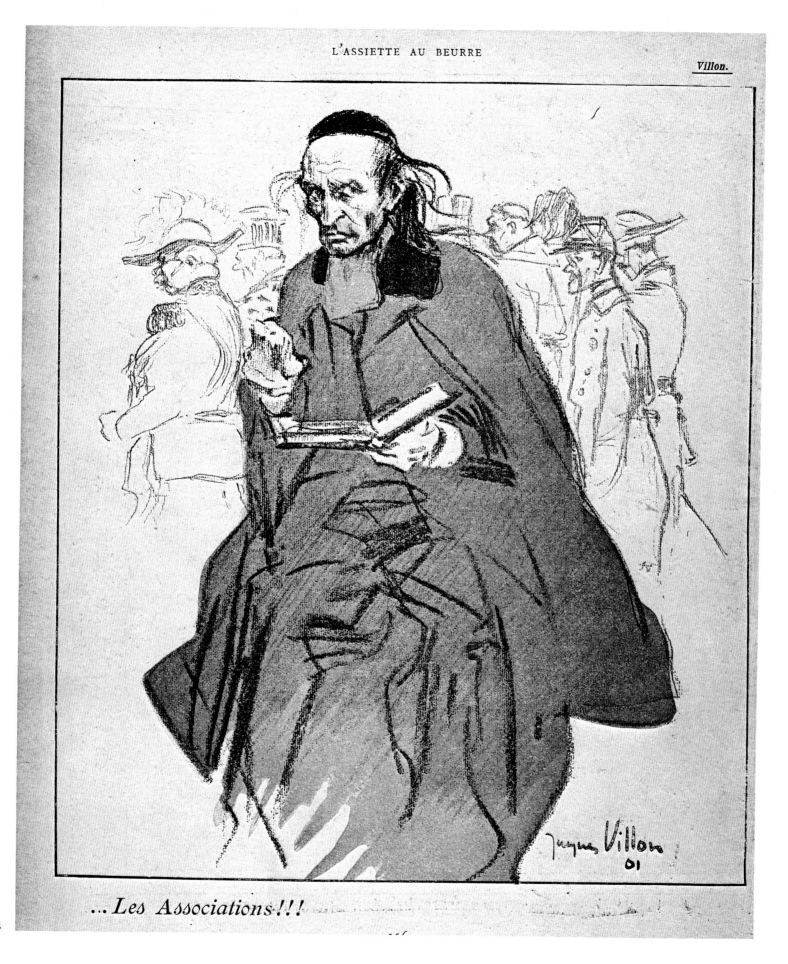

...Les Associations!!!

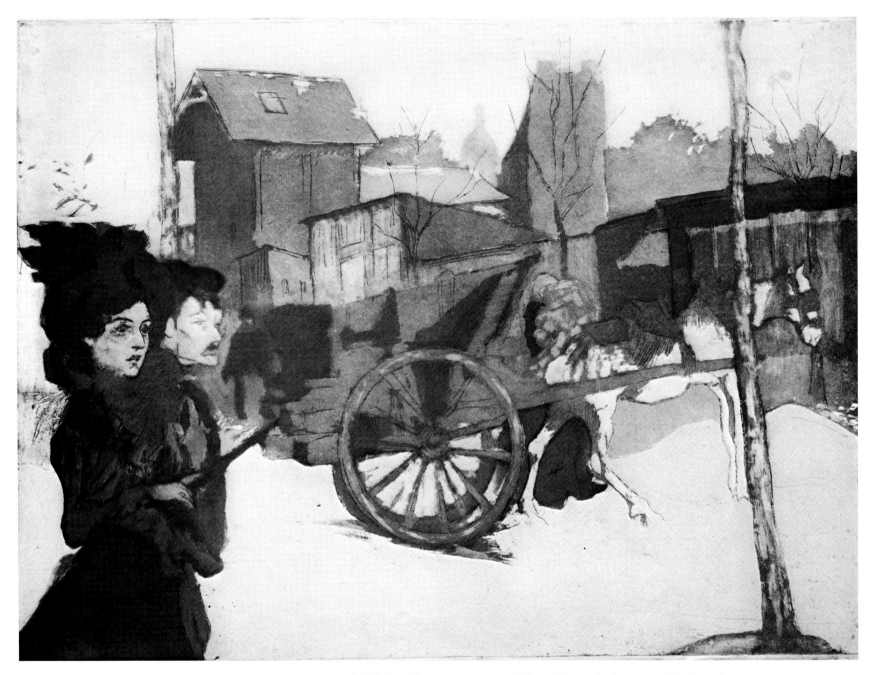

◄ Jacques Villon. Illustration for *L'Assiette au Beurre* No.9, 30 May 1901.

Jacques Villon *Maquis Caulaincourt*, 1901. Aquatint.

bird sings," he said. In fact, he was still influenced by post-Impressionism. The forcefulness of his portraits, the variety of style and medium, did not redeem the banality of the subject or the weakness of the composition.

His aquatints had greater depth; the subjects were convincing, and the working out of his vision was confident and precise. *Woman in Red* (La Femme en Rouge, also known as Sur un Banc) was published by Hessel, the Rue Laffitte art

dealer, and became a great success, although Edmond Sagot reproached Villon for his disloyalty. *Sulking* (Boudeuse) was exhibited at the Salon of the Société Nationale des Beaux-Arts in 1901. It was influenced by a contemporary engraver, Louis Legrand, whose popular success was at its peak; Villon, however, said that whenever he did anything he liked it was "like a mirror-image of Bonnard or Vuillard".

His posters, too, were very successful; the most beautiful 15

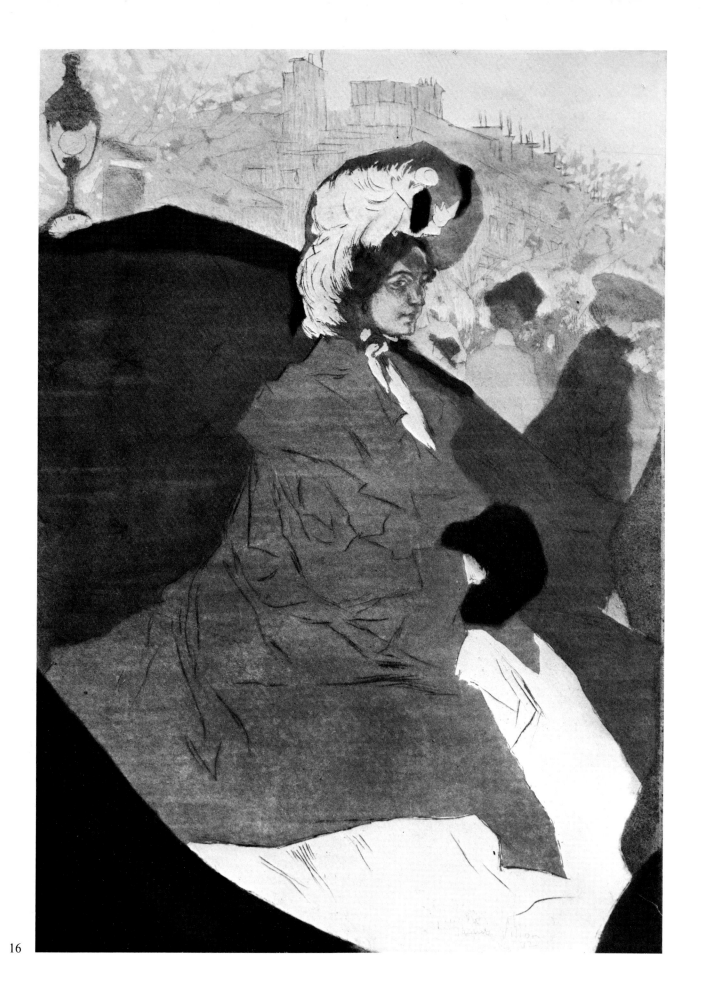

16

is also the best known and was done for Le Grillon American Bar Concert in 1899. In the same year, André Mellerio, the editor-in-chief of *L'Estampe et L'Affiche*, commissioned the lithograph *Dancer at the Moulin Rouge*. Villon knew the Moulin Rouge well, and had met Lautrec there a few years earlier. He did few lithographs altogether—Sagot published the best collection, *Impressions*, in 1907. The fresh colours and scenes taken from life have great charm; several plates are reminiscent of Manet in their extraordinary harmony.

Raymond Duchamp-Villon's sculptures were still influenced by Rodin, but his own decorative art-nouveau overtones resulted in such baroque works as *Head of Woman with Long Hair* (Tête de Femme aux Cheveux Longs)[2] (ca. 1900) and *Yvette Guilbert*,[3] a statuette of the singer. The draped folds of her dress form a sort of chalice at her feet. The Caf' Conc' was very popular with artists, influenced as they were by Degas, Lautrec, and the spirit of the Belle Epoque.

In 1904, Duchamp-Villon modelled a bust of his father[4] which harks back to Rodin's style. The sculpture is powerfully defined. "When he (Raymond) entered the fray and began to sculpt, he kept all the determination of someone who has chosen a certain art-form," Jacques Villon told Dora Vallier.

Very few of Duchamp-Villon's early works have survived; those few are notable for their varying influences, and one can perceive the signs of a young man painfully searching for the right track. Perhaps we can recognize a new direction in the oddly stylized statuette, *Aesop*,[5] whose impact lies more in a search for depth than in the treatment of the matter. The bust of Nicolle,[6] also dating from 1906, is a compromise: the subject is immediate, the planes of the face are firm, and the almost geometrical construction helps to concentrate the expression.

In 1907, Raymond Duchamp-Villon's work took a new turning. When his brother settled in Puteaux, the link between the Neuilly-based sculptor and the painter grew stronger and they saw each other often. Raymond's sculpture, *Torso*, was exhibited at the 1907 Salon d'Automne. *Torso* bore direct witness to his knowledge of musculature, doubtless gleaned from his earlier studies in anatomy. At that time, the young sculptor was mainly interested in realistic forms taken from nature but expressed as art. The indubitable power of the two busts of his sister Yvonne, one with short hair[7] and one long-haired,[8] springs from his architectural composition based on deliberately "taut" rhythms, and the simple use of mass. The long-haired work was inspired by a

retrospective exhibition of Gauguin's Maori figures at the 1906 Salon d'Automne.

Duchamp-Villon's drawings are rounded, well constructed designs done on a level plane and outlined in black. None of his contemporaries would have dared to draw nudes like that for fear of being too academic. But Duchamp-Villon avoided this pitfall, because his forms were so powerful and so rigidly delineated.

Duchamp-Villon started off by conventional methods, "turning" the model, but then aimed at showing the shape as a structural mass telling against space. Only the outline was modelled from the interior. Then the sculptor tackled the problem of light, influenced by Villon whose engraving technique had impressed him greatly. His essentially feminine nudes were built up from a basis of strong contrasts between light and shade, which are defined by the model's musculature. He stressed their character with highlights in white chalk.

Through the outward appearance, Duchamp-Villon saw what lay beneath the skin.

His *Pastorale*[9] shows a naked man and woman bowed like atlantes beneath a broken architrave. Apart from the decorative aspect, the art-nouveau overtones already prefigure the later preoccupation with architectural features. A year later, these same figures, released from their function as supports, surrounded the base of Duchamp-Villon's *Decorative Basin* at the 1910 Salon d'Automne.

His real breakthrough came in 1910 with his *Torso of a Young Man*, also known as the *Athlete*, a vibrant twentieth-century antique whose lines of force and intrinsic mass—in an incredible foreshortening—focus the impetus that jolts the figure forward like a tree stripped of its branches. It represents both energy and vitality.

Duchamp-Villon first exhibited in 1902 at the Salon of the Société Nationale des Beaux-Arts, and took part again in 1903 and 1904, the year Marcel Duchamp visited his brothers in Paris. Marcel went home to Rouen in 1905 to his parents and remaining three sisters. He did a term of apprenticeship at a printer's and reached a high standard in typography. He qualified as a "skilled worker" as a result of his brilliant success in the examination and thereby received a dispensation for two out of three years' military service, which delighted him.

All three Duchamp brothers were now artists. It is difficult to dissociate them from their Norman origins and background, the artistically-inclined, liberal bourgeoisie, which Villon respected, and which Marcel lampooned in an attempt to repudiate its influence. Nevertheless, like all his brothers and sisters, he remained attached to it.

The Flaubertian notary, his wife and his six children lived

Jacques Villon *Premiers Beaux Jours*, 1902. (First Fine Days). Colour aquatint.

in a bohemian yet claustrophobic atmosphere. Their spare time was taken up with chess, painting and music. Both closeness and alienation grew up within this nucleus: Madame Duchamp had a marked preference for her younger offspring, and, after his older brothers had left, Marcel, as the only son at home, was very lonely. But he was already learning to buttress himself by assuming a haughty detachment. His later aversion to marriage and children was probably due to his mother's attitude. His outlet was his love for his sister, Suzanne, who took up painting in her turn in 1905. In 1952, half a century later, Marcel repaid her with a joint exhibition at Rose Fried's in New York: the Duchamp Brothers and Sister—Works of Art.

The notary was understanding. He had let his two eldest sons go to Paris to become artists, and he did the same for Marcel, helping all three until he died. He had strong feelings about freedom, and probably thought he might vindicate Nicolle's engravings and his wife's flowers through one of his sons. M. Duchamp was also thorough. He painstakingly kept an account of everything he spent on his sons, and deducted the amount from their respective inheritance. Thus Villon, who, as the eldest, had received most—150 francs a month—for the longest period, found that his father had left him nothing, while the youngest Duchamp, Magdeleine, inherited a goodly sum because she had always lived with her parents and had had no outside expenditure. This amused Marcel greatly.

Nevertheless, family life at Blainville bequeated to him a lasting love of chess, which always played an important part in his life.

Once he had done his year's military service, he went to Paris, enrolled at the Académie Jullian, and tried, unsuccessfully, for a place at the École des Beaux-Arts. Thanks to Villon, he was able to earn a living by doing cartoons. Villon's drawings of women in lace bloomers and corsets, lecherous old men, coarse soldiers and narrow-minded clerics were very popular, and he was able to put his brother on the right track, though his curiosity and his horizons were limited.

Unlike Jacques Villon, Marcel Duchamp worked under his own name.

Villon's style was bold and incisive. He used his remarkable powers of observation to score a direct hit with his visual punch-lines. His cartoons, rather like his rough sketches, show a confidence that is lacking in his paintings, which were hamstrung by tradition and imitation. Some of his street scenes have the charm and spontaneity of a jotting. Villon was not cruel or cynical like Lautrec or Forain; he did not set himself up as a judge or a social reformer, but remained a witness.

His verve had already been harnessed for the *Rouen Artiste* and *L'Etudiant* in his home town, but the more vivid Parisian characters gave him wider scope, particularly those of the *demi-monde*, the basis of every humorist's repertoire: prostitutes, actresses, madams, dressmakers, artists' wives, and "widows" with their following of gigolos and spongers. The setting was the Paris of the Belle Époque and its playgrounds, with an occasional foray into garrets and maids' rooms, workshops, cafés and streets.

Villon's comedy of manners, spiced with mockery and mild eroticism, is biting but not mean. He was neither cynical nor bitter, though some of his controversial pieces are made passable only by their stylistic sincerity. The witness sometimes turned moralist, but without condemning or labouring the point.

Like Villon, Duchamp was influenced by Rouen Impressionism, which was far less fluid and luminous than that of the Ile-de-France, and at times even coarse and heavy. The painters were less preoccupied with light and colour than with a direct expression of their subject through solid outlines and clear colours. This is true of Marcel's first known paintings, *Landscape at Blainville*,[10] *Church at Blainville*,[11] and *Garden and Church at Blainville*,[12] all dating from 1903. Marcel soon mastered portraits and figures, but he stayed in this rut for several years.

His favourite model was his sister Suzanne, who was also close to him as a fellow artist. He drew her portrait in coloured pencils at Blainville in 1903. The following year, in Paris, he sketched Jacques Villon engraving in his Rue Caulaincourt studio, and Raymond Duchamp-Villon. While he was in Paris, he also sketched a few street characters; his love of detail is seen in his drawings of the *Moulin de la Galette* and of one of the domes of the Sacré-Cœur, as in his 1903-1904 Rouen study of a hanging gas lamp. This gas lamp motif was to become an important feature of his work.

"Between 1906 and 1910 or 1911, I rather drifted between various forms: Fauvism, Cubism, more classic styles," he said.[13] "My discovery of Matisse in 1906 or 1907 was a very important event in my life."

"In artistic circles," he added, "talk revolved round Manet. He was the master. It wasn't the Impressionists, or Cézanne and Van Gogh. Nobody had heard of Seurat. At that time, a lot of people regarded Cézanne as a flash in the pan."

Jacques Villon

La Partie de Jacquet, 1903. (Game of Backgammon).
Etching and colour aquatint p.19

Portrait of Monsieur Pierre D., 1903. Oil on canvas. p.20

Femme Nue assise, 1910. (Seated Nude). Oil on canvas. p.21

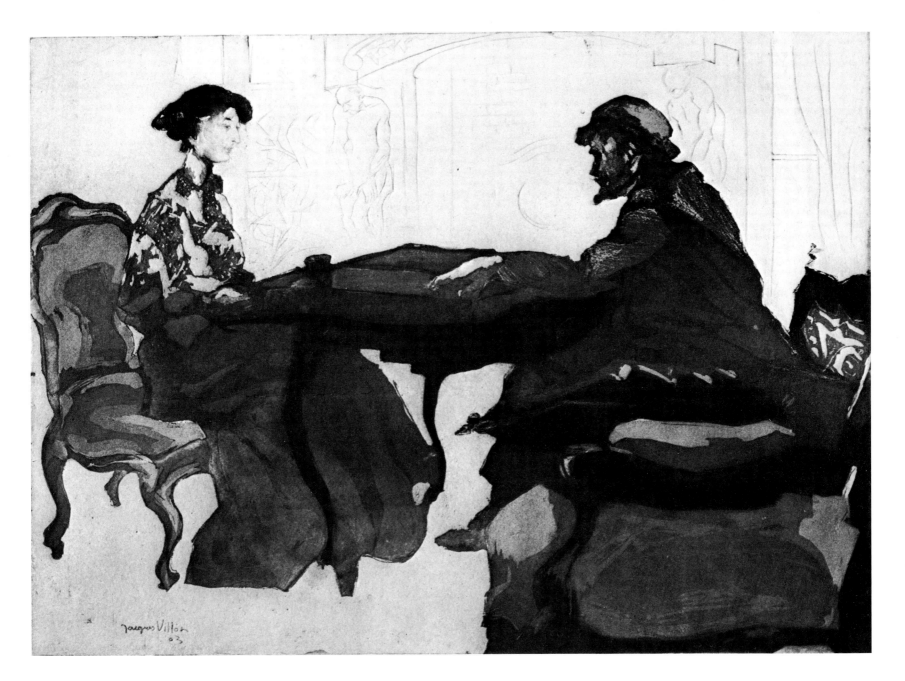

We must not forget that Villon and Marcel Duchamp mainly frequented the humorists of Montmartre and that both lived there. These were the circles of struggling magazines, newspapers and cafés rather than those of studios and art galleries, and consisted of people like Willette, Léandre, Abel Faivre, Forain, Georges Huard, etc. They had nothing in common with the groups of daubers hanging round Montmartre, the Bateau Lavoir, the Lapin Agile, and other places dominated by a small Spaniard with black eyes, one Pablo Picasso. The Duchamp brothers did not know him until later.

In his drawings, Villon had no scruples about lampooning the painters: one shows a portrait painter making a flattering picture of a hideous woman and saying to a friend, "If she goes on boring me I'll paint her more as she really is." (*Courrier Français*, 7 May 1889). In *Le Frou-Frou*, No 91, a classified advertisement "Painter seeks model, apply 222 Rue Tourlaque" is headed by a cartoon of the advertiser opening the door to a hatted applicant to reveal two naked women waiting patiently in the studio.

He sometimes went farther. A respected Master is showing his latest creation, a statue, to some extremely impressed 19

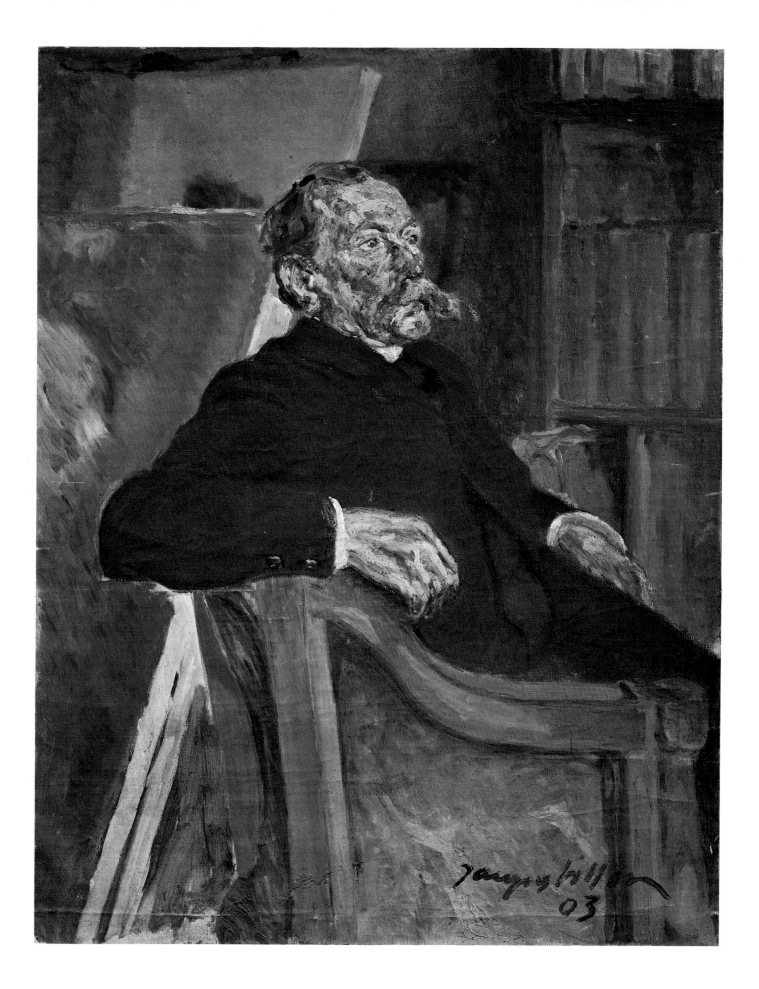

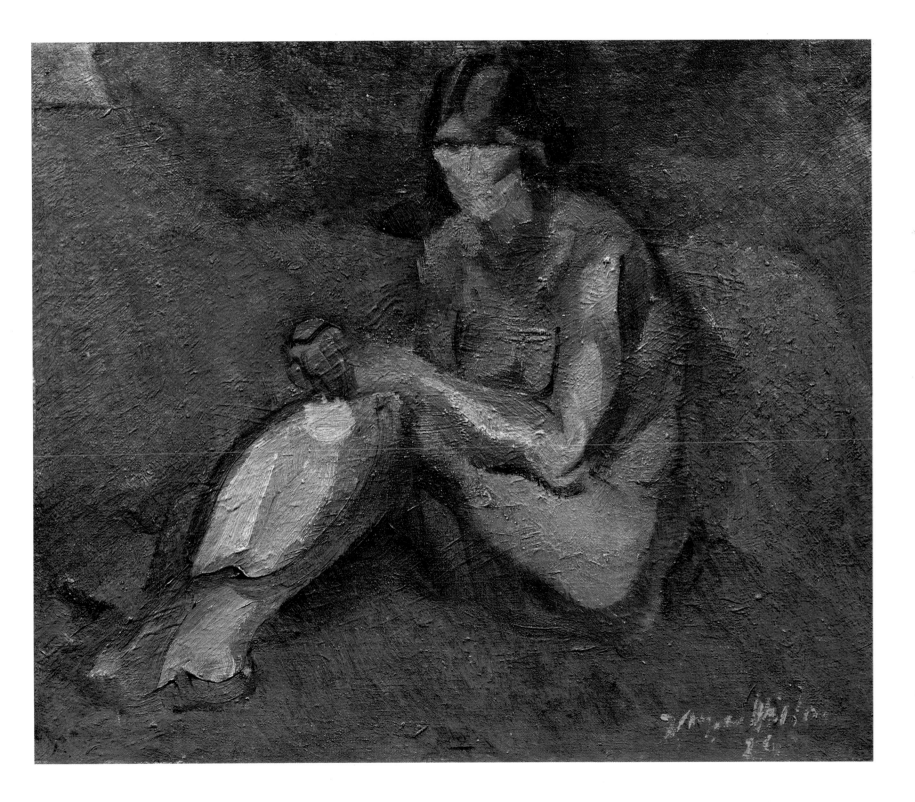

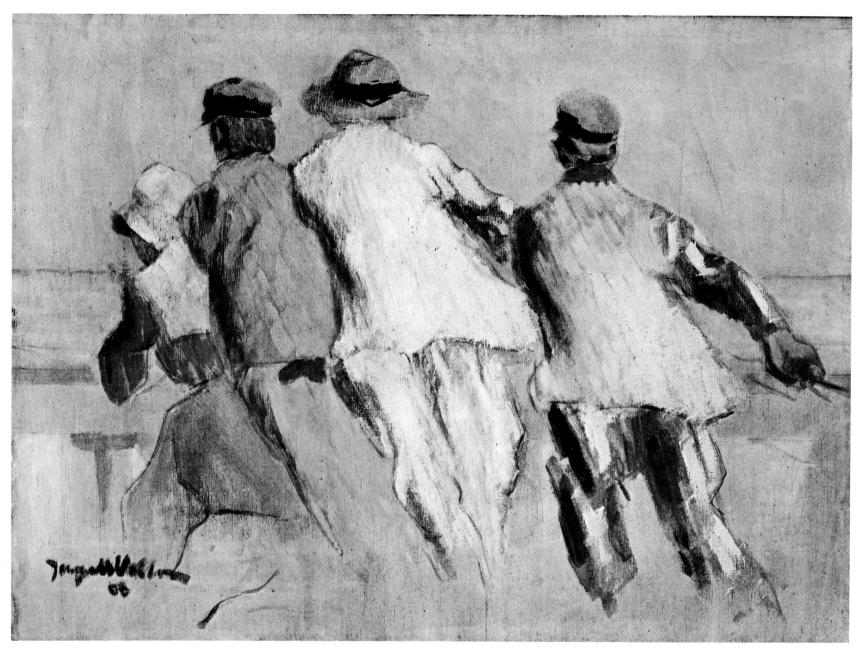

Jacques Villon *Les Haleurs*, 1908. (Haulers). Oil on canvas.

visitors, and behind a curtain lurks an artist in a smock, clutching the tools of his trade. The caption reads: "The Masterpiece—the artist did it, the Master takes the credit." (*L'Assiette au Beurre*, 1901). Visually, the cartoon is typical of Villon's sincere and beautifully drawn style.

Villon was such a natural artist that, Duchamp remarked, if he had an idea but no pencil to hand, he would outline the drawing in mid-air with his finger.

Humour was really a second string to Villon, as it was to Van Dongen, Kupka, Juan Gris, Marcoussis, and several others who chose to do journalistic pictures because painting could not keep body and soul together. "It took me fifteen years, though, to get out of the rut," said Villon. Duchamp rarely contributed to the *Courrier Français* or *Le Rire*, and found the pull of humoristic circles far less strong than his brother did. Villon's regular participation in the Salon

d'Automne showed how strongly he wished to be a painter, but nevertheless he was gradually fettered by his second string. He had a gentle but weak character. "The worst thing for me was when my friends started to encroach on me. They came over to smoke their pipes, brought along their women friends, and stopped me working. I had to make up at night for the time they wasted during the day."

Already Villon's kindness, linked with an inability to stand up to anyone stronger than himself, was the dominant feature of his character. He needed peace and quiet, so he decided to leave Montmartre for the rustic suburb of Puteaux, which then seemed like the other end of the world. Villon, like Marcel, was probably not sure where he was going, for he could not assess his resources very well and vacillated between the relative security of journalism and the uncertainty of an artist's life, of which neither he nor his brothers yet knew very much.

Marcel was the first to choose freedom, triggered by his discoveries of Fauvism and Matisse, although he rarely saw the latter. "His paintings at the 1905 Salon d'Automne really moved me, particularly his big, flat-tinted red and blue figures," he said. "It was a big thing at the time, you know. It had a tremendous effect."[14] Duchamp also went to the Galerie Druet in Rue Royale, where Bonnard and Vuillard exhibited. "They were anti-Fauve." He admired Vallotton "because he lived at a time when everything was red and green, but he used dark browns and dull, cold colours. He foreshadowed the Cubist colour-range."[15]

From 1906 to 1908, Marcel Duchamp's paintings traded Impressionist subtlety for Fauve boldness. The splashes of colour, almost unmixed in *On the Cliffs* and *Red House Among Apple Trees*, give strength and consistency to his still very conventional landscapes. But they had the added bonus of a Van Gogh-style series of light strokes, and something of Bonnard's flaky intimacy: a strange mixture.

Villon now combined engraving and his work for magazines. Away from Parisian life, he found the peace he needed; his temperament was not really suited to the Montmartre rabble, or to nights spent talking, drinking and smoking, and to the dances and cabarets with their dubious fauna. And anyway, he had got married.

His subjects still harked back to 1900: from *demi-mondaines* to social characters by way of street scenes. As in his cartoons, Villon's sharp Parisianism occasionally revealed the steel underlying his light sketches. The facile tricks of Helleu, "the steam Watteau", mingle with Forain's ferocity and workers in Steinlen's, or even Raffaelli's, style, inspired by Bibi la Purée, and rub shoulders with paintings of Parisian life synthesized in the Nabi manner. Villon's mere hints at background and outline give his aquatints a very bold abstract quality reminiscent of Bonnard.

Le Garrec, Sagot's son-in-law and successor, successfully exhibited Villon's aquatints and drypoints, such as *Autre Temps, 1830* (Old Times, 1830) (1904) executed for the Henri Monnier ball, which was organized by Maurice Neumont, the painter. Villon exhibited this important engraving, typical of its time, at the 1905 Salon de la Nationale.

The Game of Chess (La Partie d'Echecs), a popular subject with the Duchamp family, is a drypoint engraving and aquatint (1904) showing Marcel and Suzanne playing chess. The firm, boldly engraved lines reflect Villon's sureness of hand. Large well-placed white areas give plenty of breathing space to the two players, who are also visually excellent.

From 1904 to 1907, when Villon stopped doing coloured aquatints, his engravings show his enthusiasm for contrasting light and shade, and the charming effect of these nuances on the play of lines. He was gradually moving towards a more precise composition: deeper blacks, hatching spaced more closely to add intensity to the mass. By way of his etchings Villon was approaching a painting style he did not yet know or sense.

Several important engravings date from 1905: *Sur la Plage, Le Tréport* (On the Beach), a clearly coloured aquatint whose companion piece is an equally enchanting gouache watercolour of the same place. *Sous la Tente* (In the Tent), *Blonville, Le Potin* (The Gossip), *La Normande, Au Val-de-Grace, Femme au Chien Colley* (Woman with Collie Dog), and *Transatlantique* (Gaby Villon) encompass beaches, drawing rooms, cafés, studios and street scenes. The engraver's eye was also that of a reporter chronicling his era in sensitive detail.

Les Petits Haleurs (The Haulers) (1908) is the first version of a theme to which Villon returned several times during his lifetime.

In 1905, his paintings, drawings and etchings were exhibited at the Galerie Legrip in Rouen, together with Duchamp-Villon's statuettes, busts and drawings. Duchamp-Villon first exhibited at the Salon d'Automne in the same year and continued to do so regularly until 1912.

"What did I know about painting at the time?" Villon asked Dora Vallier fifty years later.[16] "I suppose it didn't really interest me. Anyway, what was there? The Nabi school. I'm not sure if I knew that term; I had vaguely heard of Maurice Denis, Bonnard, Vuillard... I knew very little about Fauvism... I was too wrapped up in journalistic work and engraving to take much stock of that movement... At that time colour fascinated me, but I had no science to back it up, and the Fauve experiment couldn't have meant much to me. In my own painting, I was nowhere near giving colour much importance."

Villon was at a geographical and mental distance from artistic Paris, without news or outside encounters, and was, besides, busy with his artistic contributions and his engravings. He only heard about the outside world through his brothers. Picasso? "I saw him from a distance," said Villon. Braque? "I hardly knew him," answered Duchamp. "I merely said hello to him, but we didn't talk... There was also the difference in our ages." Delaunay? "I remember going to Bullier[17] and seeing him holding forth at length, from a distance, but I didn't even meet him," said Duchamp, who hardly knew Matisse and frequented Picasso only in 1912 and 1913. From 1906 to 1908, Raymond seems to have been the most enterprising of the three brothers: it was he who sought, and received, information, but it was Marcel who was to "tip the scales", according to Jacques Villon.

Villon exhibited four pictures at the Fauve-oriented 1905 Salon d'Automne: *Partie de Dames* (Game of Checkers), *Jour de Pluie* (Rainy Day), and two portraits, as well as a pastel, *Le Potin* (The Gossip), a drawing, *Province*, and three engravings.

The following year his contributions comprised *Petite Boudeuse* (Sulking), painting and drawing, three further drawings and one engraving. In the same year, 1906, he left Montmartre and moved to 7 Rue Lemaître, in Puteaux, where he lived with his admirable wife, Gaby (Gabrielle Bœuf) until his death fifty-seven years later. In 1905, the year he married, he painted a neo-Impressionist portrait of his wife in a flowing, close style marked by impasto and a luminous aura. These traits reappear in some of his other surviving pictures of the time, such as *Sous la Tente sur la Plage* (Tent on the Beach), *Portrait of Raymond Duchamp-Villon and His Wife Playing Chess*, *La Couture*, etc.

The sculptor married around the same time as his brother. His bride was Yvonne Bon[18]; his brother-in-law, Jacques Bon, was a strange, skinny personage, a jack of all trades, who helped Jacques Villon with his work and was one of his most picturesque friends until the little phalanstery of Rue Lemaître broke up.

Marcel Duchamp rarely went to the Salon. "All the same, it was at the Salon d'Automne that I decided I could paint," he said.[19] At Rouen, he had been influenced by a very talented boy, Pierre Dumont, whose personality was already extremely forceful; Dumont had lived in Paris, but impecuniousness hastened his return to Rouen where his paintings, with their violent Fauvism, irritated the local bourgeoisie, who found his colours vitriolic. In 1909, he founded the Société Normande de Peinture Moderne whose avant-garde exhibitions included works by Villon and Duchamp, were championed by Apollinaire, and scandalized high society.

Three years later Dumont and Villon helped found the Salon de la Section d'Or in Paris. Dumont adhered to Cubism, but after the war his work was often interrupted by bouts of mental illness. He died in 1936 in poverty and obscurity, with his right hand paralysed. Attempts have since been made to restore him to his rightful place.

"Pierre Dumont did what I did, only more so," said Duchamp.

Few works survive from the three brothers' formative years, apart from the now catalogued series of Villon's early engravings and cartoons.[20] He and Marcel were still in their Fauve period, the latter more interested in colour, his elder brother already fascinated by proportion and harmony. Today it is hard to understand the passionate controversy over unmixed colours. "You should have heard what happened when Matisse had the nerve to use pure green in a painting!" said Picasso. "Everyone thought he'd gone mad." The press of the time clearly reflects the general reaction.

During those early key years of modern art, the Duchamp brothers witnessed the inevitable uneasiness of a time when every artistic tradition underwent renewal and change. While the public accepted innovations in science and technology, it could not stand any changes in its concept of visual art. It seemed as if the very foundations of day-to-day existence were directly threatened; no sooner had people learnt—with great difficulty—to accept Impressionism than a new outrage appeared. As the three Duchamps themselves belonged to the Norman bourgeoisie by origin and upbringing, they were very circumspect; they liked neither gratuitous risks nor groundless rebellion, and avoided emotional excesses. "Art is the expression of some basic truth, not a romantic outpouring," Villon once said. The Duchamp brothers all shared this creed.

In autumn 1907 the painters' circle in Montmartre was shaken to the core by *Les Demoiselles d'Avignon*. Picasso showed the great composition on which he had been working for months at his Bateau-Lavoir studio to a few dumbfounded friends. The shock did not carry as far as Puteaux and, had it done so, the reaction would have been the same as that in Montmartre. No one realized that a revolution was beginning.

At the 1908 Salon d'Automne, Matisse examined three Braques painted at L'Estaque in Provence during the summer, and talked about "cubes". In *Gil Blas*, 14 November, Louis Vauxcelles took up the term in an article on abstract art. "Braque reduces everything to geometrical forms, to cubes," he wrote. The following spring, when describing

Jacques Villon *Suzanne au Piano*, 1908. Drypoint.

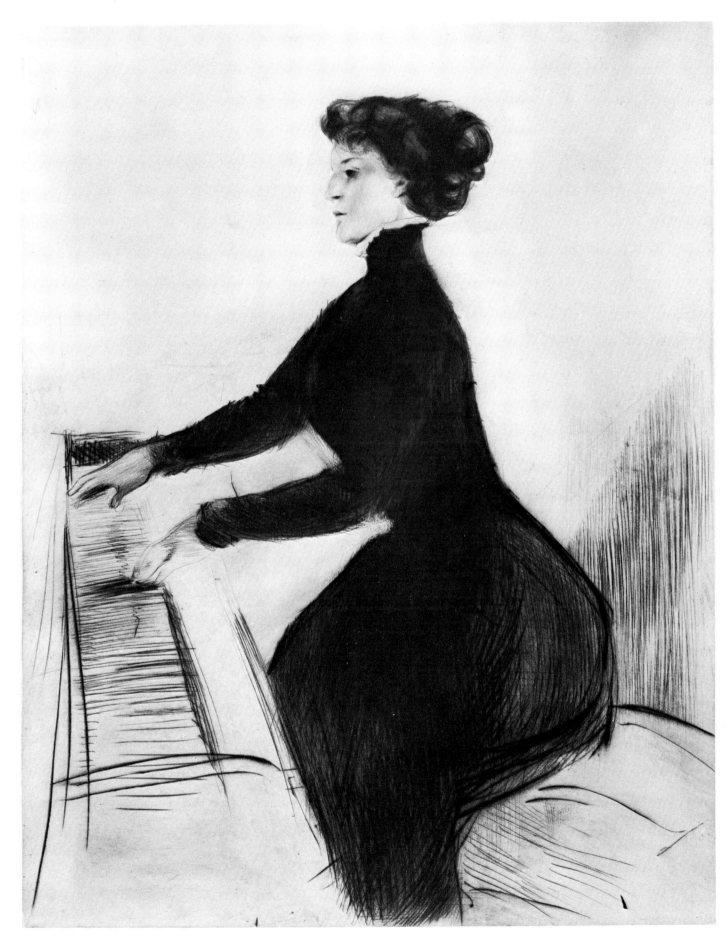

25

Jacques Villon *La Lecture sur l'Herbe*, 1910, second plate. (Reading Outdoors). Soft-ground etching and two-tone aquatint.

new paintings at the Salon des Indépendants, Vauxcelles mentioned "Georges Braque's cubic oddities".

There was some contention as to who had invented Cubism; finally, the question became irrelevant, and both Braque and Picasso set the example to painters who were interested in the relation of an object to time and space, or vice versa, the position of time and space in relation to an object seen from every angle and from inside. But these experiments took place virtually *in camera* and had no discernible effect on painting: at that time, the art world of

Paris was very insular, and there were very few contacts between the variously affiliated groups. Few people knew what was going on at Montmartre. Nevertheless, Cubism spread like wildfire, and the first general Cubist exhibition took place at the 1911 Salon d'Automne, to which neither Braque nor Picasso contributed. The critics and the public were able to take stock of the vitality of a movement that had already overtaken its original concept.

Duchamp's Fauve period ended in 1910. He had exhibited for the first time at the Salon des Indépendants in March

Jacques Villon *La Lecture sur l'Herbe*, 1910, third plate. (Reading Outdoors). Drypoint and colour aquatint.

1909 with *Saint-Cloud* and *Landscape*. In October, he sent *Study of a Nude*, *Veules (the Church)* and *On the Cliff* to the Salon d'Automne, and exhibited two *Studies of Nudes*, a *Still Life* and *Masque* at the Indépendants in 1910. These works cannot be identified today; either they are lost or known under different titles.

Duchamp sold the Saint-Cloud landscape to an unknown art dealer for 100 francs, and at the Salon d'Automne of 1910 or 1911, Isadora Duncan bought one of his nude studies. Later, when he knew the famous dancer, Marcel thought of asking her what had become of the painting, but decided against it. With his usual detachment, he said, "She must have bought it as a little Christmas present for one of her men friends."

Like Villon, Marcel disliked the Montmartre bohemian set and being one of the mob, so in 1908 he settled at Avenue Amiral-de-Joinville in Neuilly, near the flat in Rue Parmentier where he was to stay the six months a year he spent in France until he died. The youngest Duchamp, Magdeleine, never married and now lives in that very house.

27

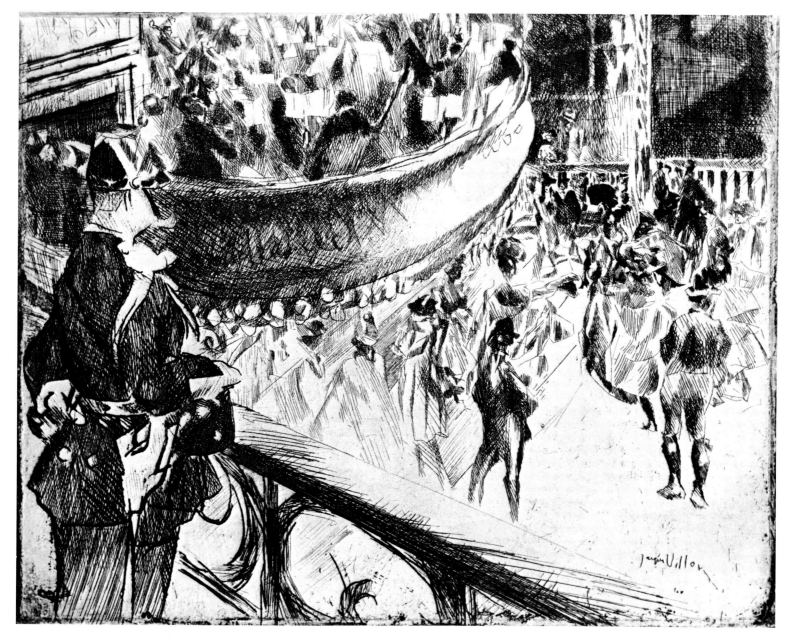

Jacques Villon *Bal au Moulin Rouge*, 1910. Etching, second state.

None of the Duchamp brothers liked moving or indeed any change, not even Marcel. They were happiest at home, and would not have dreamed of changing their decor to fit in with new architectural or technical trends.

Marcel was fond of peace and solitude: he kept quiet about his love affairs and had few friends. He was not gregarious and did not like the idea of collaboration, or art discussions. He wanted, above all, to retain his independence and, like Cézanne, hated people to lay down the law for him. His two brothers, for whom he had the greatest affection, were "artists". He disliked both the term and the concept.

Jules Roques died in 1910, and the group of contributors to the *Courrier Français* dispersed. Villon handed in his two last drawings (one signed Duchamp) on 9 April. He was stunned, and it was Raymond who comforted him.

THE PUTEAUX CONSPIRACY

At the end of his life, Villon often told his friends how sad he had been about giving up his chronicling of Parisian life, and cited the example of Constantin Guys, whom he admired. "The art of pictorial journalism has been lost completely," he said. Maybe he could have reinstated it. Duchamp-Villon encouraged his brother to paint. Villon may have been a painter already, but he was uncertain what direction to take, what language he could choose to create a form rooted in imagination rather than reconstructing reality. "I felt as if I weren't in tune with the painting going on around me," he said. During that time Marcel Duchamp was forging ahead. "We paint because we want to be free," he said. "We couldn't go to the office every morning."

At Puteaux, in August 1910, his brothers and their respective wives posed for *The Chess Game*,[21] which Marcel exhibited at the Salon d'Automne together with four other paintings. That same year he and Villon took part in the first exhibition of the Société Normande de Peinture Moderne in Rouen. *The Chess Game* was Marcel's largest painting to date: it was the apotheosis of a series of pictures done in the year when he tried to go beyond the synthesis of Impressionism and Fauvism by including one or more people—nudes, faces, then a grouping. These works express psychological intent rather than pictorial experimentation; Marcel Duchamp's mental processes were clear though not yet fully achieved because of his links with contemporary painting. He did not know how to replace them, as he had no style of his own.

The portrait of M. Duchamp, the artist's father,[22] the provincially Fauve head of the Rouen painter Chauvel,[23] and the portrait of Dr Dumouchel[24] also date from 1910. Marcel later described this last to his friends the Arensbergs: "The portrait is very brightly coloured (red and green), and there is a humorous note, which already suggests my future change of direction and my rejection of purely retinal painting."

These paintings display Duchamp's reliance on form, colour and composition to express—as in *The Chess Game*—other people's attitudes, stance and character. His use of

Marcel Duchamp *Fillette laçant sa chaussure*, 1902. (Girl Lacing her Shoe). Wash.

29

30 Marcel Duchamp *Suzanne Duchamp Seated*, 1902. Watercolour. Marcel Duchamp *Landscape at Blainville*, 1902. Oil on canvas. ▸

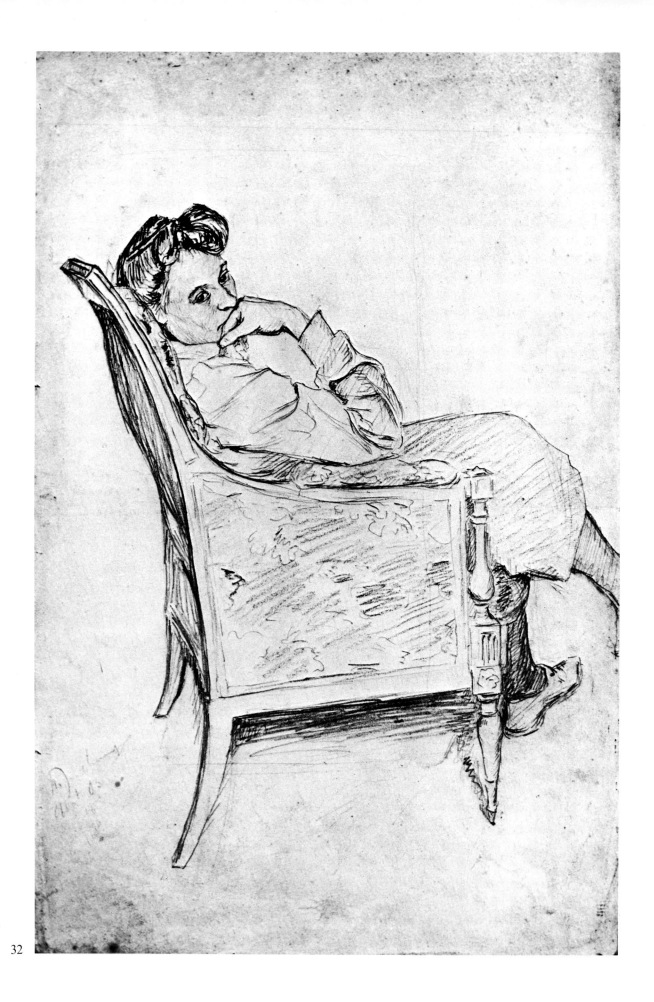

Marcel Duchamp

Suzanne Duchamp Seated in an Armchair, 1903.
Coloured pencils. p.32

Raymond Duchamp-Villon, 1904–1905. Pencil. p.33

Portrait of Yvonne Duchamp, 1909. Oil on canvas. p.34

Portrait of the Artist's Father, 1910. Oil on canvas.
 p.35

unmixed colour was already a pledge; in spite of technical differences, his build-up of colour is reminiscent of Cézanne and hints at his aim to release the core of being conceptually rather than visually. But the results were still unsure.

Laundry Barge,[25] painted at Neuilly in 1910, is among his most "Fauve"—untamed—pictures of that period. Unmixed colour swamps shape and captures the violent impact of a landscape on the senses. Marcel's theme is richly expressed by large, thickly painted areas of colour. However, true Fauvism was already several years out of date.

"Apropos of your face, my dear Dumouchel": thus Marcel dedicated the portrait of his friend, whose face and hands he had outlined with a sort of coloured halo. The head is drawn solidly and plainly, with prominent cheekbones and a strong nose and chin. Large, thickly painted masses of blue, pink, green and purple provide harmony, and the humour probably lies in the method—original at the time—of painting a person in a Fauve-Naturalist style. Nobody painted like that at that time. Dumouchel is seen naked as Adam in *Paradise*,[26] painted about the same time as his portrait, a light ochre Adam and a crouching, brick-red Eve in a landscape of harsh but deep greens.

The mockery was obvious. The traditional theme and characters, the design, the colouring, even the positions of the protagonists are imbued with the same sense of parody as *The Bush*[27] and *Baptism*[28]. However, we must not attach more importance to this style than Duchamp himself did; to him, it was just a stepping stone.

On the other hand, he loved talking about *The Chess Game*, thanks to which he was made "sociétaire" (member) of the Salon d'Automne. But that was not the reason why he liked it: it was the threshold to adventure.

The picture shows Jacques Villon and Raymond Duchamp-Villon playing chess in the garden at Puteaux. The two bearded men are bent over the chessboard, deep in thought. Their two wives, one sitting by the tea table, the other semi-recumbent on the grass, are careful not to break the players' concentration. This family scene, with its bright colours and long lines emphasized with black strokes, with its fleecy yet heavy style, is a fresh homage to the game the Duchamps loved.

Marcel was aware of the gulf between *The Chess Game*, painted in August, *Sonata*,[29] begun in Rouen in January 1911 and finished in December, and *Portrait (Dulcinea)*,[30] which must be dated before October 1911 as it was exhibited at the Salon d'Automne in that month.

Draft on the Japanese Apple Tree[31] was painted at Puteaux in 1911, *Young Man and Girl in Spring*[32] in Neuilly, also in 1911 and dedicated to Suzanne on the occasion of her marriage to a Rouen chemist. Marcel was deeply shaken by this event as he thought of it as the end of his close relationship with Suzanne.

The allegorical subject of *Young Man and Girl in Spring* foreshadows the *Large Glass*: the Virgin becomes the Bride sought by the Bachelor. The complexities of the painting, and particularly its lack of sexual differentiation between the young man and the young woman, left it open to various, even scurrilous, interpretations. That was to happen often with Marcel's work, especially the *Large Glass*.

These two 1911 paintings, *Draft on the Japanese Apple Tree* and *Young Man and Girl in Spring* are both symbolic, half realist and half visionary works. The rare but subtle bursts of colour—pink, blue, grey and green—the drawn-out or broken lines, and the atmosphere are in direct contrast with the black outlines, harsh colours and large forms of many earlier works, notably the strange *Baptism*. In *Draft on the Japanese Apple Tree*, which is really only a corner of the garden at Puteaux, a sort of female Buddha crouches under a pink tree in green-hued surroundings; the model often posed for the Duchamps at that time, and they called her "*la Japonaise*". Arturo Schwarz writes[33]: "The role of the Tree and the Apple in various religions is too well known to be commented on... whereas in esoteric writings draughts are always associated with Revelation, the figure seated in exactly the same position as that attributed to Buddha seems to indicate that the neophyte of *The Bush* and *Baptism* has finally reached a state of illumination."

Duchamp's watercolour of "*la Japonaise*", *Nude with Brown Skin*, is his only work to have appeared at a public sale— John Quinn's in 1927—until the sale of a set of optical disks in Bern in 1958. Marcel dedicated *Draft on the Japanese Apple Tree* to his sister-in-law, Gaby Villon: "To Gaby. Marcel Duchamp, circa 1911", and it was published in the *Almanach Surréaliste du Demi-Siècle* in 1950.

This period was marked by many paintings and studies; *Sonata* was Marcel's turning point. The reason for this change was Cubism.

"I took it very seriously," he said.[34] But he did so with a certain caution shared by Villon and Duchamp-Villon. "Distrust of stereotyping," added Marcel, stressing, "I could never bring myself to accept established formulas, or to copy or be influenced to the point where I remembered something I had seen in a shop-window the day before."

Marcel Duchamp *Red Nude*, 1910. Oil on canvas.

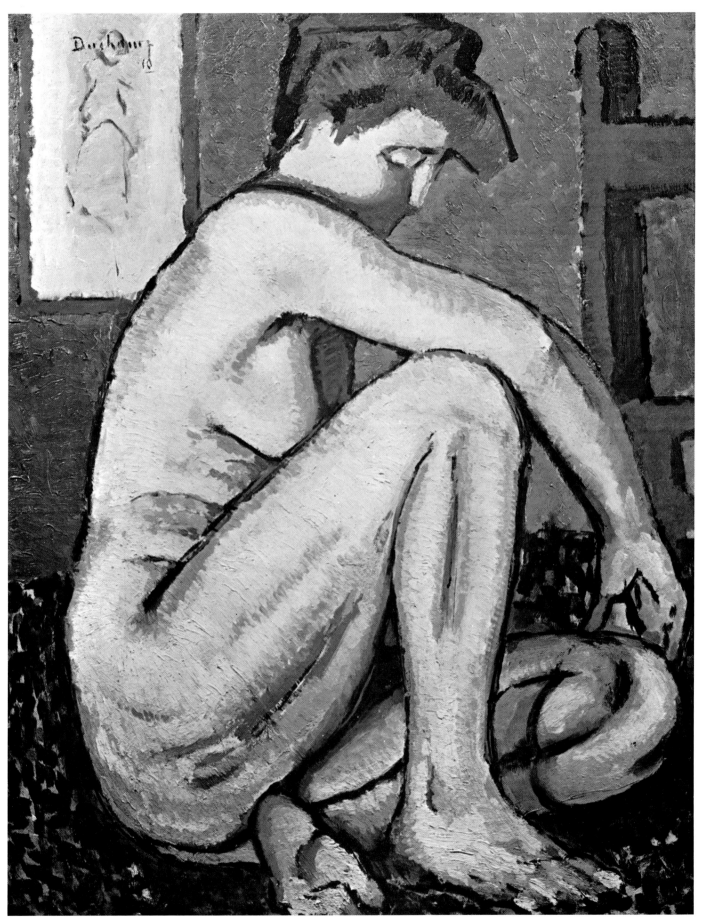

"When I realized that a picture wasn't just a window through which one sees a landscape," said Villon,[35] "but a real invention and re-creation of something seen, I felt like a new man."

They knew very little about Cubism, and that little was gleaned from conversations between critics and artists at the Puteaux studio. The three brothers were not shocked by Cubist paintings, but, characteristically, assimilated them calmly. They visited—mainly Duchamp—the Galerie Kahnweiler in Rue Vignon, the only place where it was possible to see the works of Braque and Picasso: Braque had not exhibited in the Salons since the Indépendants in 1909, and Picasso never did.

On 20 February of the same year the *Manifeste du Futurisme* (Manifesto of Futurism) had appeared on the front page of the *Figaro*, and on 11 February 1910, a year later, Balla, Carrà, Russolo, Severini, Boccioni and others signed the *Manifesto of Futurist Painters* (Manifeste des Peintres Futuristes).

Marcel Duchamp and Duchamp-Villon took part in the 1910 Salon des Indépendants and Salon d'Automne. At Kahnweiler's Fernand Léger met Braque and Picasso, who was painting a series of portraits of Braque, Vollard, Kahnweiler and Wilhelm Uhde, described as "analytical Cubism". With the help of precise realistic overtones, the models are shown from every angle in staggered perspective and juxtaposed planes acting on each other rather like splashes of colour in Impressionist painting. Each form is intensified or attenuated by its juxtaposition to the next, and this succession of simultaneous evolutions vitalizes the whole.

At Puteaux, meetings were held on Sunday, and again the next day at Gleizes', in Courbevoie, and sometimes again on Tuesdays at Paul Fort's, at the Closerie des Lilas. From 1912 on, Fort gave well-attended dinners in Balzac's former house in Rue Raynouard at Passy. Another meeting place for artists, critics and their friends was a café in Place de l'Alma.

There was a definite schism between the Puteaux-Courbevoie group and the Braque-Picasso set, which held court in Montmartre and at Kahnweiler's in Rue Vignon, its urban headquarters. The two sides observed each other across the Seine and the town.

Among those who frequented Puteaux were Kupka, the Czech, who had lived in a neighbouring house in Rue Lemaître since 1906, Villon, Tobeen the Englishman, Gleizes, Metzinger, Picabia, one of the pioneers of non-figurative art, La Fresnaye, Le Fauconnier, André Mare, and Fernand Léger. Although Léger had been exhibiting at Kahnweiler's since 1910, he felt more affinity with the Puteaux group than with Braque and Picasso, his fellow-exhibitors.

The Puteaux group did not confine themselves to discussions beneath the shady trees; they practised archery, played darts, games of chance and other games. From a distance, one cannot single out any one particular moment or earth-shaking event, but the meetings at Puteaux are, as a whole, vital to the history of contemporary art, and—still lurking in the shadows—its battles, pledges and feverish preparations for the future.

Apollinaire occasionally assumed the role of liaison officer between Montmartre and Puteaux. No one took him seriously, though he tried hard. He was a strange man: charming, inconsistent, intrepid and loyal, he was said to know nothing about painting, and often made blunders. He spoke and wrote at random, and his changeable opinions depended on chance encounters, friends, and financial needs.

Duchamp, who did not know him very well, said, "He was a butterfly. He stayed with us and talked about Cubism, and the next day he would be reading Victor Hugo in a drawing room."

In fact, Apollinaire was leading a difficult life. The demands of journalism took up most of his time and allowed him no mental leeway. Nevertheless, he coined some felicitous phrases about some of his artist friends, and though his essentially poetic criticisms lacked weight, they showed genuine insight.

Cubism dumbfounded him. Its conceptual forms went beyond his grasp of the purely retinal, but though he did not understand the content of the paintings, he sensed the revolution they were initiating. He was close to Picasso, Braque, Derain, Kahnweiler, Picabia and Léger, and through them he tried to find the dialectic means of moulding his analytical language to the Cubists' new artistic language. He was instinctively for them, because they were innovators, but it was hard to define this novelty in words.

Marcel Duchamp

Laundry Barge, 1910. Oil on cardboard. p.39

The Chess Game, 1910. Oil on canvas. p.40

Portrait of Dr R. Dumouchel, 1910. Oil on canvas. p.41

Nude With Black Stockings, 1910. Oil on canvas. p.42

Baptism, 1911. Oil on canvas. p.43

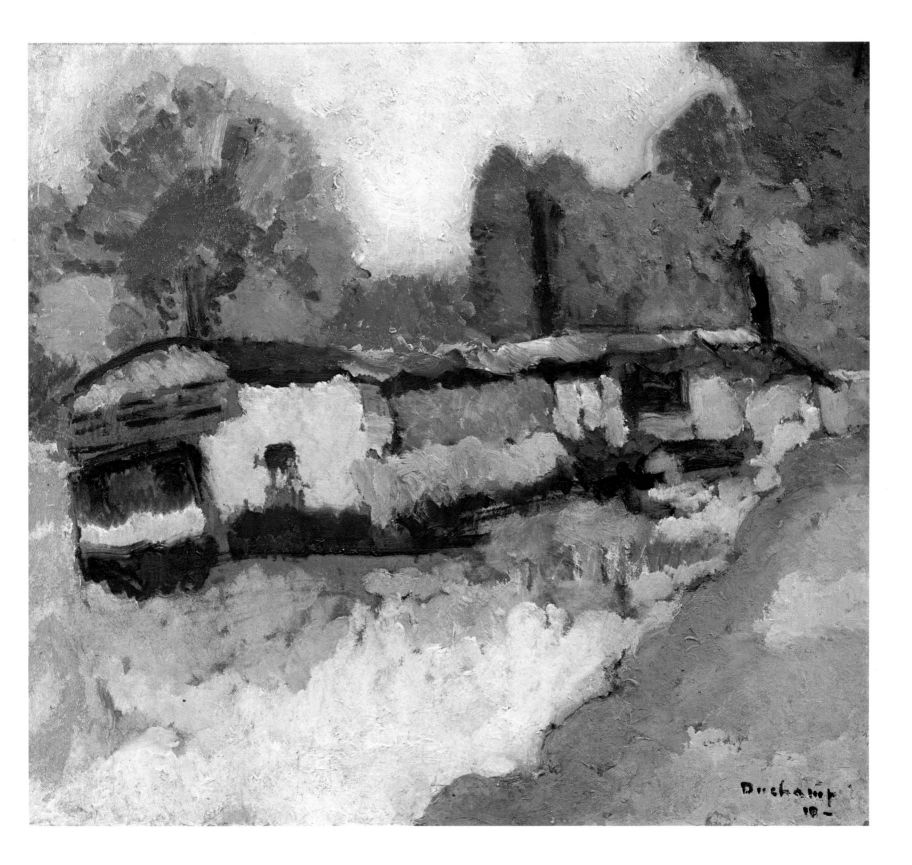

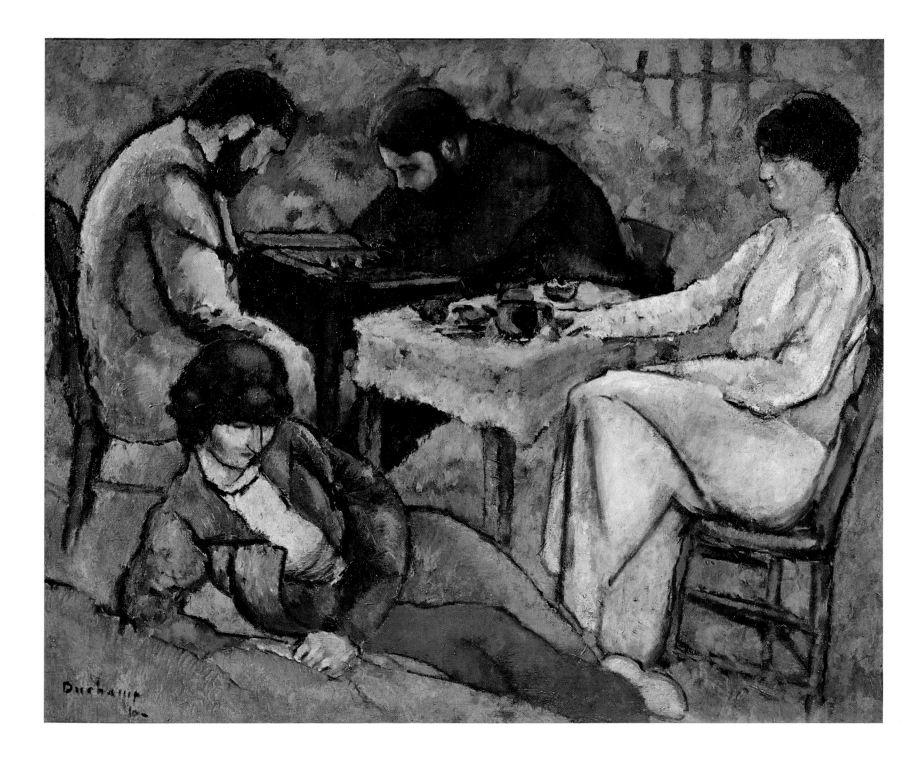

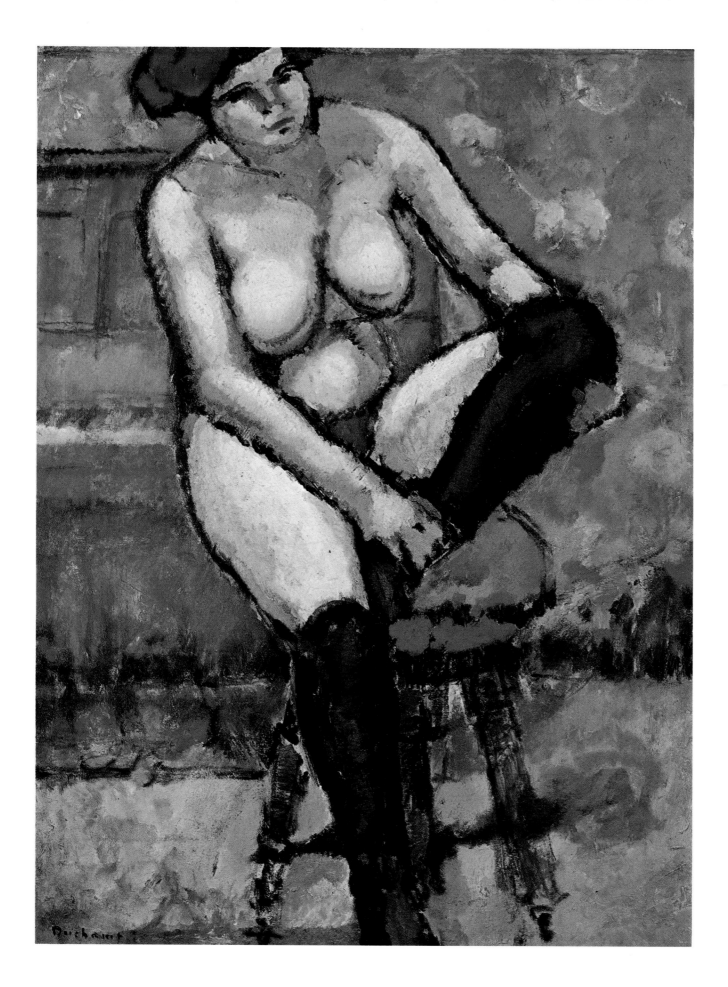

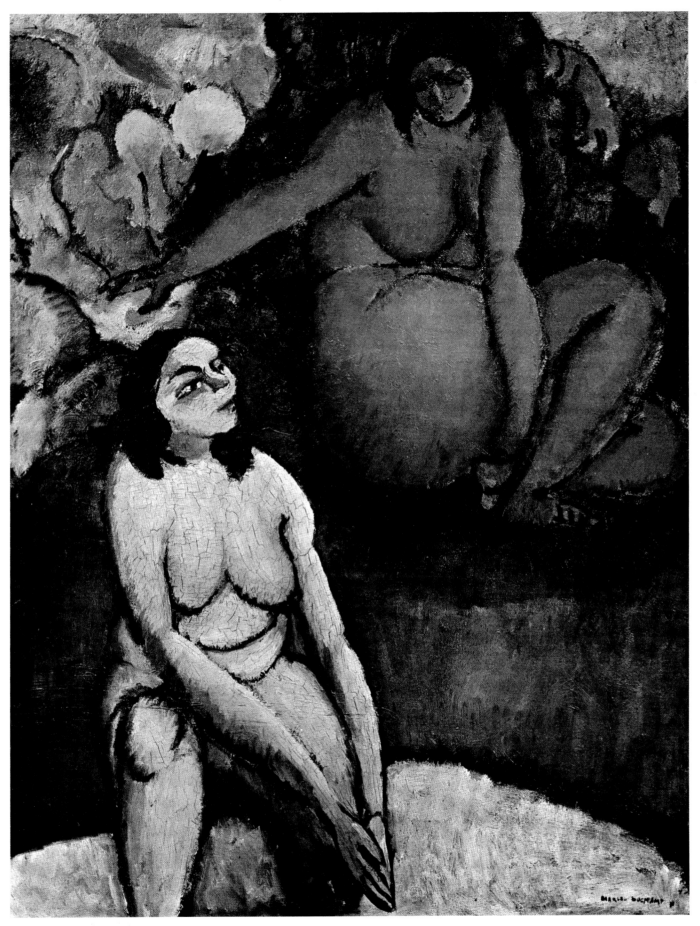

"I must also mention Villon's nude studies of little girls," Apollinaire wrote in his summary of the tenth exhibition of French painters and engravers (*L'Intransigeant*, 13 November 1910). It was his first mention of Villon, whose work he probably disliked; in his article on the 1911 Salon d'Automne, he virtually disregarded "Jacques Villon's chubby portraits" (*L'Intransigeant*, 3 October).

Apollinaire was blinded by Cubism and Picasso's and Braque's dazzling personalities, and paid no attention to Villon until he joined the movement. The still life he exhibited at the 1912 Salon d'Automne seemed to Apollinaire "full of novelty" (*L'Intransigeant*, 3 October). At the same Salon, Apollinaire noticed "Marcel Duchamp's strange drawing", which was catalogued as *Virgin* and was a study for *The Passage from Virgin to Bride*.

Up till then, Apollinaire had been only vaguely interested in the young artist's work. As a harried journalist working to a deadline, with thousands of pictures to take into account, he could hardly be blamed for having inexplicably gibed at Duchamp's "hideous nudes" at the Indépendants in 1910, or found his contributions to the following year's Salon d'Automne merely "interesting". Nevertheless, at the November 1911 exhibition of the Société Normande de Peinture Moderne at the Galerie d'Art Contemporain in Rue Tronchet, Apollinaire found that Marcel Duchamp was "making great progress".

The "strange drawing" of 1912 may have affected him. In an article entitled *The Beginnings of Cubism*, in *Le Temps*, 14 October, Apollinaire mentioned the "new tendencies" which had arisen within the movement, and added: "Picabia broke with the conceptualist formula and, at the same time as Marcel Duchamp, devoted himself to an art form without rules."

Apollinaire rarely went to Puteaux, because he was afraid of being reproached by Picasso and Kahnweiler. Artistic Paris was so insular, and the groups so divided, even hostile, that he would have been accused of "treason". Nevertheless, it was he who introduced Maurice Raynal and André Salmon to Villon, whose circle included Olivier-Hourcade, Louis-Napoléon Roinard, Roger Allard, Ribemont-Dessaignes, and Princet the maths teacher, a boring theorist of Cubism. "He played at knowing the fourth dimension, so we listened to him," said Marcel. Henri Martin-Barzun, who made a career as painter and writer in the United States, also frequented Rue Lemaître. Duchamp-Villon also met the American painter and critic Walter Pach at the Salon d'Automne and brought him into the group.

Picabia and Kupka were the most "progressive" of the Puteaux painters. Picabia had been a popular post-Impressionist, whose pictures sold well. From 1898 to 1908 he was one of the stars of the official Salons and fashionable galleries, but then made a complete turnabout; we know his astonishing abstract forms of 1907, *Paysage de la Creuse* (Landscape) (1908) and *Caoutchouc* (1909), as completely non-objective works, whatever the opinion of those who think that Kandinsky invented pictorial abstraction.

Pierre Dumont introduced Picabia and Marcel Duchamp at the 1911 Salon d'Automne, and they immediately became fast friends. Picabia's lack of confidence astounded Marcel, to whom doubt was the spark that set off a paradoxical and fascinating play of conversation. This attitude clashed with that of the artists surrounding Villon and Gleizes at Puteaux, who were all analytical serious men. Picabia, though, was contradiction itself, which delighted Marcel, who was only waiting for an opportunity to get away from his stifling environment.

Kupka was older than most of the Rue Lemaître regulars; he came to Paris in 1895 and was variously influenced by Forain, Ensor, Lautrec, and—through him—the Japanese. He knew Villon at *Le Rire*, the *Courrier Français*, *L'Assiette au Beurre* and other satiric magazines to which he contributed for a living. At first he was frankly academic, but from 1906 to 1910 he moved towards a populist Expressionism; then followed a period of active experimentation bordering on abstract art. His three 1910 pastels, *Femme Cueillant des Fleurs* (Woman Picking Flowers), herald the *Plans par Couleurs* (Planes through Colour) of 1910-1911. Kupka's interpretation of movement showed him to be greatly in advance of painters still wrangling with such problems. His broken harmonies are both muted and subtle, and give his pictures a certain mystery.

While Kupka affected Villon artistically, Picabia affected Duchamp psychologically. Picabia's wife, Gabrielle Buffet, said that there was an extraordinary rivalry between the two men where paradoxical and destructive ideas were concerned. This had its humorous side. Madame Picabia-Buffet added that these arguments demolished formal ideas of art and began to replace them with personal dynamism and vitality.[36]

Marcel Duchamp

Yvonne and Magdeleine Torn in Tatters, 1911. Oil on canvas. p.45

Draft on the Japanese Apple Tree, 1911. Oil on canvas. p.46

Apropos of Little Sister, 1911. Oil on canvas. p.47

Sonata, 1911. Oil on canvas. p.48

Portrait (Dulcinea), 1911. Oil on canvas. p.49

Young Man and Girl in Spring, 1911. Oil on canvas. p.50

46

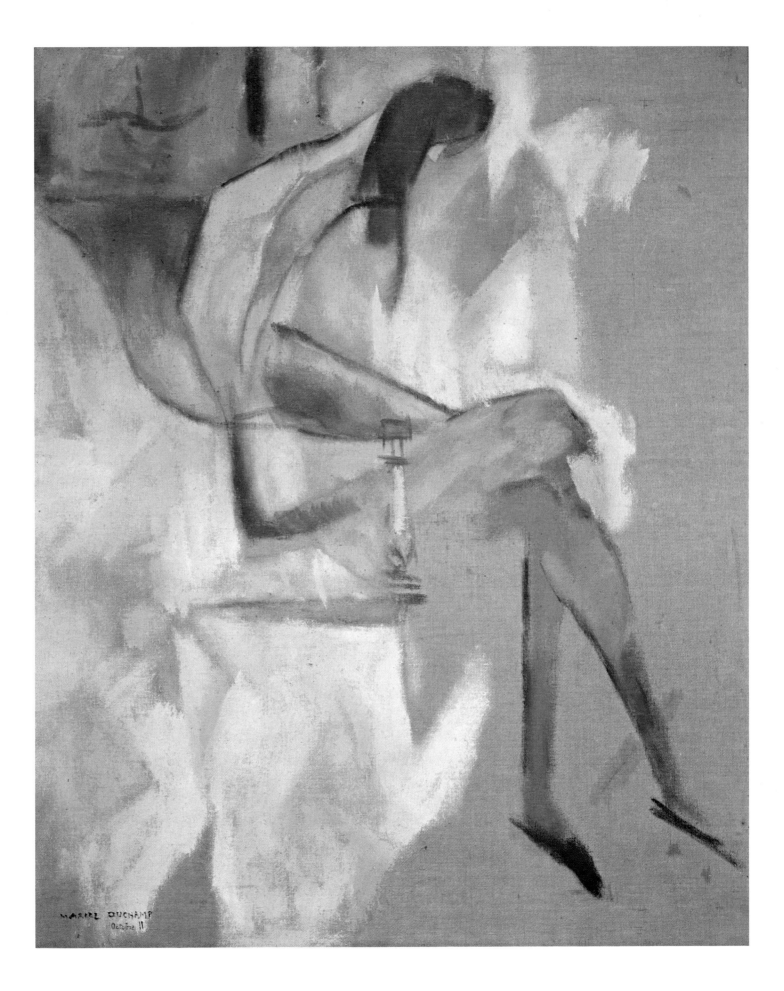

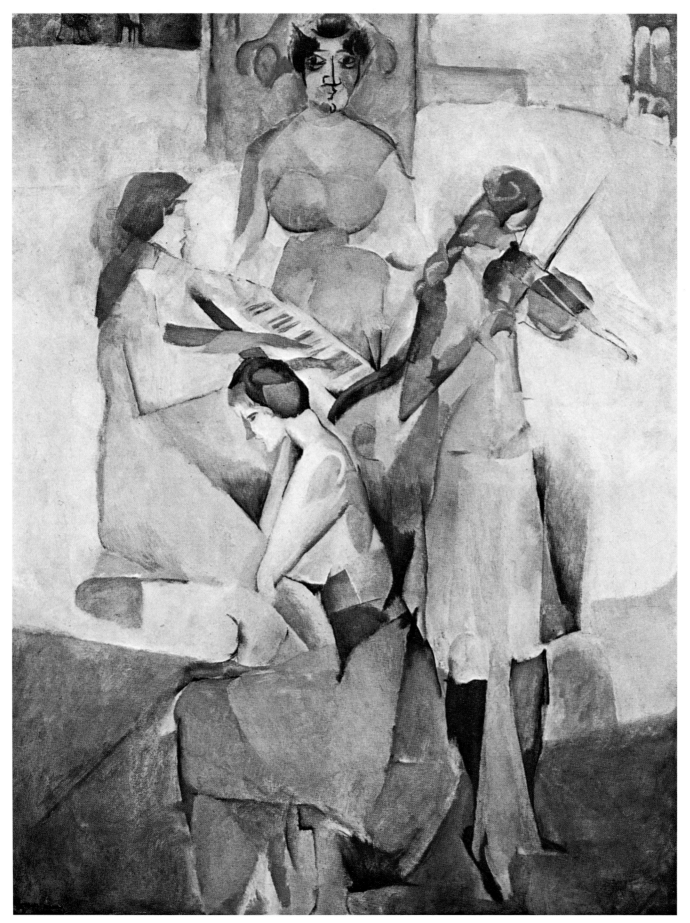

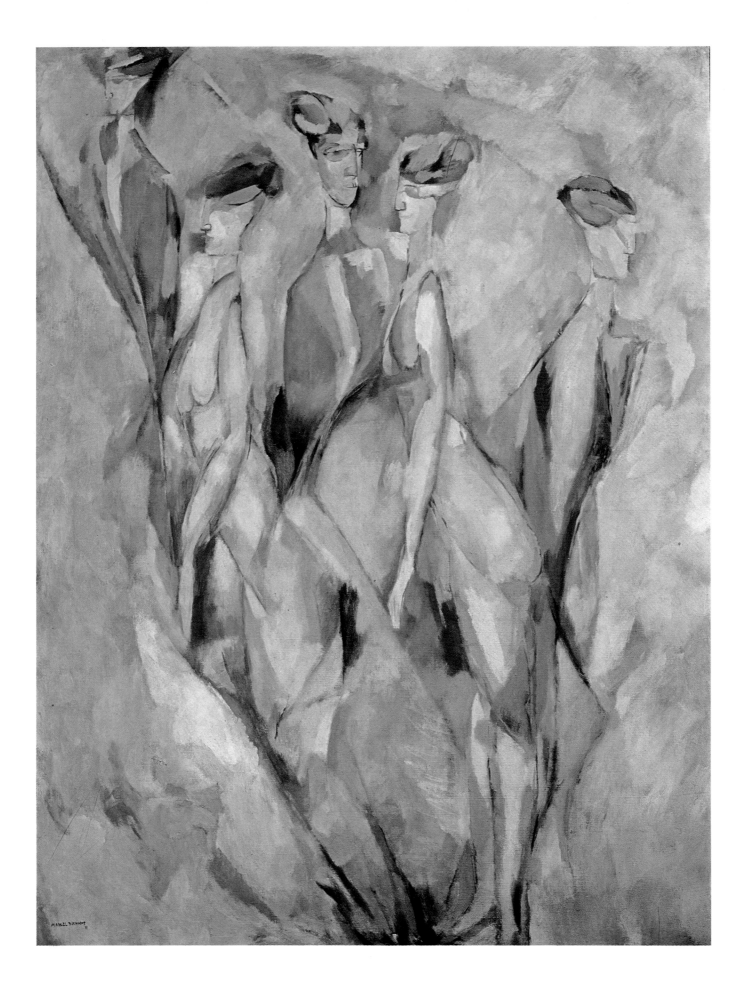

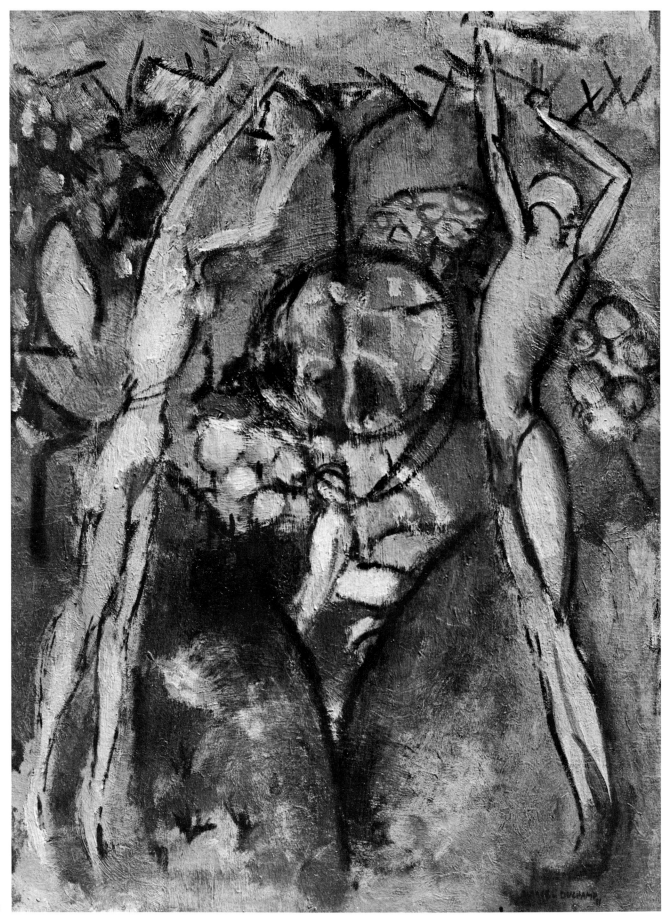

Marcel Duchamp Study for *Portrait of Chess Players*, 1911. Charcoal drawing.

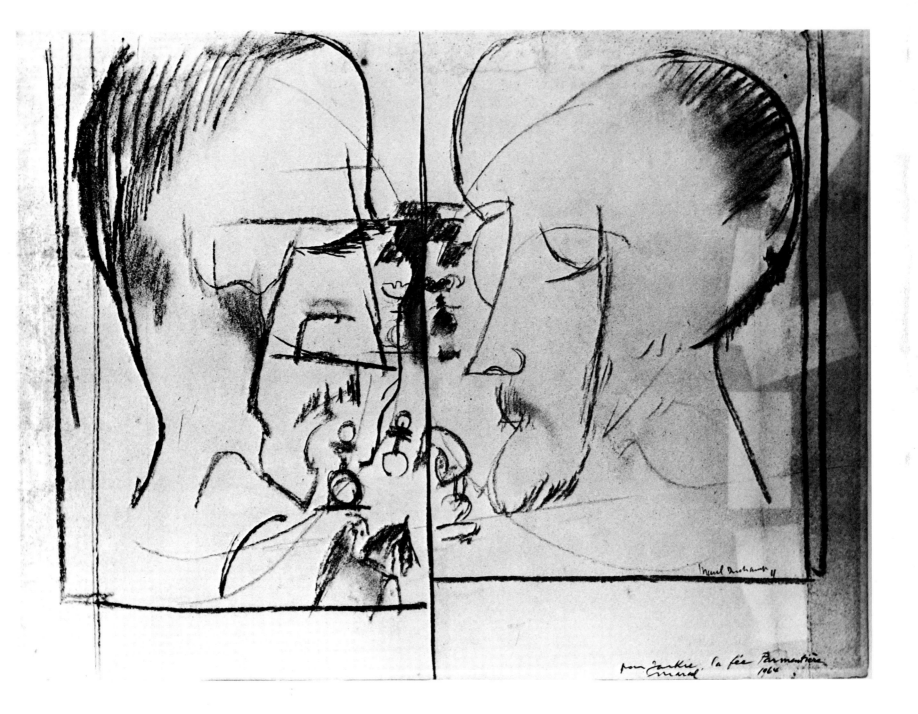

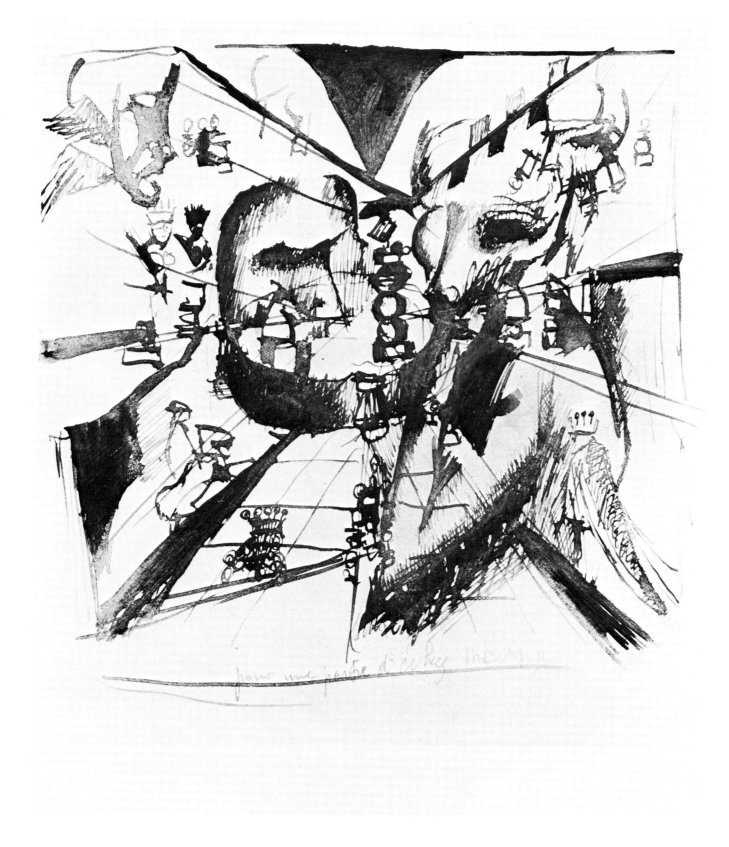

52 Marcel Duchamp *For a Game of Chess*, 1911. Ink and watercolour.

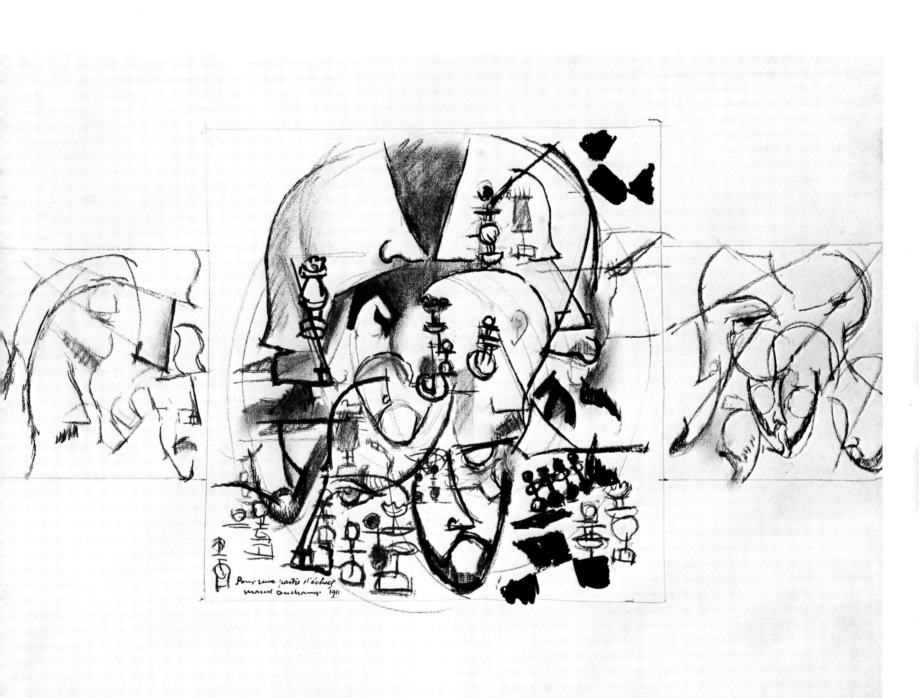

Marcel Duchamp *For a Game of Chess*, 1911. Charcoal and India ink.

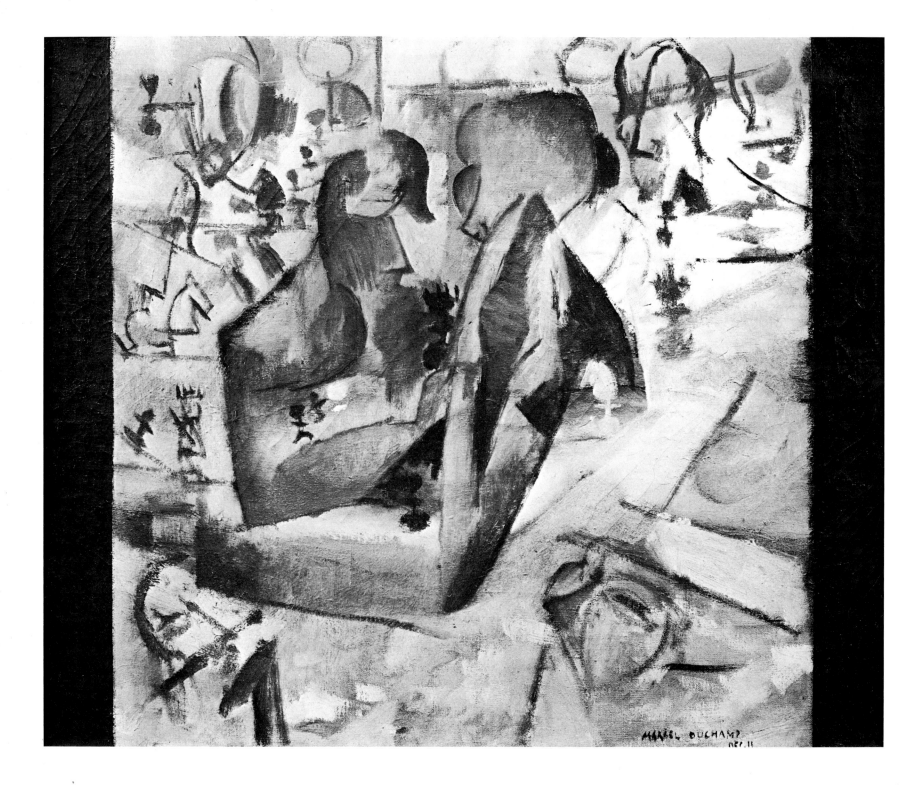

54 Marcel Duchamp *The Chess Players*, 1911. Oil on canvas. Marcel Duchamp *Portrait of Chess Players*, 1911. Oil on canvas. ▶

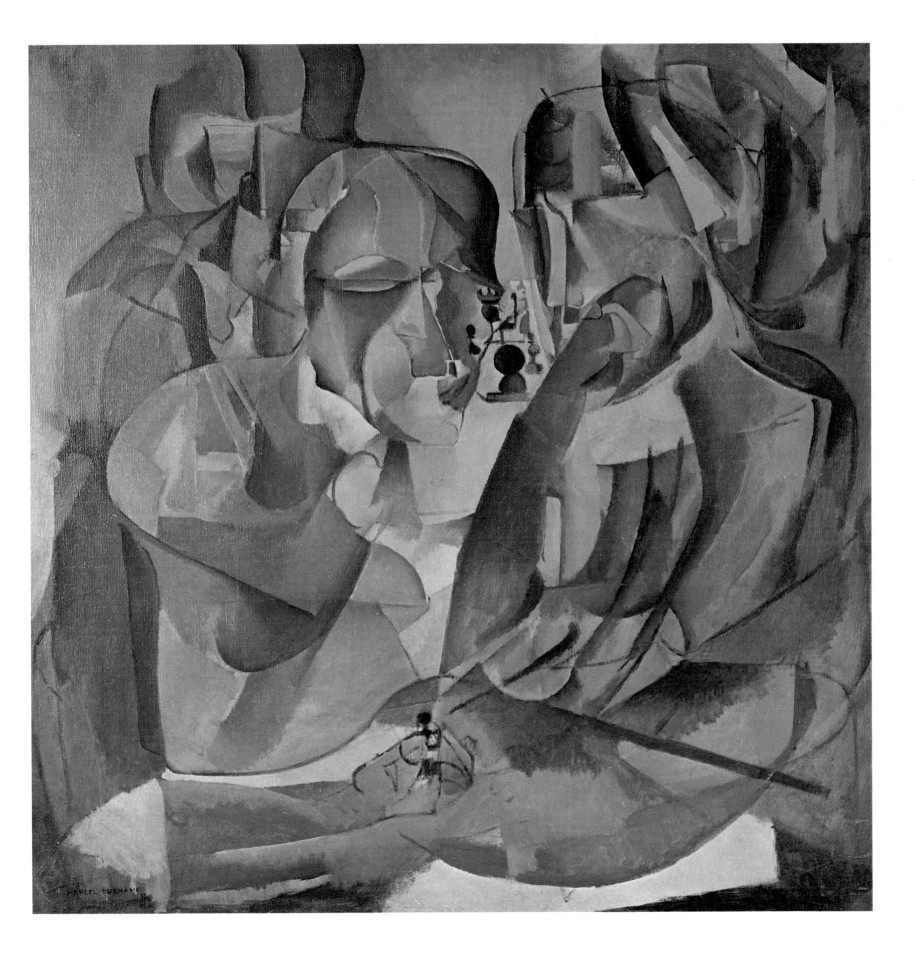

56

At the 1911 Salon d'Automne, Raymond Duchamp-Villon exhibited his stone *Decorative Basin* (ceramic by Messoul), *Wood Nymph*, and the bust of Baudelaire. This marvellous huge-skulled head crammed with thoughts and dreams is a static, finished unit with almond eyes and pursed lips. The American critic, Walter Pach, compared it to the figures on the royal portal of Chartres, and acknowledged its "aura of prophetic grandeur". There is nothing more tragic than this shattering mask of mankind with its severe economy of form, in which the spirit of synthesis was the sculptor's primary preoccupation. This bust should have been given its rightful place in the Luxembourg Gardens.

In an unpublished text, Duchamp-Villon bewails the public's lack of interest in sculpture at the Salons. "It's true that, more than any of the arts, it makes people think by appealing to the mind in its own way, which is often unfamiliar to the viewer, whom artists don't consider enough," he wrote.

"There hasn't been any religion of sculpture for a long time," he said, attributing this lack to "a sole wish to please and flatter public opinion by giving it mediocre conventional works, whose great flaw is that they are commonplace".

"This misunderstanding will continue as long as the public insists that sculpture should be immediately accessible."

"Like music or painting, sculpture can create a world of special harmony rooted in nature. It is master of three dimensions, able to use line, plane, and depth, and the balance, cadence and rhythm of life provide its subject matter..."

"Around 1911," said Villon [37], "we told one another that if Raymond's bust of Baudelaire exploded, it would explode according to certain lines of force; they represent the core of the object and determine its shape. They can either be traced or underlined by coloured planes."

What Villon liked about Cubism was a "discipline that goes further than Impressionism or Fauvism". The picture lost its open-window aspect to become an end in itself. "A thing in itself whose order delights, which is enlivened by its subject, yet detached from it, a new category, showing all the vagueness and mystery of the unknown... Something with the possibilities of a dream." [38]

While Duchamp-Villon regarded Cubism as a synthetic procedure that allowed sculpture to become architecture too, his elder brother found in it a means of fulfilling both his love of order and his fascination with the pictorial expression of an inner life. Villon was, after all, a compatriot of Poussin, who said, "It is in my nature to seek order." The circumspect and thoughtful Norman wanted to reconcile intellect and emotion.

Villon's tastes in Cubism did not tend toward Braque's and Picasso's Cartesian dialectic, but the discipline on which it was founded. He was not an intellectual, and he intended to remain a visual artist, but to base his vision on geometrical constructions and make painting an architecture of light to which he could adapt landscapes, people and still lifes. Starting from Leonardo da Vinci's pyramidal system, his Cubism trapped the poetic universe to which he was bound, not by strict images, but by its most fragile manifestation, the hopes and feelings of life.

Orthodox Cubists created the object from the form, but Villon and others, named—rather ineptly—"French Cubists", did exactly the opposite. Villon had been engraving for a long time, using construction methods well in advance of Cubism, and this was the springboard for his new methods.

At a distance of more than sixty-five years, this development seems natural, but at the time it led to passionate arguments beneath the shady trees at Puteaux. At the age of thirty-five, Jacques Villon, a sensitive cautious man, battled painfully with his conscience. Raymond had also gone through this agonizing phase. He, too, was looking for the right path.

Jacques Villon's portrait of Renée, a friend's daughter (1908-1909), was built up by coloured diagrams, as was his 1909 self-portrait, in which he was preoccupied with structure while retaining a sharp realism; he used a formula of synthesis. His own solidly painted face peers out from curious tiers of overlapping, juxtaposed rectangular strokes. The whole is so disparate that the head, background and shirt-front look as if they had been done by three different people.

This geometrical structure gives a peremptory touch to the *Samurai*, a statuette of Oriental origin, and even more to *Sancta Fortunata*, the bust that became so popular with artists and art-schools. Yet when Villon included both these objects in a still life, his distribution of the broad planes and masses was much freer.

Les Haleurs (The Haulers) harks back to the bold sweeps and rapid unfinished strokes of his watercolour sketches. In 1907, Villon had done an aquatint of the same subject, which shows his interest in expressing movement.

Jacques Villon *Sancta Fortunata*, 1908. Oil on canvas.

Jacques Villon *The Samourai*, 1909. Oil on canvas.

He often depicted the same subject in a drawing, painting, watercolour and engraving. That method had certain pitfalls, mainly the different demands of each medium, but the multiple experiments also provided a "check" on the subject. The portrait of Raymond Duchamp-Villon[39] defines the artist's development. At that time, the sculptor was his closest friend: an obstinate experimenter, he more than replaced the Montmartre friends whom Jacques had been too kind to throw out but who had stopped him working. "Raymond was a very energetic fellow," he told Dora Vallier. "He needed to express his feelings, and he influenced everybody." Except Villon himself and Duchamp, judging from their work at the time, but he stimulated them. After all,

Raymond had been the first of the brothers to show his determination when, at twenty-four, he gave up his medical studies for sculpture, a stirring example for Jacques Villon and Marcel Duchamp.

Jacques Villon

Portrait of the Artist, 1909. Oil on canvas. p. 59

Petite Mulâtresse, 1911. Etching. p. 60

Renée de face, small plate, 1911. Etching. p. 61

Renée de trois quarts, 1911. (Renée, three-quarter face). Drypoint. p. 62

Renée de trois quarts, 1911. Oil on canvas. p. 63

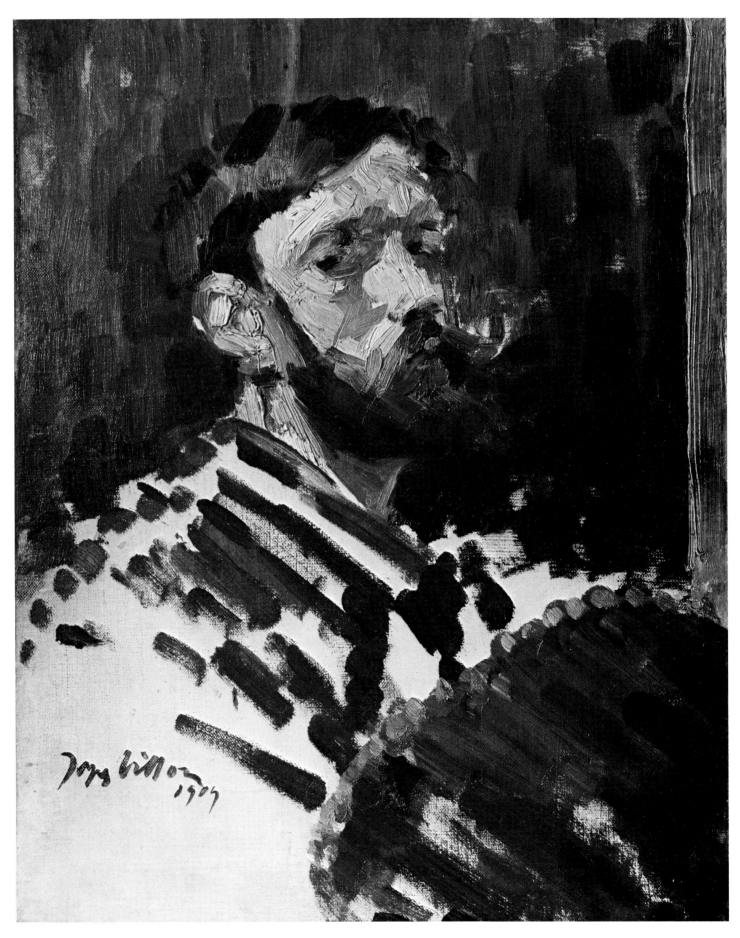

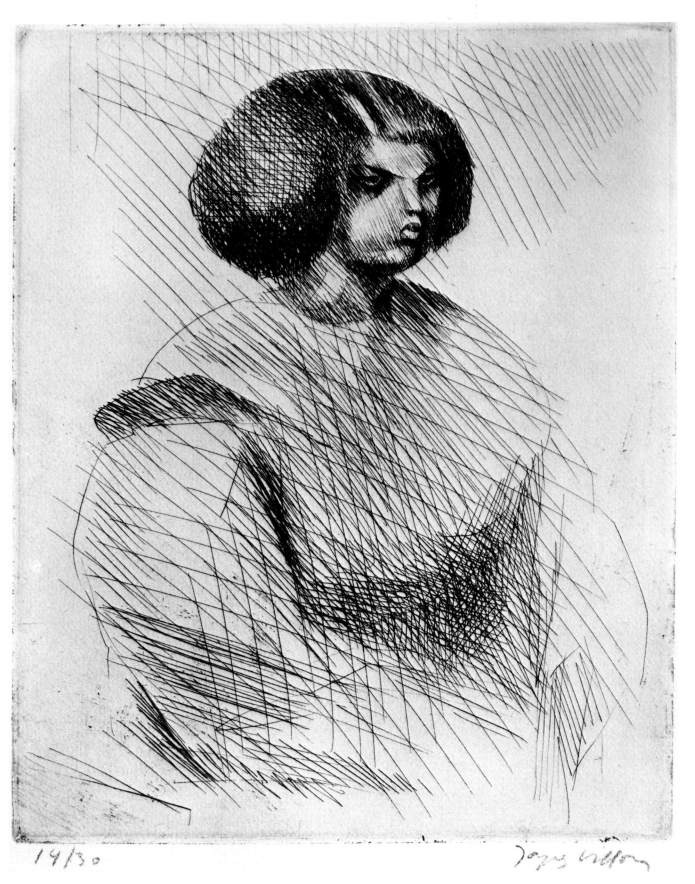

14/30

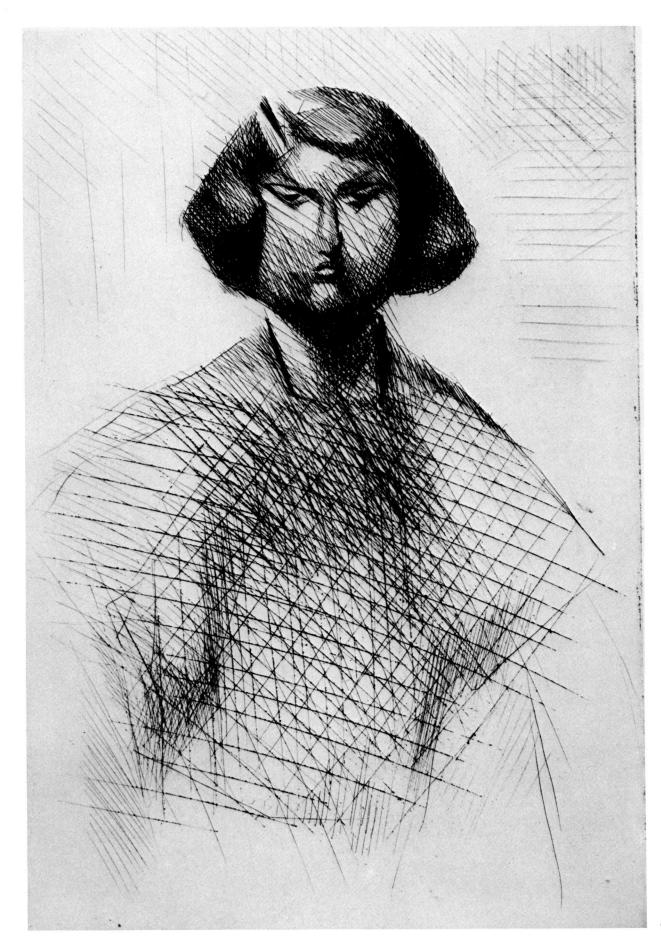

61

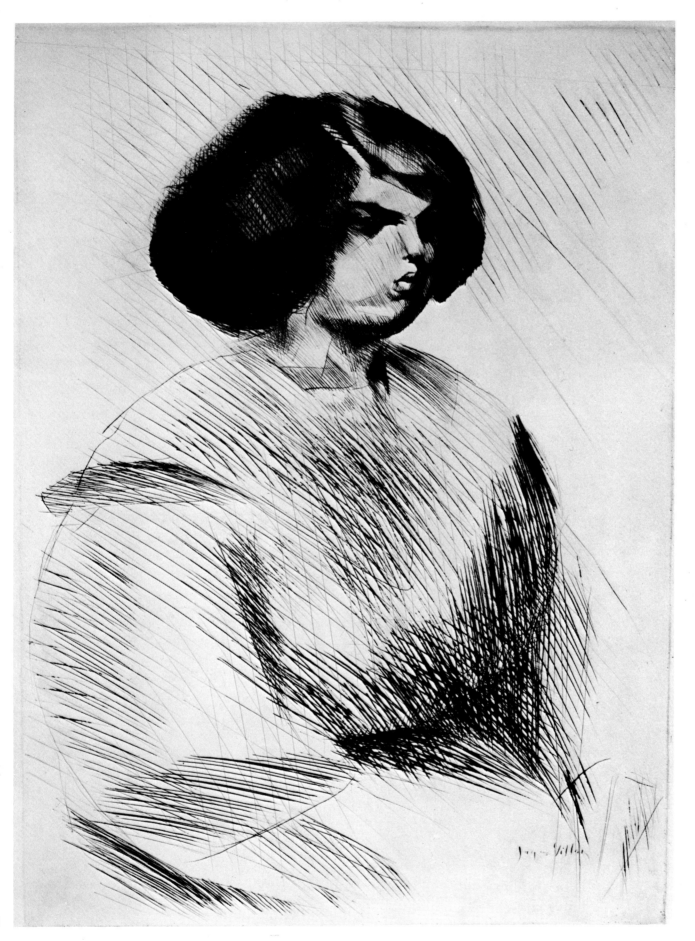

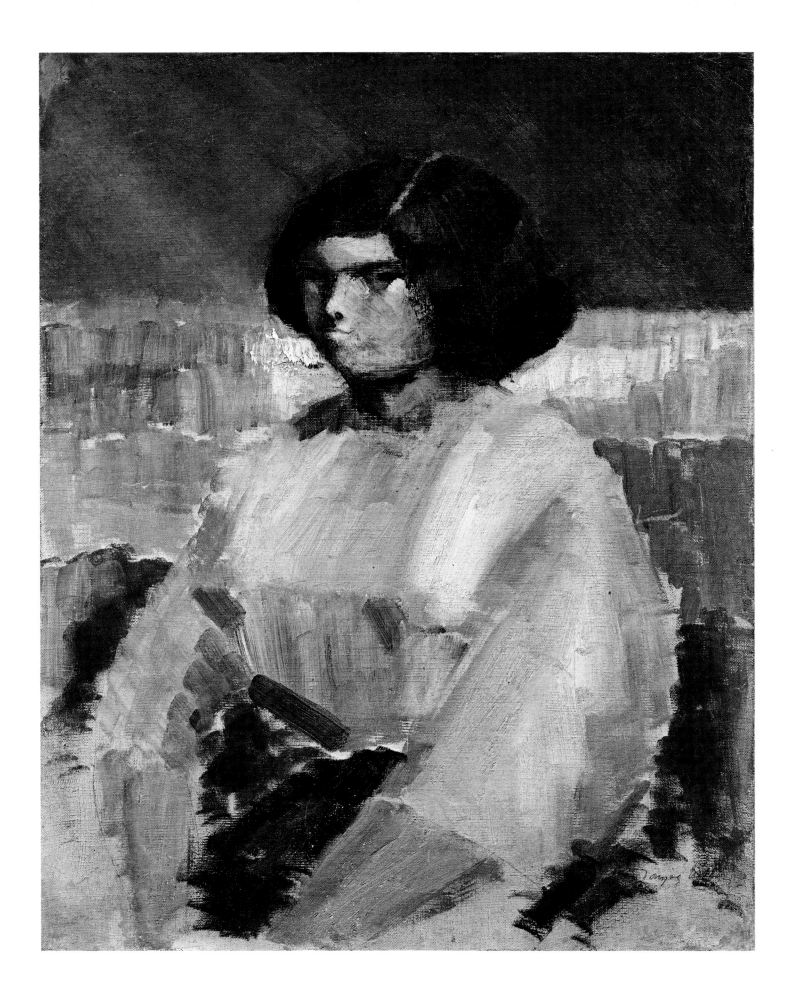

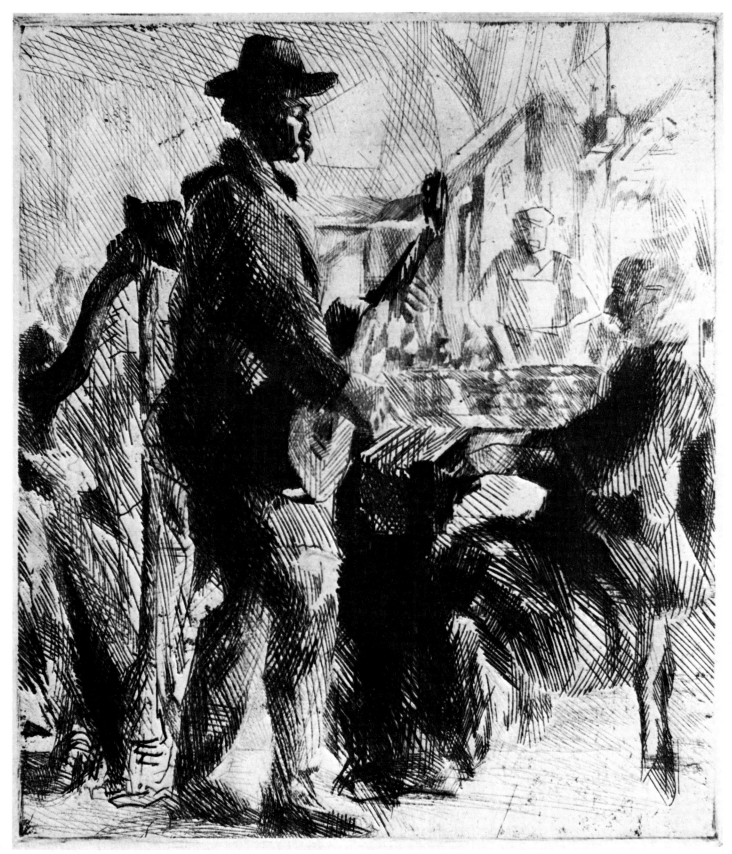

64

"For my 1908 paintings, I depended a lot on lightning sketches," Villon told Dora Vallier.[40] "At that time I was interested mainly in the intention, the inner line of a movement, which, in *Les Haleurs* for example, enabled me to synthesize the movement."

The 1911 portrait of Duchamp-Villon is remarkable for its contrast of traditional methods with new stresses: the use of values, the pale face on a dark background, the mysterious halo round the features. The formula of synthesis of the 1908 self-portrait was outdated. The head is built up from very simple overlapping planes which define the face, but its severity is softened by tonal areas lending it a touching sensitivity.

Villon was where he wanted to be, at the discernible frontier of intellectual Cubism. There was a great leap to this portrait from his earlier ones. The painter gave most importance to light; this tendency had marked his recent engravings and, as in the picture, it was linked with the working out of an architectural form. His subsequent etchings were as follows: *Femme de Dos* (Woman from Back) (etching, 1910), *Renée de Face* and *Renée de Trois-Quarts* (Full Face and Three-Quarters) (drypoint, 1911) and *Petite Mulâtresse* (etching 1911). Engraving was always Villon's medium for experimenting, "my primary discipline" he said: through this severe school he approached painting.

He wanted to create a unity of form, colour and composition through light and lyricism. He had his own way of capturing reality caressingly yet obstinately.

Nor did Marcel Duchamp throw himself blindly into Cubism either. That was not his way: he had always been a temperate man, not one to act impulsively. Picabia's enthusiastic airing of his opinions amused Marcel, but it also made him think; while his friend was effusive, he was reflective. "With Picabia, it was always 'yes, but...', 'no, but...'. Whatever you said, he disagreed with you. It was a game," said Marcel,[41] to whom Picabia's "buts" opened doors that he would have preferred to contemplate first, or to bypass altogether.

"I had to do a lot of manual work in order to adapt to the new technique of Cubism."[42] Marcel Duchamp's admission says a great deal about the conscientiousness of a man too often considered defiant and aggressive. The word "technique" is important, for at that time Marcel was particularly interested in the "manual work"; he was not at all concerned with the cerebral element of Cubism, because he feared both its stereotyping and its immobility.

Jacques Villon *Musiciens chez le Bistro*, 1912. Etching.

Jacques Villon *Portrait of Raymond Duchamp-Villon*, 1911. Oil on wood panel.

"I was interested in Cubism for only a few months,"[43] he said. "By the end of 1912 I was already absorbed in other things. So it was an experiment rather than a belief. From 1902 to 1910, I swam a lot..." Villon had a noticeable influence on his younger brother, who stressed, "Where drawing was concerned".

Sonata shows Madame Duchamp standing, with her three daughters: Yvonne at the piano, Magdeleine playing the violin, and Suzanne seated. *Portrait (Dulcinea)* shows five women's silhouettes, partially superposed. "The most amazing thing is the technical fluidity," Marcel said of these paintings. He did several smaller versions of *Portrait (Dulcinea)*, but they have been lost. This work was followed 65

in September by *Yvonne and Magdeleine Torn in Tatters*,[44] done at Veules in Normandy, and in October by *Apropos of Little Sister*[45] (Magdeleine Duchamp) on the reverse of which is written "Une étude de femme/Merde" (A study of woman/Shit). In the same month he did several studies for *Portrait of Chess Players*, showing Villon and Duchamp-Villon facing each other. In November-December, an oil sketch for *Portrait of Chess Players*, Duchamp's only work in a French museum, the Musée National d'Art Moderne in Paris, preceded the December *Portrait of Chess Players*,[46] also done in Neuilly.

In *Sonata*, a disintegration and fragmentation of planes on a purely visual level show a decided Cubist influence. In *Portrait (Dulcinea)* a woman is shown several times in Avenue de Neuilly, and depicted in five graduating, almost monochrome silhouettes. At that time, the main aim of this repetition was—said Duchamp—to "de-theorize" Cubism and render it more freely.[47] This painting gives the first inkling of *Nude Descending a Staircase*, but the painter denied Delaunay's influence and the coincidence, though he admitted having seen several of his works, notably *Les Fenêtres*. As for the Futurists, Villon confirmed his brother's opinion: they did not know them.

Cubism permeated rather than influenced them. At the time it was the same thing to Jacques Villon in his engravings of *Renée de Face*, *Renée de Trois-Quarts*, *Petite Mulâtresse* and in his oil portrait of Raymond Duchamp-Villon. However, the Cubist concept of the disintegration of the face influenced Duchamp more strongly; he stressed that in *Yvonne and Magdeleine Torn in Tatters*, "this tearing was basically an interpretation of Cubist dislocation".[48]

These paintings were only watered-down Cubism. Arturo Schwarz saw an "individualistic style" in Duchamp's above-mentioned paintings. It is rather the lack of style that would seem conspicuous: it was Marcel Duchamp's main characteristic in 1911.

Portrait of Chess Players was painted by the light of his old gas lamp. "I wanted to see what the change of colour would be like," said Duchamp. "It was an easy way of getting muted tones, a sort of grisaille." The picture is, indeed, painted in colourless greys, greens and slightly yellowish ochres, found in many Cubist works at the time. The word "portrait" in the singular shows the artist's intention of fusing his brothers' juxtaposed heads into a single design. Like Duchamp's earlier paintings, this one is most valuable for what it heralds.

LIGHT AND MOVEMENT

1911 drew to a close. Juan Gris, whom Villon had met at *L'Assiette au Beurre, Courrier Français* and other humorous publications to which they had both contributed, took up Cubism in his turn. Delaunay now had dealings with Kandinsky and Jawlensky, and had been asked to take part in the first Blue Rider exhibition in Munich in December. The *Journal* critic Gabriel Mourey had described the Cubist room at the Salon des Indépendants as "a return to primitive savagery and barbarity". The Salon d'Automne increased his wrath. "Cubism is the swan song of pretentious impotence and smug ignorance," he wrote. Among those who stood up for the new art form were Salmon in *Paris-Journal*, Apollinaire in *L'Intransigeant*, Roger Allard, Olivier-Hourcade and Gustave Kahn. Picasso had spent the summer at Céret with Braque, Gris, Manolo, and others, and was giving his first transatlantic exhibition at the Photo-Secession Gallery in New York.

Another highspot of 1911 was the performance of Raymond Roussel's *Impressions d'Afrique* at the Théâtre Antoine. Duchamp saw it with Apollinaire and the Picabias, and its impact remained with him for the rest of his life. The man whom Breton called "the greatest contemporary mesmerizer" and who was without doubt one of the few real geniuses of our time, could hardly have left Duchamp unmoved, with his extraordinary manipulation of language and his passion for word-play.

Duchamp was shaken by the revelation of Roussel and his visionary, craftsmanlike use of language. This strange man who had nothing to say except a new way of saying it wanted to exert a kind of dialectic omnipotence on time and space: naturally he did not succeed. He was criticized, dubbed a madman, a megalomaniac and an idiot. Obviously, his ambition was boundless, and it is easy to see why Duchamp and Picabia, who had received Roussel's message in its purest form (*Comment j'ai écrit certains de mes livres* was not published until 1935) regarded it as a sign of general liberation. The re-creation of language is the re-creation of mankind.

Just as Roussel's work evolved outside the literature of his time, Duchamp's work evolved outside its art: he fled it, travestied it and repudiated it.

Duchamp did not try to strike up an acquaintance with the author of *Locus Solus*, any more than he had with Picasso, Delaunay or Matisse. He merely said, "I once saw him playing chess at *La Régence*, much later... At that time, I was in touch with him through books and the theatre, and that gave me plenty to think about, I didn't need to intrude on his privacy. Attitude counted far more than influence, knowing how he had done all that, and why..."[49]

Duchamp's attitude was taking shape. In November-December 1911 he undertook a series of some ten illustrations after Laforgue. One of them, *Once More to this Star*, can be regarded as the original idea for *Nude Descending a Staircase*, though it shows someone going up the stairs. Nevertheless, the study of movement was precise. The first version of the painting, which was to cause a tremendous scandal in the United States, dates from December 1911.[50] In the same month, he painted *Sad Young Man in a Train*.[51]

It seems symbolic that the starting point of Duchamp's creativity, coinciding with his discovery of Roussel, should centre on Laforgue, who was said to see most things differently from other people, and on his somewhat detached sensibility and irony. In different ways they both relied on wordplay and contempt for everything; they were equally waggish and similarly endowed with a sort of disillusioned humour. The irresistible complex mechanics of eroticism form ubiquitous undertones.

Duchamp regarded Laforgue's *Moralités légendaires* "as an exit for symbolism". He was linked pictorially, verbally and socially to the spirit of the *fin de siècle* and knew that the time had come to make a break.

Sad Young Man in a Train and *Nude Descending a Staircase* show obvious similarities in the play of forms displaced by movement. In the latter picture, these look like overlapping, jostling leaves, while in the first they seem to be moving on the spot. The two movements, that of the train and that of the young man going to and fro in the corridor, run counter

to each other. The rhythms are dismembered in a succession of broken stratified planes, like the geological layers of a slope; the colouring of the paintings is almost identical— ochre, grey-green, yellow-browns which Duchamp had used before and would use again.

The break with classic representation would not have been so complete without movement. Duchamp said about *Nude Descending a Staircase*: "The movement is an abstraction, a conclusion contained in the picture, and there is no need to know whether or not a real person is descending an equally real staircase. Basically, the movement is in the eye of the spectator, who incorporates it into the picture."

The definitive version of *Nude* was painted at Neuilly in January 1912,[52] a month after the first. In New York five years later, Duchamp redid it in watercolour, pen, pencil and pastel on a photo, and signed this third version "Marcel Duchamp (fils) 1912-1916".

Nude Descending a Staircase contains a very free harmony of yellow-brown, ochre and umber colours, which are the framework for a rapid decomposition of the movement.

"One can't avoid psychoanalysis or the dream interpretation of the steps as a symbol of love-making," wrote Marcel Jean.[53]

The influence of the cinema is obvious. "In an illustration to one of Marey's books, I saw how he showed galloping horses, and people fencing, by a method of dotted lines that demarcated the various movements. That was how he explained the idea of basic parallelism... That gave me the idea for *Nude Descending a Staircase*. I used that process a bit in the rough draft, but mostly in the final stages of the painting..."[54]

Duchamp denied any Futurist influence. When Apollinaire described *Sad Young Man in a Train* as the essence of Futurism, with reference to Carrà's and Boccioni's "state of mind", Duchamp said firmly, "I had never seen those", and added hastily, "Let's say it's the Cubist interpretation of a Futurist formula."[55]

Sad Young Man in a Train and *Nude Descending a Staircase* are linked not only in the expression of movement, which preoccupied many artists at the time; both paintings depict progression, and therefore awareness of time. There is a certain autobiographical element: Duchamp said that the *Young Man* could well be himself on the train to Rouen. As for *Nude*, he did not disagree with the theory that the descent might be a symbol of himself being carried along by destiny, still encased in his bourgeois prejudices and conventions. The movement in the picture might well be that of Duchamp towards total freedom.

After finishing *Nude Descending a Staircase* he painted *Coffee Mill*[56] on cardboard for Raymond Duchamp-Villon's kitchen. Duchamp-Villon had asked several of his friends, including Gleizes, Metzinger, La Fresnaye and Léger to decorate the room; the result formed a sort of frieze.

Marcel's picture, dating from December 1911, shows a splintered coffee grinder; the grounds are falling under the cogwheels, and the handle is seen simultaneously at several stages of its circular movement, shown by an arrow and a dotted line. It was Duchamp's first "machine", the prototype of his later inventions. "Without realizing it, I had opened a window on to something else," he said.[57]

The Puteaux group was astounded by Duchamp's incredible evolution. He was still spurred by Picabia and felt close to that man who was so different from other artists; like himself, Picabia had been deeply stirred by the cold, paradoxical humour and challenges of *Impressions d'Afrique*. Like Jules Laforgue, whom Picabia also admired, Roussel was a serious yet ironic revolutionary, both shrewd and thoughtful, even formal. This unhoped for, absolute freedom burst with unexpected timeliness into the routine aftermath of the "Belle Époque".

A barrier arose between the Duchamp-Picabia tandem and the Puteaux neo-Cubists; there were no reproaches or questions. Duchamp said about his brothers, "They didn't even mention it. Anyway, we didn't talk about things like that much."[58]

Nevertheless, when Duchamp submitted *Nude Descending a Staircase* to the Salon des Indépendants in March 1912, Gleizes, who was one of the organizers, found the painting offensive and asked Jacques Villon and Raymond Duchamp-Villon to persuade their brother to withdraw it. They were upset: they put on black clothes and a funereal manner and went to see Duchamp, who complied with a smile, much to his visitors' relief, and left only a companion drawing to *Nude* at the Salon.

Marcel said of his reaction: "It helped me free myself completely from the past, in the personal sense of the word. I said, 'Fine—if that's the way it is, there's no question of my joining a group. You can count only on yourself, and stay alone'."[59]

Marcel Duchamp

Sad Young Man in a Train, 1911. Oil on canvas. p.69

Nude Descending a Staircase No.1, 1911. Oil on cardboard. p.70

Nude Descending a Staircase No.2, 1912. Oil on canvas. p.71

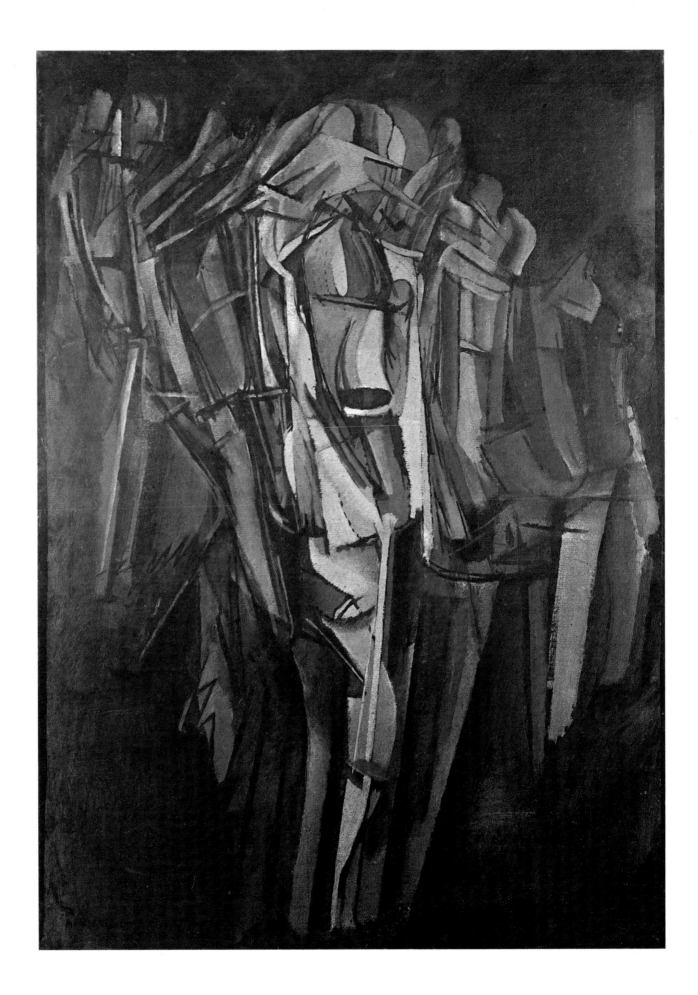

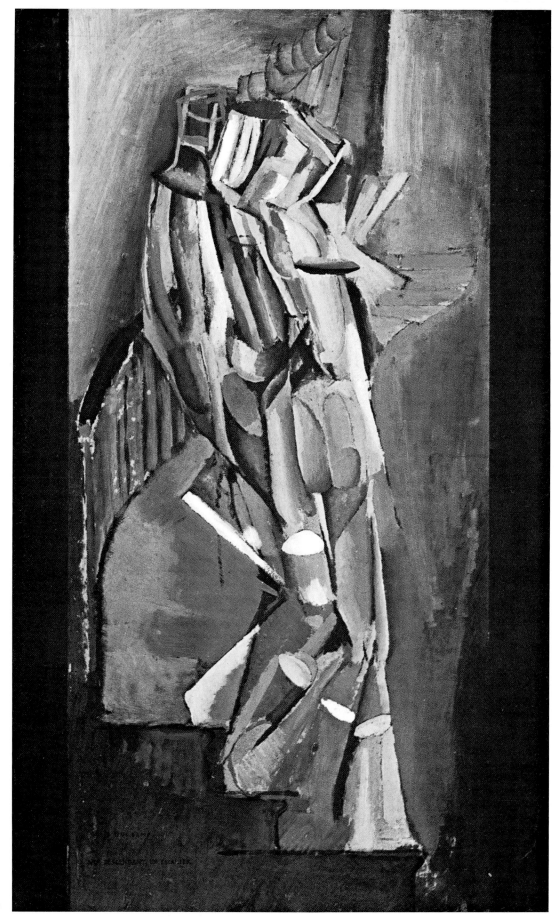

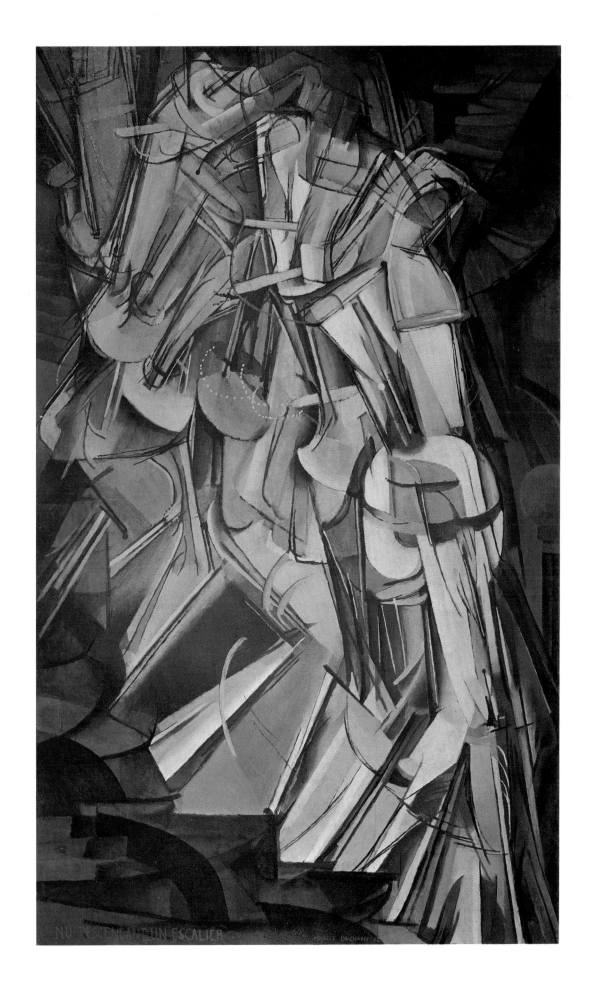

Marcel Duchamp *Coffee Mill*, 1911. Oil on cardboard.

The rejection by his peers and his brothers' action hurt Duchamp bitterly, though he never admitted it. He never protested when he was misunderstood or attacked. The wound inflicted in spring 1912 was kept secret; it was this shock that triggered off the compete revolution in his life and work.

The Futurist exhibition held at the Galerie Bernheim Jeune from 5 to 24 February was particularly important to Duchamp as it confirmed him in the new direction he had taken since the rejection of *Nude Descending a Staircase*.

Jacques Villon had been disconcerted and worried by Duchamp's development. There was no question of his following along the same path. He had not forgotten Leonardo da Vinci's *Treatise on Painting*, nor Bergson's *Creative Evolution*, published in 1907. He had always admired Cézanne, but bypassed the Fauves; his painting would never be impulsive or gushing and, like Duchamp, he examined and pondered before committing himself. Engraving had trained him to accept recognized standards; his pyramidal vision, based on Leonardo da Vinci, was a theory whereby an object and its various components were seen as pyramids, whose point was in the eye, and whose base was in the object. This concept was founded on regulating lines that served as props for the object's decomposition. Villon found it the perfect answer to his aesthetic convictions and love of analysis, his need for synthesis, and, most of all, his search for purity and discipline.

Whether he was working on copper, paper or canvas, he always "wove" his theme. Whereas orthodox Cubists analyzed an object from every angle and opened it to examine the interior, he approached it in rational stages; he did not assemble his picture on a purely cerebral structure but from the basis of its essential life and being, without excluding sensibility.

He aimed at retaining both feeling and intelligence, and wanted to let common sense put order into the chaos of visual sensations. The pyramidal geometry was also founded on the use of colour, mixing subtlety and vividness; he often transposed engraving values into bold, pure tones, and showed glimpses of a lyrical imagination.

He thought of painting as a distorting mirror reflecting very little reality—"If only we knew what reality was!" he said. But reality was present, suggested in sensitive designs, sometimes by an oblique or vertical division, speaking confidentially or through measured reserve. Villon's voice was not powerful or authoritative, but it was always melodious.

It would be wrong to qualify Villon as a marginal painter; he gave Cubism movement, and in this domain he proved his creativity without owing anything to the Futurists. "They conceive movement as a series of disintegrated leaps, which is a purely cinematographic process,"[60] said Villon, "whereas I want to express the synthesis of movement through continuity."

Movement was of prime importance to him, because it was life, and as life is mainly expressed through a human being, he preferred people to still lifes. The vital rhythms quickening his paintings were often derived from his growing collection of sketches. "The human body is alive, you can't put it in irons," said Villon. He always knew how to soften his pyramidal designs and infuse them with fresh blood, for, he said, painting "gives back fragrance, mind and soul to objects whose appearance science indexes and explains".

Puteaux Cubism was therefore fundamentally different from Montmartre Cubism. Braque and Picasso had freed painting from the conventions of Renaissance perspective; Villon reasserted its rules, but alleviated their rigidity. The vision created in painting is a light trained on living architecture to display "all the vagueness and mystery of the unknown".

Picasso and Braque recognized only their own Cubism. They did not take part in the Salons, where the "Cubist rooms" caused outcry upon outcry as one season followed another. Kahnweiler also refuted Salon Cubism, which, in his view, was a distortion of "real" Cubism and reduced its deep motives to superficial experiments. That was true of some of the "Cubisteurs", as Braque called them, who restricted themselves to exploiting the formula and fell into the trap of stereotyping. Villon's research was to lead to a new track: the Golden Section.

The *Portrait of an Actor* (Felix Barré), painted first in 1912, then repainted twice in 1913, and the drypoints of 1913-1914 based on this, show how Villon worked. The 1912 canvas is technically and stylistically similar to the portrait of Raymond Duchamp-Villon: simple planes of subtle harmony on a fine tracery of geometric rhythms. The 1913 painting re-structures the model by a juxtaposition of solid masses defined by the strong lines of the face. The painter went from the Impressionist to the Cubist vision, from ordered dispersion to concentration, from discreet ardour to severity.

The second 1913 version of Felix Barré's portrait has greater mass and rhythmic dimension: the head is the epicentre of a play of planes and contours vibrant with Impressionistic flakes of colour. Villon's colour scheme is reminiscent of Pissarro's or Seurat's: every shade is a projection of light, and the planes of the whole are both balanced and coherent. Geometry determines position, and light stabilizes.

Villon's drypoints of Felix Barré are typical of his method. The first, done between the two canvases, is a mixture of 73

several visions: swift strokes, juxtaposed and integrated with a far more elaborate design, mainly sustained from the interior. The other is a graphic companion piece to the second 1913 portrait. It is uncertain whether or not it preceded it, but the engraver in Villon was always ahead of the painter: the use of black and white expresses his wish for synthesis more than do the inflections of his painting. Nevertheless, the painting and engraving are not transpositions of each other. Often the engravings were not put into pictorial form until after a long mental assimilation: *L'Atelier de Mécanique* was engraved in 1914 and painted in 1947. *Les Trois Ordres* (Three Orders) was engraved in 1939 and painted five years later, and *Les Haleurs* (Haulers) was engraved in 1906, done also as a painting and watercolour, then taken up in a different way in 1930. Villon liked to compare his technical with his visual evolution; each affected the other.

In 1913 he also did the marvellous drypoint *Portrait de Jeune Femme* (Young Woman) in which he itemized and broke up the subject, as in his two drypoints of his sister, *Yvonne D. de Profil* and *Yvonne D. de Face*. *L'Equilibriste* was a theme to which he often returned. Like most of the artists of the time, the painter loved circuses. He recognized the affinity between his own preoccupations and the skill of ropewalkers, riders and acrobats.

In the 1914 *Petit Equilibriste* there is a tauter search for movement in the contrasting and complementary rhythms; the values have almost entirely disappeared, and the areas of white paper are arranged to give an impression of space, but there are just enough to accentuate the geometry.

In the portrait of *Marcel Duchamp Lisant* (Reading), the prismatic face is the epicentre of a diverging tracery of rhythms on a trellis of parallel cuts that form a frame for the internal design. The light plays over it subtly: the deep blacks, shadings of grey and white contribute to the power of introversion and outdistancing to which Villon discreetly yet efficiently held the key.

He used analytical methods—virtual laboratory experiments—to achieve polished, finished works. He could not bear to rely on chance, unlike Duchamp, who thrived on it. *La Table Servie* (Set Table) (1913), in the Steegmuller collection, was preceded by a series of pen, pencil and watercolour experiments, which started from a realistic basis with every detail expressed by intersecting strokes and splashes of vibrant colour and ended with a reality that was also a rearrangement—a fresh setting: the painting was the final stage. Into his pyramidal division of space, Villon inserted lines of force and their interrelation to make a homogeneous whole. *La Table Servie* shows the extent to which a taut 74 composition can also rely on light and rhythm. It must be

stressed that, above all, he did not want the pyramidal construction to become a constraint.

Rhythm, and therefore movement and its translation in space, freed the subject; the strong lines did not only define it but gave it mobility, as can be seen in *L'Equilibriste, Les Daims Surpris* (Deer Surprised), and *Les Soldats en Marche* (Soldiers Marching) of 1913-1914.

Jacques Villon himself dubbed this period of his work as "Impressionistic Cubism".

Debate continued in Rue Lemaître, where newcomers had swelled the original small group. The three Duchamps took their friends to the 1910-1911 Parisian exhibitions of the Société Normande de la Peinture Moderne at the Galerie d'Art Contemporain in Rue Tronchet, which included works by Gleizes, La Fresnaye, Léger, Metzinger, Dunoyer de Segonzac, Luc-Albert Moreau, Lotiron, Dufy, Archipenko and, of course, Villon, Duchamp-Villon and Marcel Duchamp—"making great progress", wrote Apollinaire in *L'Intransigeant*. In 1910, even Picasso was represented, by a harlequin wearing a hat of painted newspaper.

This eclecticism was no longer fashionable at Puteaux. Villon did not confine himself to experiments in painting and engraving but read a lot about theory, and this solitary, self-effacing man became the moving spirit of the group. At the meetings in Rue Lemaître and at Gleizes' in Courbevoie, the group discussed the Egyptian system of perfect proportion, Plato, Alberti, da Vinci's Treatise on Painting, and Pic de la Mirandole, who attempted to demonstrate the link between art and mathematics. Villon's ex-Nabi friends told him about Dom Verkade's work: his "divine proportions"

Jacques Villon

Portrait of E.D. (The artist's father), 1913. Drypoint. p.75

Yvonne D. de profil (Yvonne Duchamp, the artist's sister), 1913. Drypoint. p.76

Yvonne D. de face (Yvonne Duchamp, the artist's sister), 1913. Drypoint. p.77

Portrait of Suzanne D. (Suzanne Duchamp, the artist's sister), 1913. Drypoint. p.78

Portrait d'Acteur (Félix Barré), 1913. Drypoint. p.79

L'Equilibriste, 1913. (The Acrobat). Drypoint. p.80

Soldats en Marche, 1913. (Marching Soldiers). Oil on canvas. p.81

Portrait of Mlle Dubray, 1914. Oil on canvas. p.82

La Table Servie, 1913. (The Set Table). Drypoint. p.83

Le Petit Atelier Mécanique, 1914. (Small Workshop). Etching. p.84

Le Petit Equilibriste, 1914. (Small Acrobat). Drypoint. p.85

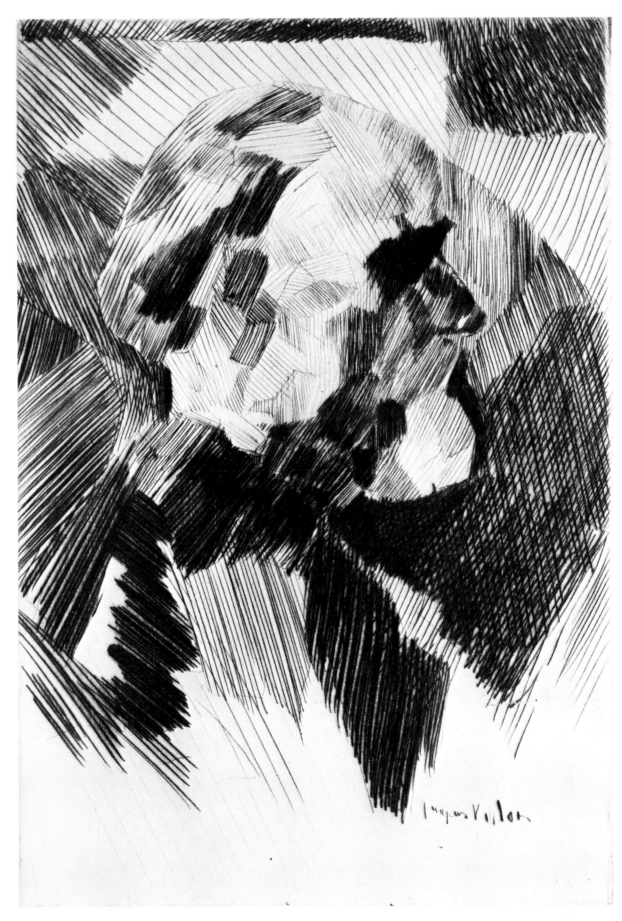

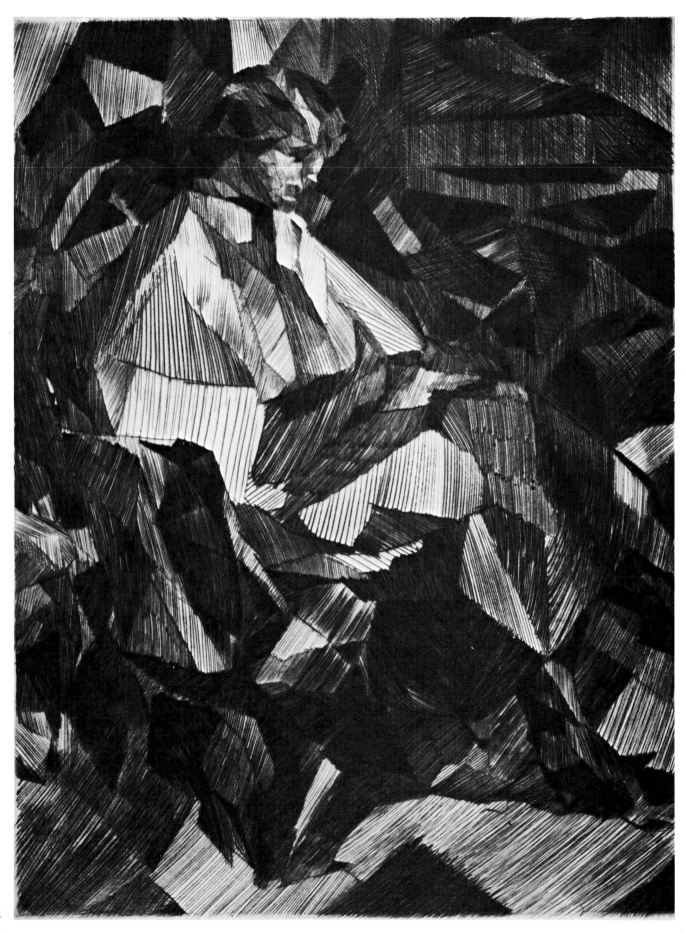

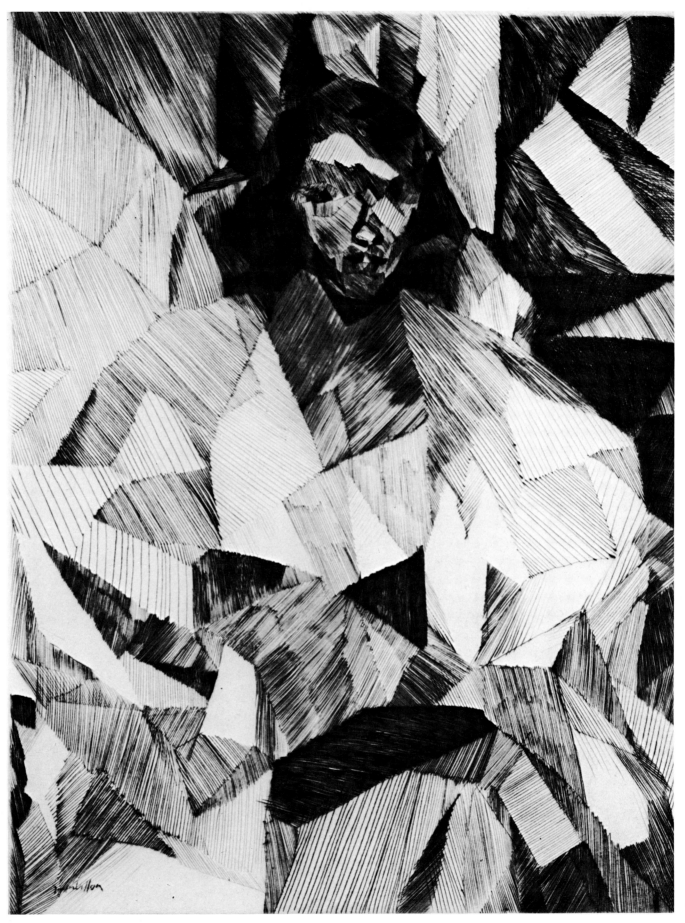

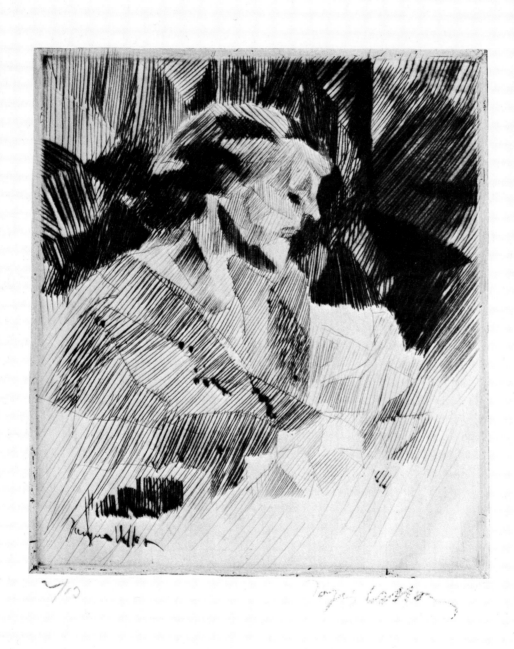

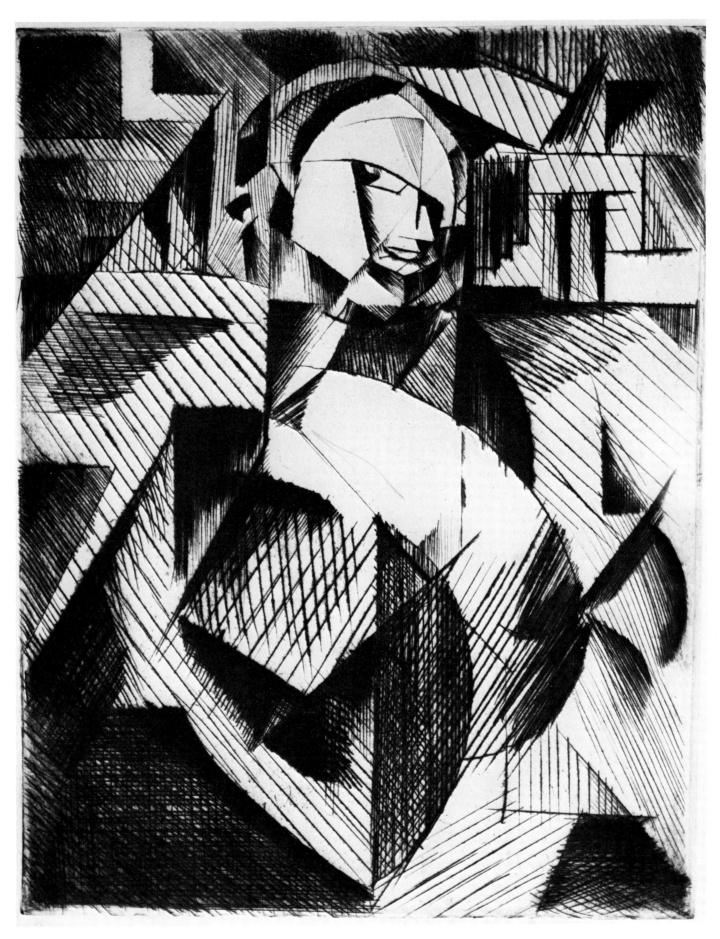

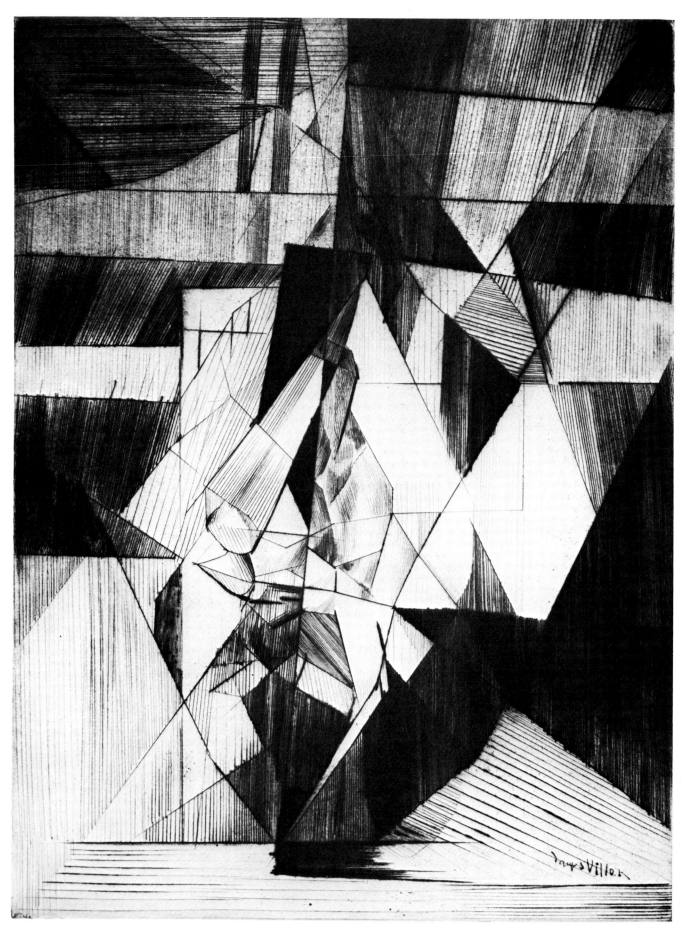

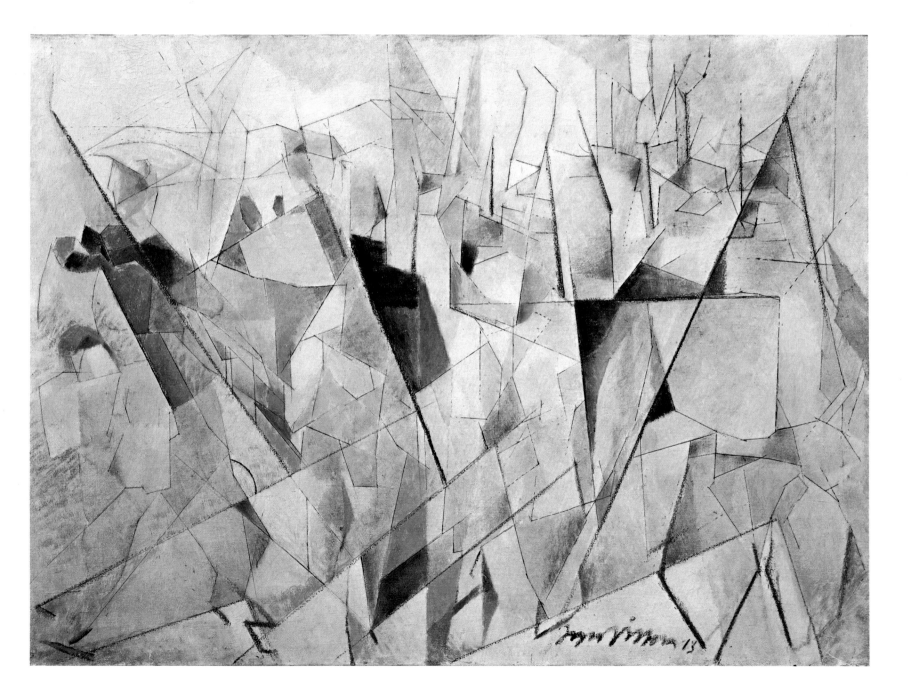

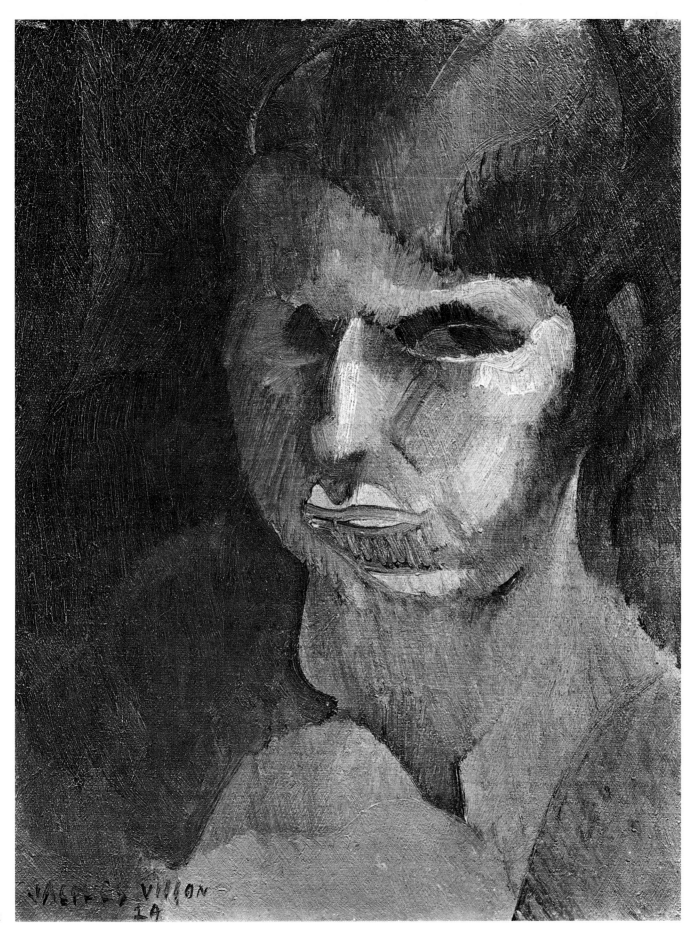

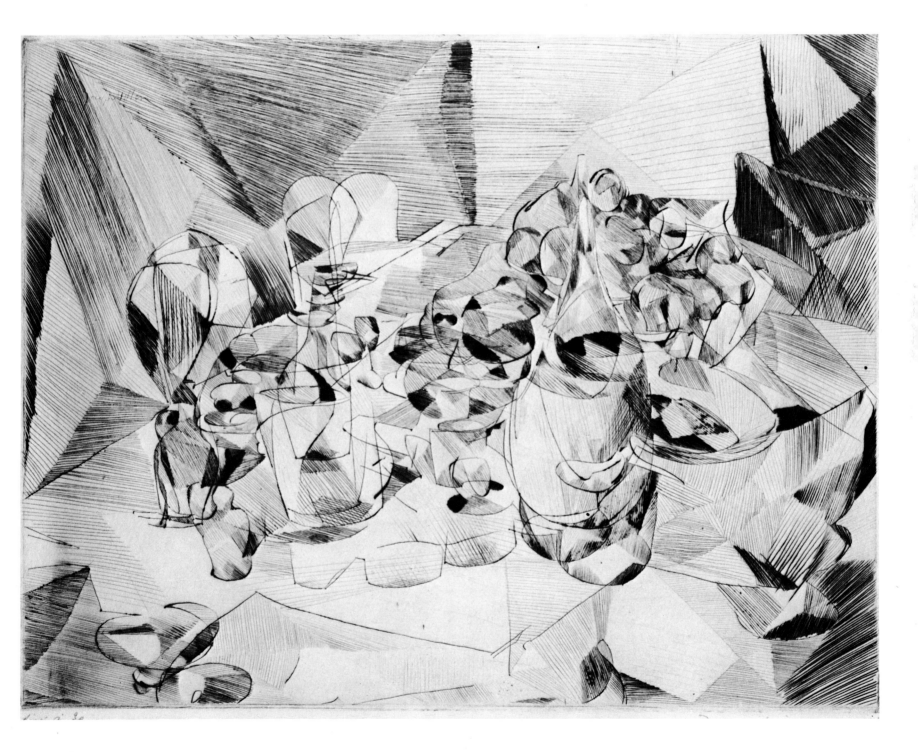

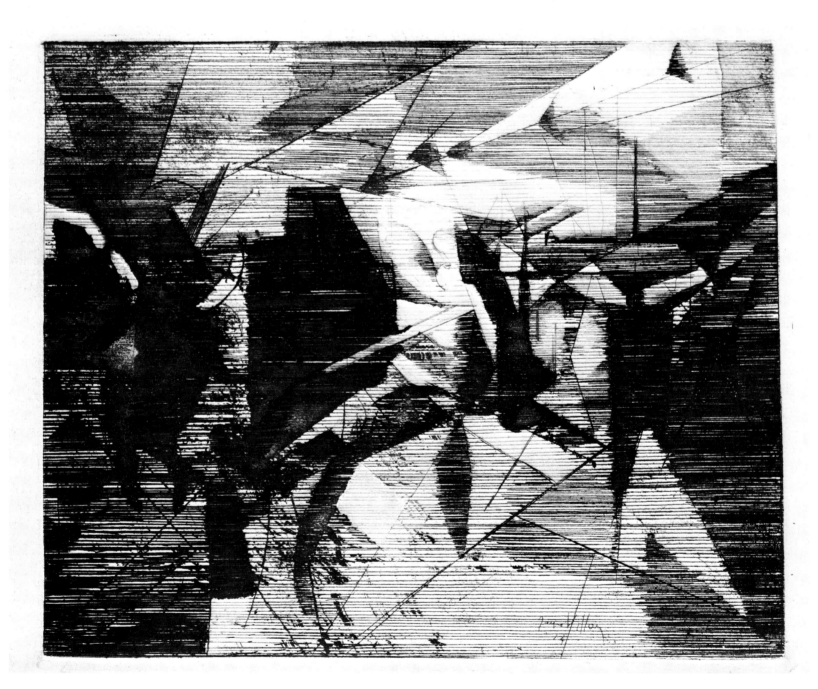

84

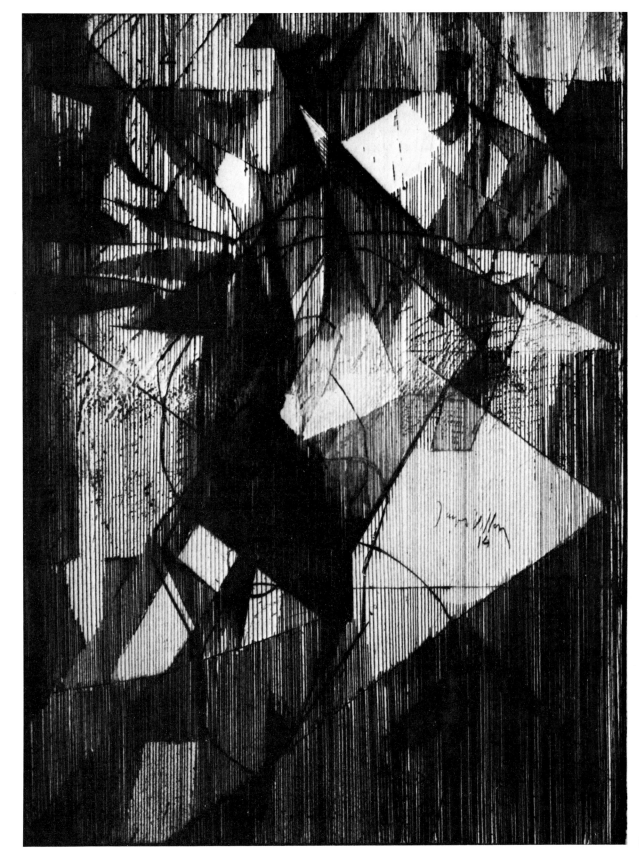

had a lot in common with Seurat's theories, which were more or less based on the work of Charles Blanc, Chevreul, David Sutter, O. N. Rood and Charles Henry.

What were the laws governing the universe? What was its source of harmony? How could the composition of a painting reflect both mathematical and aesthetic data? What part did light and movement play? Many artists asked themselves these questions: most of them did no more than think about them. Villon, however, tried to apply them in practice in his painting, asking them anew each time as they might apply to each new subject. He marshalled his research under the collective heading of Section d'Or (Golden Section), and this ideal measurement, based on the relation between the diagonal and the square, gave its name to the group that Villon always claimed to have founded, something no one ever denied.

Theories never fossilize real artists, unless they lose their sensibility, but act as stimulants. Wise, gentle Villon knew how to organize his canvases, and he showed the same ability in practical matters. "We were steadfast in our idea that a canvas should be thought out before being painted," he said. "We knew nothing about the problem of the golden section of the ancient Greeks. I read Leonardo da Vinci's Treatise on Painting and I saw how highly he rated the golden section. But our ideas grew mainly out of discussion, and we didn't get too bogged down in science."[61]

The main thing was to retain emotion and intuition.

The first Salon of the Golden Section opened on 10 October 1910 at the Galerie La Boétie, a few days after the Salon d'Automne. Marcel Duchamp's work at the time was diametrically opposed to that of his brothers: in April he had painted *King and Queen Surrounded by Swift Nudes*, the first study for the *Bride Stripped Bare by the Bachelors*.

Nude Descending a Staircase was first shown in public in May, at the Cubist exhibition organized by the Dalmau Gallery in Barcelona. The following month, Marcel went to Munich and stayed there until the end of August. There he painted *The Passage from Virgin to Bride* and *The Bride*, and did the first studies for *The Bride Stripped Bare by the Bachelors*. He went back to France via Prague, Vienna, Dresden and Berlin. Villon asked him to take part in the Golden Section, and he submitted six works, including *Nude Descending a Staircase*, which his brothers had asked him to withdraw from the *Indépendants* a few months earlier. He enjoyed his little revenge.

In various ways, for different—sometimes antagonistic—reasons, all three Duchamps were primarily preoccupied with movement at that time. Villon's *Portrait of Felix Barré* is as fundamentally different from Marcel's *Bride* as *Les Soldats en Marche* (Soldiers Marching) from *Nude Descending a Staircase*. As for Raymond Duchamp-Villon, his *Torso of a Young Man* and the figures in *Pastorale* and *Decorative Basin* showed that he was equally interested in movement, but in a decorative and architectural context.

THE GOLDEN SECTION

While the preparatory meetings for the Salon de la Section d'Or were being held at Picabia's vast apartment in Avenue Charles-Floquet, one of the exhibitors, Raymond Duchamp-Villon, was working on a project originally the brainchild of the painter and decorator André Mare: the *Maison Cubiste* (Cubist House).

In fact, it was neither a house nor Cubist. Only the ground floor was life-size, decorated and furnished, but the model showed what its final form would be. The façade was to be the entry to the Salon itself so that the visitors would have to go through the interior to get into the Grand Palais Gallery. The neo-Classical façade was ten metres long and three metres high; Duchamp-Villon had built it piece by piece in his Puteaux studio, with the help of his brothers and some friends. As anything new at the time was inevitably called Cubist, this was the name given to the Salon d'Automne house.

Since the abortive revolution of Art-Nouveau, decorating and furnishing had fascinated artists, craftsmen, critics and others who took an interest in the subject. The era was searching for an architectural yet decorative style, but every innovation was decried by the critics, who made it very difficult for architects, decorators and decorative artists to experiment. For instance, sarcasm and sneers greeted the Perret brothers' Théâtre des Champs-Elysées, nicknamed the "Zeppelin of Avenue Montaigne". In a manuscript text, Duchamp-Villon made a perceptive evaluation of the situation.

The aim of the builders of the *Maison Cubiste* and their friends was to stir up some initiative among furniture manufacturers and decorators, whose bad taste and lack of imagination were deplorable. In other countries, particularly Germany, interesting new things were being done, as shown by the Munich decorators' contributions to the 1910 Salon d'Automne; of course, the nationalist critics called them heavy and vulgar, and "Munich" became a term of abuse. But the more perceptive critics recognized their superiority.

Many painter and sculptor friends of Mare and Duchamp-Villon lent a hand with the *Maison Cubiste* in the atmosphere of free discussion and experimenting typical of Puteaux. There was not a single "historical" Cubist among them, but Apollinaire continued to ensure the liaison with the Kahnweiler group, and asked Mare if his young mistress, Marie Laurencin, could help with the work. She was put in charge of the panels for the "bourgeois drawing room".

Duchamp-Villon did the façade, and Mare furnished the entrance and designed the wallpaper and the doorway, where Raymond's *Decorative Basin* was displayed. Next came the "bourgeois drawing room" with furniture by André Mare, curtains, wallpaper, carpets and cushions by J.-L. Gampert, panels, door, clock and fireplace by La Fresnaye, panels by Marie Laurencin, and coffee set by Villon. Sabine and Richard Desvallières, Maurice Marinot, the glassmaker, Marie-Thérèse Lanoa and André Versan also contributed to the decoration of the interior, which contained pictures by Léger, Metzinger, La Fresnaye, Marcel Duchamp, and Gleizes, and sculptures by Duchamp-Villon and Wield. Decorating firms and furniture manufacturers lent furniture, panelling and objets d'art.

Unfortunately, only Duchamp-Villon showed any feeling for the idea of the whole, and for harmonizing mass and colour. He alone had sought a style: the others did not bother, and the interior of the *Maison Cubiste* reflected the chaos and disparity of the decorative arts of the time. For Duchamp-Villon, architectural decor had to be based on the principles according to which the façade had been built: economy of line and geometrical mass. It was necessary, he said, to "study the connexions between objects tirelessly, to interpret them in lines, planes and synthesized masses, which in their turn will attain a balance and rhythms similar to those of the life around us".[62]

Nothing was actually done that way; in spite of interesting ideas, the whole did not coalesce. It showed the lack of a master mind. Conservative opinion, too, obsessed with a hatred of Cubism, castigating even such artists as were only remotely connected with the movement, did not notice that lack. There was nothing really Cubist about the ill-christened

Catalogue of André Mare's *Salon Bourgeois*, Salon d'Automne, Paris 1912.

Catalogue of the *Boudoir* decorated by André Mare and his group, with Raymond Duchamp-Villon, Salon d'Automne, Paris 1913.

Raymond Duchamp-Villon. Model of the façade of the *Maison Cubiste*, Salon d'Automne, Paris 1912.

house except the straight lines and the simple, economic rhythms, which were not, after all, purely Cubist traits.

Its creators were overwhelmed with searing criticism and sarcasm; Raymond Duchamp-Villon was especially trounced in *Le Gil Blas* by the vehemently anti-Cubist critic, Louis Vauxcelles, who advised him to study medieval architecture. He was unaware of the sculptor's admiration for Chartres Cathedral and his extensive knowledge of the art of that period.

Luckily, the more clear-sighted critics understood his intentions; in *Art Décoratif*, Fernand Roches congratulated Duchamp-Villon for creating the house, which "constitutes a bold and felicitous protest against the architecture of Parisian buildings, whose ridiculous façades seem to crumple 89

like cardboard, and against the litter of shapeless sculptures like little crushed flowers..." Many visitors were also struck by the lavish colours inside: warm tones, a pleasant change from the browns, greys and pale ochres of contemporary apartments.

Thanks to Walter Pach and Michael Stein, Gertrude Stein's brother, the model of the *Maison Cubiste*, done entirely by Duchamp-Villon, was exhibited at the Armory Show in New York in 1913, where Marcel Duchamp's *Nude Descending a Staircase* was to spark off a terrible scandal. In its own sphere, the house was no less revolutionary, since the general public was very fond of heavy, over-elaborate architecture and flowing sculptures of swooning naked women and drooping foliage, which proliferated in wealthy districts. Straight lines, economy and restraint were spurned, and nobody dreamed that an apartment might be soberly decorated, light, and quietly furnished.

For Duchamp-Villon, the new influence was also manifest in the art style whose achievement he hoped to see at the Exposition des Arts Décoratifs, scheduled for 1915 in Paris. He loved sobriety and architectural purity just as he loved engineering, which, he felt, was linked with the great innovations of modern times; he wrote admiringly about the Eiffel Tower, the symbol of the industrial revolution:

"This masterpiece of mathematical energy...is more than a number because it contains a deep element of life to which our soul must defer if it is seeking emotion in sculpture and architecture..."[63]

Duchamp-Villon thought that sculpture, too, should aim at the functional simplicity of machinery. Apart from the Italian Futurists, no artists shared those resolutely novel ideas; they were not at all concerned with technological progress, industrial civilization, speed or movement. The Cubists realized how much further than they themselves the Futurists had gone in breaking the bonds of conventional art and, fearing their competition in the realm of progressiveness, they tried to limit the influence of their Italian colleagues' exhibitions and manifestos. Apollinaire hastened to show that the Futurists were "weak disciples of a Picasso or a Derain",[64] though he later revised his opinion.

Marcel Duchamp was more interested than he admitted in the Futurist experiments with movement, and so were Gleizes, Delaunay and Léger, whereas Picasso's "gang" were utterly indifferent. But though today we can see Futurism in its entirety, it was not at all like that in 1912, when, for instance, Balla's remarkable experiments on the

fragmentation of light were little known in Paris. On the other hand, Boccioni's theories on the translation of movement in sculpture became widespread during 1912 and were to have a determining influence on Duchamp-Villon's development. His big *Horse* of 1914 is Futurist both in its subject —the analogy between the horse and a machine—and in its dynamic content. His 1913 text on the subject is illuminating.

The first Salon de la Section d'Or comprised thirty-one artists exhibiting eighty works. Naturally, most of the exhibitors did not share Villon's views, and some of them had no idea what the golden section actually was and knew nothing about science. Apart from sharing an obvious basic liberalism, they were united by their contempt for the kind of ostracism practised by Picasso, Braque and Kahnweiler. Many of the exhibitors were Cubists: Archipenko, Duchamp-Villon, Gleizes, Juan Gris, Léger, Metzinger, Marcoussis, La Fresnaye and Villon. Others, such as Pierre Dumont, André Mare, Dunoyer de Segonzac and L.-A. Moreau were realists. There was also a large contingent of talented artists whose personalities and works, promising at the time, have since been forgotten.

Marcel Duchamp's contribution, *Nude Descending a Staircase*, caused a great stir, particularly with Louis Vauxcelles, Cubism's deadliest enemy. He was by no means the only person who did not understand it, and—in all fairness—he had plenty of reason not to.

Of course the conservative reviews were terrible. Using the Salon as a framework, Apollinaire delivered an apposite lecture on "The Quartering of Cubism". "The time for experiment is over. Our young artists now want to produce definitive works," he said. The *Bulletin de la Section d'Or*, which only came out once, supported the dangerous venture of Villon and his friends. The editorial office was paradoxically established at the Bateau-Lavoir, the temple of Picassian Cubism! But the sub-editor, Pierre Reverdy, lived there as Picasso had moved out to more bourgeois accommodation the year before. The future poet of *Livre de mon Bord* as well as Apollinaire, Roger Allard, Max Jacob, Princet, Salmon, André Warnod and Maurice Raynal, who probably financed the publication, contributed to this short-lived magazine.

Maurice Raynal, in fact, summarized the exhibition in terms that may seem startling now. He said that the ablest painter of the time probably was the Cubist Metzinger. He praised Picabia, Gris, Pierre Dumont, Duchamp, Marcoussis, but mentioned neither Villon, the initiator and moving spirit of the Golden Section, nor Duchamp-Villon.

THE VIRGIN, THE BRIDE, AND THE BACHELORS

At the Salon de la Section d'Or, Marcel Duchamp exhibited *Portrait of Chess Players*, *The King and Queen Surrounded by Swift Nudes*, *Nude Descending a Staircase*, *The King and Queen Traversed by Swift Nudes*, a watercolour, and two other works entitled simply *Watercolour* and *Painting*. That year, 1912, marked the beginning of the painter's creative period; those canvases still had Cubist overtones and a clearly Futurist influence—"at that point I knew about the Futurists", Duchamp said—but there was also a taste of his increasingly skilful wordplay. He was a great manipulator of paradox and juggler of symbols, and could marvellously reconcile irony, absurdity and mystery.

I had the modest role of eliciting confidences and memories, new thoughts about an adventure that was already in the past but which young artists were rediscovering as the gospel of the *art-jeu*. I listened for hours to Duchamp as he serenely unfolded the reasons for his language, its terms and content. There was only a trace of irony on his very thin lips, and the hand holding the inevitable, oft-lighted Havana hardly gestured. He spoke with simplicity and lucidity.

Villon was of the same race, but one could glimpse the fire beneath the exterior of the absorbed old painter. Duchamp was simply himself. He was not above a more or less feigned satisfaction at discovering himself, and occasionally raising new problems, which analysts and commentators seized on at once, with precious little hope of getting any real help from Duchamp himself.

He never thought of himself as a great creator or philosopher. He was always very clear-headed about himself. It would be wrong to see him as the subversive revolutionary who had upset aesthetic convention and changed the face of art; his total independence had always kept him from taking any such ill-advised stand. "I like the word 'think'," he told J.J. Sweeney in 1955.[65] "Generally, when people say 'I know', they don't know, they think. I think that art is the only form of activity in which man can show himself as a real individual. By that alone he can transcend the animal stage, because art is an opening into regions dominated neither by time nor space. Living is believing."

Duchamp always said that it was after *Coffee Mill* that he detached himself from the pictorial painting tradition to which *Nude Descending a Staircase* still belonged. Could it have been a revenge for the *Indépendants'* rejection of that painting, or a challenge to his two brothers, who had undertaken the thankless task of asking him to withdraw it? Marcel concealed the great import of that event until Villon died; he told Robert Lebel[66] that he had unconsciously decided "without even realizing it immediately, to revise my values completely". From then on, Marcel's anti-pictorial painting became anti-social as well, and even anti-family. If the King and Queen surrounded or traversed by nudes represent the father and mother, as Dr René Held[67] believes, things seem clearer: the two brothers guilty of provoking a breach are pushed aside in favour of their begetters, first stripped in order to be humiliated and confused. They symbolize everything Duchamp subsequently rejected. As for *The Passage from Virgin to Bride*[68] and *Bride Stripped Bare by the Bachelors*[69], we might see in them the image of the mother from whom Marcel was, as we know, alienated, and the indifference she felt towards him when his elder brothers had left home and he was the only boy in the feminine world over which she reigned.

These evocations of virginity threatened and finally overcome by the Battalion of Bachelors at a dance in Norman bourgeois society, and of the passage from Virgin to Bride in Monsieur Duchamp's bed, after being stripped bare in the tradition of the wedding night, are without doubt accounts of Mademoiselle Marie-Caroline-Lucie Nicolle's deflowering. They occurred in Marcel's work soon after his sister, Suzanne, had been similarly initiated from Virgin to Bride by her Rouen pharmacist husband. Her marriage had been a great blow to Marcel, and stopped him working for at least two months. After that, he became progressively more estranged from his family.

There can be no doubt that this period of his work was dominated by his mother and sister, though he formulated this equivocally, perhaps because of his distaste for femininity and his suspicion of it. One must remember that on the 91

reverse of his rather unflattering portrait of Magdeleine Duchamp, *Apropos of Little Sister*, Marcel wrote "Study of Woman/Shit" ("Merde"). The reasons for this vulgarism are somewhat unclear. Marcel declared himself "normal to the highest degree" where women were concerned. Nobody ever queried this; but if his affection for Suzanne was quite straightforward, it was nevertheless ambiguous.

Until *The Bride*, Marcel Duchamp's work was based on illustrations of what was lasting, but after it the dynamic movement seemed to stop, and we have the impression that the organ was replacing the function. Here, too, the break was complete. "It was a constant battle to make a complete, clean cut," Duchamp told me. He discarded not only his family, but the artistic milieu, movements, trends, and contemporary styles. Nothing remained of his past, and anyway, as Marcel added, "I had this obsession about not using the same things".[70]

Marcel had also acquired a growing predilection for word-play from Raymond Roussel. *The Bride Stripped Bare by the Bachelors* became, after *The Passage from Virgin to Bride*, *The Bride Stripped Bare by her Bachelors, Even*,[71] pencil on tracing-cloth, done at Neuilly in 1913. The artist himself admitted that the comma after "bachelors" and the adverb "even" meant nothing. The nonsensically poetic construction and the phonetic similarities between words with different meanings inspired some devastating thoughts among Duchamp's commentators, which amused him greatly. People got into the habit of seeing the most ordinary and minor of his creations as expressions of complicated cerebration. Marcel did not disagree with anything; he rarely read what was written about him, and soon forgot the hasty approbation he often gave to other people's theories.

Perhaps too much importance has been attached to these experimental, symbolic and mechanical contraptions of 1912-1913, and the studies of the same period based on the Virgin and the Bride, all painted confidently with carefully chosen colours. These combinations of mechanical elements and visceral shapes with their erotic suggestions are peculiarly fascinating; none of the artistic trends of the day form any part in them. Robert Lebel[72] wrote of those works, "They constitute the first inroad of modern art into the realm of intersubjective relations". They are equally far from both the aesthetic and the emotional and reveal a new mythology of being.

Apollinaire showed unusual insight into Marcel Duchamp in the short chapter devoted to him in *Peintres Cubistes*. "All men, every being who has passed near us, have left their mark on us, and these traces of life have a reality whose details we can examine and copy. Therefore all these marks together acquire a personality whose individual traits can be shown plastically through a purely intellectual process.

"There are traces of these beings in Marcel Duchamp's paintings."

The open door was soon to close again. While Raymond Duchamp-Villon and Jacques Villon went on with their experiments on movement, their younger brother, for whom the problem was already out of date, started on a path diametrically opposed to the previous one. He stopped being a painter to become... what precisely?

He had exorcised the father and mother, the mother alone, the sister, and finally his brothers. After the Salon de la Section d'Or, the break became irrevocable. Marcel was sickened by the discussions about the organization of the Salon, the quarrels about precedence, the aesthetic arguments—all the talk. He despised the "career" painters and their material ambitions. He could not see the point of the Salon, in spite of his own participation, or of those ill-assorted exhibitions in which the good and the mediocre jostled for a tiny monetary reward. He considered that the whole procedure bordered on tedious prostitution. He felt sorry for his brothers who worked so frenetically for such wretched returns. He took leave of them quietly, without explanation, and got a job at the Sainte-Geneviève library to show that he expected nothing from painting in general and his own in particular. In the same year, 1913, he left Neuilly, and in October he moved into a studio in Rue St. Hippolyte, 13th Arrondissement.

We must get back to *The Bride Stripped Bare by her Bachelors, Even*, which dates from 1913, before Marcel left Neuilly. It was the first layout for the *Large Glass*, to which he was to devote himself entirely from 1913 to 1923. He may, as he claims, have had the idea on his trip to Munich in the summer of 1912, although he did not think of using glass until later when he was using a piece of glass as a palette and, because of its transparency, noticed the colours on the other side. He had originally meant to use canvas, but as he disliked that traditional artist's prop, he enthusiastically adopted his new medium, whose fragile yet durable quality appealed to him.

The *Large Glass* originally presented itself as a "long canvas. Bride at the top. Bachelors underneath", as can be read in one of the documents in the *Green Box*, a collection of studies, sketches, notes, and calculations for its creation. These calculations are very complicated and, of course, gave rise to many interpretations, which Duchamp more or less read with more or less interest—more for the author than the theory—but which he soon forgot. He always was delighted that the genesis of the *Large Glass* and the work itself inspired such varied interpretations. He himself commented on his attitude, but did not clarify it, as he realized

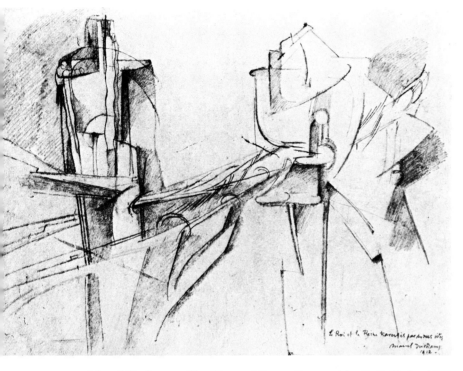

Marcel Duchamp *The King and Queen Traversed by Swift Nudes*, 1912. Pencil.

Marcel Duchamp

The King and Queen Traversed by Swift Nudes at High Speed, 1912.
Watercolour and gouache p.94

The King and Queen Surrounded by Swift Nudes, 1912. Oil on canvas. p.95

Virgin No.1, 1912. Pencil. p.96

Virgin No.2, 1912. Watercolour and pencil. p.97

The Passage from Virgin to Bride, 1912. Oil on canvas. p.98

Bride, 1912. Oil on canvas. p.99

clearly how different he was from other people, and how much his work gained from being shrouded in mystery.

"At that time we were interested in the fourth dimension," Marcel Duchamp told me. "Do you remember someone called... Povolowski, I think? He was a publisher in Rue Bonaparte... he'd written popular newspaper articles about the fourth dimension, explaining that there were flat beings with only two dimensions, and so on. It was very funny..."[73]

Duchamp may have pretended to confuse Povolowski, the bookseller and owner of an art gallery in Rue Bonaparte with Gaston de Pawlowski, author of *Voyage au Pays de la Quatrième Dimension*, published in 1912, to which he was alluding. It was Dr Held who first noticed this confusion.[74] The cultivated, intelligent Gaston de Pawlowski, editor-in-chief of *Comoedia*, was extremely fond of what is now called science fiction. From 1908 on, he published stories in *Comoedia* in which we find everything that enthralled Duchamp in *Voyage*, notably the famous speculations on the fourth dimension, with which the Cubists too were pre-occupied. But he saw it from a humerous rather than intellectual angle. "I was thinking about it while I worked, though I hardly put any calculations into the *Large Glass*," Marcel told me. "I simply had the idea of a projection, a fourth dimension that was invisible because it could not be seen with eyes." Jean Clair has read Pawlowski's book carefully, comparing it with the notes in the *Box of 1914*, and has been able to establish similarities between the *Voyage* and the *Large Glass*,[75] thereby solving a certain number of mysteries. In the *Green Box* of 1934, the references to the fourth dimension are even more explicit, and in 1955 Duchamp wrote to André Breton, "The Bride... is a projection... in four dimensions onto our three-dimensional world, and even, in the case of the flat glass, a reprojection of those three dimensions onto a two-dimensional surface." But it was not until our 1966-67 *Dialogues* that he revealed, through a deliberate confusion, the origins of his speculations. "The assumption on which the layout of the *Large Glass* is based," Jean Clair concluded, "is the same... as that of Pawlowski's *Voyage*; just as painting is the projection of a three-dimensional world onto a two-dimensional surface, that world itself could simply be the projection of a four-dimensional entity."

One can imagine Duchamp's interest in Pawlowski's definition of the fourth dimension, "the necessary symbol of the unknown without which the known could not exist". "This fourth measure without which the other three could not fully explain the universe." The place given to art could not have failed to delight him. "Without the existence of the real four-dimensional world, which our minds sense outside any idea of time and space...art would be madness. One cannot copy 93

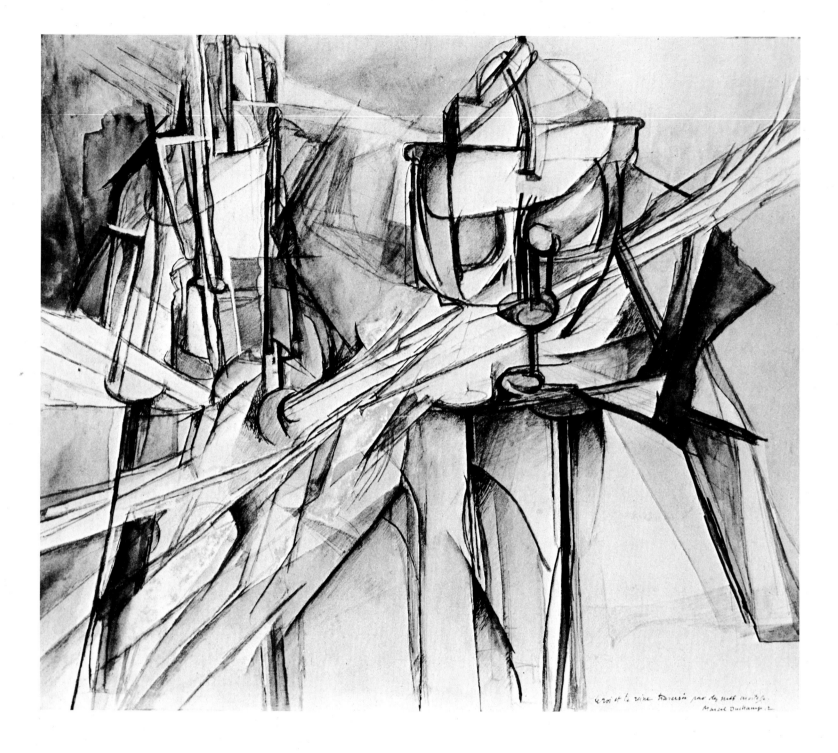

94

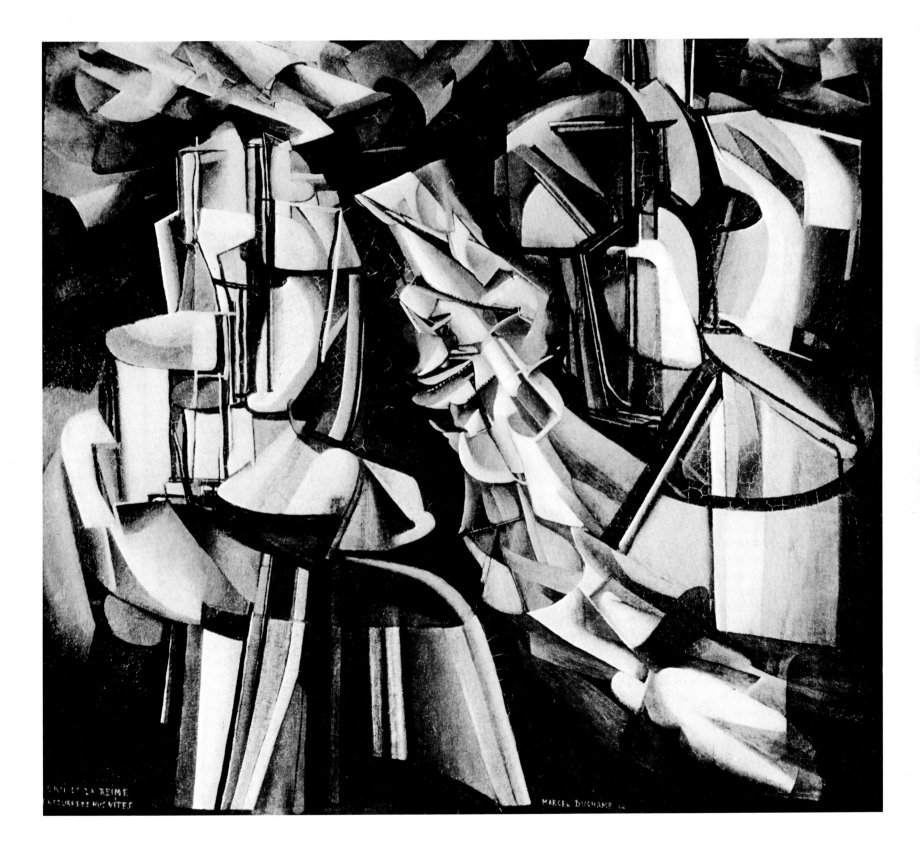

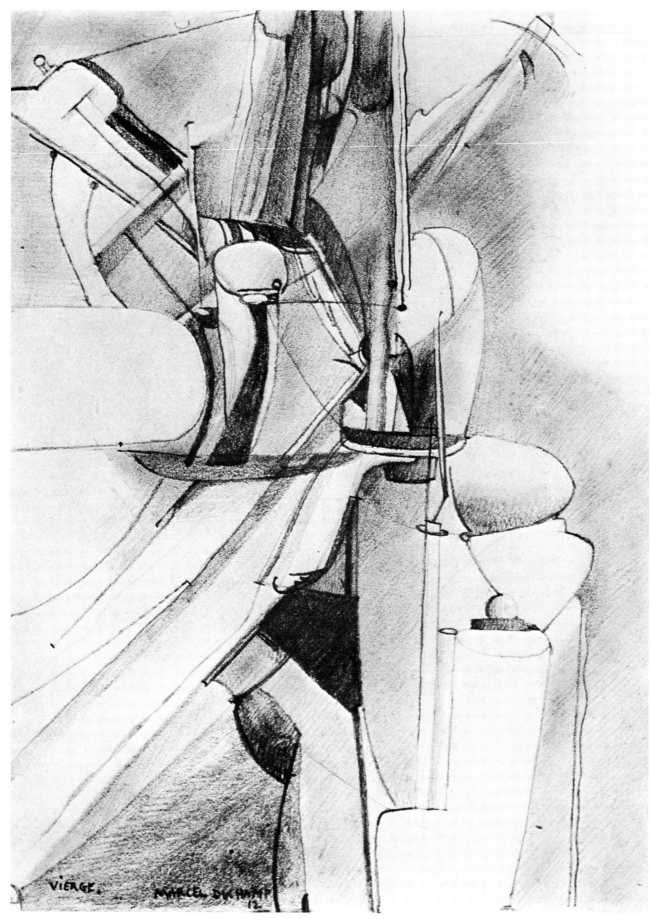

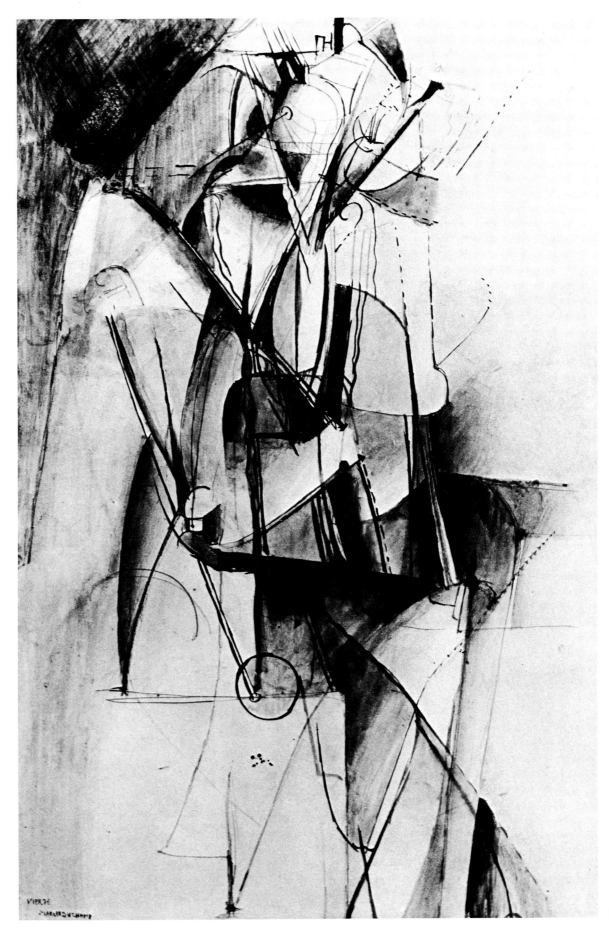

97

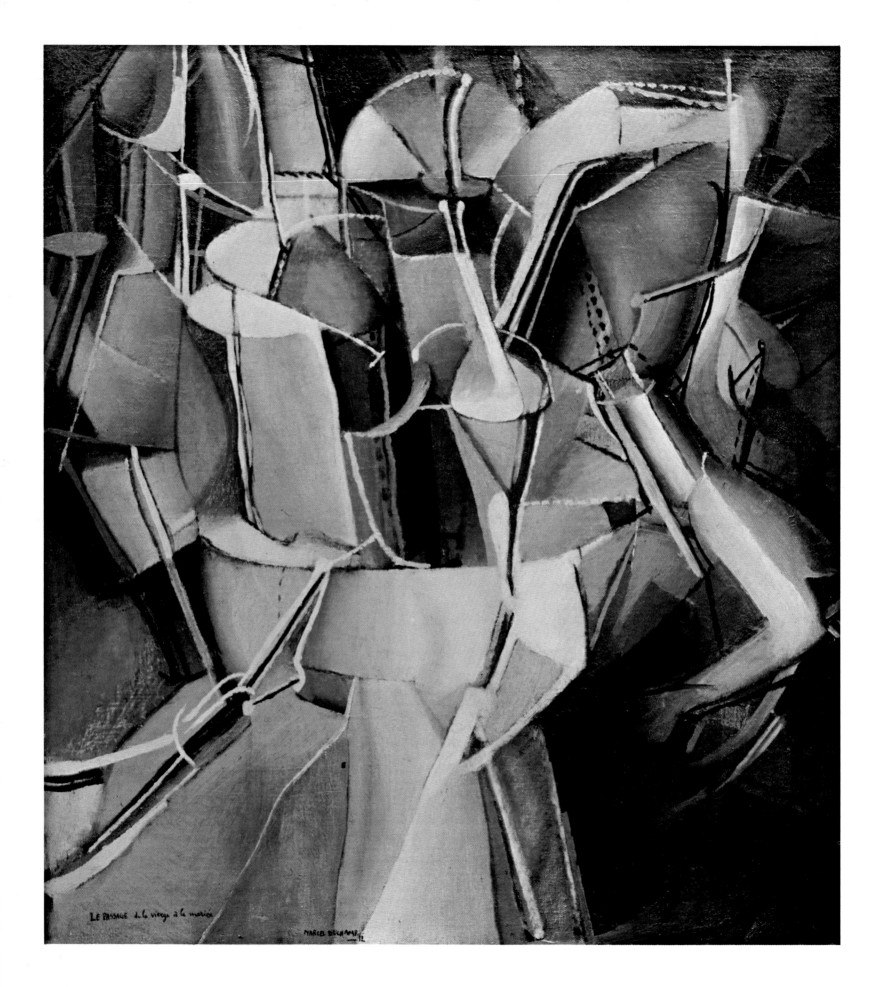

LE PASSAGE de la vierge à la mariée MARCEL DUCHAMP 12

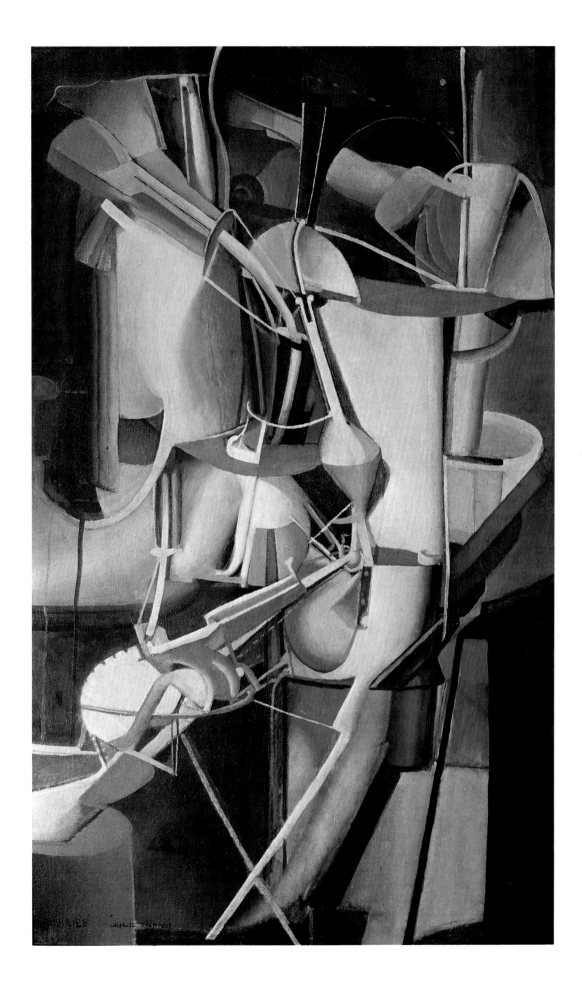

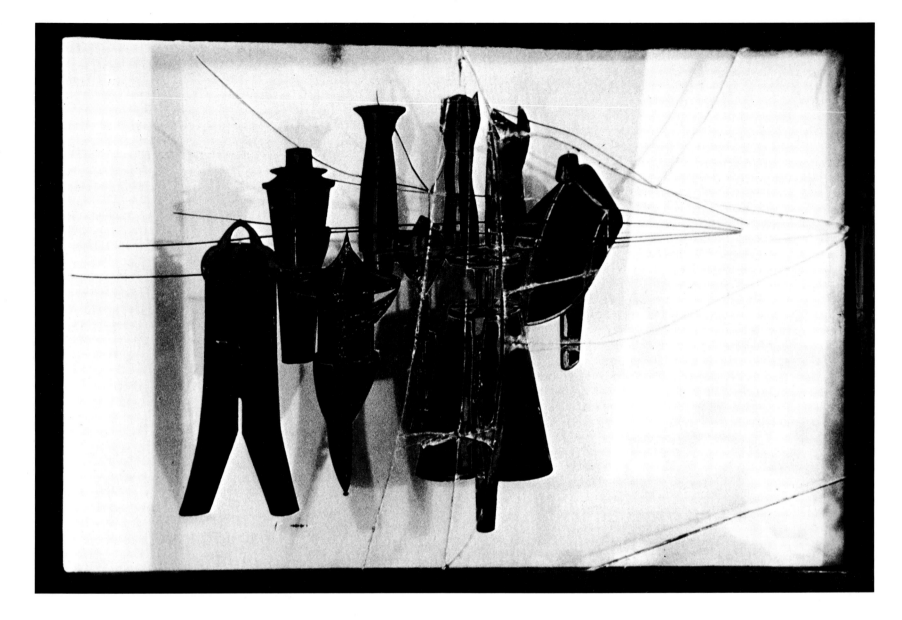

100 Marcel Duchamp *Nine Malic Molds*, 1913–1915. Oil, lead wire and sheet lead on glass.

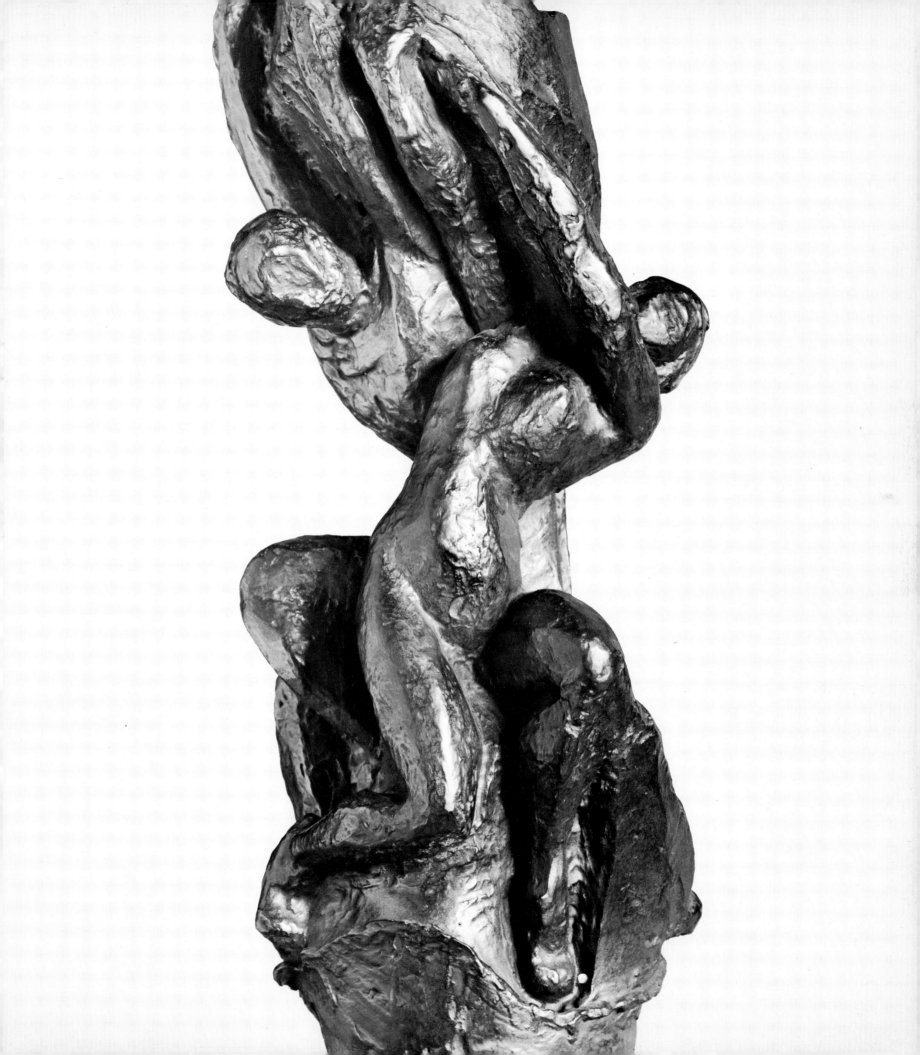

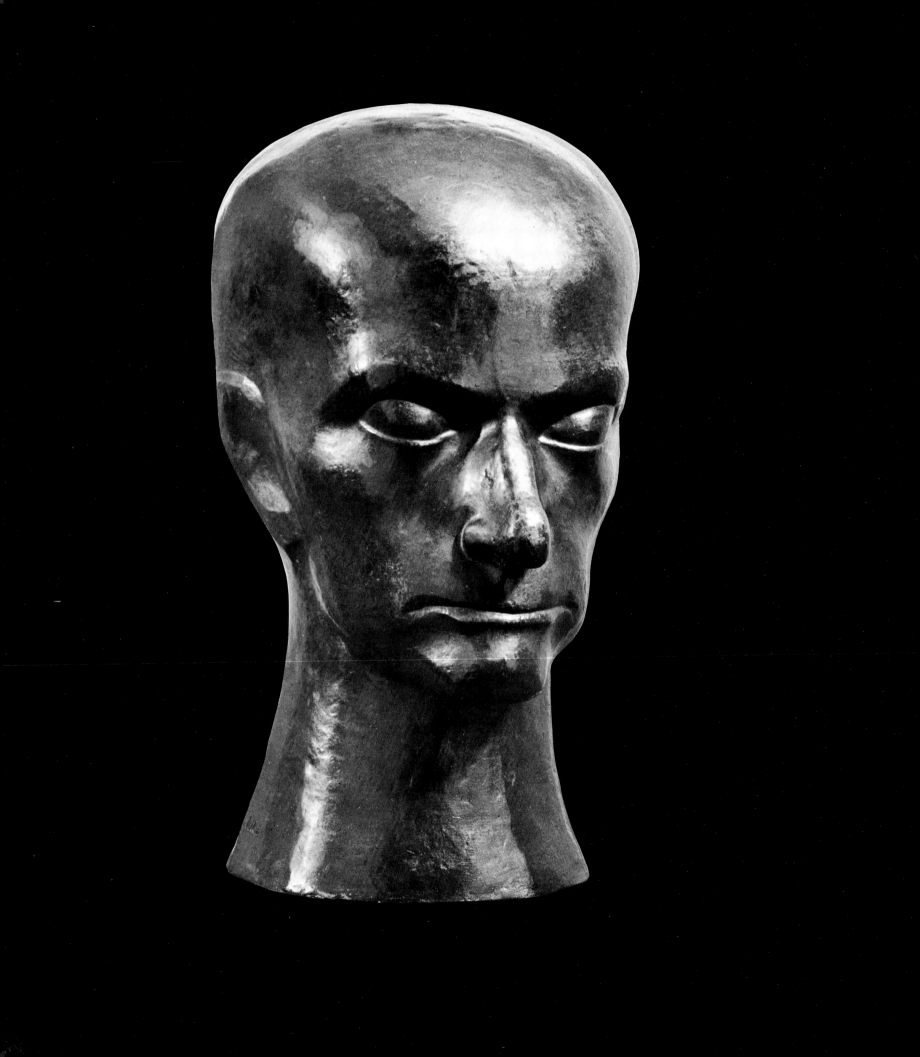

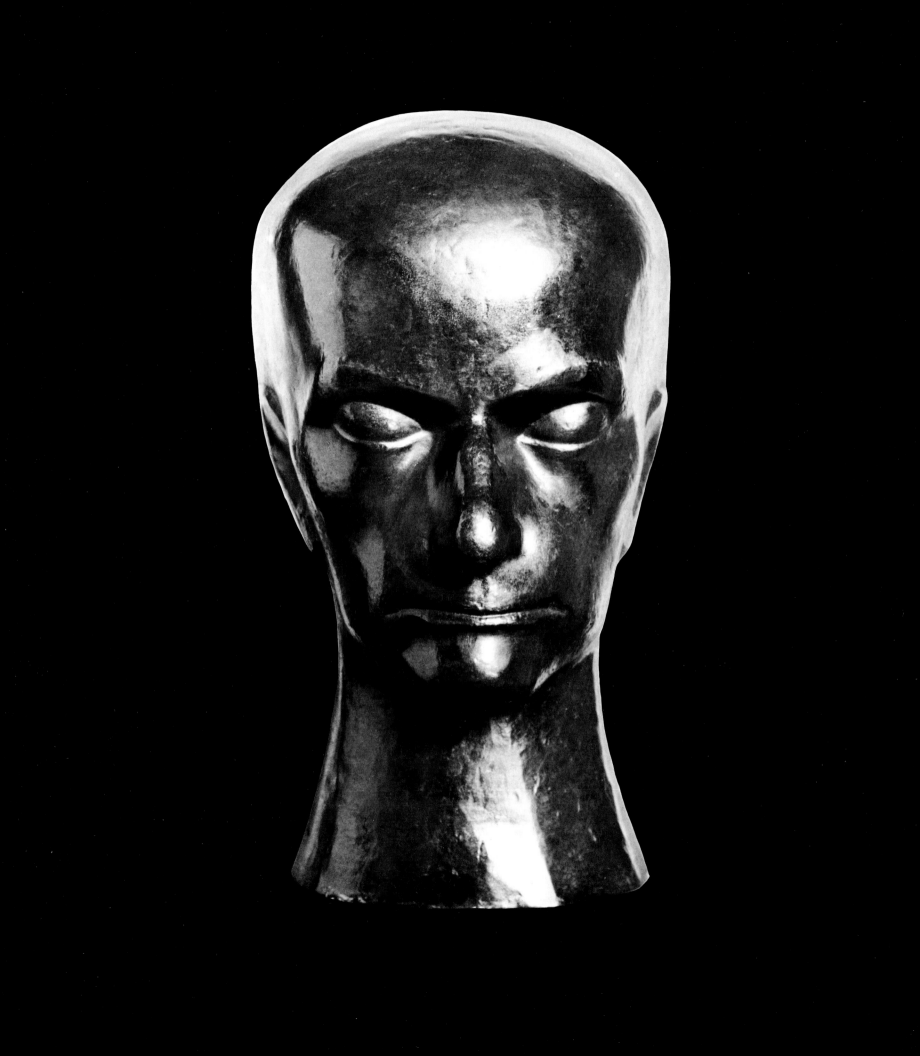

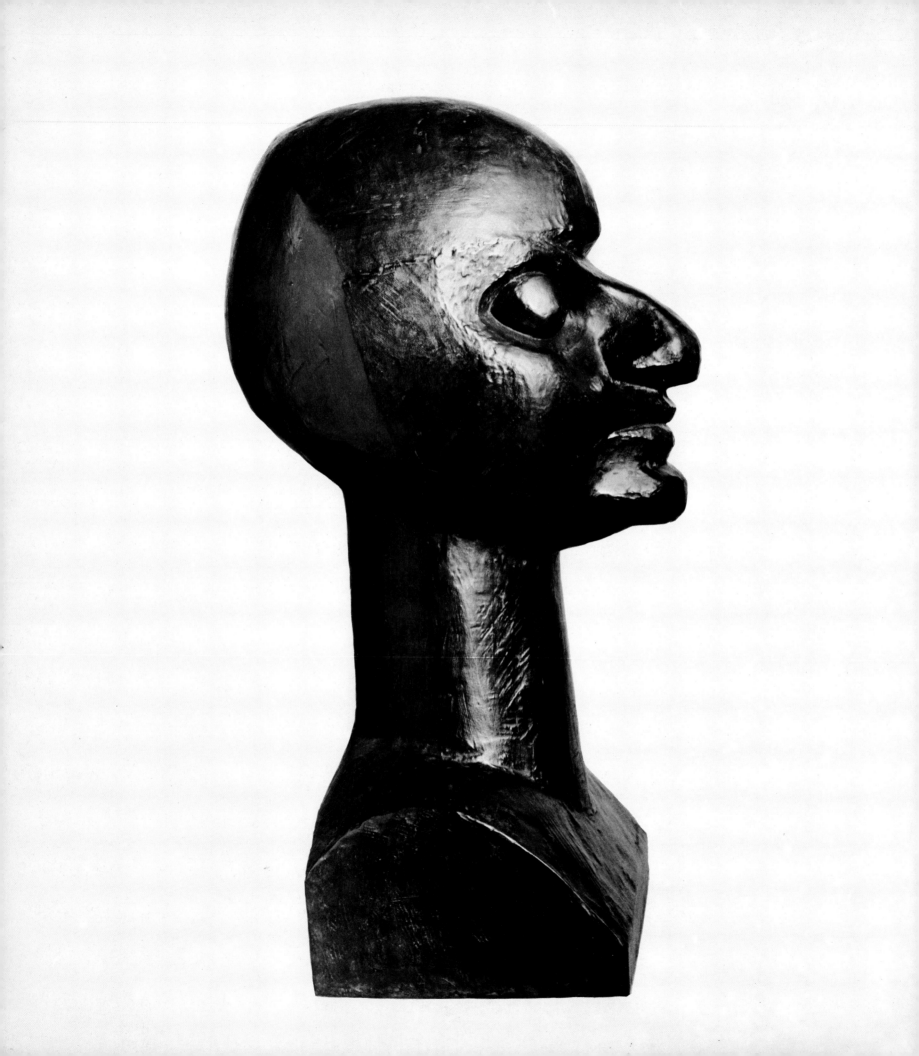

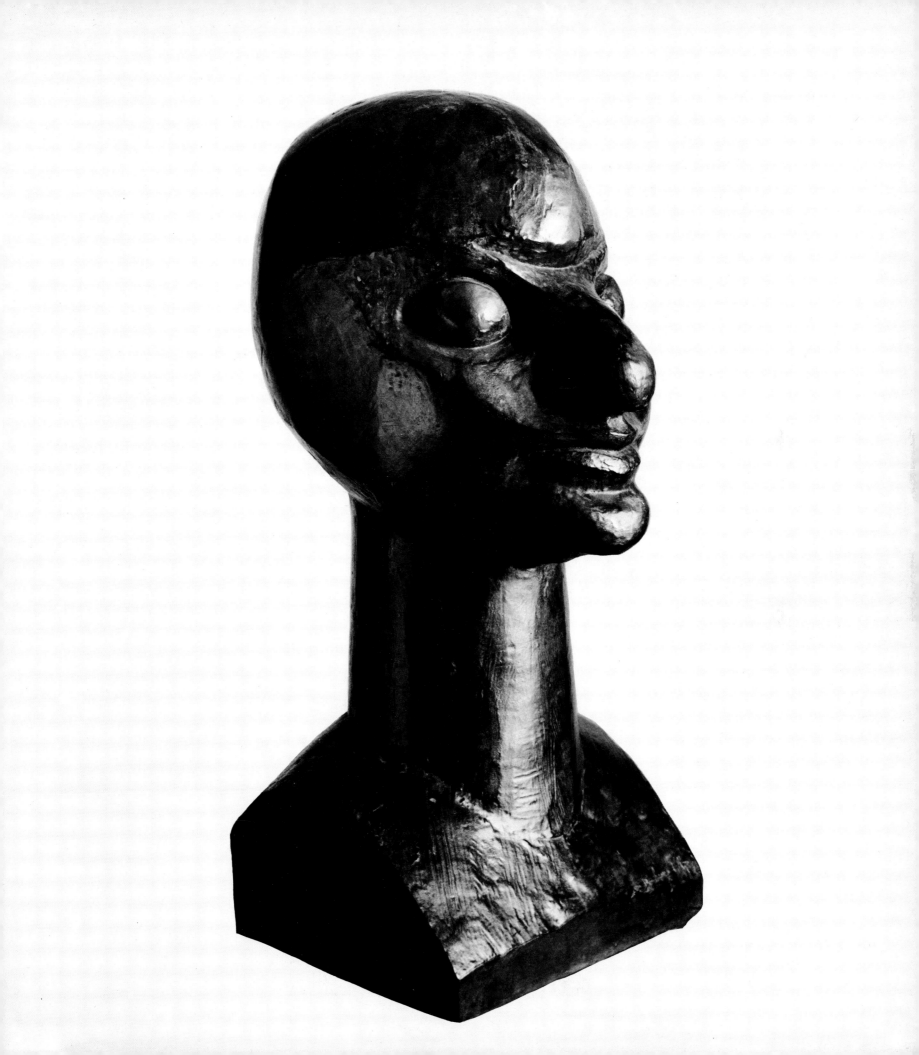

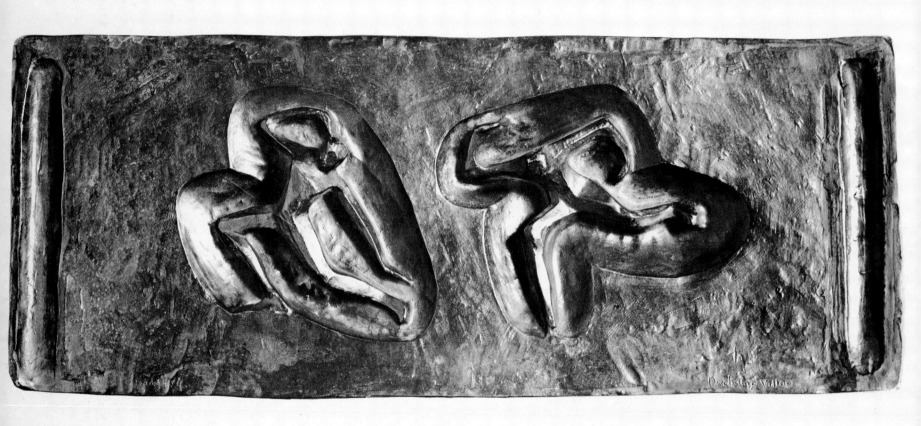

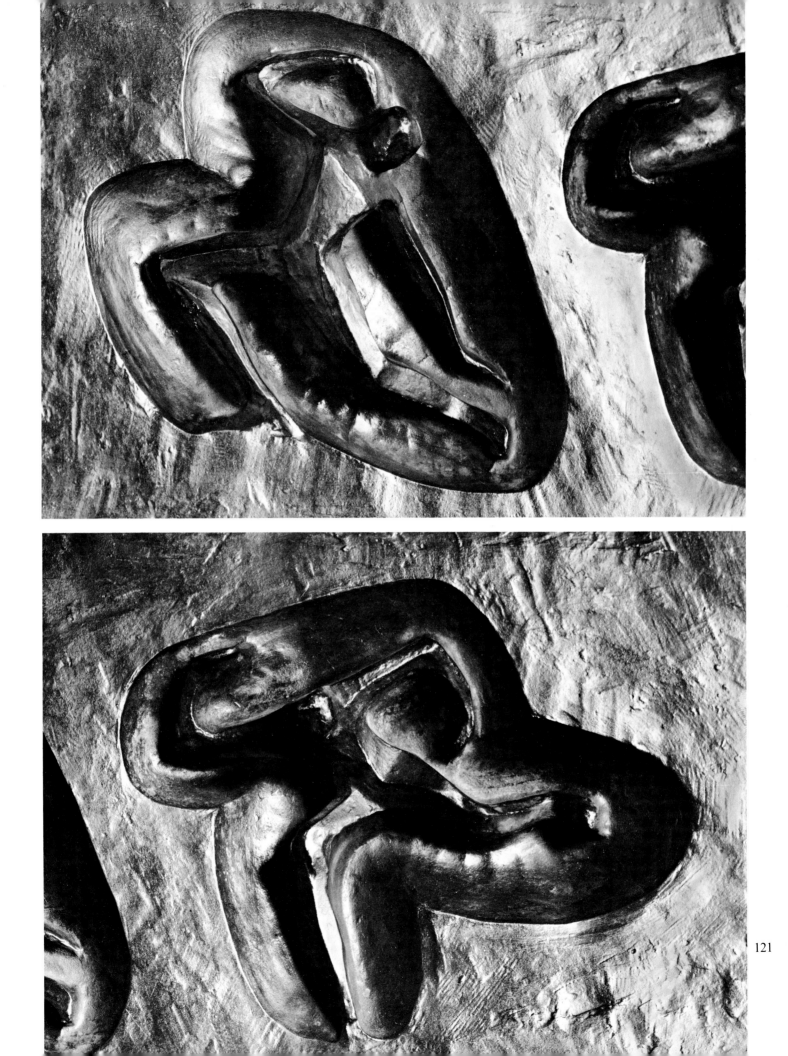

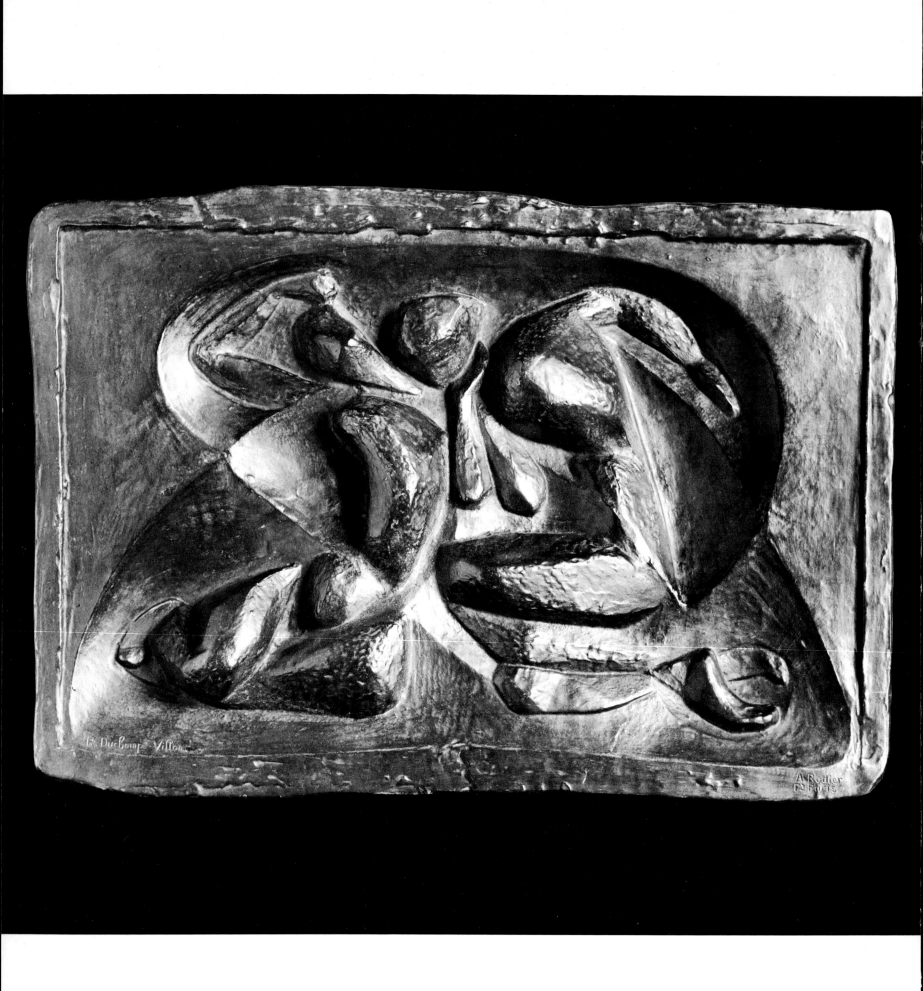

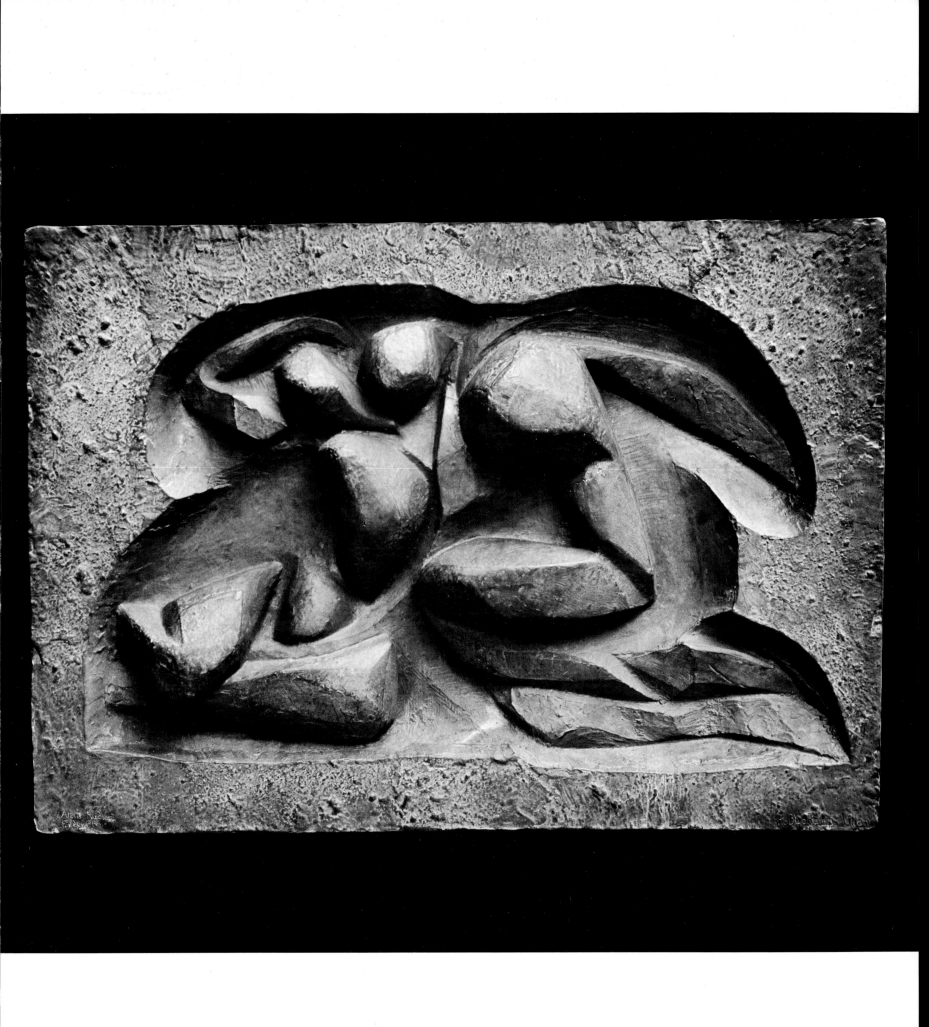

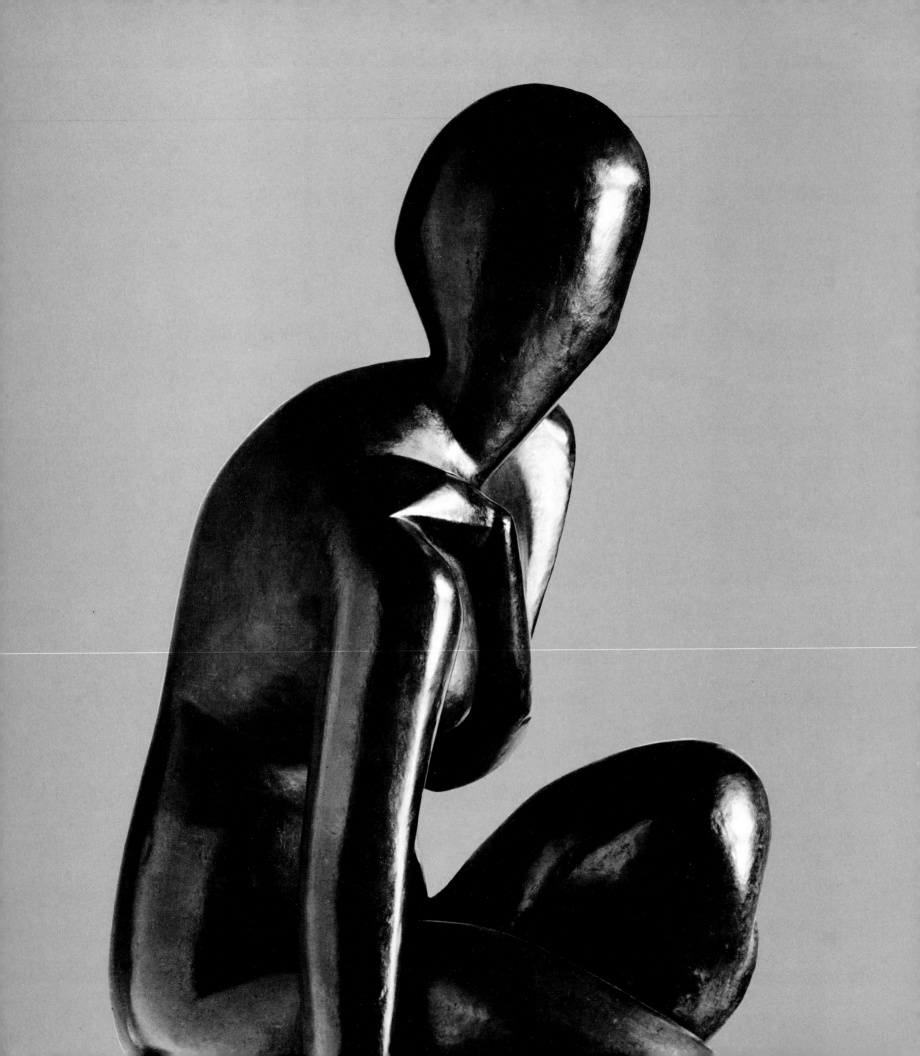

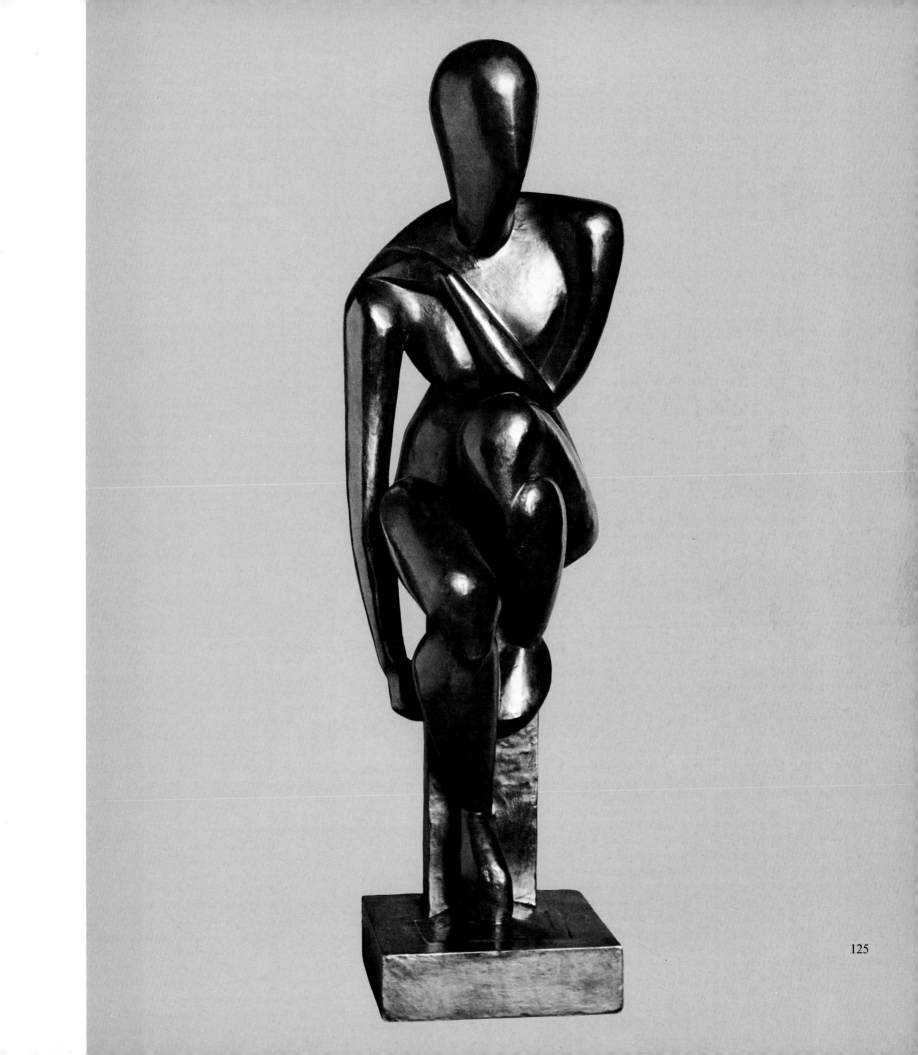

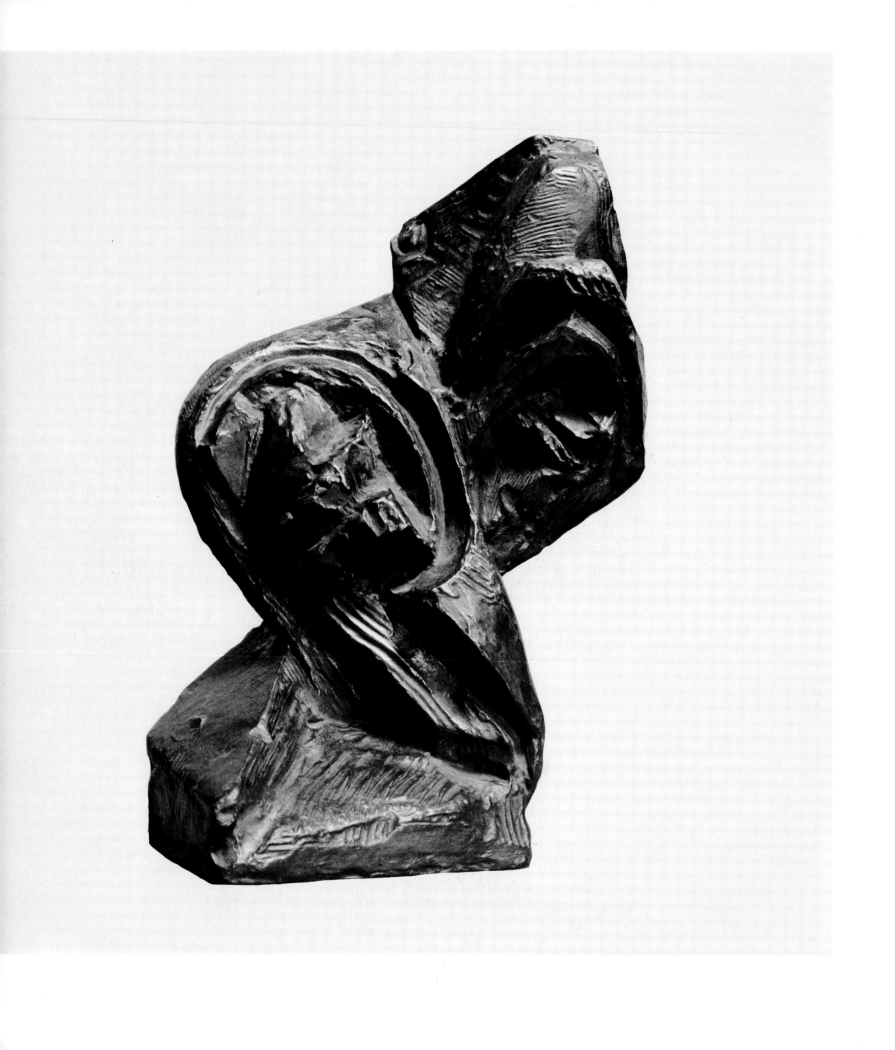

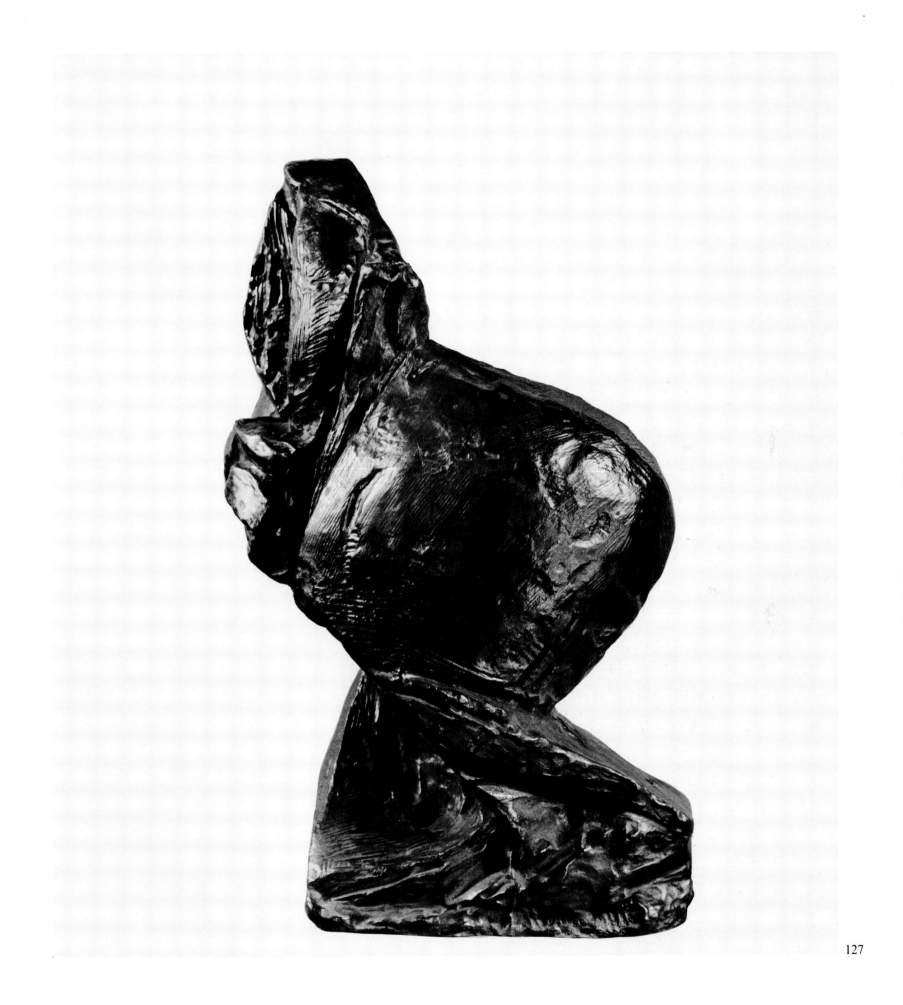

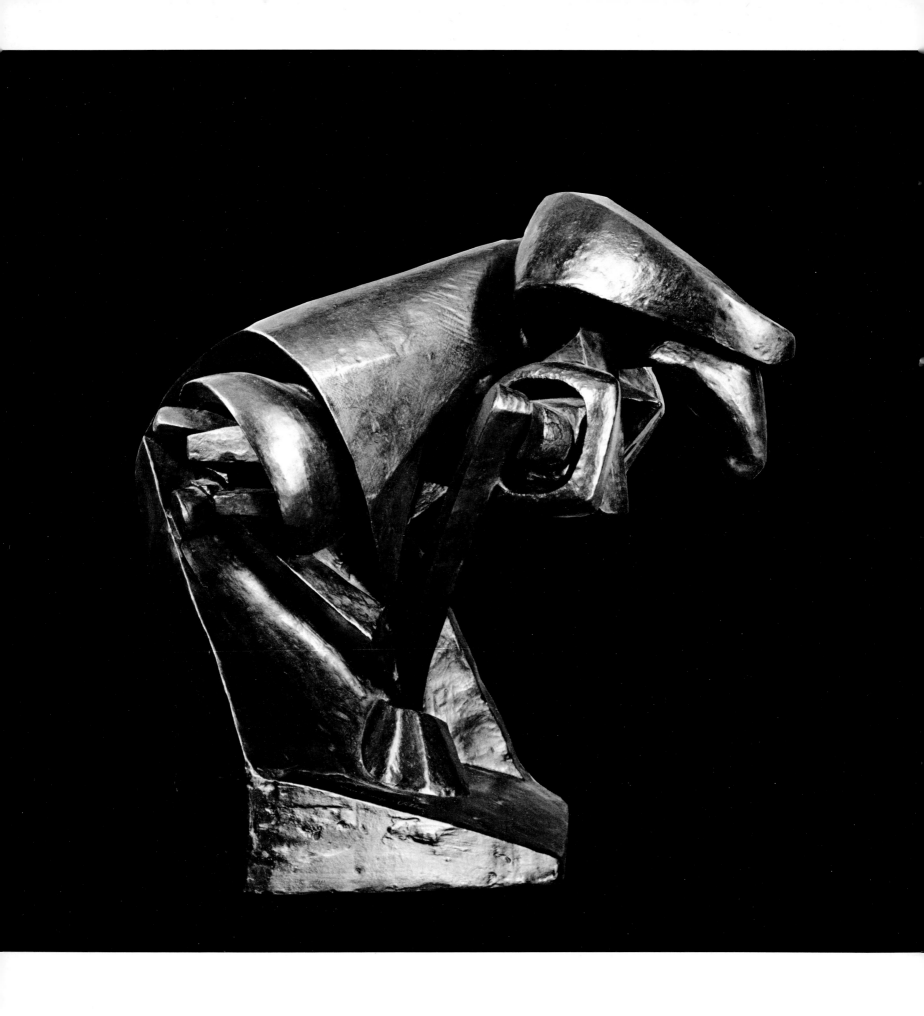

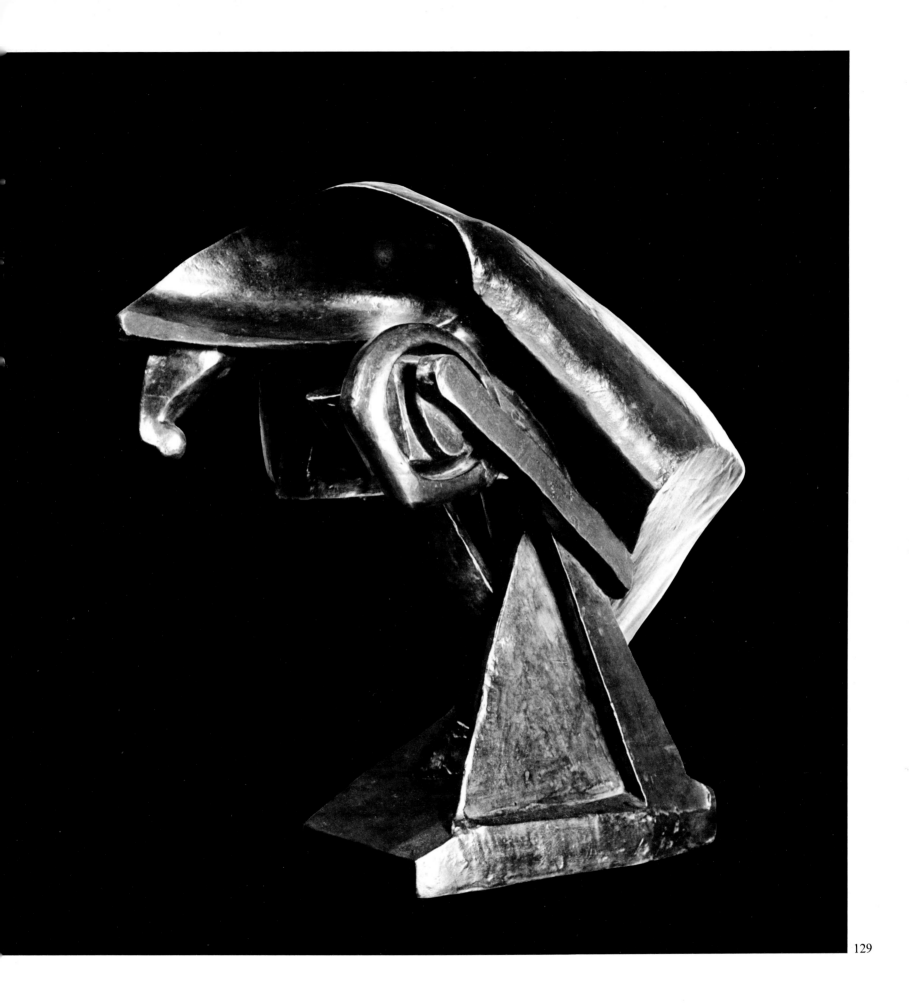

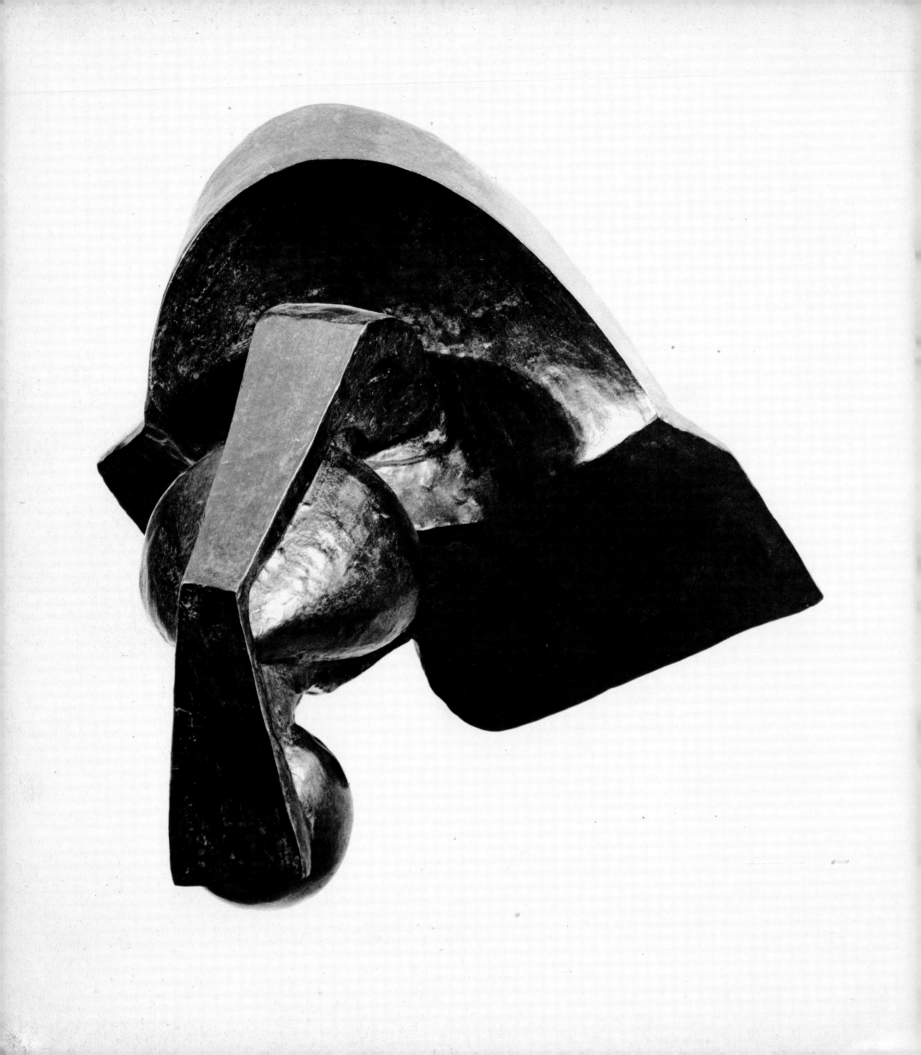

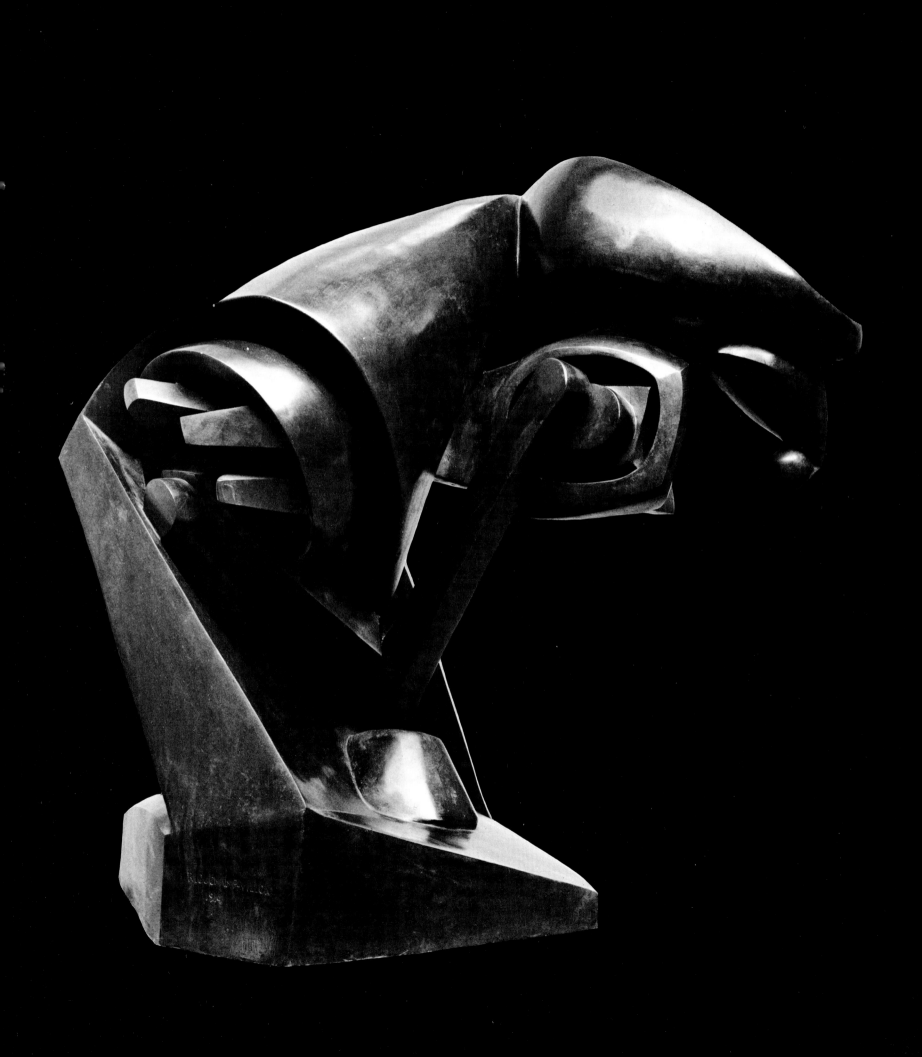

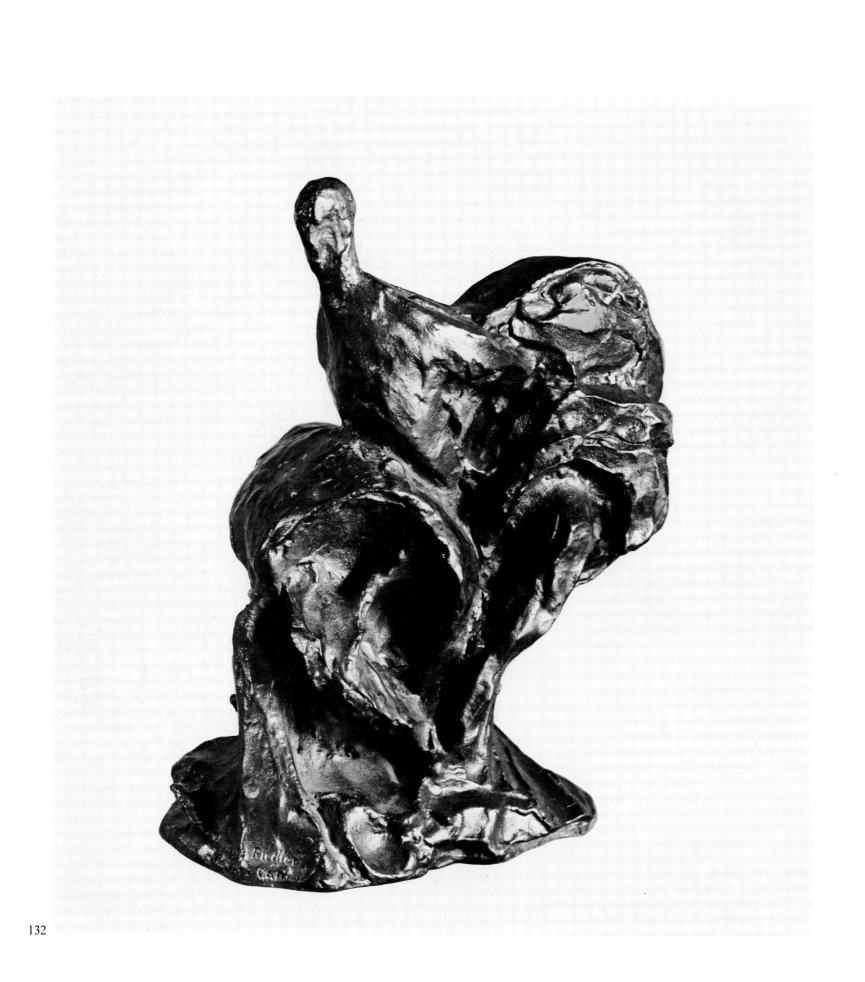

132

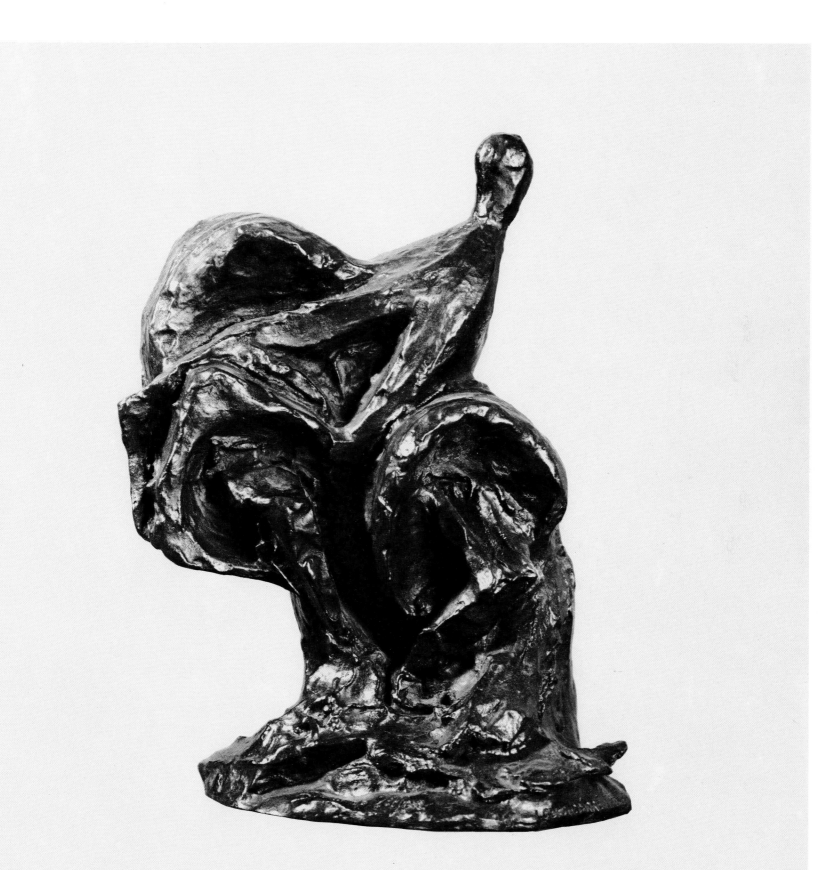

133

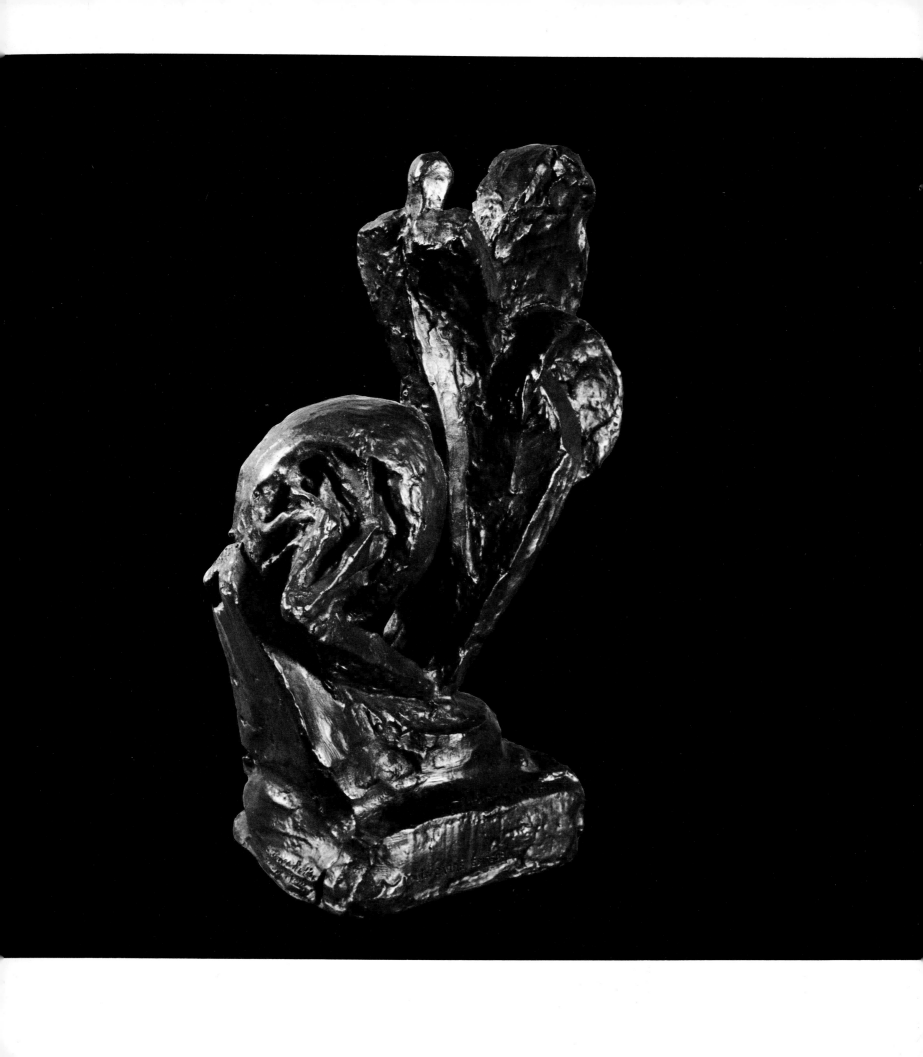

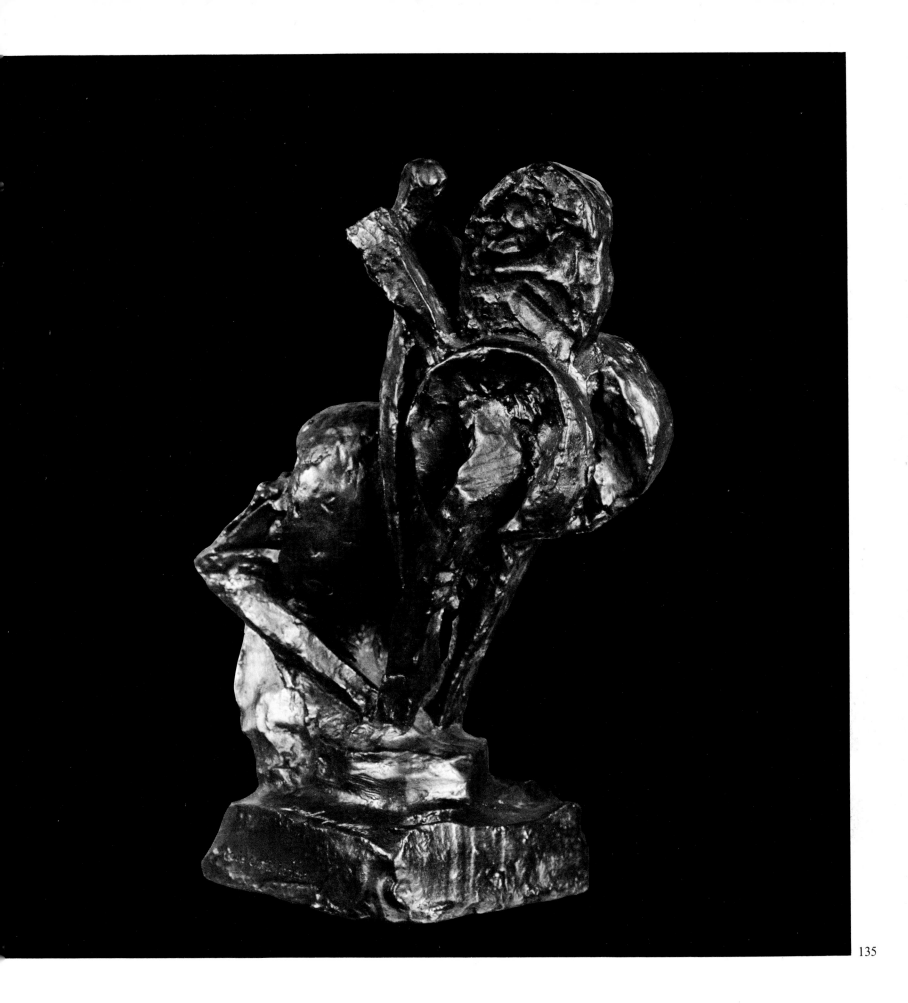

complex, which can be looked at from any angle and which pulses with life. Cubism and Futurism were both outdated, and this was something new. Cubism was self-defeating, as it only saw the form, Futurism dealt only with movement, but the combination of mass and movement in space laid the foundation for a new artistic movement.

Duchamp-Villon's *Horse* was planned down to the last detail and owed nothing to change. An unfinished manuscript, *Variations de la Connaissance pendant le Travail d'Art*, found among the artist's papers, shows his mental processes during the gradual evolution of his creation. This text tells us a great deal about the sculptor's thoughts as his studies proceeded. Duchamp-Villon's *Horse* is not only a three-dimensional feat but an accumulation of knowledge. The work's taut organic impetus and controlled mechanical power were to become fully achieved in the *Large Horse* (Grand Cheval).

Duchamp-Villon and Marcel Duchamp must surely have discussed the problems with which they were wrestling. Marcel was always very secretive about his elder brother; it is very likely that many of the ideas leading from *Nude Descending a Staircase* to the *Bride* and the *Large Glass* were sparked off by those of Duchamp-Villon, particularly in the ambiguity of equating the organism and the machine. Duchamp kept quiet about his brother's influence and at times even pretended to be unaware of his importance, even confusing the names and dates of his brother's works. This indifference sometimes went hand in hand with admiration, if not approval.

Ribemont-Dessaignes [84] said that "Duchamp-Villon...was an extremely intelligent man, who tended to universalize his knowledge, integrating art into a metaphysical concept of the representation of the world. Also, he was very kind to other people". In his preface to the Galerie Pierre exhibition in 1931, André Salmon wrote that "Duchamp-Villon's death is a tragedy comparable to Seurat's death at thirty and Guillaume Apollinaire dying before his forties..."

The *Horse* gave rise neither to interpretations nor commentaries. Compared with the complexities of the *Large Glass* it is crystal clear. It was the perfect accomplishment of a long-term goal, the gradual elimination of any descriptive element to give full impact to pure volumes and their functional arrangement.

The *Horse* was accompanied by *Head of Horse* and followed by *Large Horse*, a marvellously polished work destined for the 1914 Salon d'Automne. "A horse conceived mentally...a horse broken by an authority higher than that of any rider, and at the same time restored to the freedom of

purely intellectual creation," wrote Jean Cassou, [85] who also described the work as a "supreme obsession".

Matisse compared this dual offspring of nature and artifice, sight and knowledge, to a missile.

Shortly after his brother's death, Jacques Villon explained the development of the work: "He seemed to move farther and farther away from representing nature and he was fascinated by the mechanical side, which permeated his work. An engineer combined with the architect and sculptor, but that doesn't mean that such an ultrasensitive man as he was didn't look at life any more—on the contrary, he adored it." This is obvious from Duchamp-Villon's graceful *Seated Woman* contemporary with the *Large Horse*, and the extraordinary *Portrait of Professor Gosset*, who was his doctor after he had contracted the typhoid fever, in 1917 at the front in Champagne, from which he never recovered. That mask, Duchamp-Villon's last work, was only, as has been written, a starting point; it was clearly derived from African sculpture.

Raymond Duchamp-Villon died of blood-poisoning in Cannes, on 9 October 1918, a few weeks before Apollinaire.

His brother Jacques was mobilized in the 21st Territorial Infantry Regiment in August 1914 and was sent to the front in October. He took part in the battle of the Somme, and then his regiment was posted to Champagne. In 1916, he was moved to Camouflage; as he was attached to the Amiens workshops he worked in the front line. It was impossible for him to paint or engrave, so he made do with drawing; he not only brought back several sketchbooks from the front, but more finished pen drawings, such as *L'Entonnoir* (Champagne, 1915), *La Nuit dans une Cave à Hébuterne*, *Soldats Couchés* (pencil and purple ink), *Cantonnement à Hébuterne* and *Plantons du Commandant* (Hébuterne, 1915), in which his incisive style and sense of large built-up forms can be seen, as well as his training as an engraver.

Among the watercolours, *Corvée de Prisonniers* and *Soldat Faisant une Bague* are equally vital skilfully coloured observations of daily life at the front. [86]

Marcel refused to try that sort of life. In spite of his brothers' reproaches and those of his sister-in-law, Yvonne Duchamp-Villon, he showed no martial fervour. After all, he was exempt from military service for health reasons. He had been working hard for some time: *Chocolate Grinder No. 2* (the first dates from the year before) and *Network of Stoppages* both date from 1914, when he was still making

Raymond Duchamp-Villon *Portrait of Professor Gosset*, 1917. Bronze.

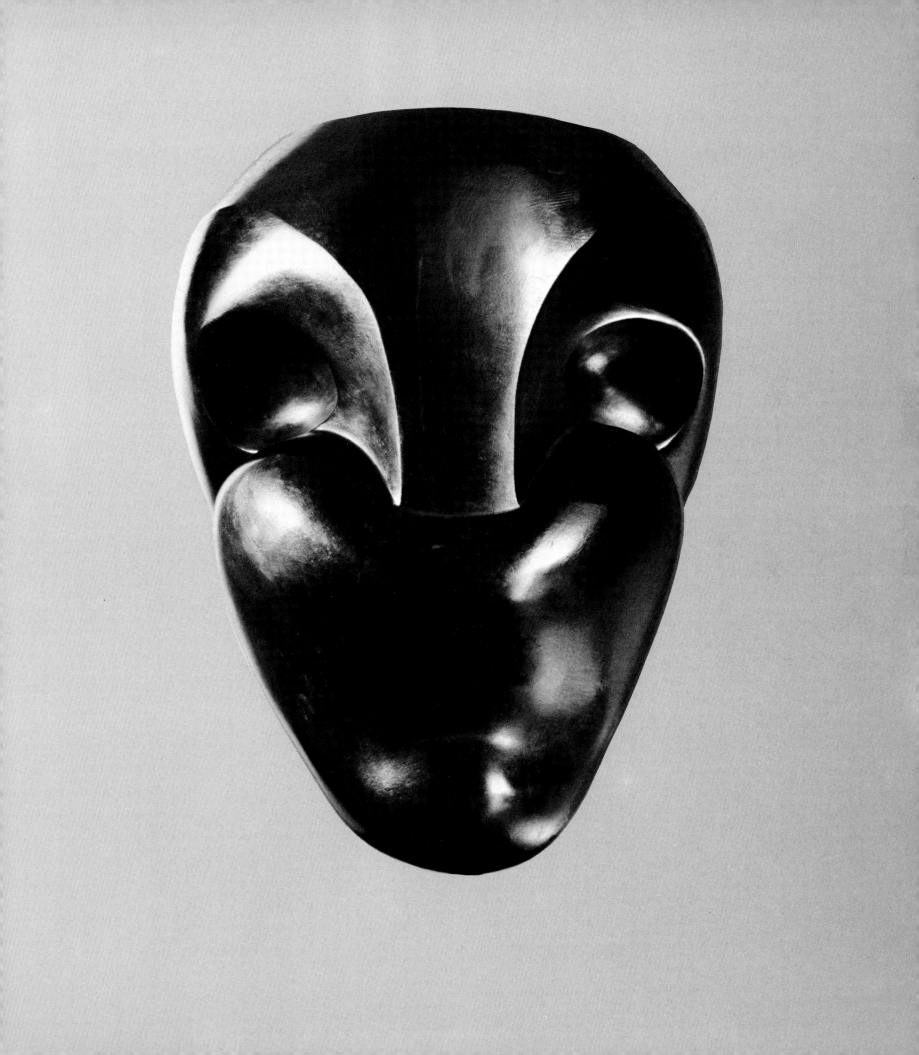

sketches for the *Glass*. He also worked on the *Box of 1914*, which contained several scrawled manuscript notes and a picture, possibly inspired by Jarry, *The Passion Considered as an Uphill Bicycle Race* showing a *Cyclist Painfully Riding Uphill*. The caption: *To Have the Apprentice in the Sun*.

A few months earlier Marcel had had the idea of fixing a bicycle wheel upside down on a stool. "It was just to pass the time," he said. "I had no specific reason for doing it, and no intention of exhibiting it, or proving anything. No, nothing like that at all..."[87]

In January 1914 he was on the train to Rouen at dusk and noticed two lamps in the distance, one red and one green, which reminded him of a chemist's. He went to an art-supply shop and bought a commercial print of leafless trees surrounding a stream, and added two spots of red and green. "That's the sort of distraction I had in mind," said Duchamp.[88]

At the Bazar de l'Hôtel-de-Ville he found a bottle-rack whose shape he liked. It is hard to define art or a work of art, to know whether an object in itself can be regarded or exhibited as art. Marcel's previous works had already got away from conventional pictures and initiated a process of aesthetic and emotional change in him. Everyday objects had become important to him, though he did not yet know where that was leading. In his revision of vision and language, the object was to take its rightful place outside its usual logical context to become autonomous. It was to be re-baptized and individualized to become its own justification for existence. There again, the shift was minute but decisive.

"When I put an upside down bicycle wheel on a stool, I wasn't thinking of a Readymade or anything else..."[89]

Duchamp said that he did it for fun, not to provoke or sneer.

One autumn evening in 1914, when France was rejoicing in the "miracle of the Marne", Walter Pach and Marcel Duchamp sat on a bench in Avenue des Gobelins, enjoying the last fine days. "Why don't you come to America?" asked the critic. *Nude Descending a Staircase* had had far-reaching echoes and there was no doubt that its author would be warmly welcomed; he would benefit as much from the adulation as the scandal—both equally exciting to the twenty-seven year old painter who was eyed suspiciously in the street because he was young, fit and not in uniform.

He stayed in France long enough to finish the *Box of 1914*, perfect the *Glider Containing a Water-Mill in Neighbouring Metals*,[90] which he took up again later, and to begin the *Nine Malic Molds*,[91] painted glass with lead wire and lead sheeting. He portrayed, rather humorously, his sister Suzanne at the military hospital where she was nursing, as well as the manager of the establishment, nurses, a pharmacist and a doctor. He stayed in France long enough to put an end to a whole era in which Marcel Duchamp had abandoned nearly all conventions of painting and drawing.

But he would be able to continue working on a new basis in America, where artistic circles were different and he was considered a curiosity. He got rid of his past and, without regret, left his native France waiting for victory, its eyes on Grandfather Joffre and George Scott's patriotic colour prints.

He left unobtrusively, as usual, after seeing his family but not his friends, who were almost all at the front. He arrived in New York in June 1915, and Walter Pach greeted him rapturously.

AMERICA! AMERICA!

Instead of the revolutionary it expected, America got a young, reserved, well brought up Frenchman; the young Frenchman was expecting a seething metropolis but found a vast "rather provincial" city with "lots of little French restaurants and hotels…" "I had a glimpse of what nineteenth century America might have been like," said Duchamp.

France was highly regarded, and so was her art, but the wealthiest collectors had Gothic castles and Renaissance palaces built to house their Titians, Veroneses, and Rubenses, next to which they hung works by such artists as Bouguereau, Meissonier, Henner, Rosa Bonheur and Sargent. A few big collections included Impressionists, but these were still avant-garde. The only artists shaken by the Armory Show were—with a few exceptions—those whose pictures did not sell. Everyone still remembered the scandal over *Nude Descending a Staircase*; three months after Duchamp's arrival, the magazine *Arts and Decoration* printed his first American interview under the title, *A Complete Reversal of Art Opinions by Marcel Duchamp, Iconoclast*.

He obligingly took the role of iconoclast and held it authoritatively for fifty years. No other twentieth century artist deserved this label more than he did.

Iconoclasm started with *Nude*, and in America Marcel found a fertile soil. In France the war seemed likely to last a long time, notwithstanding official propaganda, and he would have had to adapt to war-time conditions and all the humiliations of war work. But in New York it was different. Although his fame had not spread very far afield, Walter Pach virtually became his manager and soon made him known to many artists and collectors, ensuring him a wide public. The interview in *Arts and Decoration* led to others. As a so-called missionary of insolence, Marcel was determined not to disappoint the expectant Americans.

As soon as he had disembarked from the *Rochambeau*, Walter Pach took him to Walter and Louise Arensberg's house in 33 West 67th Street. These two rather original collectors were to acquire, over the years, the biggest collection in the world of Duchamp's works. They are now in the Philadelphia Museum of Art. This is the only case where a single collector acquired an artist's entire output so that it is exhibited in one place; although a few works are in various museums or private collections, the main body is in Philadelphia.

Walter Conrad Arensberg went to Harvard, then made his debut as an Imagist poet in New York. As he was not immediately successful, he took on the vast and thankless task of decoding Shakespeare and Dante to discover the secret of their works and their real personalities. He founded a society upholding the theory that Shakespeare's works were really written by Bacon. When he died, he left enough to support his collaborators and the continuation of his research.

Arensberg had also experienced the impact of *Nude Descending a Staircase*, but he went to the Armory Show only on the last day, and like all of Duchamp's exhibits it had been sold. He decided to buy them back, then methodically acquired all the pictures Marcel would sell, beginning with his first post-Impressionist works, which he had sent from France. The Arensbergs sometimes waited for years for the painting or drawing they wanted; they bought the two versions of *Nude Descending a Staircase* in 1930 and 1935, *The King and Queen Traversed by Swift Nudes* in 1935, and the 1912 *Bride* in 1937. Marcel himself sometimes acted as intermediary and so earned a commission.

He stayed with the Arensbergs for three months, and in October moved to 34 Beekman Place, then to a studio in Lincoln Arcade on Broadway, where he lived for over a year. In October 1916 his patrons persuaded him to move into a studio they had fitted up for him at their house. He started the *Large Glass* in Lincoln Arcade, on a huge sheet of glass laid flat on trestles; onto this he transferred the tracings of the forms he had elaborated during the previous years, then outlined them with thin lead wire stuck on with varnish. The painted sections were then covered with lead sheeting for protection.

Duchamp continued this slow fastidious work at West 67th Street. Everything had to be calculated to the nearest millimetre, and for eight years Duchamp concentrated so carefully on this work, which he considered vitally important, that he damaged his eyesight.

As he had no means of livelihood, Walter Pach and John Quinn found him a job as librarian at the Institut Français in New York. Gradually Marcel's circle of friends increased. He met Man Ray, then a young painter of twenty-five whose main fan was A.J. Eddy, who had bought *The King and Queen Surrounded by Swift Nudes*; and the Arensberg house became a meeting place for all the avant-garde artists, poets, writers and musicians passing through New York and, of course, for most of the painters and sculptors new to the city and to America. Duchamp met some charming young women there most of whom were not indifferent to the iconoclast's rather detached charm.

And Picabia was there too. Wherever he was, everything changed, quickly and noisily, whereas with Marcel things were transformed gradually, quietly, and more durably.

Picabia had been mobilized in Paris at the beginning of the war and had himself sent to Cuba—his father's birthplace—on a special mission. Passing through New York, he was reunited with Marcel at the Arensbergs', and with many American artists he had met on his previous visit during the Armory Show, including the photographer Alfred Stieglitz, who had exhibited some of his work in March-April 1913. Picabia forgot his Cuban mission and immediately plunged into the wild New York artistic circles, whose parties usually ended in universal drinking bouts, as at the Arensbergs' three or four times a week. "We played a lot of chess," said Marcel.[92] "We drank a lot of whisky and ate cake at midnight, and the whole thing ended around three in the morning; sometimes there were real drinking orgies, but not always... it was really an artistic *salon*. Great fun too."

Less than two years earlier Picabia had immersed himself in his so-called mechanical period, which led to the extraordinary era of the *Fille Née sans Mère* (Girl born without Mother), whose compositions based on real and imaginary mechanomorphic elements, without thought of function, preceded those based on real objects before culminating in linear drawings. Like Duchamp, Picabia founded his titles on wordplay.

Most of his mechanical works were done outside France.

Marcel Duchamp was delighted to see his old friend again, but the two were very different. Picabia plunged into American life while Duchamp observed it with curiosity and detached irony. He kept his distance and worked hard, as the *Glass* was taking up most of his time. Marcel put reflection before everything, even work, and on the same level as

chess. There was a time and place for money and women, the two often being synonymous. In 1966, when he re-read our recorded dialogues, he told me, "It flows from the source". Such was his life.

In January 1916 Picabia held an exhibition of six mechanomorphic paintings at the Modern Gallery in New York, but his various excesses were affecting his health and he became very ill. As he was physically incapable of painting, he took up writing and composed the first of his *Cinquante-Deux Miroirs*, which were published in Barcelona in 1917. As soon as he was well enough he went to Cuba to complete his mission—buying molasses for the Army Commissariat—and on his return appeared before the French Draft Board in New York, who let him take a well-earned rest. In August 1916, he and his wife went to Barcelona.

New York painters were puzzled by Marcel Duchamp's attitude: he had not only renounced traditional props and what he called "turpentine intoxication", but he kept out of the commercial circuit and neither exhibited nor sold. Was he an artist and what were his connexions with art? What did he call an artistic "work" and what were his intentions in creating the *Glass*—of which everyone was talking but which no one had seen—from cryptic notes and calculations? His thin lips remained sealed in an enigmatic smile.

The bicycle wheel and bottle-rack were in Paris, but Marcel had brought *Pharmacy* to New York and gave it to Man Ray, who kept it for a long time. While he was in America, his sister Suzanne and his sister-in-law cleared out the Rue Saint-Hippolyte studio, and threw away the bottle-rack. But he continued to be deeply interested in objects because their very banality constituted a repudiation of the work of art. The irony and changes which an object experienced in relation to its utility, function, and environment did the rest. The mass-produced objects Duchamp chose did not automatically become works of art by some magical process. There was an imperceptible mutation through the aesthetic into the ethical; the artist confirmed the priority of his moral responsibilities, at the same time shedding a new light on the modern industrial and urban setting. What was regarded for a long time as a demonstration of anti-art was, in fact, the first of a series of reassessments based on the denial of the common traditional notion of value.

Marcel Duchamp *Bottle Rack*, 1914. Readymade: galvanized-iron bottle dryer.

140

In New York in 1915, Marcel Duchamp gave his objects their full expression by naming them: "At that point, the word Readymade came to me.[93] It seemed a good description of those things, which weren't works of art or sketches, which didn't correspond to any accepted art term…"

His choice "depended on the object. I had to be careful to avoid the 'look'. It's very difficult to choose an object, because after two weeks you either love it or hate it. You have to become so indifferent that you have no aesthetic feeling. The choice of Readymades is always founded on visual indifference and a total lack of good or bad taste."[94]

He managed this through "mechanical design. It can't be good or bad, because it's outside any pictorial convention."[95]

Duchamp did a second (lost) version of the *Bicycle Wheel*,[96] then took a snow-shovel and wrote underneath, "In Advance of the Broken Arm"; it was the first inscribed Readymade. *Comb* followed in February 1916, with the inscription "*3 ou 4 gouttes de hauteur n'ont rien à voir avec la sauvagerie*" (3 or 4 drops of height have nothing to do with savagery).

With Hidden Noise, dating from Easter of the same year, was an assisted Readymade, like *Bicycle Wheel:* a ball of twine between two brass plates joined by four long screws. Duchamp did three versions on the same day, two of which were lost; Arensberg kept the third and put a small object into the ball of twine. This rattled when the whole was shaken, and from this it derived its title. Marcel wrote on it in French and English, both incomprehensible as some of the letters were missing. He never knew what Arensberg's object was. "The noise was mainly hidden from me," Marcel said.

This was followed by *Apolinère Enameled*, a signed and rectified advertisment for Sapolin enamel. The rectification added an element of mystery and phonetic humour because of its connexion with the name Apollinaire. *Traveler's folding Item* was an Underwood typewriter cover, and *Trap*[97] was an assisted Readymade, a coat-rack nailed to the floor. *Fountain*, another assisted Readymade, was an upside-down urinal signed R. Mutt 1917.

The originals of these Readymades have been lost. It would have been inconsistent for Marcel Duchamp, the determined opponent of fetishist obsession with the uniqueness of a work, to keep them. He redid some of them at different times, and even let others do and sign them for him, to the disgust of some of his friends. In 1964 he allowed the Milanese art-dealer, Arturo Schwarz, to do fourteen series of eight numbered Readymades. A supplementary series was reserved for its author.

Marcel Duchamp's contemporaries did not understand his baptism of objects; a little later he was classified as a 141

Marcel Duchamp *Pulled at Four Pins*, 1915. Etching.

ing through or staying in New York, including Gleizes and his wife Juliette, Francis and Gabrielle Picabia, Henri-Pierre Roché and Jean Crotti, his future brother-in-law. There were also plenty of American artists. Duchamp was particularly friendly with Arthur Dove, one of the first American abstract painters; he met Oscar Wilde's pseudo-nephew, the bizarre Arthur Cravan, a boxer, lecturer and adventurer, and his mistress Mina Loy, an Imagist poet, and many other women. These circles also included Alfred Stieglitz, though he did not get on with the Arensbergs, Marius de Zayas, the painter, Edgar Varèse, the composer, Henri-Martin Barzun, Man Ray, Walter and Magda Pach, Ernest Southard, the neurologist, and Beatrice Wood and Katherine Dreier, who both played an important part in Duchamp's life.

He made some concessions: he submitted several Readymades to exhibitions at the Bourgeois Gallery (modern painting since Cézanne) and the Montrose Gallery (with Gleizes, Metzinger and Crotti). He also had a hand in founding the Society of Independent Artists Inc. with Walter Pach, W. C. Arensberg, John Sloan, George Bellow, and others. Like its Parisian counterpart, this salon had neither "jury nor prizes", so Duchamp took the opportunity to submit *Fountain*, the urinal signed R. Mutt 1917, and didn't bat an eyelid when his shocked colleagues put it behind a screen. Even anonymously, Marcel Duchamp was as embarrassing to the New York Independents as to their counterpart in Paris. But as he had expected this reaction, he was delighted. "I didn't have the traditional attitude of a painter submitting his picture, wanting it to be accepted and praised by the critics," he said, a trifle hypocritically.

Henri-Pierre Roché publicized the incident in a short-lived magazine, *The Blind Man*, and the national press took it up. Duchamp ostentatiously resigned from the Board of Directors of the Society of Independent Artists Inc., and overnight the urinal took its place alongside *Nude Descending a Staircase* among the incunabulae of the American avant-garde.

Fountain seemed to be jinxed; Walter Arensberg bought it, then lost it, and it was known only through photographs

Dadaist though he was far from being one. It was only after the Second World War that the Readymades took on all their historical and ethical importance. The young Neo-Dada American generation responded to the extended power of expression of the mass-produced object, but it has never been understood or appreciated in France.

Henri-Pierre Roché, who knew Duchamp well, said that in 1916, in America, Marcel "created his legend like a young prophet who…finds everyone repeating his words…"

At the Arensbergs', Duchamp was the life and soul of the group, which always comprised several French people pass-

Marcel Duchamp

Apolinère Enameled, 1916–1917. Rectified Readymade: advertisement for Sapolin enamel, partially modified by the artist. p.143

You-Me (Tu m'), 1918. Oil and pencil on canvas, with bottle brush, three safety pins, and a bolt. p.144

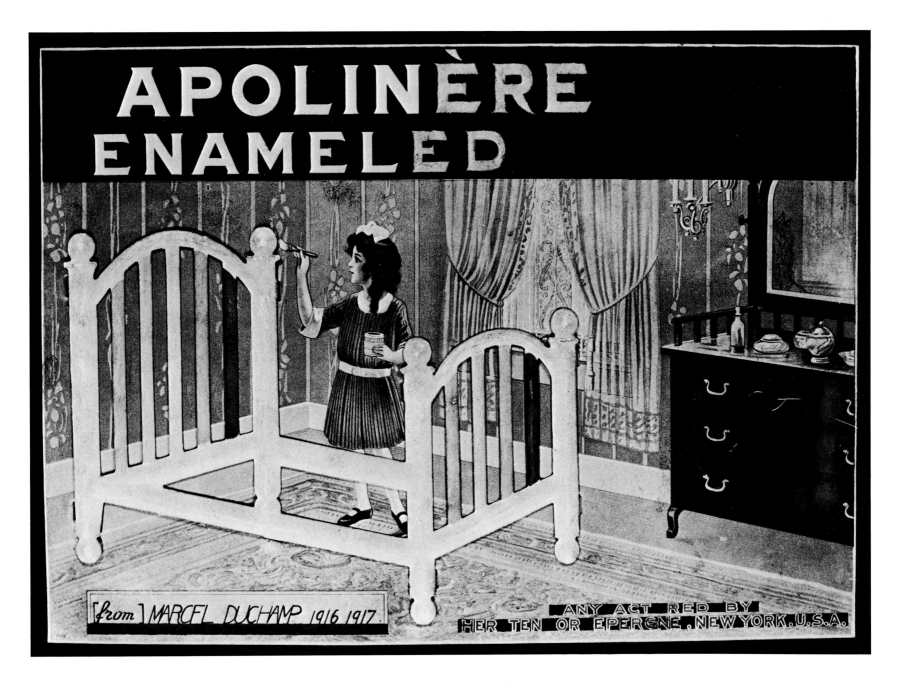

143

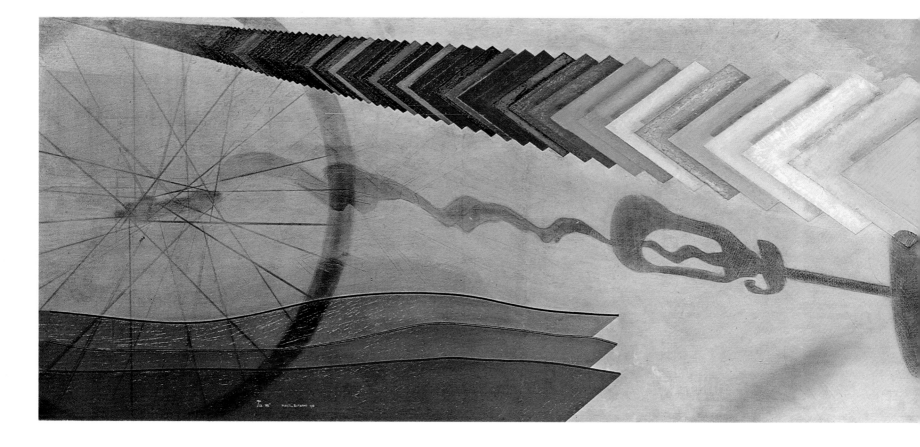

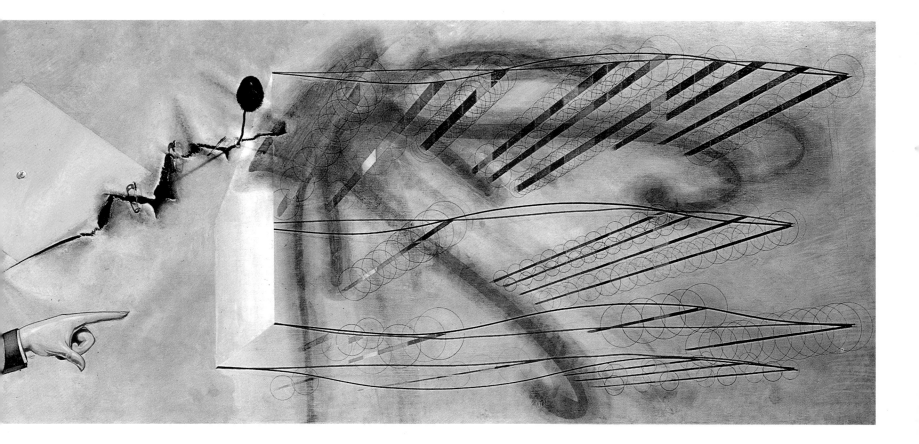

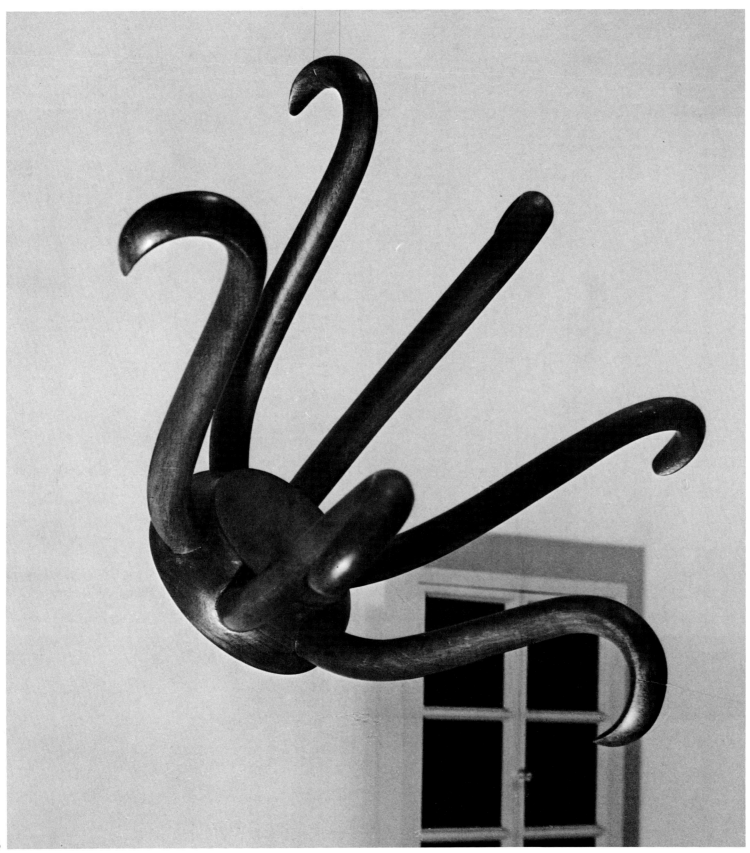

until Duchamp made a copy of it for the American dealer and collector Sidney Janis, in 1951.

Tristan Tzara's book *La Première Aventure Céleste de Monsieur Antipyrine* had just arrived from Europe, and its novelty was disconcerting. No one in New York had heard of Tristan Tzara, or Dadaism, though Duchamp's group was undoubtedly pre-Dadaist, as were the small magazines published since the Armory Show to encourage the innovating spirit among painters, poets and writers.

Among these were *291*, the number of the building on Fifth Avenue in which Stieglitz had his avant-garde gallery; *Others*, financed by the Arensbergs; Allen and Louis Norton's *Rogue*; *The Blind Man* and *Rongwrong*, founded by Henri-Pierre Roché and Marcel Duchamp with the help of Beatrice Wood, the actress. These last two had only three issues between them, but they nevertheless have a place in the history of the beginnings of modern American art.

While Picabia was resting in Barcelona after a disintoxication cure, he started a magazine called *391*, and when he came back to New York in April 1917 he brought out three new issues. It was he who enlightened Duchamp and his friends about Dadaism.

Although the editors of *391* knew virtually nothing about the European Dadaists, the magazine took an equally extreme stand and challenged the notion of art and the artist's traditional role with extraordinary aggressiveness. It also showed how absurd it was to attribute excessive importance to inspiration and style in the creation of a work.

Duchamp and Picabia asked Arthur Cravan to give a lecture on modern art in order to clarify their audacious position. On the night, a snob audience eagerly awaited Oscar Wilde's pseudo-nephew. Every three minutes a loudspeaker blared, "Don't worry, Cravan's coming!" The wait was shortened by drinks. Finally, Cravan arrived, dead drunk, and said that the heat was unbearable, so he was going to lecture in the nude. Some shocked puritan sent for the police, who forcibly dressed Cravan again and arrested him.

So, on 12 June 1917, America had its first public taste of the Dada spirit.

Marcel Duchamp was rapturous. All his actions had heralded the Dadaist reversal of values; he was not only its precursor, but its most faithful exponent. Duchamp thought, breathed, and lived Dadaism; it seemed to have been invented for him, at the other end of the world by people who had never heard of him. It was this pristine Dada spirit that protected him from materialist contamination and compromise. He was one of the most fashionable people in New York, sought by dealers, collectors and very rich women, but he did not budge an inch; he went on quietly working at the *Glass*, and did several Readymades, but not many, as it was difficult to choose them, and to make more than a few would have offended his strict standards. During his three years in America he made fewer than ten.

Marcel Duchamp preserved his independence by giving French lessons (like Laforgue), and became secretary to a captain of the French military mission. This amazed the Americans, who did not understand why he did not take advantage of his notoriety and his vogue to do business. In fact, there was no market for art in New York, and the number of avant-garde galleries could have been counted on the fingers of one hand.

Also, the atmosphere grew oppressive when America entered the war on 2 April 1917.

But it did not affect Marcel's romantic love affair with Katherine Dreier, whom he had known from the New York Independents days. He did *Tu M'* (You-Me) [98] for her, a "real" painting—oil and pencil with bottle-brush, three safety pins and a bolt on canvas—whose length is due to the place it was to occupy above the bookshelves in her library. This work combines coloured abstract geometry and identifiable elements: pencil tracings of the projected shadows of three Readymades, *Bicycle Wheel*, *Hat Rack* and *Corkscrew*, beside a *trompe l'œil* imitation tear in the canvas, and a pointing hand like those done by sign-painters. Some of the real objects are humorous, like the safety pins holding the edges of the tear, the bolt riveting the first of the colour samples, of which the shades graduate from pale to dark; while others, like the bottle-brush, are symbolic, but they are used ironically, not with the same significance as in a Cubist collage. *You–Me* is the inventory of Duchamp's challenges and bugbears; in *Glass* logic, it also shows a purely cerebral process as opposed to stylistic theory and emotional outpourings.

Marcel thought it an important work. "It was a sort of summary of the things I'd done earlier, because the title is meaningless. You can put in any verb you like..." [99]

Patriotic fervour when America joined the war, which Duchamp had left France to avoid, compelled him to take refuge in Buenos Aires. Although he was exempt from military service, he asked the French military mission for permission, and they—"very kindly, actually"—granted him six months' leave. He left New York in June 1918, taking with him two *Sculptures for Travelling*.

Marcel Duchamp *Hat Rack*, 1917. Assisted Readymade: wooden hat rack hung from ceiling.

147

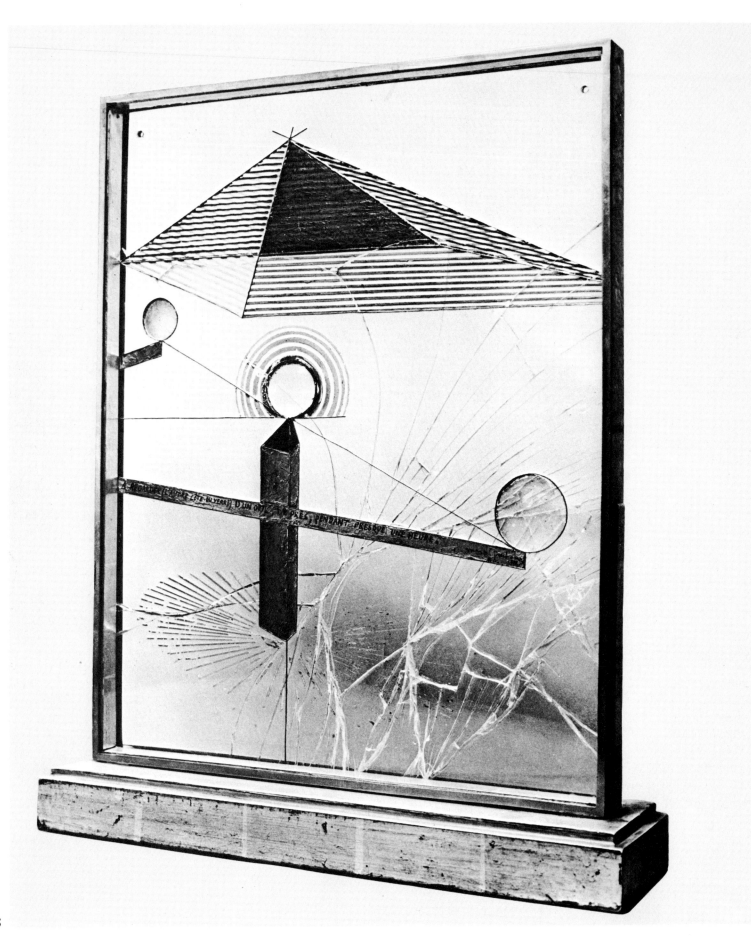

In Buenos Aires, Marcel finished *To Be Looked At (from the Other Side of the Glass) with One Eye, Close to, for Almost an Hour*, also known as the *Small Glass*, lead wire, oil paint, rusty metal, magnifying lens, and silver leaf on glass. Katherine Dreier later cracked it. The other sculpture consisted of different coloured strips of rubber bathing caps held together by string and hung from the ceiling of his New York studio.

"You could vary the lengths of the strings, because the shape went any way you wanted it to, that's what interested me. The game lasted three or four years, but the rubber rotted away." [100]

This *Sculpture for Travelling* is known only through photographs taken at 33 West 67 Street.

Duchamp spent most of his time in Buenos Aires working on the *Small Glass*. He also produced a rectified Readymade, *Handmade Stereopticon Slide* (Hand Stereoscopy), two photos to which he added two drawings of reflected pyramids. Before leaving New York, he sold the unfinished *Large Glass* to Arensberg, or rather Arensberg paid for it by settling Duchamp's monthly rent payments. Katherine Dreier acquired it a few years later, and bequeathed it to the Philadelphia Museum.

After the war, Arensberg bought all the old pictures Marcel was able to have sent from France; he pounced on his idol's lowliest sketches, scraps of letters, calculations and rough scribbles. Marcel found this very funny, though he never tried to take unfair advantage of it. But thanks to his patron's acquisitiveness, and a few small jobs, he was relatively free from material worries and could do much as he liked. "We knew very well that there were people who earned a lot and who in their turn realized that there were yet other people, called artists or even craftsmen, who couldn't earn a living. So they helped them. The rich made a virtue of helping them." [101]

Duchamp was in Buenos Aires when he heard about Raymond Duchamp-Villon's death at Cannes, on 9 October 1918, and a month later of Apollinaire's death, two days before the Armistice. He had not realized how serious his brother's illness was, and he was deeply shocked by his death. Meanwhile, he had also heard that his sister Suzanne, who had been divorced from the Rouen pharmacist, had married Jean Crotti. He sent her the *Unhappy Readymade*, a geometry book to be hung up on her balcony in Rue

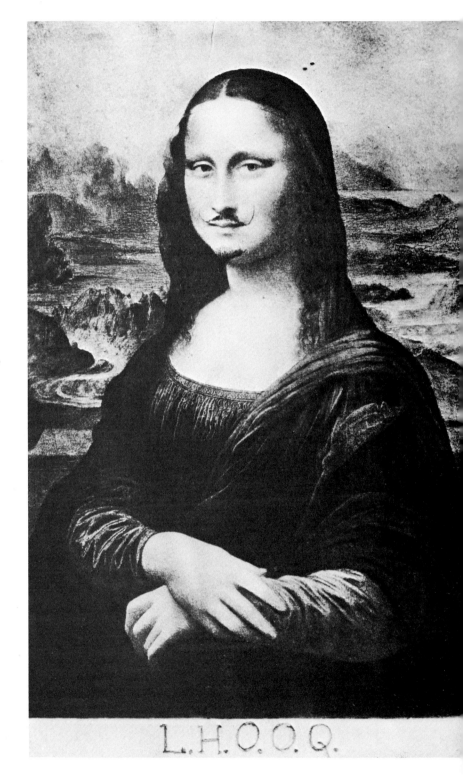

Marcel Duchamp *To Be Looked at (from the Other Side of the Glass) with One Eye, Close To, for Almost an Hour*, 1918. Glass, lead wire, oil paint, magnifying lens and silver leaf.

Marcel Duchamp *L.H.O.O.Q.*, 1919. Rectified Readymade: pencil on a reproduction of the *Mona Lisa*.

Marcel Duchamp

Unhappy Readymade, 1919. Geometry textbook exposed to the wind on the balcony of his sister, Suzanne.

Suzanne Duchamp

Marcel's Unhappy Readymade, 1920. Oil on canvas, after her brother Marcel Duchamp's *Unhappy Readymade*. ▶

150

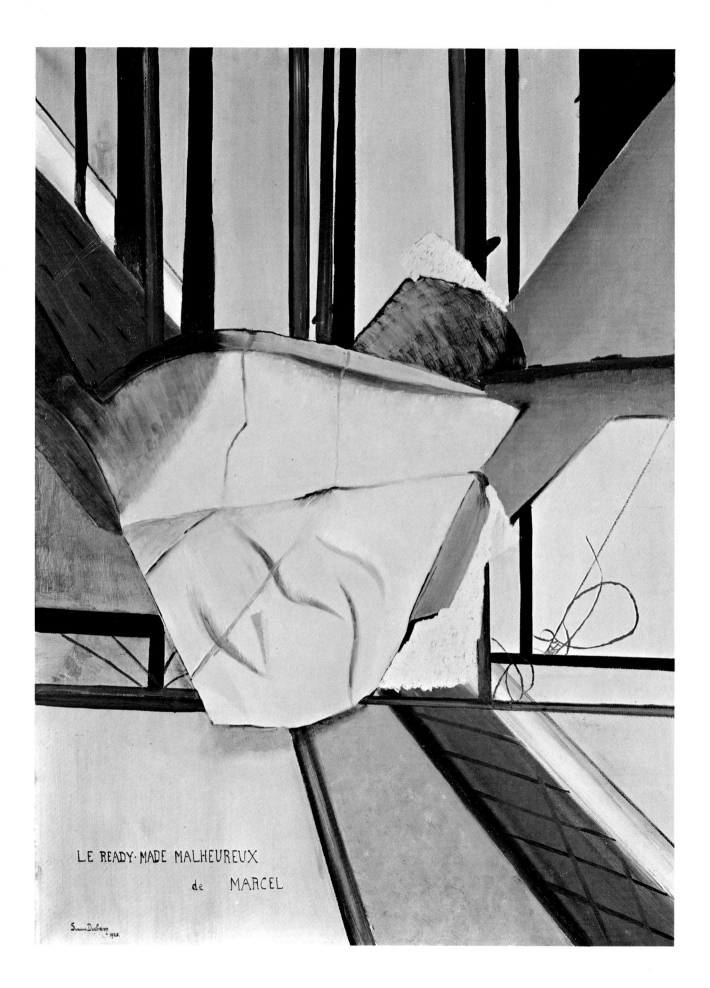

Marcel Duchamp *Network of Stoppages*, 1914. Oil and pencil on canvas.

Condamine according to his written instructions. "The wind was meant to go through the book, choose its own problems, turn and tear out the pages,"[102] Marcel said. But the Readymade gradually deteriorated. "It was fun bringing the concept of happy and unhappy into Readymades, and the idea of rain and wind and the flapping pages was amusing..."[103]

Suzanne made a painting of it—*Marcel's Unhappy Readymade*—before it was completely destroyed.

Marcel had inadvertently brought about his sister's marriage. He had met Jean Crotti and his wife Yvonne in New York in 1915. Crotti did a peculiar silhouette of Marcel in lead wire, with moulded lead hair and china eyes. At Marcel's instigation, he also did some work on glass. When Crotti

Marcel Duchamp *Why not Sneeze, Rose Sélavy?*, 1921. Assisted Readymade: small painted cage, marble sugar lumps, thermometer and cuttlebone. 153

went back to Paris in 1916, he was entrusted with messages for Marcel's family, notably Suzanne, who was still working as a nurse in a military hospital. The attraction between the painter and the young woman was sealed by an exchange of letters when Crotti went back to New York, and his divorce followed. He married Suzanne a few months later, in April 1919. Marcel came back to Paris in July.

Everyone knew about his American exploits through Picabia, with whom he was staying, particularly the Dada group. Those young post-war protesters saw Marcel as an almost mythical figure; his calm, his long silences, and his ironic smile enhanced the mystery, but his charisma had something equivocal and disturbing. His uncompromising stand commanded respect: the man of scandals was above all a rejecter, and rejecting was more important than anything else to those young post-war artists and intellectuals.

This was expressed in the irreverence and defiance of Dadaism. At the time, no one was more iconoclastic than Marcel Duchamp: when he appended a moustache and beard to Leonardo da Vinci's *Mona Lisa* and dubbed the result *L.H.O.O.Q*, the anti-art gesture took on the value of a proclamation. Duchamp never advertised his actions sensationally or indeed sought a wide public for them; they gathered an audience naturally because they were effective and important.

Duchamp did not care what became of his things, as he called them, and he was indifferent to their loss and mis-representation, which were, after all, just part of the game. Marcel brought his Mona Lisa to Picabia's to pack for his return to New York, and Picabia himself reproduced it, without the beard, for the March 1920 issue of *391*, under the title *Tableau Dada de Marcel Duchamp*. "Picabia's Mona Lisa is often reproduced as mine," said Duchamp, but he was not unduly upset.

Nor was he upset when Picabia used some of his Ready-mades in his own paintings, and even for the sets of Tzara's *La Première Aventure Céleste de Monsieur Antipyrine* at the Théâtre de l'Œuvre. Duchamp himself never borrowed from anyone.

He took a small glass ampoule called *50cc of Paris Air* to New York for Walter Arensberg. The label read *Serum Physiologique*. The ampoule was broken, stuck together again, and Duchamp himself remade it in 1949.

As soon as he was back in New York, he set out to finish the *Glass* and complete his studies on movement. He did not go back to Paris until June 1921.

VILLON BETWEEN THE SCHEMATIC AND THE LYRICAL

When Jacques Villon came back from the war, he did not hold out much hope for the future. He had lost contact with artistic circles, which four years of war had transformed; the Paris of 1919-1920 was not the same as that of 1914. Cubism had been travestied by second-rate artists, who used geometry superficially in a way quite divorced from pre-war experimentation. In different ways, Picasso and Braque were moving away from purely cerebral art to something easier to understand and more in tune with an age of facility, but they barely avoided the trap of "good taste". A would-be French neo-Cubism sprang up, and its formalism soon lapsed into the merely decorative.

Both the public and the critics were taken in, but they had some excuse, as real Cubism was forgotten and its strongest examples had been sequestered at Kahnweiler's gallery, to be auctioned off between 1921 and 1923. Bad imitations throve and, among these saccharine examples of a movement he had previously detested, Monsieur Louis Vauxcelles was in his element. He wrote about the 1920 Salon des Indépendants: "The picture-puzzle has had its day... Purely 'conceptual' painting is not viable. You can't turn your back on nature as soon as you pick up a paintbrush."[104]

Roger Allard had more insight. "The Cubist room is a second-hand shop," he wrote after visiting the Salon.[105] He complained that decorative art had "definitely become the dregs of Cubism". The exhibits were "dated, fit only for export and for the covers of more or less experimental magazines". His article was entitled "Stock-taking Sale".

These two extracts are very indicative of the state of mind that prevailed among certain critics and in many artistic circles; the French demanded a "return to order", and this was to be the theme of a campaign sparked off by one of Lhote's sayings about Braque, and the title of a book by Cocteau in 1926. Headed by Picasso and Braque, a very few painters subscribed to this campaign. The return to order constituted a rejection of pre-war excesses and incomprehensible paintings, and a return to nature and sensibility, avoiding enfeebling and pernicious foreign influences. Along with many others, Roger Bissière, a thirty-four year old painter and contributor to *L'Esprit Nouveau*, demanded "balanced, harmonious and lucid art", containing "basic and permanent characteristics". He wrote, "We are living in an age of revised values." André Salmon, the champion of the pre-war Cubists, echoed the desire for a general new beginning under the banner of order, and André Lhote seconded him.

These reactions took place in the setting of an ultra-nationalist age: the fear of Bolshevism went hand in hand with the fear of speculation, because money corrupts. Christianity seemed to be threatened. The Joan of Arc cult and resumption of relations with the Vatican were not enough to exorcise the threatening forces, Dadaism among them. However, its Parisian adherents did not really worry the public, who saw Dadaist writings and proclamations merely as the japes of demented intellectuals. The more pessimistic thought that Moscow had a hand in it, and the upholders of order had to keep an eye on virtually everything.

The situation was difficult for a man like Villon. Raymond was dead and Marcel was in America, so his solitude had a bitter tang. He was out in the wilds of Puteaux, poor and completely out of step with post-war Paris. Of course, he was diametrically opposed to Dadaism: he had hardly seen Marcel during his stay in Paris, as they moved in such different spheres that frequent meetings were impossible, though their affection for one another remained intact. Duchamp and Villon were living on different planets. "It was something else," the old man told me rather sadly, forty years later.

Nevertheless, Villon had to work in order to survive. He had a lot of problems to resolve on copper and in paint. In his first paintings of this period, he handled the objects on 155

Jacques Villon

La Table d'Echecs, 1920. (Chess Table). Etching. p.156

Jeu (La Table d'Echecs), 1919. Oil on canvas. p.157

planes, so that the volumes would have more impact. He had already been considering this before the war.

"I arranged the object in superimposed layers, so that I could give more expression to the volumes," he told Dora Vallier.[106] "Each layer of colour was lighter, and the result was a new object with itself as a source of light."

The 1919 *Jeu d'Echecs*[107] (Game of Chess) was, as usual, preceded by a lot of drawings, some of them not unlike Picabia's mechanical studies, and illustrates the process of "constructive de-composition" that he was using at the time. The object, a chess board, is seen in dual perspective inside a pyramidal construction, whose superimposed planes serve to some extent as the object's foundation. This sober, powerfully structured art is justified by scientific knowledge of the object's shape, volume, position and development in space. Villon opens it up like a box and dissects it with surgical precision.

Jacques Lassaigne wrote of this method:[108] "The picture opens out like an accordeon, thereby taking on a consistency that ruins and nullifies the well-known concept of a flat surface covered with colours put together in a certain order. The colours play on the edges of this density, and mark the successive stages of the construction in space."

Villon went from analysis to synthesis. In several of his 1920-1922 canvases, the study of planes, ranging from the biggest to the smallest, was based on a system of measurements, with the object central but embodied in space, which was itself changed in relation to the object. Therefore the picture became an entity in which the object became part of the plane, and lost the visual importance it had held in the pyramidal system. Curves were replaced by straight intersecting lines mingled with cones, lozenges, and sharp angles.

This move towards a more rational approach to art coincided with Villon's experiments with colour. "My interest in colour began around 1920," he said.[109] "Before that, if I sensed blue, I put blue. But from that moment on I wanted a science of colour as my basis. I wanted to create in absolute terms. If only I had known neo-Impressionist theories before, I would have made faster progress. I had to retrace my steps... Little by little I began to learn from my experience, and I eventually knew how to make use of the science of colour. That was around 1930."

Through volume and colour, Villon created works lacking neither imagination nor humour, owing nothing to fashion or popular taste. For that reason few people noticed him; the painter made no bids for attention and was not involved in the tumultuous *années folles*.

Villon's first post-war engraving was the 1920 *Jeu d'Echecs* or *Table d'Echecs* for the German magazine *Die Schaffenden*.

It was a transposition of his previous year's painting into an engraving in which the superimposition of planes, the style he adopted from then on, appeared for the first time.

He also engraved *Baudelaire avec Socle*, after Duchamp-Villon's bust; many of the late sculptor's works were housed in Villon's studio and remained there until his death.

In 1921, he did only three etchings, all based on paintings: *Noblesse*, *Le Cheval* and *L'Oiseau*.

Villon agreed to take part in another Golden Section exhibition, possibly to shake off his loneliness and re-create the pre-war atmosphere of work and community. Archipenko, Survage and Gleizes organized it; Gleizes wanted to widen the circle and invite painters outside the movement. Villon was unenthusiastic about this as it seemed a betrayal of the group's convictions. They also decided to put Paul Dermée in charge of a literary section, and through him and Picabia, the Dadaists were asked to take part.

This decision sparked off heated arguments that nearly led to physical violence. In the end, at a general assembly, the vast majority voted to expel the Dadaists. Because of Marcel Duchamp, Villon stayed out of it, though his brother was in New York at the time; Villon had in any case remained aloof from something that was so far removed from the original concept of the Golden Section. After all, he had in some ways been its founder.

He was well aware that it would be a mistake to hark back to the past, as the conditions of life and work of the artists in the group had changed since 1912: many of them had given up Cubism, which had itself undergone many changes. The public and critics were different. What then was the point in reestablishing a rational speculative art based on a scientific balance of forces? Wasn't it just another phase in the return to order?

"Maybe it was," Villon told me in 1958. "But not the way people like Lhote meant it. We had never actually abandoned order. Our rules were the same as before the war. In 1912 we wanted to show that an art of construction and analysis founded on duration could exist in the face of the breach expressed by Cubism. In 1919 and 1920, Cubism had lost its point. We also introduced colour and movement. But not by chance... Our experiments went from the effect to the cause..."

"But weren't the problems raised by the Golden Section already dated by 1920?"

"Art never dates, if the painter sticks to the truth. To life."[110]

Jacques Villon *Baudelaire au socle*, 1921, after the sculpture by Raymond Duchamp-Villon. Etching.

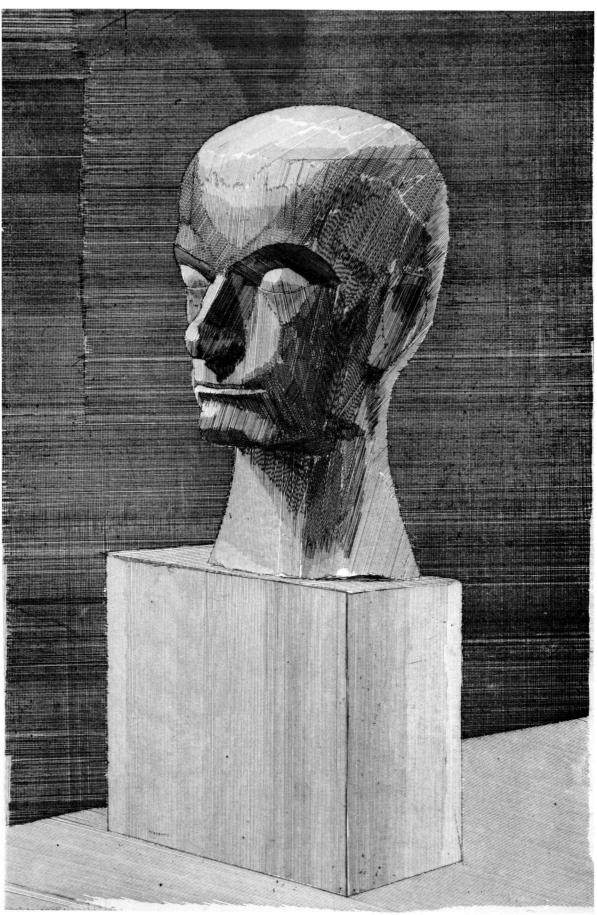

159

The second Golden Section Exhibition was held at the Galerie La Boétie in Paris from 4 to 17 March 1920. Archipenko, Serge Ferat, Gleizes, Nathalie Gontcharova and Larionov, Survage, Braque, Valmier, Brancusi, Henri Lau-

A third Golden Section exhibition—a summing up of the movement—was held at the Vavin-Raspail Gallery in January 1925. Works by Braque, Delaunay, Gleizes, Juan Gris, La Fresnaye, Marie Laurencin, Léger, Lhote, Mar-

Jacques Villon *L'Oiseau*, 1921. (The Bird). Etching.

rens and Villon took part. It was a complete failure: there were very few visitors, and nobody was interested. "Twenty paid admissions in two weeks, just under one and a half people a day—official declaration of the Galerie La Boétie," Picabia wrote in April 1920, in the first issue of his magazine *Cannibale*, exaggerating somewhat. Jean-Gabriel Lemoine, the critic, wrote in *L'Intransigeant* that "the constructive methods of Cubism are undergoing the same crisis of disorganization as everything else. Every Cubist puts forward his own case, like a public confession of today's individualism, without admitting a hierarchy and order based on common consent." [111]

coussis, Luc-Albert Moreau, G. Ribemont-Dessaignes, Tobeen, Valensi, Villon, Duchamp-Villon, and Picasso, were arranged eclectically, fully illustrating the confusions and misunderstandings of the era.

In Jacques Villon's 1920-1921 paintings, the space of the picture became increasingly important, reducing the object's space to a bare minimum. The object was first left in a sort of suspension, then rapidly became part of the work's actual construction. Colour converted into subjective vision created both the object and its space, its form and movement; it even determined, as in *La Pipe* or *Silence*, the idea at which

160

Jacques Villon *Gallop*, 1921. Oil on canvas.

the parallel coloured planes hint. "The object was replaced by the concept of the object," Villon said.

This abstract period was the apotheosis of his search for the Golden Section, a sort of synthesized absolute culminating in pure art.

"And so I achieved an abstract that wasn't pure invention. By defining it. At its starting point in reality, to become more solemn, instead of inexplicably rounding off that reality." [112]

In complete solitude and unknown to most of his contemporaries, Jacques Villon did a number of pictures that are among the best of a little known period.

He created a sort of emblematic order in pictures such as *Noblesse*, a black, white, yellow and red blazon, with the actual frame painted as part of the picture, now in the Ragnar Moltzav collection in Oslo, *L'Equilibre Rouge*, *Repliement*, *Joie*, as well as a series on the decomposition of movement, including *Galop*, *Les Courses* (Races) and *Cheval de Course* (Race Horse).

Villon's titles sometimes seem obscure—*Noblesse*, for instance. "The picture started with a seated woman, and when it was finished, I had an impression of nobility, so I called it *Noblesse*," said Villon.

He also said, "You must extract the rhythms and volumes from the subject, the way you'd extract a diamond from its matrix." His abstraction lies mainly in distilling the essential elements of his subject matter. Somehow, he never became hackneyed, because he saw a painting not only in terms of geometry but as a poem; what others did with words, he did with the subtle harmony of colour and line. Even his most severely constructed pictures have a sort of sensitive impetus blending with graceful rhythm. He made no concession to sentiment or legibility, as he dealt in revelation as well as analysis.

This abstract period comprised his experiments on the golden number and heralded the refined landscapes of the second post-war era. Villon adhered to the spirit of Cubism but not its rigidity, in the way Seurat adhered to Impressionism. They discovered the endless possibilities of each form, where those with less insight would only have seen rules and theories.

Throughout his life, Villon swung between reason and intuition, going from analysis to nature, but never losing the ability to measure and polish.

Villon's aim was to isolate the world's rhythmic and emotional powers and incorporate them into his own vision. All his paintings resonate with overtones between the ruling lines, the hierarchy of planes and the play of colour; these colours fill out—the painter's own word—its flesh and bones, which could be almost those of a living entity. "And shade brings about a change in the colour scale which has to give the impression of shade," said Villon; [113] "but without dirty tones, always pellucidly, and always axed on a central plane. When the central plane becomes shade, everything changes, everything has to be redone."

Villon carried out this painstaking work in solitude and poverty. He was involved neither in the return to order nor the Montparnasse movements, rarely went out and exhibited regularly only at the Salon d'Automne. "Jacques Villon's is one of the most private lives; he rarely unburdens himself," wrote André Salmon. [114] "Apart from his completed works, I know nothing about him."

In 1920-1921, Villon did thirty-four engravings for *Architectures*, an important album conceived by André Mare and Louis Sue, comprising a "presentation of the architectural work, interior decoration, painting, sculpture, and engraving that have helped to form the French style since 1914". The album was preceded by a dialogue by Paul Valéry, which became *Eupalinos ou l'Architecte*.

For several years Villon earned a living by engraving. No dealer, collector or gallery was interested in the pure language of form his paintings expressed. The only exception was the Povolovski gallery, which exhibited his works and those of Latapie in 1922. Thanks to Walter Pach, Villon next exhibited at the Brummer Gallery in New York in 1928, the Arts Club in Chicago in 1933, and the Marie Harriman Gallery in 1934. In December 1925, Villon took part in the Art d'Aujourd'hui exhibition in Paris, one of the first displays of abstract art in France, organized by the Polish painter Poznanski at the headquarters of the Syndicat des Antiquaires in Rue La-Ville-L'Évêque. Villon did not exhibit at the Cercle et Carré Gallery 23 Rue La Boétie, in April 1930, as most of his fellow-exhibitors of the other exhibitions did. This group, dominated by geometric abstraction, was superseded by Abstraction-Creation. Villon figured in the first two *Cahiers* (Notebooks) of the movement, published in 1932 and 1933. A few years later, he was one of the exhibitors —most of them stemming from the Cercle et Carré and Abstraction-Creation—at the first Salon des Réalités Nouvelles at the Galerie Charpentier in 1939. He did not have his first big Paris exhibition until 1944, at the Galerie Louis Carré, when he was already sixty-nine.

162

Jacques Villon *La Pipe (Silence)*, 1922. Oil on canvas.

163

Maurice Raynal[115] wrote about the painter's exhibition at Povolovski's: "Perhaps rather esoteric art, mainly to interest those professionals for whom the play of combinations and coloured shapes is what painting is all about. But it is legitimate art, because it is purely pictorial and based on established aesthetics... Villon knows that a line, a curve, or a volume have as much specific weight as a word, a sentence, or a full stop."

Around 1922, the Galerie Bernheim-Jeune commissioned Villon to engrave colour plates after major nineteenth and twentieth century paintings, including those of the Douanier Rousseau, Matisse, Picasso, Cézanne, Braque, Dufy, Modigliani, Utrillo, Van Gogh, Manet, Bonnard, and Signac. Villon spent ten years on these, interpreting technically and atmospherically disparate works completely in keeping with the spirit of the originals. All thirty-eight works are now at the Chalcography in the Louvre, and are considered one of the landmarks of engraving. Villon engraved *Composition Cubiste* after one of his own paintings. Thus, one of the future masters of contemporary art took his place among this august company, although he was only a humble craftsman reproducing the works of others for a living.

His absorption in this work prevented him from working for himself; it was not just a matter of time, his whole being was involved elsewhere. Nevertheless, he was able to continue and develop his experiments without succumbing to the facile expediency of his time, which induced successful artists like Picasso, Braque, Matisse, Bonnard, Derain and Vlaminck to substitute the flabbiness of "good taste" for imagination. Villon would have nothing to do with the proliferation of neo-Cubists, and he was completely out of tune with Surrealism. Marcel Duchamp was one of its leading exponents.

Engraving stopped Villon from falling into the formalism that might have resulted from his geometrical pictures. "I must have problems to solve," he said. He gradually left abstract constructions and returned to blending colour and rhythm. His geometry was softened by lyricism. Every nuance gives the impression of being suspended in space but held back by delicate linear tracings, like gossamer.

The 1925 *Figure Pincée*[116] is built on triangular planes to become a prism of light with the ruling lines very much in evidence, as if clothed in rare and exquisite shades. The ironic expression on the mask at the end of the long neck reminds us that Villon loved life, food and women, and was by no means the austere scientist one might imagine. His secluded life and hard work were not the stuff for spicy anecdotes, but he was in no way a monk; he was pleasant, hospitable and reputedly very gallant.

His experiments thrived on solitude. He could go from strict geometry to the most baroque arabesque and try out new flights of the imagination without having to worry about the reaction of dealers and critics. He concentrated on faces, that is portraits, particularly his own, then went back to abstraction, mixing Cubist analysis with absolute realism if it seemed right to him. He was conceptual, but never boring, realistic but not imitative, and his characteristic *naiveté* always tempered his more analytical side. He worked in subtle monochromes, as well as in vivid almond greens, soft pinks, mauves, orange and blue that prolonged the glow of Impressionism. But Villon handled this glow with moderation, because his direct vision of reality was always filtered through reason.

"I was always interested in portraits," he told Dora Vallier.[117] "You should never monopolize the person. A portrait must paint itself. You must be alert. When the sitter reveals anything, you must get it down before it goes away. It's theft, and you have to go about it stealthily."

Villon then made a sudden detour into abstracts, with all the mobility his freedom allowed him. From time to time his fondness for fusing realism and imagination, thought and feeling, crept into his work.

He had a second abstract period between 1930 and 1931. He had finished his commission for Bernheim and was concentrating on painting. His work of that period is very strange; the elaboration of a geometrical space, a sort of cell with clearly demarcated planes, in which he drew rigid lines at acute and right angles. *Architecture ou l'Espace* constituted the painter's return to the emblematic order of his early post-war period; in *Les Fenêtres* (Windows) of 1932-1933, he achieved a mathematical severity bordering on the absolute.

There is something of Mondrian in the way the picture is divided into equal sections by vertical and horizontal lines; the surface consists of rectangles of various sizes and colours, in different perspectives. *Les Fenêtres* is a characteristic example of the range of Villon's experiments.

Jacques Villon

Femme Tête Penchée, 1924. (Woman with Head Bent). Oil on canvas.
p.165

Echecs sur une Table, 1924. (Chess on a Table). Oil on canvas. p.166

Tabouret aux Papiers, 1926. (Stool with Papers). Oil on canvas. p.167

Nature morte aux Noix, 1929. (Still Life with Nuts). Etching and drypoint.
p.168

Parade, 1931. Oil on canvas. p.169

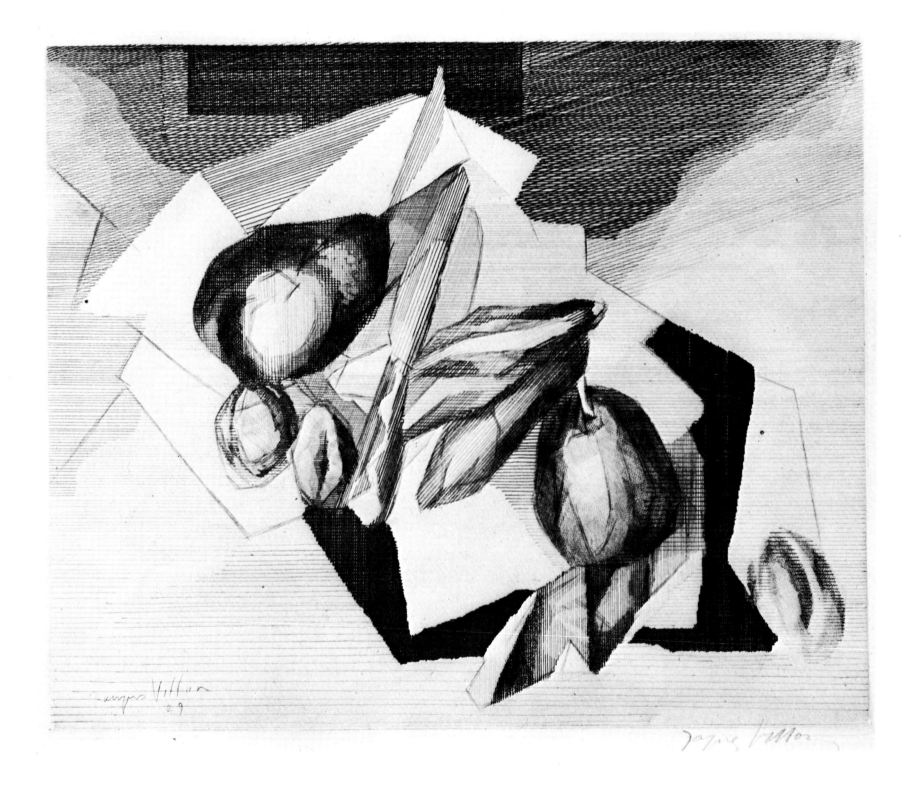

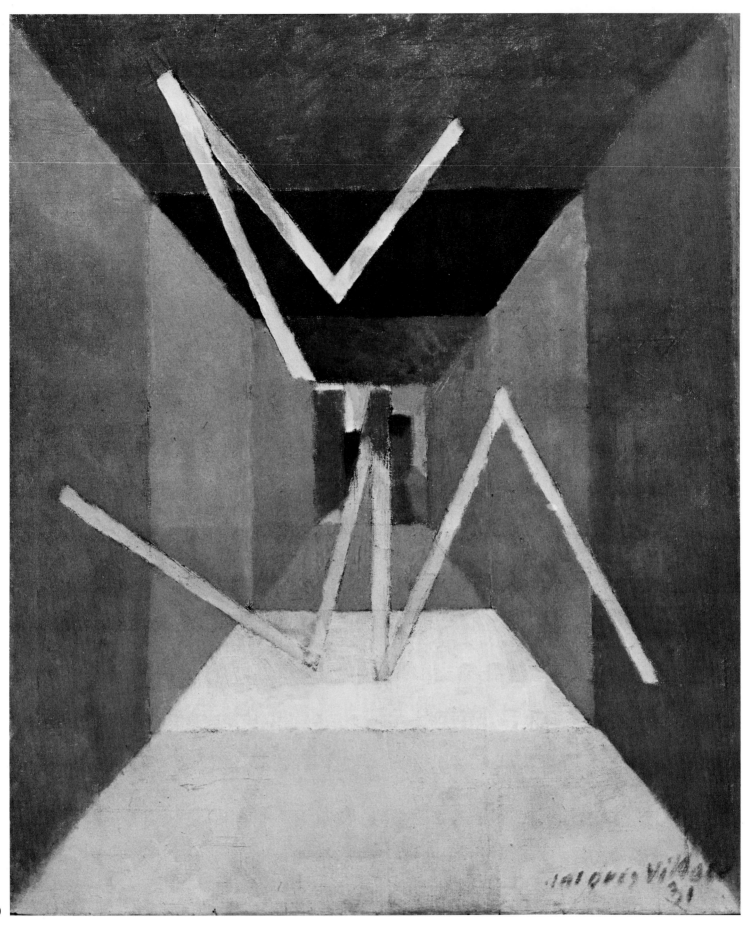

"Creation, abstraction, the logical outcome of all the successive sheddings that have stripped painting of its documentary, utilitarian, flattering and social aspects. But it is very difficult not to let this shedding become regret."

In these terms Villon marked an epoch in the 1932 *Cahiers Abstraction-Création, Art non-Figuratif*, together with Freundlich, Arp, Calder, the Delaunays, Moholy-Nagy, Pevsner, Schwitters, Van Doesburg, Vantongerloo, Mondrian, Gleizes, Herbin, Kupka, and others. There was a warning in the *Cahiers:* "Only artists who consider themselves definitely non-figurative are invited to join the group." Villon was also included in the 1933 *Cahiers No 2*, but not in the subsequent 1934, 1935 and 1936 issues.

After 1936, he perfected a method of decomposition by planes, which he explained to Yvon Taillandier twenty-three years later:[118]

"First, I build up two squares, one on the right and one on the left. Their sides are the same length as the shorter length of the canvas and, except for one of their sides, their circumference is the same as that of the picture.

"In a normal layout, these two squares are partially superimposed. The area of superimposition is indicated by two vertical lines somewhere near the middle of the canvas.

"Once the squares are done, I give each of them a colour. For instance, the left-hand square could be red, the right-hand square blue. I also choose a colour for the picture as a whole. Let's say it's going to be yellow. This choice of colour constitutes the basic harmony and represents three planes to me. The red left-hand square is the foreground, the yellow surface is the middle ground, the blue is the background.

"All these colours act on each other according to their place in the picture, and their planes. In that way, the red in the foreground will affect the yellow middle ground on the left side of the picture. The result will be orange.

"In the middle, that is, the area where the blue and red squares overlap, there is a mixture of three colours: the red in the foreground, the yellow middle ground and the blue background, because there the three planes are meant to be superimposed.

"Finally, the yellow middle ground will mix with the blue background on the right of the picture.

"I don't do all the mixing on the canvas, I only paint the result. But I don't get the result by mixing colours from a tube. I mix them mentally from optical data. What I paint is what you would get if they were made in a laboratory with coloured rays."

Villon's abstraction was not only geometrical; a certain baroque quality, the love of movement surviving from the Cubist experiments, creeps into the arrangement of the planes and breathes life into them. This unobtrusive vitality adds a dimension to a major work like *Amro* (1931), now in the Musée d'Art Moderne in Paris.

"Amro, a made-up word, a baptismal name which became the title of a picture. Why?" Villon wondered. "Because that picture, which started as a pile of paper, is too far from its origins to have a title evoking them. It became a picture in itself. To set it apart from other canvases and describe it, I christened it. As for the word Amro, I chose it because its arabesque echoed the rhythm of the picture."

The work is one of the high points of Villon's output. Its supple rhythms blend with balanced planes, its charming delicate colours and its combination of lyricism and severity. The connexion between the arabesques formed by the name Amro and those of the picture on which the title is inscribed contribute to the sense of unity the painter aimed at; his own italicized name and the date form part of the composition.

Jacques Lassaigne wrote that Villon's portraits had a place "among the most accurate attempts at revealing the essence of a being". Painting is never a miracle; here we have the exact expression of three preoccupations: seeing, understanding, and revealing. Villon succeeded in capturing his model's innermost core through a skilful arrangement of line and colour, a personality stripped down to the bare essentials and, after 1945-1950, even acquiring a sort of impressive ghostly reality clothed in delicate harmonies.

Villon's art was knowledge. All his experiments sprang from a burning desire to know, and surely nothing could be more exciting than unravelling the mystery of a face. The painter not only restored his model's individuality, but retained his spiritual likeness. In the same way as he had once decomposed a horse's gallop to find the exact movement, he now decomposed the face into triangles to extract its real appearance. He proceeded in stages, as can be seen in his slow construction of tiny fragmented lines, small disjointed strokes and coloured planes, a mosaic through which

Jacques Villon

L'Architecture, 1931. Oil on canvas. p.170

L'Espace, 1932. Oil on canvas. p.172

Les Fenêtres, 1932–1933. (Windows). Oil on canvas. p.173

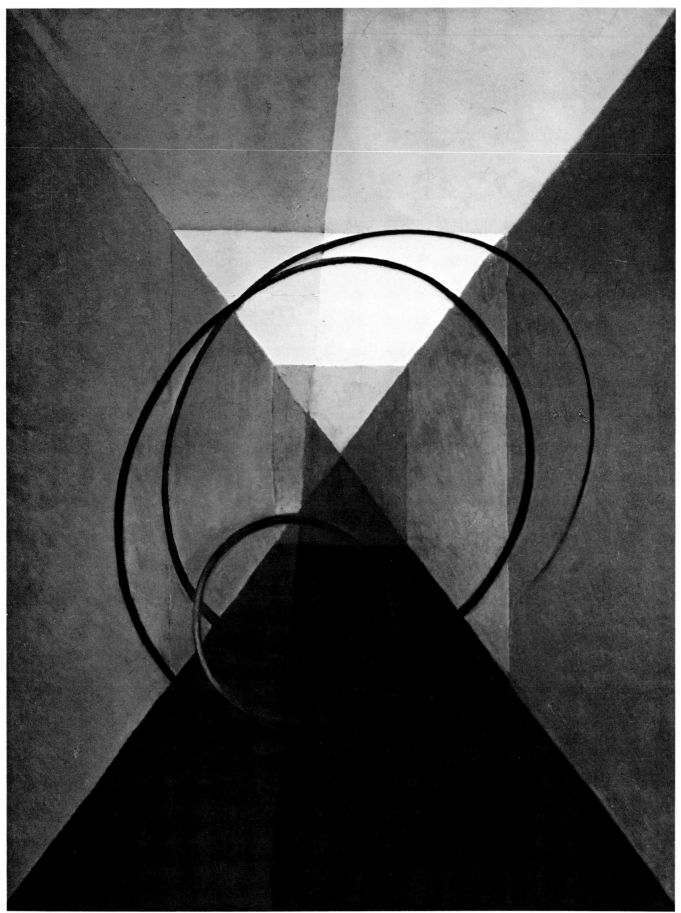

172

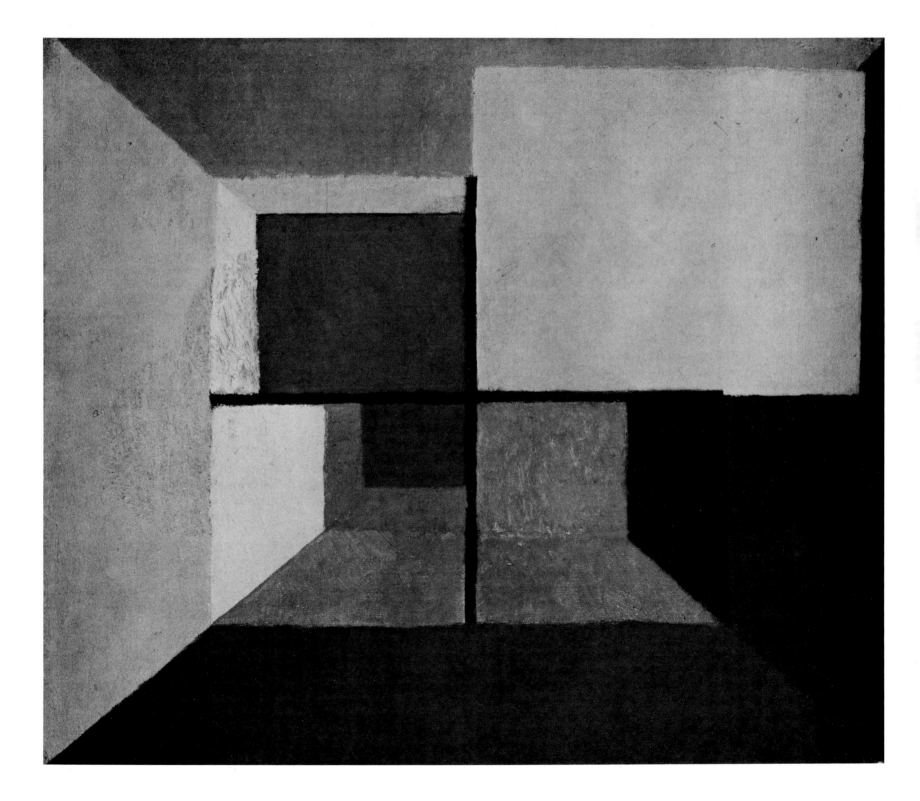

the face gradually is created. This method also conveys Villon's trepidation about painting faces and people, vessels of the soul.

L'Epicurien displays this trepidation, with its technique of juxtaposed planes enclosed by concentric circles, and the deep eye sockets. In his 1935 self-portrait, now in the Steegmuller collection, Villon shows himself casually seated in an armchair, smiling slyly and surrounded by juxtaposed, bisected planes. The innocence of the subtle colouring belies the strict calculations. The greatest portrait painter of our time was not only the most sensitive but the most intelligent. He had an abundance of that rare gift, grace, and he used it with humility. And when times were bad, it helped him to see that the joy of painting was the whole point and meaning of his life. Villon's paintings were never less than illumination.

THE DUCHAMP MYTH AND THE LARGE GLASS

Although in Paris no one was particularly interested in Villon's solitary experiments, in New York Marcel Duchamp was still the darling of that strange fashionable intelligentsia, which he could charm or scandalize at will, but in which he always found support and an audience for his latest exploits. He had built up a tremendous reputation in America, unique in our time, with his peculiar, unpredictable "things". Duchamp was the instigator of just about anything new or creative in New York; he obviously took full advantage of the situation, of women, of rich collectors, and luck, but he never went too far. He was careful to avoid excess, just as he avoided repetition and stereotyping, traps into which others might have fallen.

In fact, Duchamp was slow to realize the full effect of his attitude and actions. After the Second World War, he responded to the cult whose object he had become with ironic amazement, but retained his native nonchalance. It is obviously tempting to compare his extraordinary luck and his whole personality with Villon's struggles and humility, but Duchamp's stroke of luck was his discovery of America and the way he made use of it. The gulf between the two men was really that between continents: one of them Europe, clinging to its traditions, a centuries-old concept of art and the artist's role in society, hating change and innovation, afraid of anything that might threaten its visual complacency or its security; the other, America, open to any challenge, throwing itself into discovery, in love with freedom and novelty, and unafraid of controversy, defiance and failure.

Duchamp never contemplated failure, because he never thought of the possibility of success, whereas Villon, like most European artists, relied on success to enable him to live and work freely. It would come to him very late in life.

During his second visit to New York, Marcel concentrated on optical experiments based on real movement. Man Ray helped his friend to produce *Rotary Glass Plates (Precision Optics)*, five glass plates of graduating sizes, on which black and white lines were drawn; when they were set in motion by a motor, they gave the impression—looked at from a yard away—of continuous concentric circles. Four years later,

Duchamp produced *Rotary Demisphere*, based on the same process as the 1931 optical disks, for Jacques Doucet, the collector. In the 1925 *Rotary Demisphere*, he combined movement and word-play: the phrase "Rrose Sélavy et moi esquivons les ecchymoses des esquimaux aux mots exquis" was engraved in a circle on the copper disc surrounding the demisphere, and turned with it, so that the words formed a circle in time as well as in space.

Rrose Sélavy was Duchamp himself. One day he felt like changing his identity by taking a Jewish name, but as he could not find a surname he liked, he decided not to change race but sex. Rrose Sélavy is a typical example of Marcel's word games; to begin with, he called himself Rose, but in Paris the following year he spelt it Rrose in the dedication on Picabia's *L'Œil Cacodylate* at the Bœuf sur le Toit, and decided to keep the second "R". Then he had himself photographed by Man Ray as a woman (Rrose Sélavy, a play on *c'est la vie*, that's life) and appeared as such on the label of "Beautiful Breath, Veil Water", which was also the cover of *New York Dada*.[119]

Katherine Dreier had the interesting idea of grouping all the most original innovatory productions of the time in a permanent collection. The name suggested by Man Ray, Société Anonyme, was adopted. By the time the war broke out in 1939, the society had organized over eighty exhibitions, lectures and sponsored various publications. Katherine Dreier presented the works in this first American collection of modern art to the Yale University Art Gallery in 1941.

Marcel continued his work on the *Large Glass*, into which he incorporated his successive experiments, such as the 1920 *Oculist Witnesses*, oculist charts transferred on to a silvered area of the glass. This took him six months. He also produced *Fresh Widow* in 1920, and *Why Not Sneeze?* the following year. *Fresh Widow* was a painted wooden window with black leather panes, and Duchamp obviously found the pun of "French Window" funny. He signed it Rrose Sélavy.

Why Not Sneeze? consists of marble sugar lumps, a thermometer and a cuttle-bone in a small birdcage, the whole painted white.

175

In June 1921 Marcel went to Paris for seven months. He could only spend six months in America unless he asked for a prolongation as he had been staying as a tourist, which allowed him to get a reduction on the crossing. He did not want to ask for a prolongation, so he left.

Tristan Tzara and Jean Crotti invited him to take part in the Salon Dada at the Galerie Montaigne, to which Marcel replied with a telegram: "Pode Bal" (Peau de Balle—nothing doing), thereby showing that he would never be affiliated to any movement whatsoever. He confirmed this by writing to Crotti, "You know very well that I have nothing to exhibit— that the word exhibit is like the word espouse. So don't expect anything, and don't worry…" Marcel reminded his correspondent that he was himself "espoused", for Crotti had been married to Suzanne Duchamp for two years, the marriage that inspired Marcel's *Unhappy Readymade*. The word-play is rather ambiguous.

In April 1921, Suzanne Duchamp and Jean Crotti had held an exhibition of their works at the Galerie Montaigne, and it was thanks to their intervention that the Dadaists were able to hire the gallery. The couple submitted genuinely Dada collages, objects and constructions that Jean Crotti had done in New York, and Suzanne's paintings, including *Marcel's Unhappy Readymade*.

In June 1921, Man Ray came to Paris, where Marcel welcomed him and introduced his friends. Throughout the summer, Man Ray helped Marcel with his optical machines in the garden at Puteaux, while Villon looked on curiously. Duchamp went back to New York in January 1922, where he did very little, but earned a living giving French lessons. His inactivity might seem odd compared with the extraordinary energy of his Dadaist friends and their multiple exhibitions, events, tracts, insults, and noisy bids for attention, or with the rage for life sweeping through American youth. New York was, after all, a perpetual party with innumerable stimulations.

Duchamp had nothing to do with Dada after it relinquished its underground character to become an official movement, insolence and all. He thought, logically enough, that it was impossible to maintain a constant level of excitement, and that the repetition of actions and demonstrations could only become stereotyped. He always felt it was important to be, and to remain, self-sufficient.

His attitude naturally increased the prestige he nurtured so strategically both where the public and his deliberately mysterious productions were concerned, though he pretended great indifference.

His work on the *Glass* had become a sort of demented ritual, and Duchamp was worried about the outcome. Luckily, his periodic absences enabled him to detach himself, more or less voluntarily, from his work, which could have no real completion in spite of its strictly defined content. The time when he stopped work, 1923, coincided with the birth of Surrealism, and though the *Glass* had nothing in common with Surrealist works, in which Duchamp was not very interested, it could be considered a sort of forerunner of the reaction against painting.

Just as the Cubists had never seen Picasso's avant-garde *Demoiselles d'Avignon*, because it was in his studio, the Surrealists did not see the *Glass*, because it was in New York with Duchamp.

Duchamp had great prestige on both sides of the Atlantic. Of course, his name was rarely mentioned in artistic magazines and newspapers of the time, but André Breton had been one of the first to see how different Duchamp was from the other Dada artists and to recognize his exceptional quality, mainly through hearing of Duchamp's American exploits, the mysterious *Glass* about which no one in Paris knew much, and his complete detachment from those of his actions that expressed his disillusionment with art, society and mankind.

The Dadas broadcast their ideas noisily, but Duchamp kept quiet. His protests, the *Bicycle Wheel*, the *Urinal*, and the *Large Glass*, spoke for him. He never said, "Art is dead"; unobtrusively, he simply killed it.

The indubitable logic of such an act made proclamation nonsensical. Breton and his friends were bewildered by the fact that Marcel Duchamp acted as if his own works did not exist.

It would be impossible to gloss over the residue of his "artistic" past, which occasionally surfaced in the midst of his nihilism. He let dust gather in his New York studio for months, even on the *Glass*, laid flat on wooden trestles. When he thought there was enough dust, he had Man Ray photograph the *Dust Breeding*, then he cleared it away, but left certain areas where he fixed the dust with varnish. These areas took on a yellowish tinge, which would seem like an aesthetic experiment if Marcel had not said that it was purely accidental. This "technical trick" contrasted strangely with the meticulously mathematical conception of the *Glass*, which left nothing to chance, but the gesture must have appealed to the mischievous side of Marcel's character.

176

Marcel Duchamp *Rotary Glass Plates (Precision Optics)*, 1920. Five painted glass plates of different lengths mounted on a metal axis operated by electricity: in motion, the painted lines appear as continuous concentric circles.

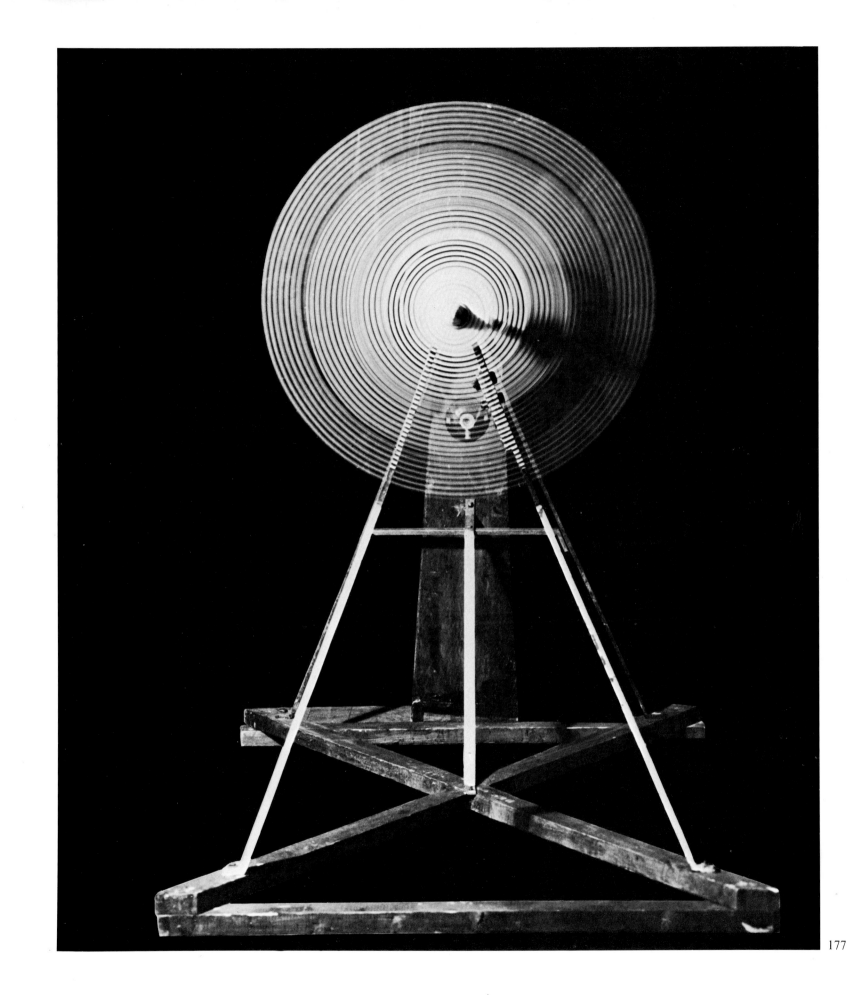

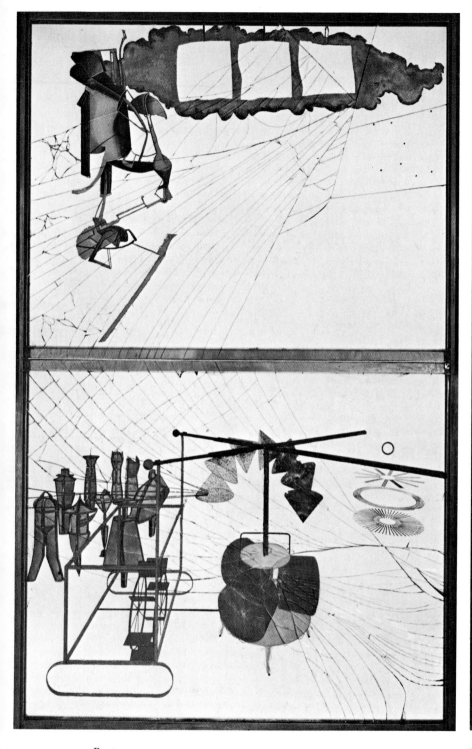

Recto. Verso.

Marcel Duchamp *The Bride Stripped Bare by her Bachelors, Even (Large Glass)*, 1915–1923. Oil, varnish, lead wire and foil on glass (cracked), mounted between two glass panels in a wood and steel frame.

178

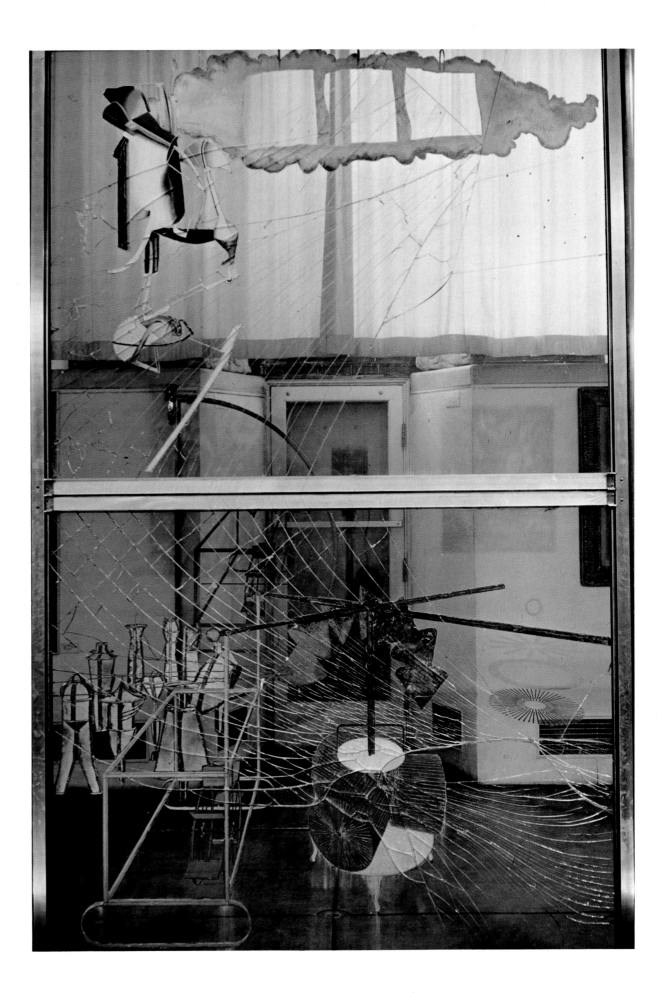

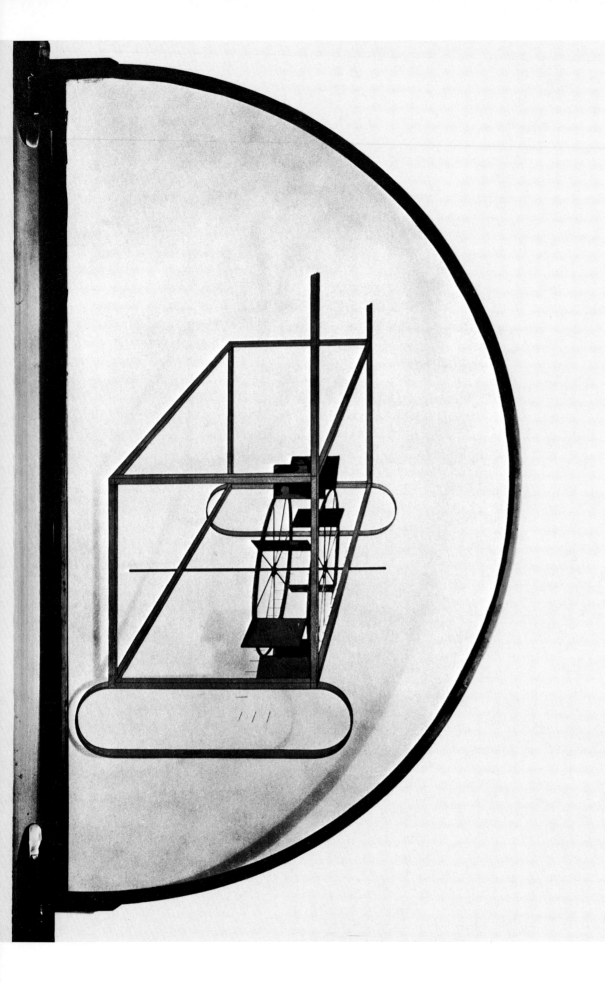

Marcel Duchamp

Glider Containing a Water Mill in Neighbouring Metals, 1913–1915. Oil and lead wire on glass.
p.180

Glider Containing a Water Mill, 1965–1966. Detail from the *Large Glass*. Tempera on paper. p.181

The Bride, 1965–1966. Detail from the *Large Glass*. Tempera on paper. p.181

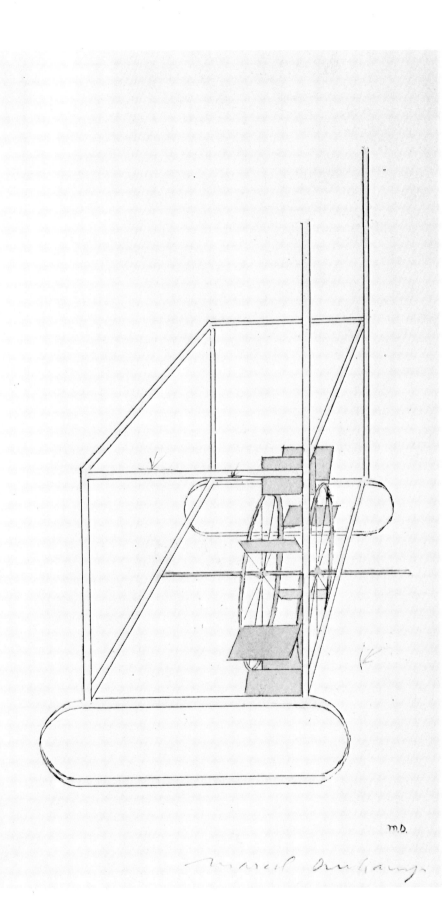

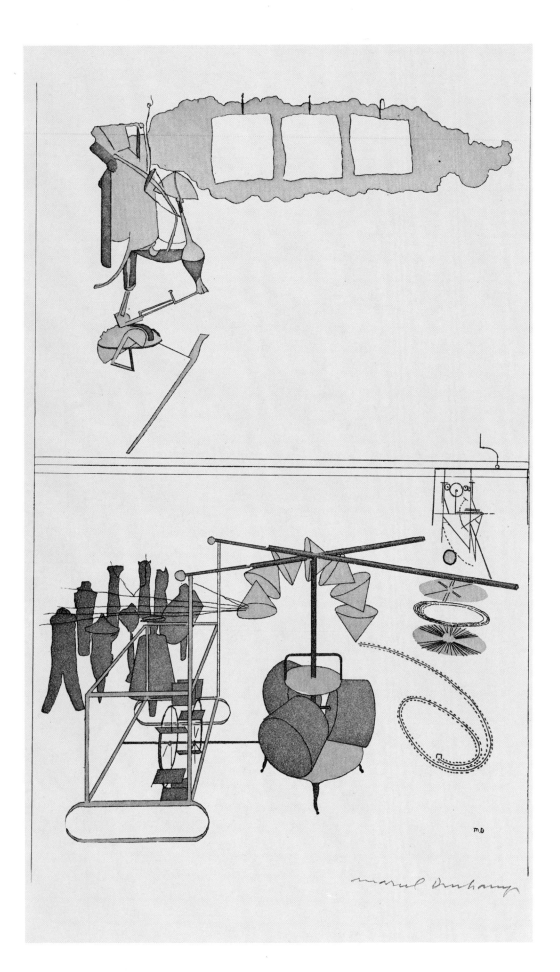

◀ Marcel Duchamp *Large Glass Completed*, 1965–1966. Colour engraving.

Marcel Duchamp *Nine Malic Molds*, 1965–1966. Detail from the *Large Glass*. Tempera on paper.

It would have been ungracious for Duchamp to hide his pleasure at an article by Breton singing his praises, in *Littérature*, October 1922. "There was a real affinity between us then. Breton was a nice friend. He had great influence in literary circles."

From 1922 to 1926, Marcel lived in Paris, doing nothing definite, giving French lessons to young Americans, producing several "things" with various meanings, and playing chess; in 1924 he became the Haute-Normandie chess champion. He appeared naked and bearded as Adam in Picabia's and Satie's ballet, *Relâche*, which was performed only once, by the Rolf de Maré troupe, at the Théâtre des Champs-Elysées. An equally naked young woman played opposite him as Eve. The young man who did the lighting fell in love with her and married her. His name was René Clair.

For Marcel, it was also a period marked by numerous love affairs with rich, beautiful women, including the enchanting Mary Reynolds, with whom Marcel had, as he said, "a very pleasant affair". She was an intelligent, independent, pleasure-loving American, who was able to understand Duchamp's complex personality. He blossomed physically and intellectually during this period of dreamy dilettantism. 183

In 1926, he made a film, *Anémic Cinéma*, with Man Ray and Marc Allégret. "I was mainly interested in the optical side," said Duchamp.[120] "Instead of making a machine that turned, as I did in New York, I thought, why not make a film? It would be a lot easier. I wasn't interested in filming for its own sake, it was a more practical way of getting my optical results..." It was craftsman's work, as the cinema was still in its fairly early stages. "A scene couldn't be filmed at just any speed, it went out of focus, and as it was turning quite fast, we got an odd optical effect. So we had to give up the mechanics and do it manually..."[121]

When Marcel Duchamp went back to New York in October 1926, after nearly three years in Europe, he did not feel like going on with the *Glass*, which was therefore never finished. (Neither was *Demoiselles d'Avignon*.) After that, he did not touch a paintbrush or any of the paraphernalia associated with a work of art. Duchamp had indeed cut himself off from the traditional idea of the painter and had relinquished "turpentine intoxication", but after the *Glass*, he broke completely with artistic methods; from that time on, his works became few and far between. But he entered chess championships, married (it lasted only seven months) and, like a lot of artists and writers at the time, took up dealing and also regularly sold his old paintings to Arensberg, after buying some of them back. He was always detached, self-sufficient, and therefore respected, particularly by the Surrealists, to whom he had refused any commitment. Under Breton's patronage, they became the first audience of the "Duchamp myth".

He had nothing in hand, nothing in his pockets. "I was really defrocked, in the religious sense of the word," he said, talking about his break with art, and added hastily, "but not deliberately. It disgusted me."

"I'd rather live and breathe than work... Every second, every breath, is an uninscribed work, which is neither visual nor cerebral. It's a sort of constant euphoria."[122]

In 1954, he told Alain Jouffroy: "A person doesn't have to stick to the same profession from the age of twenty until his death. I've broadened the method of breathing."[123]

In 1961: "I stopped, partly out of laziness, partly because I hadn't any ideas, as I don't paint for the sake of painting. I've never considered myself an artist in the professional sense. Painting is one of many means towards a rather indefinable end. I have no intention of judging myself, or reaching a neat, premeditated social goal."[124]

Duchamp's 1923 break with art may have been a form of courage. In a sense it certainly was, because he had a rich, enthusiastic patron in Walter Arensberg, rich friends and solid friendships which he could have fostered with a regular output; there was little risk, and he would have been secure. Instead, he stopped working, and seemed pleased to be doing nothing, or doing things that had nothing in common with artistic creation, but which could be seen as a sort of prolongation of his protest: chess, for instance.

When Jouffroy expounded this theory to him, Duchamp replied: "I have never made a distinction between my week-day activities and my Sunday ones."

He did not explain his conduct until 1945-1960, when the American avant-garde dragged him out of virtual seclusion and took the relay of the myth the Surrealists had created, to make Duchamp the master of *art-jeu* and the exponent of technical metamorphosis.

In 1923, he did not dream of justifying his attitude, and anyway no one asked him to, though his break with art shook the Surrealists, especially Breton, who was always sorry that he had no real influence over his friend. His criticism of Duchamp's escape into chess, "execrable Harrar", voiced mainly his disappointed affection. Unlike Rimbaud, however, Duchamp did not, consciously or unconsciously, break with art; this is proved by his decision to call himself an engineer instead of an anti-artist. By cutting himself off from art and anti-art, Duchamp also cut himself off from history; he solemnly asserted his aloofness and his solitude.

At the end of January 1925, Marcel Duchamp, Jacques and Gaby Villon, Suzanne and Jean Crotti, Magdeleine and Yvonne Duchamp, Raymond Duchamp-Villon's widow, and a number of friends and relatives gathered in front of the family tomb at the Cimetière Monumental at Rouen for old Madame Duchamp's funeral. On 3 February, a few days later, the notary died. Villon had done a portrait of his father[125] a few months before; the Cubism of the stylized yet fluid face has something ironic in the way it seizes on the essential personality of an old man.

Marcel used his share of the inheritance to buy works of art to sell. "You've got to do something to eat," he said.

A SOLITARY PAINTER AND A DILIGENT ENGINEER

Thanks to Walter Pach, Raymond Duchamp-Villon's work was not forgotten. He held exhibitions in New York, wrote pamphlets and articles, and persuaded his friends and collectors and American museums to buy Raymond's work. In January-February 1929, Pach organized the Memorial Exhibition of the Works of Raymond Duchamp-Villon, 1876-1918, at the Brummer Gallery, which exhibited forty-five works, and the Arts Club of Chicago exhibited twenty-five during March and April. Two years later André Salmon wrote the preface for the sculptor's first Paris exhibition at the Galerie Pierre; during his life, Duchamp-Villon had never exhibited except in a group or at the Salons.

His reputation grew, and he took his place among the best Cubist sculptors; on several occasions, Duchamp-Villon was associated with his two brothers, and he was included in the main international exhibitions of Cubism and living art. His work belongs to the history of the avant-garde. Nevertheless, French historians and critics have taken very little notice of him, except Adolphe Basler in his 1928 *Sculpture Moderne en France* and Christian Zervos, who wrote an article about him in his magazine *Cahiers d'Art* in 1931, and included him in the *Histoire d'Art Contemporain*, published in 1938, together with a reproduction of one of his works.

Villon's structural experiments with closely meshed cross-hatching, and the play of light and shade in his etchings in the thirties, gave rise to a remarkable work, *Philosophe*. As usual, most of his prints preceded or followed paintings. The allusive *Peintre* (1931) culminated in a spectral analysis of the model, Villon himself, the man who knew the inmost secrets of both the visible and invisible. There were several portraits in the same vein between 1930 and 1932, including a self-portrait and Villon's portrait of his friend Patrelle, a notary's clerk whom he met during his military service, and again during the war.

As he often did, Villon took up an old work again; in 1930 he went back to the theme of *Les Haleurs* (Hauleurs), which he had done as an engraving twenty-three years earlier, then painted the following year. He felt that this work marked the crucial introduction of movement into Cubism. The hatching and play of values are extremely powerful here. Villon attached great importance to these *Haleurs*, which he rightly considered a primordial landmark in the history of Cubism.

He continued to do portraits until the war. Hatched trellises of varying intensity demarcated the planes, creating different depths from whose oblique rhythms the face peered out. Thus the mask seems to be springing from these adroit graphic combinations, particularly in the *Savant*, where the power of the gradations from grey to black is extraordinary, while the stopped-out patches of white breathe life into the engraving.

In 1926, Villon met Camille Renault, well-known for his corpulence (he sometimes weighed as much as 240 kilos, or 528 lbs.), his restaurant, his artist friends, his collection, his truculence, his cunning, and his generosity. The "Gargantua of painting" as he was called was a strange mixture of kindness and vanity, deviousness and candour. In 1925, he opened a restaurant in Rue de la République in Puteaux; before that, he was an apprentice pastrycook, a pastrycook, and Lyautey's chef at the Résidence Générale in Rabat. Camille Renault was deeply interested in painting and made the rounds of the galleries during an era when the Fauves were ridiculed and the Cubists treated like daubers. He loved colour so much that he used the colour schemes of his favourite artists to decorate his cakes and dishes.

Puteaux was then one of the foremost "Red suburbs", and Renault's restaurant was frequented by a succession of Socialist congresses, avant-garde theatre companies, conferences on popular education, wedding parties, and first communions. The *Patron* always liked painting and picked up bits and pieces; then one day a cousin brought Picabia along, and other painters followed. Renault took on a few young, untalented unknowns under contract, but gradually his taste developed, and Villon came into his life at just the right moment.

Jacques Villon *Le Philosophe*, 1930. Etching.

author of *Mirobolus, Macadam & Cie* painted Renault as an enormous turnip with paws. Renault bought so many works by failed painters that it is difficult to credit him with any personal taste or criteria. His insatiable appetite for paintings is excuse enough for his limitations and mistakes; the man, whose generosity was unbounded, but not always unrequited, never claimed to be an expert on art, and never hid his somewhat dubious transactions, from which many credulous Americans suffered.

Villon was very happy to have Renault's friendship and admiration; he had little at the time, and at Renault's he felt at home in the company of other painters, including Lhote, Kupka, Desnoyer, Gromaire and Crotti. He got into the habit of eating there every Monday, a ritual that only old age could break, as I was still his table companion, after hundreds of others, in 1961. Villon could invite anyone he liked: for every hundred meals, he gave Renault a picture. Neither of them kept an exact count, but within a few years "Big Boy" owned a superb collection of his friend's paintings, and Villon did several portraits of him. The most famous, painted in 1945, was hung by the table where Villon ate every week.

In the Rue de la République, Villon could invite whom he liked at minimal cost, and when he became famous he was surrounded by a group of young artists, who swelled Renault's clientele. When Villon became well known, dealers and collectors offered "Big Boy" large sums for the paintings: they were accepted or refused as need and circumstances dictated. Renault was always able to dissemble his native cunning behind a guileless façade, and though he admitted having "done" some rich clients, usually foreigners, it was only to help his painters.

When Villon was really short of money, Renault gave him a certain amount, and the painter put whatever he wanted —watercolours, gouaches, drawings—into a cardboard box. Neither of them verified the exchange, for they shared a sense of delicacy and respect for others.

After the Second World War, "Monsieur Villon" and "Monsieur Renault", as they called each other, went on several motoring trips together, notably to the South of France. A young woman painter from the Puteaux "stable" acted as driver. The painter could not stand being overtaken by other cars, and lost his temper every time it happened.

"Now, now, Monsieur Villon," Renault would say, "that's an American car, it's worth a lot, you know... a very small painting of yours, a 'four' or 'five' for instance..."

At that time the painter's works were beginning to be priced very highly. Villon, mollified, would nod and mutter, "No, that's not right, it's much too expensive." But he was less upset at having been overtaken.

What did the Puteaux chef think of the Rue Lemaître recluse, who is said to have had assignations at his restaurant? So many artists frequented the Rue de la République restaurant that we may wonder whether Renault had the time or means to choose between them. It was probably the fame of a Villon, Poliakoff, Dubuffet, Kupka, Bazaine or Pignon that gained "Big Boy" his reputation; the future

186

Jacques Villon *Les Haleurs*, 1930. (Haulers). Etching.

Jacques Villon *La Plaine entre Cannes et Mougins*, 1934. Etching.

What kind of man was Duchamp in 1927-1933, those years he spent in Paris, which was then in the grip of the Surrealist fever he was careful to avoid? Not only did he never sign a Surrealist tract, but he never called himself a Surrealist, in spite of his friendship with Breton. Marcel Duchamp was too independent to accept any edicts, but even so he and Breton remained on very good terms.

Some people wondered whether he was a hoaxer, others thought of him as a dilettante who collected attractive rich women. To others again he was merely an art-dealer, or a

chess player. Only the Surrealists placed him highly among the avant-garde of contemporary thought, and after the *Green Box* was published in 1934, André Breton wrote an article in *Le Minotaure*[126] entitled *Phare de la Mariée*, which gives a very clear assessment. The cover of that issue was a reproduction of one of the *Rotoreliefs* that Duchamp had shown at the Paris inventors' fair.

The few people who had seen the *Large Glass* in New York spoke of it as a quasi-mystical object in the image of its creator, who was careful to keep up the aura of mystery. The

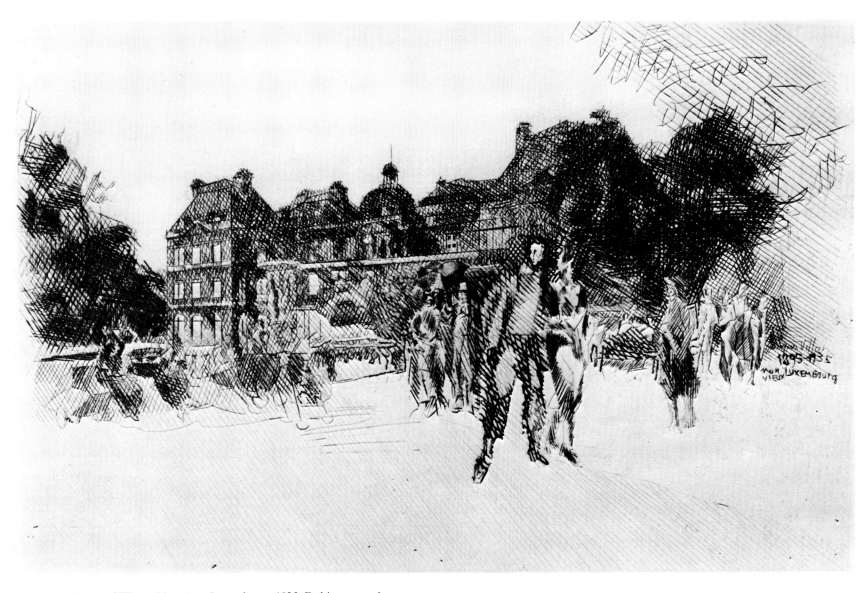

Jacques Villon *Mon vieux Luxembourg*, 1935. Etching, second state.

Glass broke on its return from the International Exhibition of Modern Art in Brooklyn in 1927, and the fortuity of this mishap amused Duchamp, if no one else.

The *Glass* had been packed carelessly, and the two parts packed one on top of the other broke in exactly the same place. Duchamp was in Europe at the time and did not hear about the accident until he went back to New York in 1933; he repaired the *Glass* three years later, leaving the cracks, which blend so well with the whole that they might have been put in on purpose.

The *Green Box* fulfilled Duchamp's oft-expressed wish to collect his various productions and preserve them. He felt that each of them demanded "a fair amount of precision and time, which were worth preserving". Apart from this, he seemed to concentrate on nothing in particular, because he never lost sight of the fact that time exists to be filled. He simply filled it doing a lot of diverse things.

"Fantastic Art, Dada, Surrealism" at the Museum of Modern Art in December 1936 shook New York. It was not perhaps the Armory Show, but it still had a great impact, 189

190

Jacques Villon
L'Aventure, 1935. Etching. p.190
Orpheus, 1934. Oil on canvas. p.191

192

Jacques Villon *Le Petit Dessinateur* (Self-portrait), 1935. Ink on tracing paper.

Jacques Villon *Le petit dessinateur*, 1935. Etching.

because once again Europe exported dynamite to America. Eleven of Duchamp's works there preceded his subsequent one-man show at the Arts Club in Chicago, where Villon had exhibited a few years previously. The Arts Club had also organized a major exhibition of Duchamp-Villon's sculptures. Julien Lévy wrote the preface to Duchamp's catalogue.

◀ Jacques Villon *Homme dessinant*, 1935. (Man drawing). Oil on canvas.

The exhibition lasted from 5-27 February 1937, and only nine works were exhibited, all major ones.

Duchamp was working on *Box in a Valise*, which was not finished until 1942, and which he had to leave in 1938 in order to prepare the Exposition du Surréalisme at the Galerie des Beaux-Arts in Paris. It was his idea to have a grotto in the centre, where twelve hundred coal sacks were suspended over a brazier near Dali's pool; he also dreamed up the revolving screens to hang pictures and objects.

The pre-war days were coming to an end. Along the "Rue Surréaliste" at the Galerie des Beaux-Arts, the female mannequin in Duchamp's hat and coat, called Rrose Sélavy, had a charming but enigmatic face; the future was to wear the same aspect.

Marcel went to see Villon in his Puteaux studio, where the countryside was already threatened by mushrooming apartment blocks. Villon was still living a solitary, laboriously ordinary life, poor but uncompromising. After all, he neither needed nor asked for anything. He probably suffered secretly from Duchamp's rather paradoxical reputation, for his brother had lampooned and condemned everything Villon held dear, and all he lived for—painting and pictures.

There was a family bond between the two brothers, but few common memories because of the twelve years' difference in age, and their divergent views on art had dug a deep gulf between them. Villon represented retinal art, oil painting, which, Marcel said, "has only been going for five hundred years after all... (and) is beginning to look old-hat". Nevertheless, Villon never said a word against Marcel in public. That does not mean he was indifferent: Marcel's doings surprised and baffled him. He was an incurable experimenter, fascinated by the mystery of a painting, and did not understand Marcel's attitude except in the context of a childlike and gullible America. Villon was both amused and saddened by his brother's fame.

He himself was practically unknown. Art magazines and histories of the thirties and forties clearly show this. Although Walter Pach was his loyal and enthusiastic commentator in America, no French critic bothered with him. It would have been little use, anyway, as he never exhibited.

It is difficult to decide whether Villon was a sensitive geometrist or a mathematically-minded poet. Although dealers and collectors knew nothing about Villon, many painters held him in great esteem, including Gromaire, whose loyalty never wavered, André Lhote, Goerg and Desnoyer. The young painter Bazaine, who met him through Gromaire in 1936 or 1937, became one of his closest friends. He wrote about Villon with great insight in the *Nouvelle Revue Française* in 1941, and in *Poésie 44* three years later.

But apart from these, the pre-war articles about his work can be counted on the fingers of one hand. I remember seeing, in the Puteaux studio, a treatise entitled *Visite à Jacques Villon* by R. Valençay, published by the magazine *Sang Nouveau* in Charleroi, probably during the thirties. The painter had very few visitors at that time. In December 1938, Jean-Daniel Maublanc published *Jacques Villon et le Cubisme* in *Le Bon Plaisir*, one of the few occasions in the period between the wars when the critics noticed him.

The year before, Villon had submitted only three canvases to the big *Rétrospective des Maîtres de l'Art Indépendant*, while Marquet submitted thirty-eight, Derain thirty, and Waroquier twenty-seven. It was a triumph for safe modernism. The French president, Albert Lebrun, was present at the inauguration at the Petit Palais, but he was not shown the Cubist, Surrealist or Abstract rooms in case they shocked him.

Two of Duchamp-Villon's sculptures were exhibited, and Villon had also submitted some engravings. Duchamp was completely ignored. Annoyed at the treatment of the more modern movements and their exponents, Christian and Yvonne Zervos led a group of artists in a retaliatory demonstration in the basement of the Musée du Jeu de Paume. Villon took part reluctantly, but Duchamp was absent. However, it is possible that none of his works were available as most of them were at the exhibition in the Arts Club of Chicago.

During the summer of 1938, Marcel organized an exhibition of sculpture at the Guggenheim Jeune Gallery in London which included works by Raymond Duchamp-Villon, Arp, Brancusi, Calder and Pevsner.

Villon had been commissioned to do a decoration for the Aeronautics Section of the 1937 Exposition Internationale des Arts et Techniques. In this section, modern art was best represented because Gleizes, Beaudin, Robert and Sonia Delaunay, Survage and Crotti were all included. Villon was in charge of the stand of the French Aeronautic Federation, which was a good choice as he had always been fascinated by aviation and painted many pictures on the theme. For *Conquête de l'Air* he built small wooden aircraft, which he kept and which were still on the shelves in his studio when he was an old man.

Villon was barely mentioned in the official report listing the artists who had contributed to the exhibition; in one he was even called Jacqueline! His paintings and engravings nevertheless earned him two diplomas of honour and a gold medal.

His paintings made wide use of colour. His landscapes and figures were rich and tense, and the subtle changes in rhythm form the counterpoint to the all-important planes. The 1936 *Les Pommiers à Canny* (Apple Trees at Canny) evokes a handful of confetti thrown into a metallic space of rarefied air, and redistributed in large masses from the areas of contrast between light and shade. It is reminiscent of Seurat, not only because of the Pointillist technique of juxtaposed colours modelling form and light, but because of Villon's idiosyncratic way of expressing volume structure without depth, and giving the values their poetic measure.

Jacques Villon *Pommiers à Canny*, 1936. (Apple Trees). Oil on canvas.

He is saved from stereotyping by his quality of feeling; although Villon set out to paint the world rather than his feelings about it, his unconscious mind found an outlet in his coloured surfaces, making his paintings a dual representation of himself and reality.

His work also shows an artistic compulsion rare in his contemporaries.

D'Où l'on tourne L'Épaule à la Vie[127] (Turning one's Back on Life) (1938) is like a vision outside time and space, with delicate colours and more sustained radiance. The broken rhythms overlap to create a half-geometrical, half baroque architecture, whose aura of fantasy is rather piquant. *Le Joueur de Flageolet*[128] (The Flageolet Player) (1939) shows the musician's face looming out of its trap of juxtaposed planes and lines. The whole is arranged in a perfect square moored in space, where the richness of the colours upholds the rhythmic tension.

His paintings were accompanied by a lot of drawings. "If I had an eternity before me in which to work, I'd spend years just drawing," Villon said. Engravings preceded or complemented his paintings and gave him a chance to extend his pictorial experiments.

Villon's work between the wars is generally neglected in favour of the work of his famous old age, when an unhoped for commercial success came to crown more than half a century of obscurity; on this Villon commented, "The first fifty years are always the worst."

But those who now offered him their belated appreciation were not interested in the 1920-1940 paintings, possibly because of a certain distrust of abstract art. In fact, Villon did not fit into any category. He oscillated between several styles; he went from abstract to concrete and, as he himself said, his Cubism was also Impressionist. He had to pay heavily for these changes, the experiments of a free spirit which certain rigid schools of criticism refused to recognize.

This ostracism ended only when an important dealer took Villon's work in hand, and when Villon himself, spurred on by age and by his new security, perfected his henceforth indefinable style, which no longer disconcerted people but became a feast for the eyes and mind. From then on, he was successful. Strangely enough, the pre-Cubist and Cubist periods vanished: at the Musée d'Art Moderne retrospective in 1951, there were only three early post-Impressionist works and six Cubist ones. Ten years later, at the Galerie Charpentier there were only five works dating from 1900 to 1913 and only three Cubist paintings.

In France, Villon's pre-Cubist and Cubist pictures were reproduced only in Dora Vallier's excellent work, published in 1958 by *Cahiers d'Art*, but, with very few exceptions, their owners are not named. It is a pity that Villon did not, like Duchamp, have an Arensberg to acquire virtually all his works, for there are many inexplicable gaps.

The War could start. Marcel had packed; the *Box in a Valise* contained miniatures or models of all his works. He had done little else for several years, apart from art-dealing and playing chess. He spent the summer of 1940 with the Crottis in Arcachon, and Jacques and Gaby Villon were in Bernay with Madame André Mare, and later stayed with her children, Mr and Mrs Marc Vène, at La Brunié in Tarn, where Villon was enchanted at discovering new phenomena of nature, and worked hard.

Thanks to his friend Gustave Candel, Duchamp had a pass, identifying him as a cheese merchant, which enabled him to make several trips to Unoccupied France to transport the various components of *Box in a Valise* to Marseilles. He left for New York with only his box and arrived unencumbered in America on 25 June 1942.

The situation was not at all as it had been during the First World War. America had caught up artistically, and many artists fleeing from Europe, including many Jews, had gone to live there. After 1942, Max Ernst, Ozenfant, Hayter, Frederic Kiesler, Kurt Seligman, Breton, Léger, Mondrian, Masson, Yves Tanguy, and Wifredo Lam formed the main body of an active colony, whose muse was the vibrant Peggy Guggenheim, who married Max Ernst. Her Art of This Century Gallery became the sanctuary of the avant-garde. There, as in many other places where exhibitions were organized, Duchamp was quietly active and had considerable influence, mainly because of his uncompromising attitude and strong moral stand. Katherine Dreier lent the *Large Glass* to be exhibited at the Museum of Modern Art in New York, and this contributed to a revived interest in him: he was still America's Number One Iconoclast. He had given an impetus to Dadaism, the first American avant-garde movement, and now, twenty-five years later, he was influencing the second one, which was supported by the German Expressionists and the Surrealists, and was to give birth to the School of New York.

Jacques Villon

Arbres, 1938. (Trees). Oil on canvas. p.197

L'Oiseau empaillé, 1938. (Stuffed Bird). Oil on canvas. p.198

Le Joueur de Flageolet, 1939. (The Flageolet Player). Oil on canvas. p.199

L'Effort, 1939. Etching. p.200

La Lutte, 1939. (Wrestling). Etching. p.201

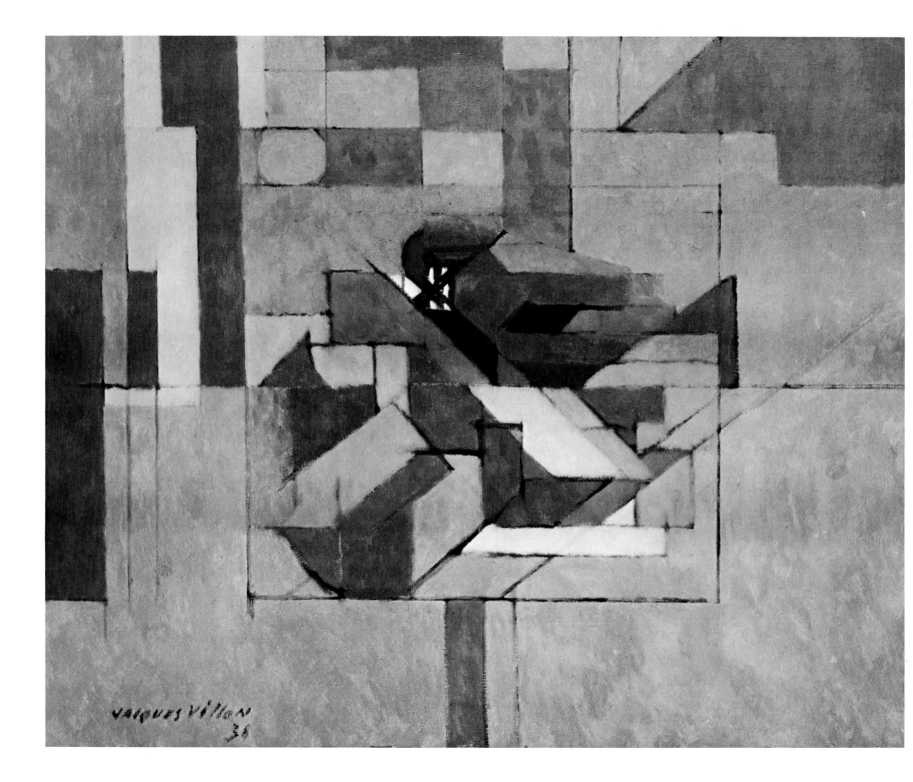

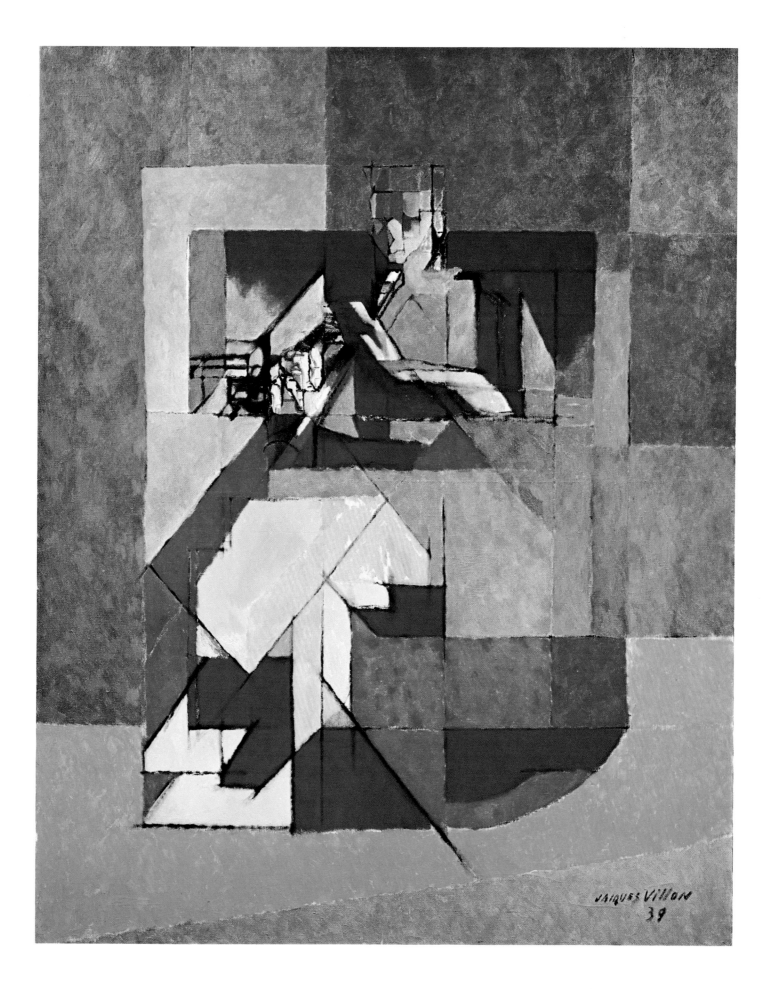

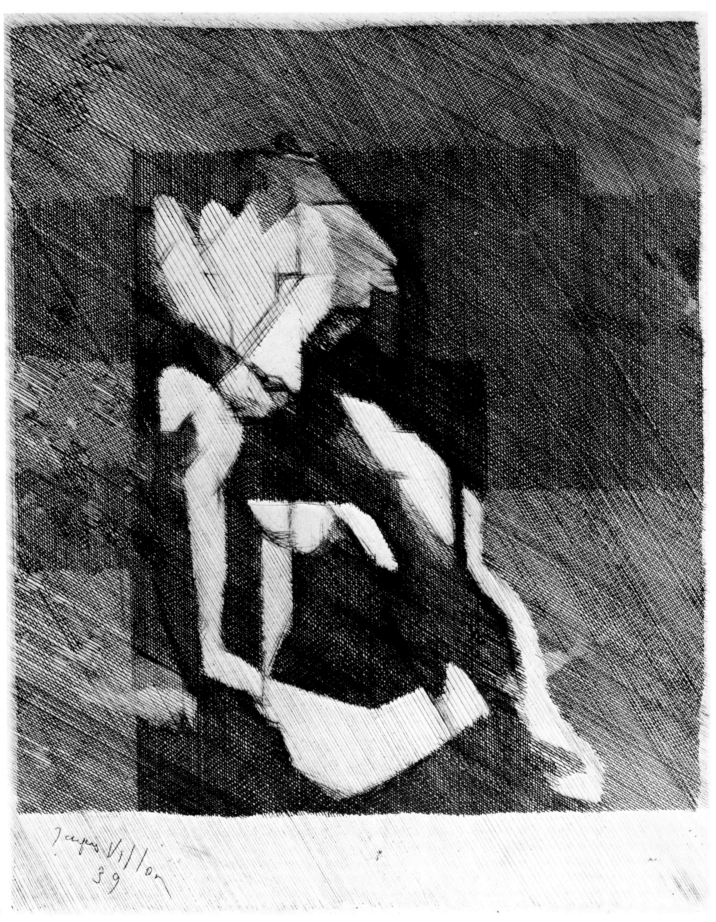

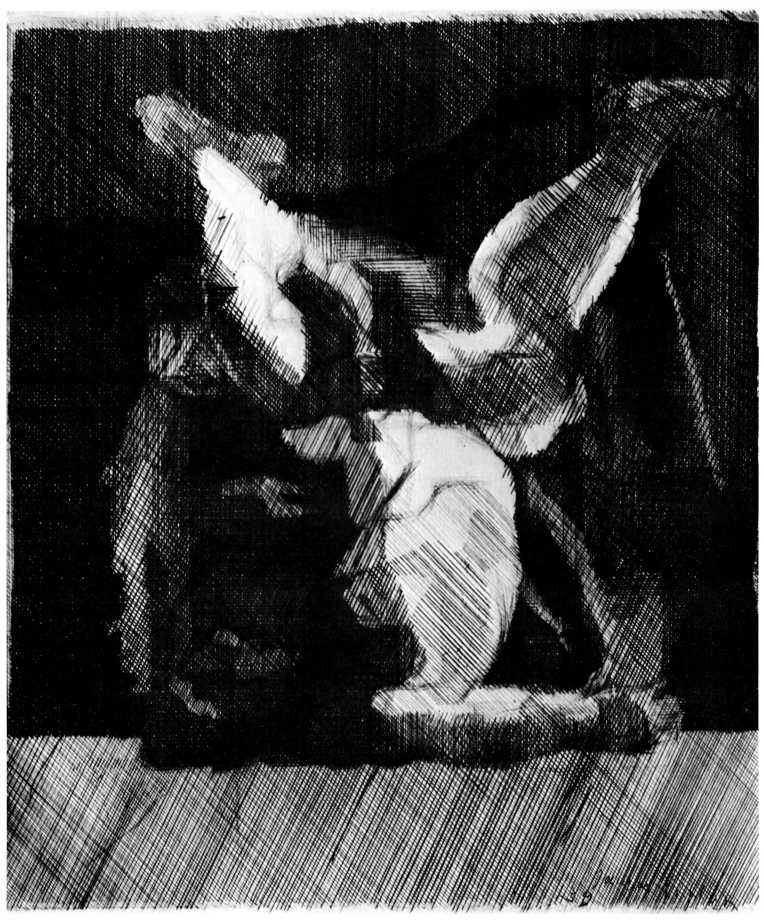

The 1944 Société Anonyme gift of its permanent collection to the Yale University Art Gallery gave Marcel the unexpected job of writing the catalogue's thirty-two notes on artists including Picasso, Matisse, Picabia, Léger, Chirico, Derain, Man Ray, Archipenko, Arp, Calder, Boccioni, Csaki, Klee, Braque, Miró, Severini, John Covert, Pevsner and Marcoussis. It may seem surprising to see the founder of the society, Katherine Dreier, described as a "painter, lecturer, writer", but no more so than finding Emile-Frédéric Nicolle side by side with his three grandsons, Marcel Duchamp, Raymond Duchamp-Villon, and Jacques Villon.

Duchamp drew up his notes very conscientiously, careful not to give any opinions. "It was a collection, there was no call for an appreciation, and my judgment wasn't important," he said.

In 1945, there was a family group exhibition at the Yale University Art Gallery, with works by all three brothers. The Galerie de France in Paris had had the same idea three years earlier, but Villon naturally headed the list because, at the time, he was the unchallenged artist of the family. In any case, Duchamp's post-Cubist work was almost unknown in France. In 1945-1946, an itinerant American exhibition presented Duchamp's and Villon's works in various galleries and universities.

In March 1945, the magazine *View* published a special issue on Marcel, who did the cover. Among those who collaborated on it were Breton, Man Ray, Charles-Henri Ford, Mina Loy, Cravan's ex-friend, Gabrielle Buffet, Picabia's ex-wife, Robert Desnos, Harriet and Sidney Janis, Julien Levy, James Thrall Soby and Nicolas Calas. A few months later, Duchamp went back to France after a three-year absence.

His return aroused no notice. He might have been America's Iconoclast, but things were different in Europe, particularly in France, where he was regarded as a rather crazy failure, except in Surrealist circles. Nobody looked for any reasons beyond laziness and boredom to account for his opting out of the artistic arena. If he was so much as mentioned in histories of contemporary art, it was among second-generation Cubists or Surrealists. But in 1945-1950, the young generation of the movement saw Marcel Duchamp only as a has-been.

JACQUES VILLON'S FAME

During the war, while Marcel was still riveting New York, Villon's peaceful existence was disrupted by an unexpected event: Louis Carré, one of the foremost Paris dealers, bought his studio and gave him the first contract he had ever had.

Though times were bad, the Tarn landscapes had enthralled Villon, now in his seventies. At La Brunié life went on peacefully in a pastoral setting. Villon had neglected nature for years, and now he rediscovered trees, plants and animals, and the constantly changing light with a fresh ardour. "I wasn't much given to speculation and almost every day for three months I sat and observed nature," he said. "I drew and measured and painted. I used these studies and drawings as the basis for landscapes... the trees and houses, sky and earth were caught up in a play, a sort of enchantment, and exuded a vitality that only needed to be expressed."[129]

As usual, Villon was restrained. At his age, he was not going to relinquish the rhythmic architecture that clothed his modulated lyricism for the sake of novelty. He once told me that he had never been tempted to let chance intervene in his pictures and had always found that a good way to work. The analyst in him was not carried away by the intoxicating light imbuing the bright landscapes of those beautiful, miraculously preserved summers; he overlaid emotion with design, bringing order and discipline to his initial vision of uncontrolled nature.

Many canvases illustrate the return to nature, including *Potager au Matin*[130] (1940) (Vegetable Patch in the Morning), *Potager à La Brunié*[131] and *Entre Toulouse et Albi*[132] (both 1941), *Le Potager aux Citrouilles* (1942) (The Pumpkin Patch), *Le Cerisier en Fleur*[133] (Cherry Tree in Blossom), *La Moisson*[134] (Harvest), and *Les Jardinières*[135] (Women Gardening) (all 1943), and *Oliviers entre Cannes et Mougins*[136] (1944). Villon embodied the essence of the landscape in his vertical architecture bisected by panoramic horizontals. He loved Impressionism and combined its fleeting plays of light with classical rules of order and symmetry. These landscapes, based on the relationship between light and colour, were the outcome of countless drawings and engrav-ings on the theme, some of them dating from before the war. In *Entre Toulouse et Albi* (Between Toulouse and Albi) everything hinges on two triangles opposed at their lower acute angles to frame a third, isoceles triangle, topped by a long rectangle. However, the freedom of space is unaffected, and the values harmonize through the greens, ochres, and mauves in a felicitous marriage of sight and knowledge.

Bazaine, the young painter who had been among the most loyal of Villon's pre-war followers, wrote a homage to the artist in the August 1941 issue of *Nouvelle Revue Française*. He praised him for his "courage in rigorously considering space-colour, one of the deepest, most complex and insoluble problems of painting: all the changes in the economy of a picture that the coloured transposition of light and its inte-gration into a plane can entail. Colour is both a value and the object's structural dimension."

It was Bazaine who took Villon to see Louis Carré, whose gallery in Avenue de Messine was one of the foremost in Paris. Louis Carré was an intelligent stubborn Breton who had started as an expert on antique silver; his works on French hallmarks are still authoritative. He soon went on to other things. In 1933 he organized an exhibition of ancient sculptures from the Acropolis Museum in Athens, which had considerable repercussions as fourth-century Greek art was still officially thought "barbaric". The novel simplicity of his presentation and the use of lighting broke with museo-graphic tradition and were highly successful. He organized several other exhibitions in the same way, including Benin bronzes, Georges de La Tour's recently discovered paintings, the Le Nain brothers, and Toulouse-Lautrec. In 1938 Louis Carré moved to Avenue de Messine and concentrated on contemporary artists, including Vuillard, Bonnard, Matisse, Dufy, Léger and Gromaire.

Louis Carré made Villon internationally famous, rescuing the old man, whose only joys were conversation and painting, from complete obscurity. In 1942, he bought all the works in his studio and after that ensured the painter's output by monthly payments. The artist found this sum a goldmine; since the war, his life had been harder than ever. The two

204 Jacques Villon *Potager à La Brunié*, 1941. (Vegetable Patch). Oil on canvas. Jacques Villon *Potager*, 1941. (Vegetable Patch). Oil on canvas. p.205

206

men had first met in 1937 at the Petit Palais exhibition of the Maîtres de l'Art Indépendant. They met again two years later at the wedding of André Mare's daughter to Marc Vène, when the Villons held an informal reception in their garden. Then Bazaine brought them together again.

Louis Carré's regular purchases did not change Villon's life much; he continued to paint calmly and untrammeled in his old Puteaux studio. As Duchamp was still unknown in France, he resented his older brother's belated fame. When he returned to Europe in 1945, Villon was beginning to be known, and his following continued to grow. This increased Duchamp's bitterness until he himself became the mentor of the young avant-garde thanks to Dadaism and Pop. So the scales were balanced again. Villon thought that, all in all, "turpentine intoxication" had its points. But Duchamp could not accept the fact that a major dealer was promoting his brother on an international scale while no one in France had ever been interested in him.

Villon's wartime pictures also hymned the "back to the land", the working of the fields, but not in the puerile "Vichy" sense. The decomposition of the immediate view into lasting elements gives an extraordinary dimension to the most fleeting actions, as in *Colin-Maillard*[137] (1942) (Blind Man's Buff), which evokes a play of prismatic mirrors reflecting a rainbow.

Between 1945 and 1950, Villon produced many abstracts, with a mere hint of realism, in which he gave priority to the organization of space and movement. In *Les Grands Fonds* (Broad Acres) the painter evokes distance by angular horizontal planes which define the spatial expanse. About the same time he did several portraits, including one of his patron's daughter, Colette-Martine Carré, remarkable for its earnest serenity and skilful gradations.

Villon also did another self-portrait.[138] This face is very strange: fragmented, divided, deformed by the juxtaposition of triangles, which expand and spread over his clothes and the background. The head is reminiscent of the obsidian skulls of pre-Columbian civilizations, which hold and receive light at the same time. The asymmetry of the eyes, the hollow cheeks and the thin, pinched mouth are those of an old man who seems to expect nothing more from life and gazes resignedly into nothingness.

Seven years later, in 1949, Villon did another self-portrait, *Le Scribe*.[139] The geometry is much softer, its contours are blurred by the supple undulating rhythms. The strict economy is replaced by large calm areas like ponds or flowerbeds.

Jacques Villon *Portrait of the Artist*, 1942. Oil on canvas.

The head is drolly deformed and adorned with a comical hat, *à l'artiste*, which crowns this symphony of greens, blues, buttercup yellows and gentle purples.

When Jacques Villon came back from his southern retreat, he was reunited with Camille Renault, who had lost a bit of weight because of food rationing, and had also been deprived of his artist friends, who had fled occupied Paris. Villon had begun his portrait of Renault in 1942, redone it, and destroyed it, but it eventually was taken up again and became the glory of the collection, holding pride of place in the Rue de la République.

Jacques Villon *Madame de Bernay*, 1940. Oil on canvas.

Renault had more spare time than before the war. In spite of his 175 kilos, he went round the galleries and Drouot's, buying or selling according to his mood and means. One day, he stumbled upon *Nu aux Persiennes*, an energetic painting with flat tints outlined in thick impasto. He liked its aggressive simplicity, and bought it; it was the first painting that an unknown artist called Dubuffet had ever sold. Camille bore it back in triumph to Puteaux. "When I showed Lhote the picture, he lost his temper," said Renault. "'It's taken from a child's drawing! Look, there are six fingers on the hand!' Villon didn't say anything—he never said a bad word about anyone."

In December 1946 René Jean, the critic, prefaced the catalogue for Villon's first exhibition at Louis Carré's; it comprised thirty-nine paintings and was his first Paris exhibition since 1922. Critics and painters voted it a great success, but the collectors were struck dumb by an art form with which they had lost touch. In spite of limited space, the newspapers praised Villon. "An anxious, ardent seeker" (Waldemar George, *Résistance*); "Leader of a new generation of painters, who flock to him spontaneously" (André Warnod, *Figaro*); "A born logician, in the style of Valéry" (E.P. Giresse, *Front National*). Gaston Diehl extolled his integrity in *Libération-Soir*, and Frank Elgar his "discreet, fervent and exceptional offering… the miraculous fruit of forty years of solitary, ardent and obscure work".

Although he was enthusiastic, Waldemar George asked, "Why must his paintings have such a theoretic, experimental character?" He considered the Galerie Roux-Hentschel exhibition of Civet, Marchand, Gruber and Venard the main event of the week, rather than Villon's.

In *La Bataille*, Jacques Lassaigne expressed his reservations: "This art is cold, almost unreal," he wrote. He thought Villon's landscapes "seemed dead", but liked his portraits. "There his work is alive." In *L'Amour de l'Art*, Jacques de Laprade went further: "Jacques Villon does not seem to me to get beyond an intelligent, charming analysis", to which Jean Grenier replied, "He decomposes nature intellectually and compensates emotionally" (*Combat*).

In December, Bazaine wrote another luminous study of the Puteaux master in *Poésie 44*. "What Poussin already called neglecting nothing means taking everything; it means not weakening and limiting oneself by deciding at the outset, but letting an unpredictable inner world take root and flourish." He also praised Villon's "great peace, the happy tenderness of his latest paintings".

Bernard Dorival was the first French art writer to devote several pages to Villon in *Les Étapes de la Peinture Française Contemporaine*, published in three volumes in 1944. He said that Villon's art "shows itself to be the agent of the purest

208

Jacques Villon *Portrait of Camille Renault*, 1944. Pen drawing.

Jacques Villon

Portrait of Camille Renault, 1944. Pen drawing. p.209

Portrait of Camille Renault, 1944. Pen drawing. p.210

Portrait of Camille Renault, 1944. Oil on canvas. p.211

Portrait of M.A., 1945. Oil on canvas. p.212

Portrait of Mlle Colette Carré, 1945. Oil on canvas. p.213

210

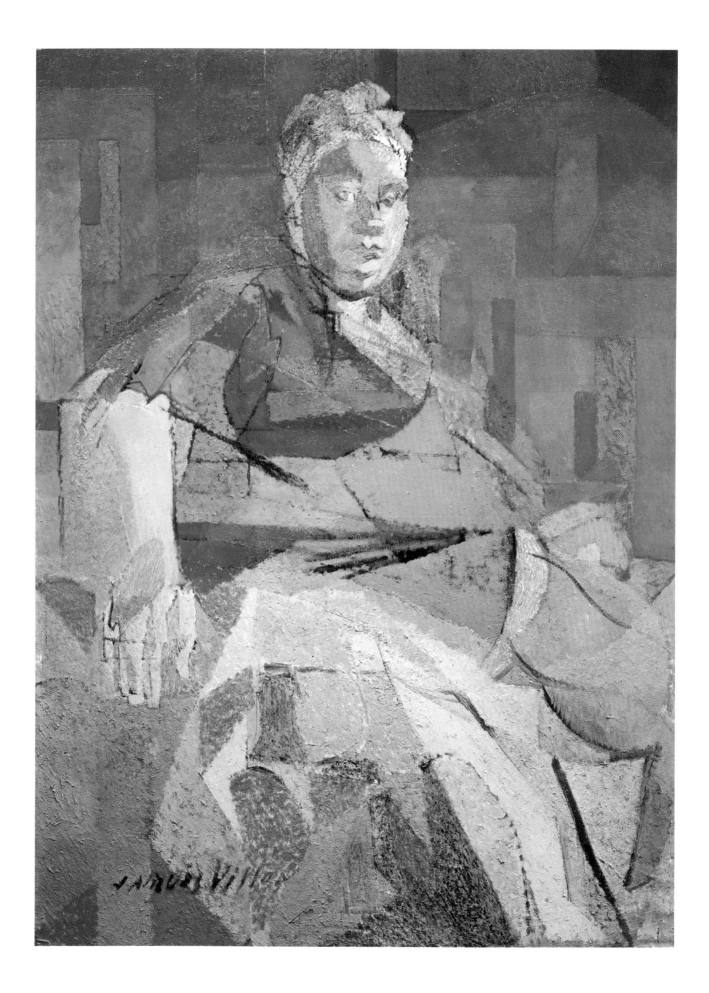

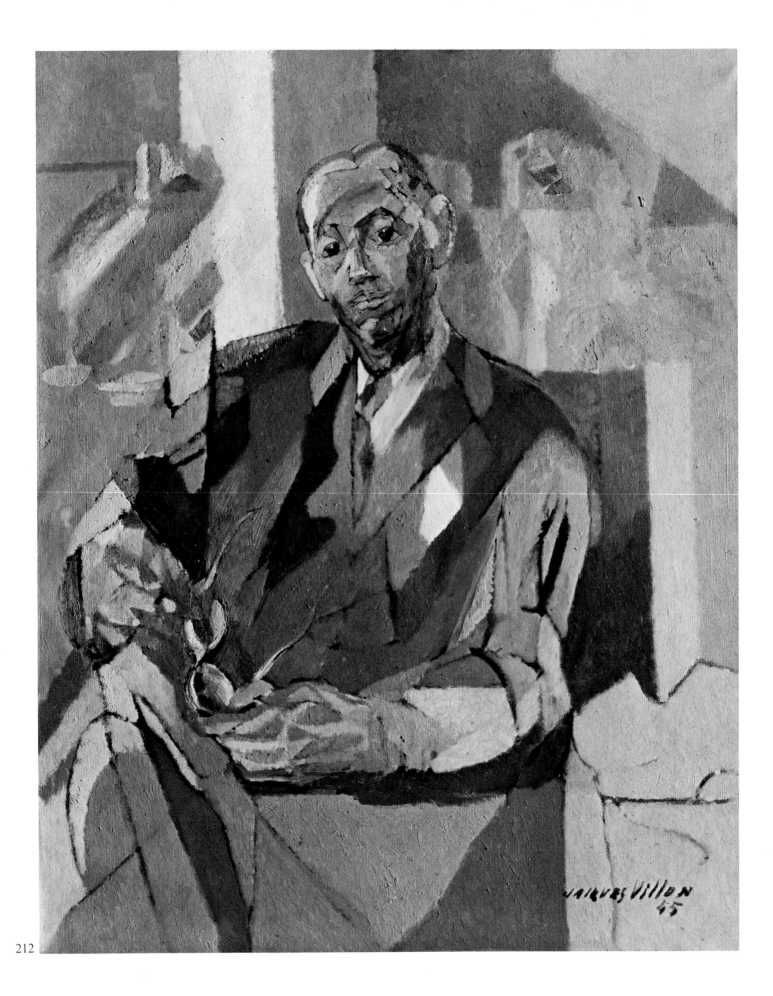

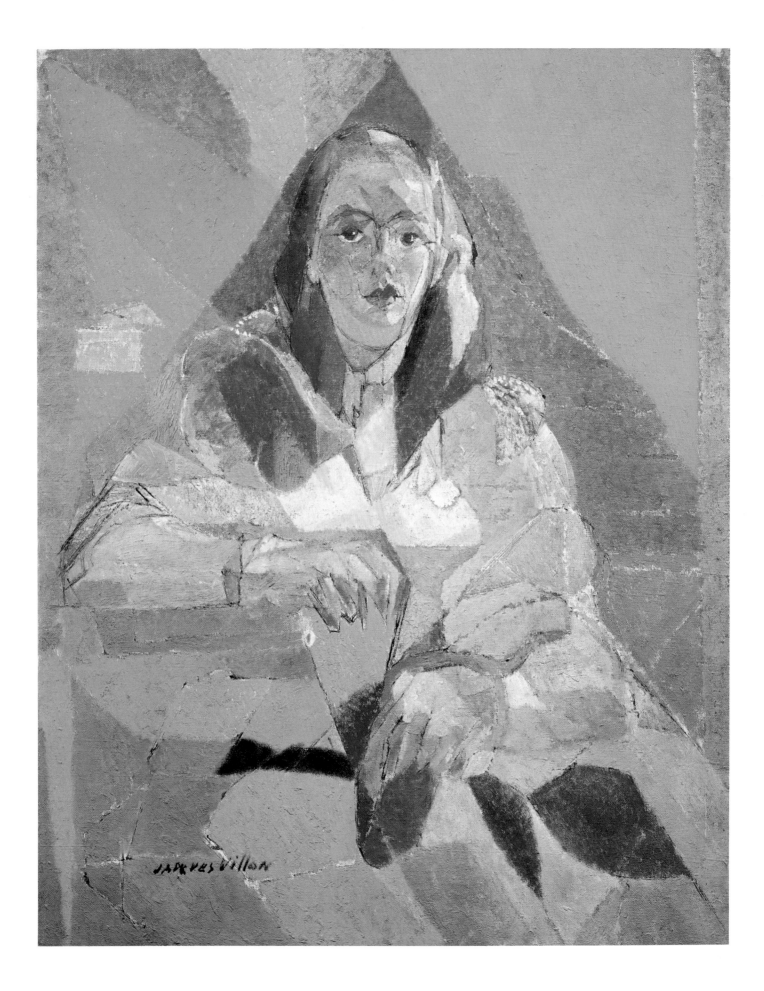

Jacques Villon *La Meule de Blé*, 1946. (Corn Stack). Oil on canvas. Jacques Villon *L'Avare*, 1949. (The Miser). Oil on canvas. ▸

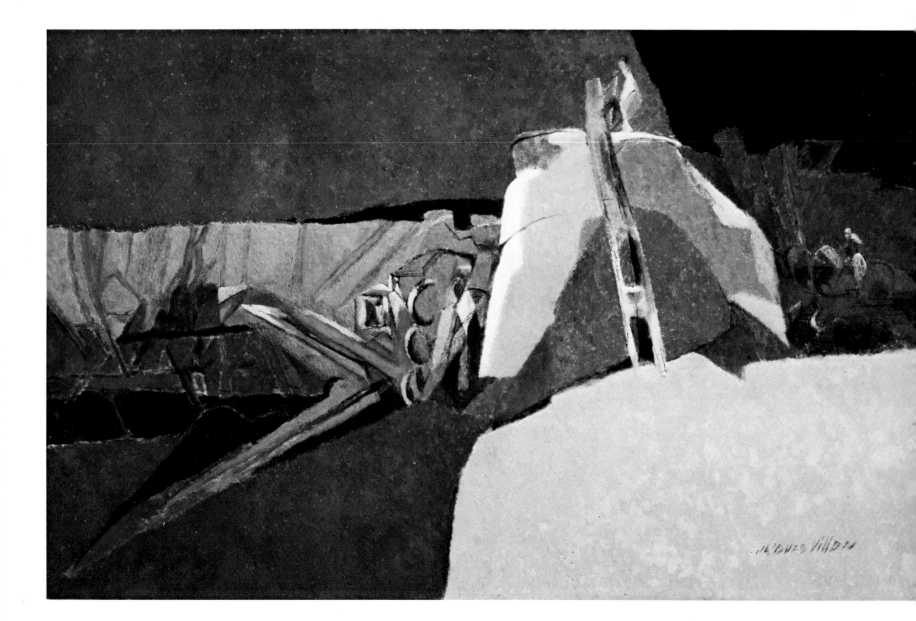

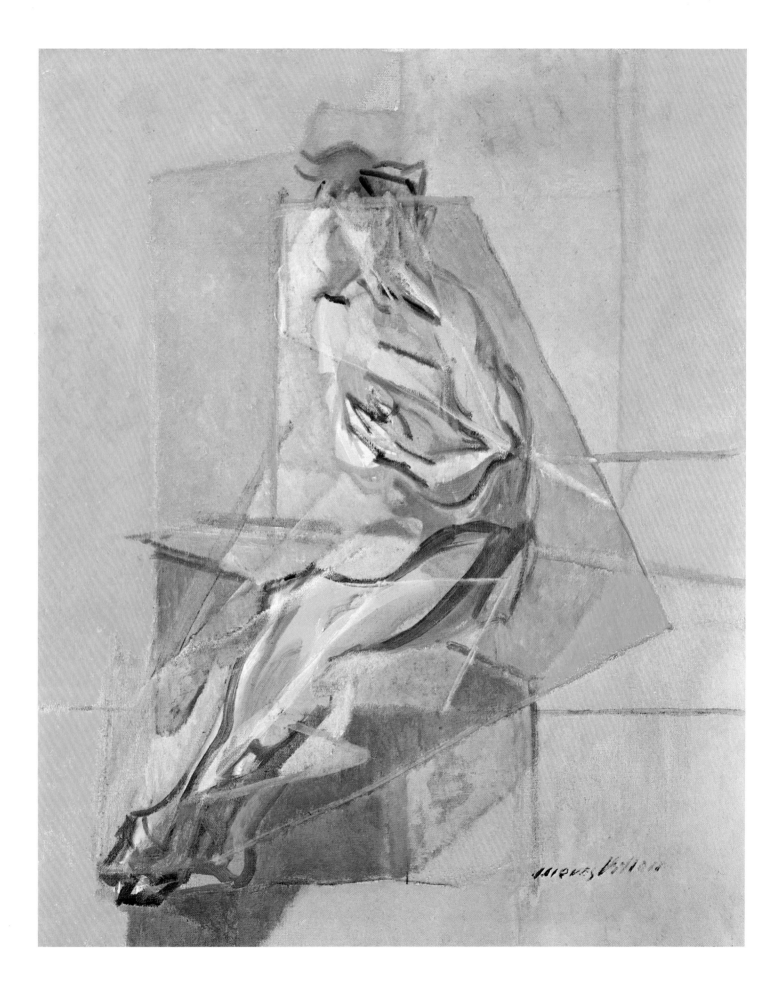

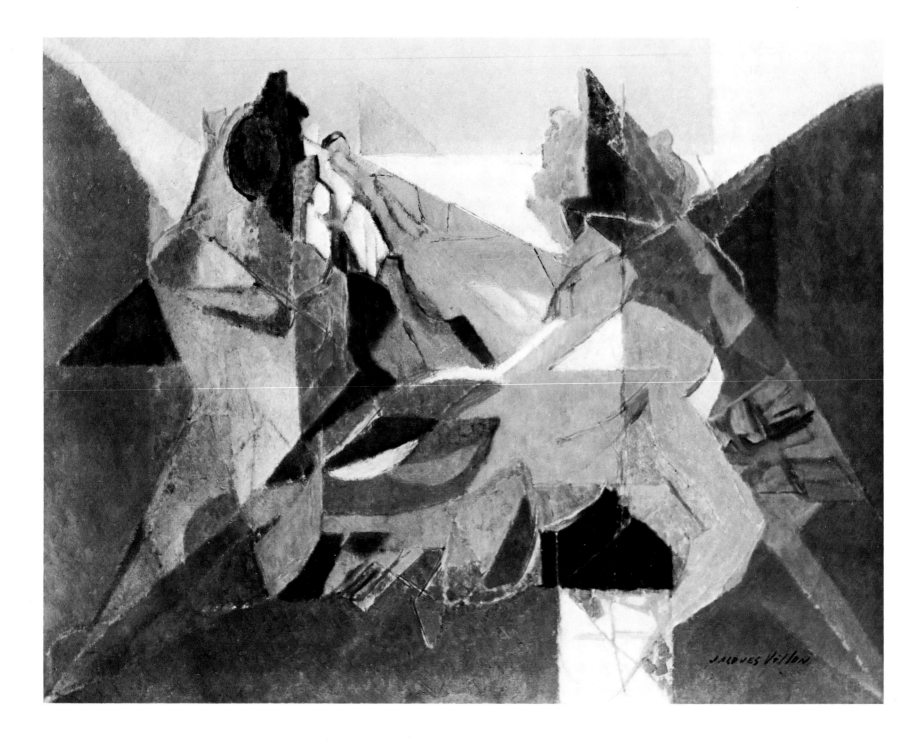

216 Jacques Villon *Nausicaa*, 1949. Oil on canvas.

French tradition, like that of Roger de La Fresnaye, his only equal among the exponents of Cubism". A few weeks later, Editions Braun published an illustrated pamphlet by René Jean in the "Initier" series; it was the first work devoted to the seventy-year old painter.

The second was *Jacques Villon ou l'Art Glorieux* (1948), also by René Jean, with a very fine poem by Eluard. Two years later Carré published the *Catalogue de l'Œuvre Gravé* by Charles Pérussaux and Jacqueline Auberty. In the same year Editions de Beaune published *Jacques Villon* by Jacques Lassaigne, with thirty-two black-and-white plates.

It was the immediate post-Liberation period. The era was marked by the comeback of Picasso, the herald of the "committed" art of the 1944 Salon d'Automne, and it took stock of its present and future masters: the violent trend started with the painter of *Guernica*, the "doves" with Bonnard. At the same time, abstract art opened fire, and the "geometrists" first occupied the ground. Kandinsky, who died in December 1944, was still almost unknown; the popular painters of the day were Fautrier, whom Francis Ponge immediately hailed as "the most revolutionary painter in the world since Picasso", and Dubuffet, much to Camille Renault's delight.

Villon and Bonnard were recognized as the leaders of the sensitive-abstract—called "French"—and realist school, who supported a certain open-window style. Villon, whose Salon d'Automne exhibits earned him more followers, was abashed by this; Bonnard died in 1946. With his customary humility, Villon took on a role for which he had been unprepared and which Bazaine had defined perfectly in his 1941 article. "Jacques Villon is a skilful painter... who has faced the infinite number of problems of art [and] was not afraid to study in depth those golden rules of the Renaissance in order to make his way in the world of shapes, and found in the strictest Cubism a way of re-examining these vital problems on the threshold of a new world."

The Duchamp, Duchamp-Villon, and Villon exhibition at the Yale University Art Gallery was shortly followed by the itinerant Duchamp and Villon exhibition organized by the Société Anonyme. What did Duchamp think of his older brother's unexpected and belated fame? "I was delighted that, of the family, Villon held that position," he said.[140]

Note the ironic "of the family". Marcel surely must have been jealous, as he himself was virtually unknown in France?

"Oh no, not at all. There were twelve years between us. Jealousy usually arises between people of the same age."[141]

Duchamp was back in Paris, where he had settled unobtrusively as usual. He had nothing on hand. Breton asked

Jacques Villon *Les Grands Fonds*, 1945. (Broad Acres). Oil on canvas.

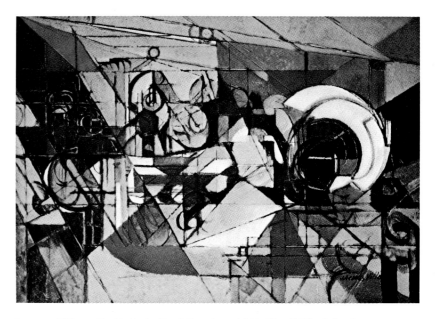

Jacques Villon *Le Petit Atelier Mécanique*, 1946. (Small Workshop). Oil on canvas.

217

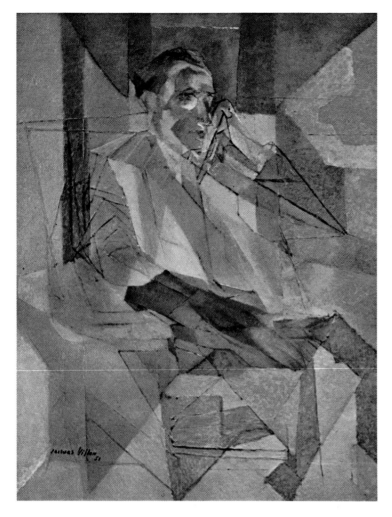

Jacques Villon *Portrait of Marcel Duchamp*, 1951. Oil on canvas.

him to help organize the "Surréalisme en 1947" exhibition at the Maeght Gallery; he imaginatively decorated the cover of the catalogue with a rubber breast and a label underneath "Please Touch". Then he went back to New York.

There is something intriguingly sick about his strange 1948-1949 plaster relief, a sort of quartered headless hermaphrodite with amputated arms and legs, and atrophied hairless genitals, riddled with holes and mounted on velvet. The title, *Given the Illuminating Gas and the Waterfall*[142] is not very elucidating. These words were already in a note in the *Green Box*, and those close to Marcel Duchamp thought that the work had not come into being fortuitously. All his activities were bound by mysterious threads to some labyrinthine thought-process. *Given* (Etant donnés...) is one of the primordial elements of the work Duchamp was doing in secret during the last twenty years of his life and finished just before his death, the last phase of the Bride plucked from her immateriality and concretized down to complete nudity.

Raymond Duchamp-Villon was associated with his brothers for a long time, but in 1960 he was the subject of an unpublished thesis submitted at the École du Louvre by Marie-Noëlle Pradel. It was the first exhaustive account of his life and works, and other studies by the same author followed: *Les Dessins de Raymond Duchamp-Villon* in *Revue des Arts*[143] and, in *Arts de France*[144], *La Maison Cubiste en 1912*, in which the sculptor played an important part.

Duchamp-Villon's first major retrospective exhibition was held at the Solomon Guggenheim Museum in New York. In France, the first retrospective exhibition in 1963 was due to Louis Carré, who exhibited fifteen works including *Torso of a Young Man*, the bust of Baudelaire, the portraits of Maggy and Professor Gosset, *Seated Woman*, and the *Horse* in its various stages, up to the superb 1914 *Large Horse*. This was cast to the size Duchamp-Villon had wished and named *Cheval Majeur* by Duchamp. Carré exhibited it in 1966. A year later, there was a very complete exhibition at Knoedler's in New York, accompanied by a remarkable study and catalogue by George Heard Hamilton and William C. Agee.

In 1968, Raymond Duchamp-Villon's *Cheval Majeur* was installed in the big entrance hall of the Prefecture of Rouen.

THE FIRST PAINTER TO SPEAK THE LANGUAGE OF THE AIR

After 1950, Marcel Duchamp produced several "sculpted things", as he himself called them, his first platic works since 1923, apart from his 1934-1935 optical experiments. These new works were *Not a Shoe*[145], *Female Fig Leaf*[146] (1950), *Objet-Dard*[147] (1951), all three in galvanized plaster, and *Wedge of Chastity*[148] (1954), galvanized plaster and dental plastic. This last was Marcel's wedding present to Teeny, whom he married in New York on 16 January 1954. This did not affect his carefree bachelor existence; the marriage brought him a ready-made family as his wife had two sons and a daughter from her previous marriage to Pierre Matisse. It also brought him a home as the couple moved into an apartment at 327 East 58th Street, where they lived for five years.

Mary Reynolds had died four years earlier, in Paris; knowing she was very ill, Marcel had crossed the Atlantic to be at her bedside. Katherine Dreier died in 1954, the year Marcel organized the Duchamp Brothers and Sister exhibition at the Rose Fried Gallery in New York. Picabia died in 1953; shattered by his old friend's death, Duchamp sent him a telegram saying, "Cher Francis, à bientôt" (Dear Francis, See you soon).

Suzanne Duchamp's artistic career proceeded parallel to that of her husband, Jean Crotti, who has certainly not been given the place he deserves. After being one of the most active Dadaists in Paris, he faded out of the limelight. "Suzanne has a good sense of humour, thanks to which she has been able to nourish and retain her individuality," Katherine Dreier wrote in the 1949 Catalogue of the Société Anonyme. Two years after the Galerie Montaigne exhibition with Jean Crotti, Suzanne had her own exhibition at the Galerie Paul Guillaume, and she contributed regularly to the Salon d'Automne and the Indépendants. During her Dadaist period she was mainly influenced by Picabia, and afterwards she tended towards a sort of dreamlike imagery; her paintings transformed reality, sometimes rather humorously. Later she produced naive, pseudo-primitive, rather laboured pictures.

She was delighted with her part in the Duchamp Brothers and Sister exhibition. Marcel was repaying her for the kindness she had shown when he was an adolescent in a family of women. At the Rose Fried Gallery, in the company of her three famous brothers, Suzanne rediscovered her youthful experiments and conquests. No gallery in Paris thought of holding a similar exhibition.

Villon's fame was an apt revenge for Marcel's oft-formulated criticism of "turpentine intoxication". If Marcel Duchamp had been less wise and ironic, he might have been disgusted that a purely retinal painter—in his own family at that—had won universal fame, which had been denied to him, though he had revolutionized America, and changed the concept of art. Like some critics, Marcel felt that Villon was the least imaginative of the three brothers. But Marcel kept quiet, because he hated aesthetic and critical judgments and, in spite of his subversive opinion of family life, had great loyalty towards his own clan.

And anyway, it did not really matter to him. Villon was not known under the name Duchamp but had virtually repudiated it.

Villon's new circuit was one Marcel had always condemned with particular passion: museum retrospectives, gallery exhibitions, biennales, decorations and rewards. From about 1948 on, not a single year, or season, went by without some new homage to Villon.

The exhibition at Carré's New York gallery was the first in a series of international events. In 1950, Lionello Venturi presented Villon at the Venice Biennale, where a whole room was devoted to him. A few months later Villon received the Carnegie prize, the highest award for painting in the world, for *La Grande Faucheuse aux Chevaux*.[149] He was overwhelmed.

"That'll help me do five more years of good painting," he said.

In 1949-1950 he did several pictures on this theme of horse-drawn harvesters, including *La Faucheuse aux Chevaux*,[150] *Les Chevaux de la Faucheuse* and *La Grande Faucheuse aux Chevaux*,[151] second version. Each of these was 219

preceded or accompanied by numerous drawings. Villon was as fascinated by the work of machines as of men, particularly machines on a human scale. He was closer to mechanics than technology. In 1941, the threshing-machine at La Brunié had inspired several of his paintings and drawings. The concrete-mixer churning outside Renault's played the same part in his work ten years later (*La Bétonnière Insatiable*)[152]. A few years later Villon became interested in aviation.

Those who object to the association of business with art are always ready to condemn the art-dealer. Picasso's famous remark probably put an end to idle discussions on the subject: "What would have become of us if Kahnweiler hadn't had any business sense?" Like Kahnweiler, Durand-Ruel, Bernheim and Paul Guillaume, Louis Carré did not increase his artists' talent by making them known internationally. Artists like Van Gogh and Seurat had become world-famous without the help of a dealer, but only after their death. Carré made Villon's last years happy and secure, and it was no one's fault that these did not necessarily constitute Villon's best artistic period. We must regret, though, that those post-war paintings became the most ubiquitous and the best known.

On the other hand, Duchamp's work was a constant challenge to the public and to dealers. At the time of his New York fame, he stubbornly refused to collaborate with any gallery. Thanks to his beautiful rich women friends, to Arensberg, and to his trade in other people's work, he had no great financial problems and no need to burden himself with obligations. Besides, he was lazy. Before the Second World War, the American market was completely different from the French; afterwards, needled by Villon's fame which he both envied and disapproved of, Duchamp ended up by accepting the museum retrospectives, the fame and money he had always refused. But, like his older brother, he did not change his life style and he never worked unless he wanted to. Though he adapted to some obligations, he had no illusions and forestalled criticism by pretending to make fun of himself. After taking part in a debate at the University of Houston in 1957, he commented on his acceptance: "I played my role of artist buffoon."

When any of his shortcomings were criticized, he answered, "I did it for fun." He once told me: "I didn't take myself seriously. I set out to make money. That has never diminished anyone, whereas seriousness..."

Naturally, Villon was delighted by his honours, his international audience, and the admiration of young artists and critics, but it all flowed over him. He went from the vibrant, clearly coloured abstract geometry of *Les Grands Fonds*

220

(Broad Acres) (1945) to the 1953 *Pigeonnier Normand* (Norman Dovecote), in which the rhythms of the fractured intersecting lines spread over large rectangular yellow, blue, green, red, mauve and black flat tints. From the 1948 *Ciel et Terre* (Heaven and Earth), where circles upheld by strict architecture confront their weights in carefully disordered space, to the bristling of *La Seine au Val de Haye* and *Grues près de Rouen* (Cranes near Rouen) (1959 and 1960), structure is all-important. In *Jardin en Fête* (Garden in Bloom) (1948), Villon built an internal trellis of perspective lines which lead the eye to the ideally blue space of a summer day.

In 1956 Carré held an exhibition of Villon's drawings in his Paris gallery. This was the first of several international exhibitions of his graphic work: at the Nasjonal Galleriet in Oslo and the Institut Français in Athens in 1957-1958, at the Bibliothèque Nationale in Paris in 1959, at the Moderna Museet in Stockholm (together with ninety-four paintings) in 1960, at the new Museum at Le Havre in 1962, and at the Zurich Kunsthaus, which exhibited eighty-one paintings, thirty-three engravings and twenty-two drawings. In January-February 1963, a few months before the artist's death, the Carré Gallery presented *La Figure dans l'œuvre graphique de Jacques Villon*. In the following year, the importance of his engravings and drawings was amply demonstrated by *Jacques Villon, Master Printmaker* at the Helen C. Seiferheld Gallery in New York, and particularly *Jacques Villon, Master of Graphic Art* at the Boston Museum, an exhibition of a hundred and eighty-nine works.

Jacques Villon

Faucheuse en Plaine, 1950. (Harvester in the Plain). Oil on canvas. p.221

L'Ecuyère au Cirque, 1950. (Circus Rider). Oil on canvas. p.222

Portrait d'Homme aux Mains croisées, 1950. (Man with Hands Crossed). Oil on canvas. p.223

Portrait of Simone, 1950. Oil on canvas. p.224

Gallop, 1952. Oil on canvas. p.225

Figure de Femme, 1951. (Woman). Oil on canvas. p.226

Réflexion, 1951. Oil on canvas. p.227

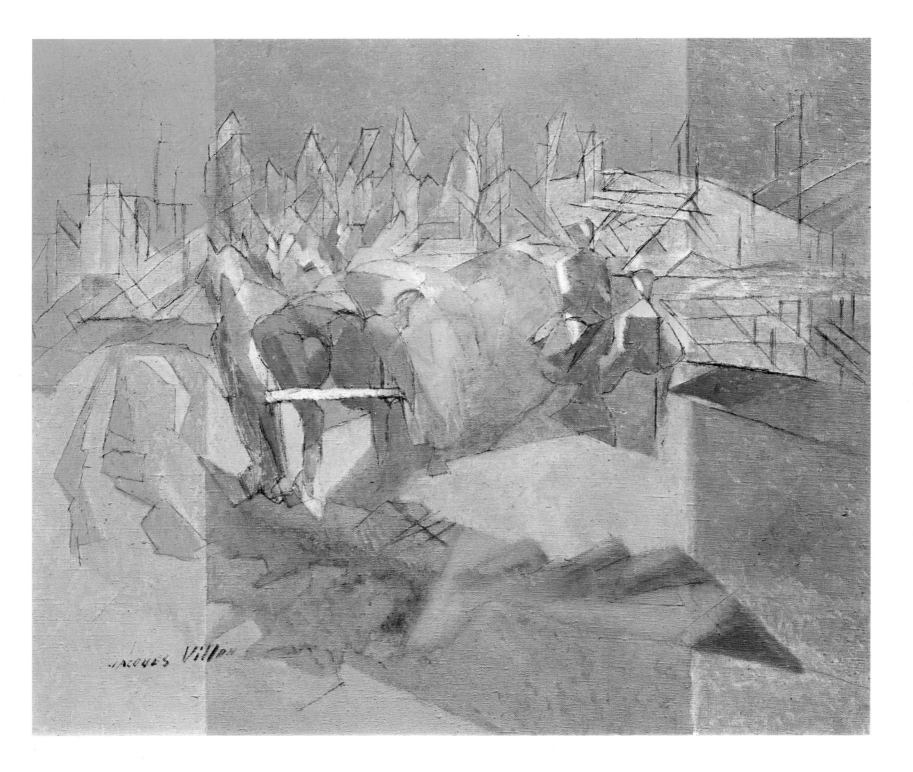

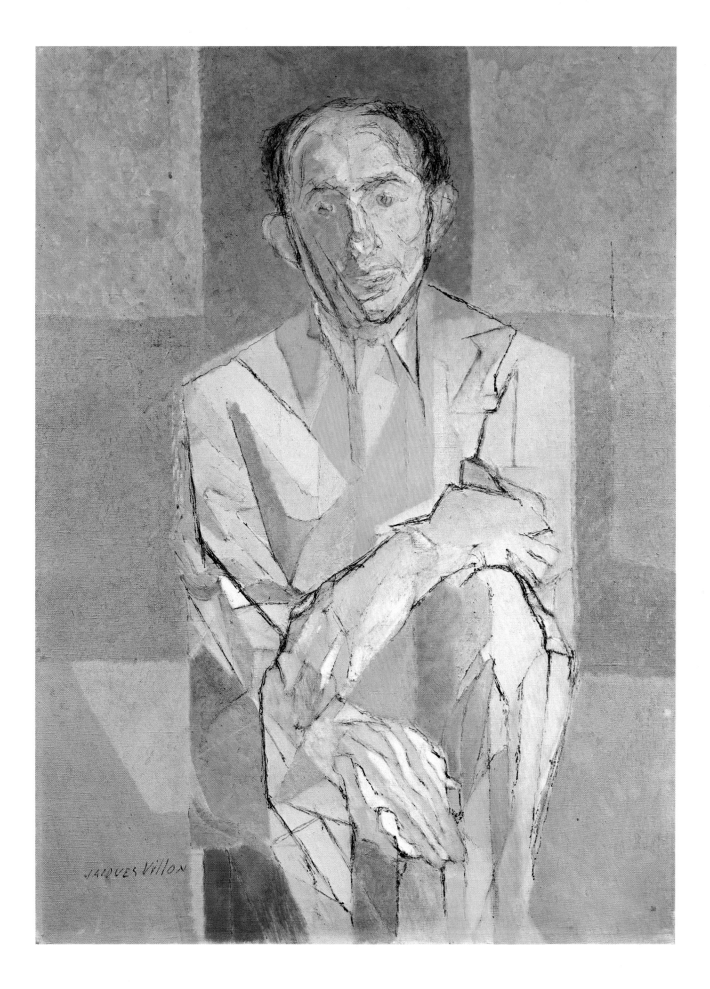

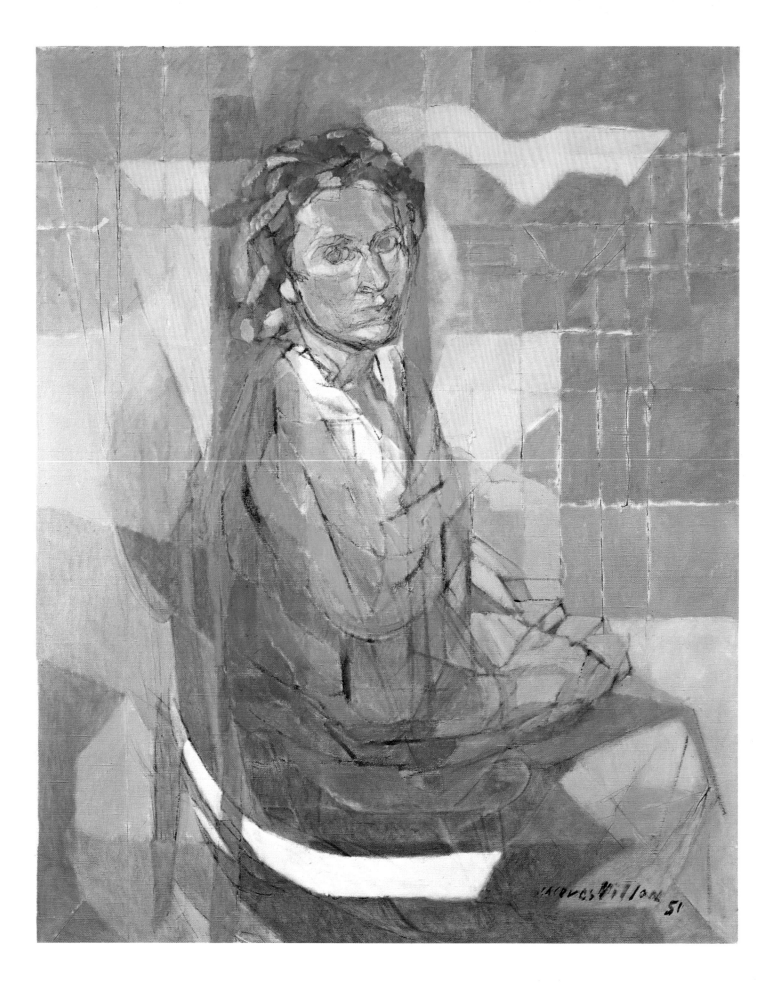

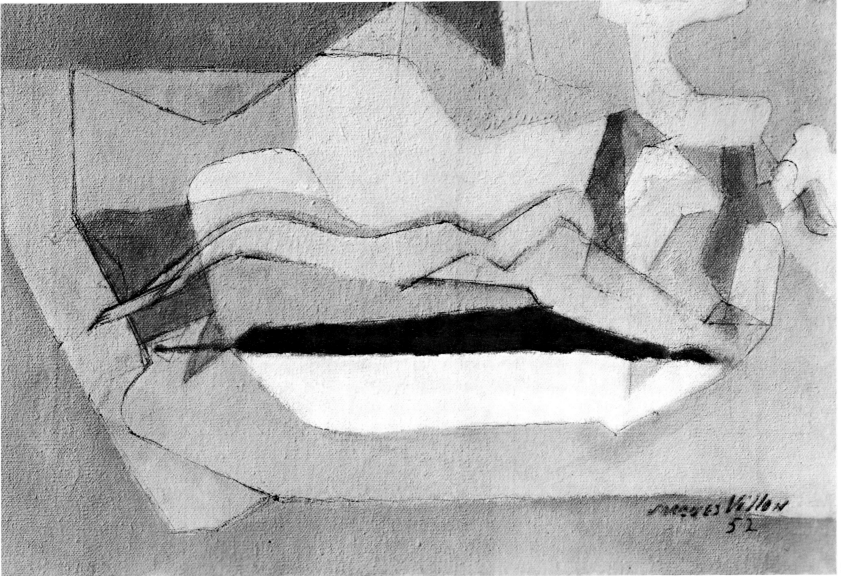

225

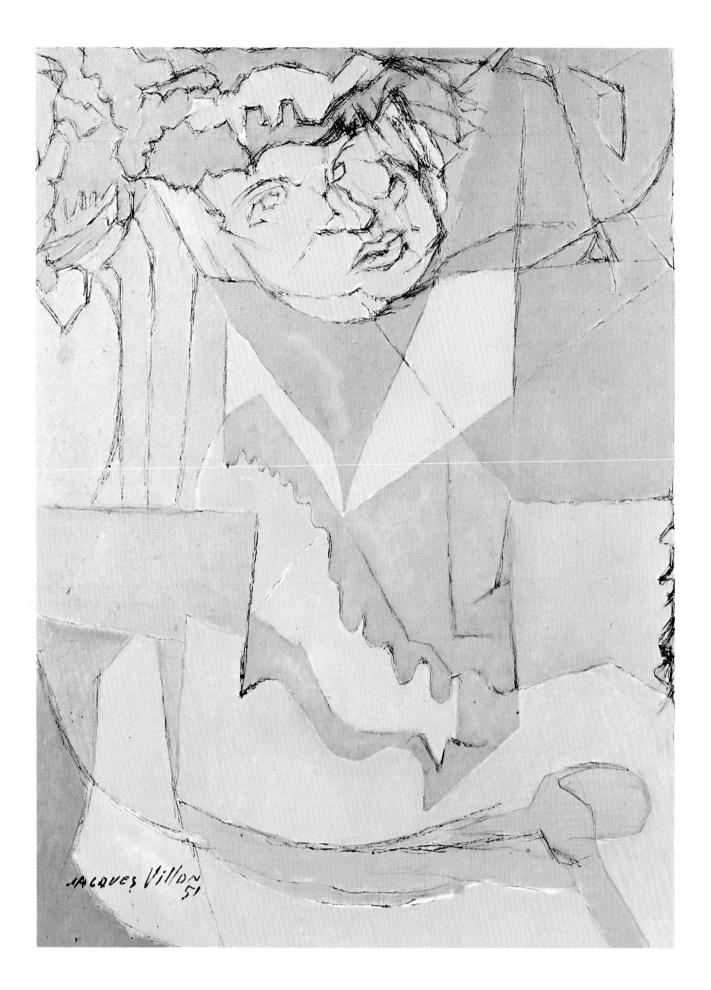

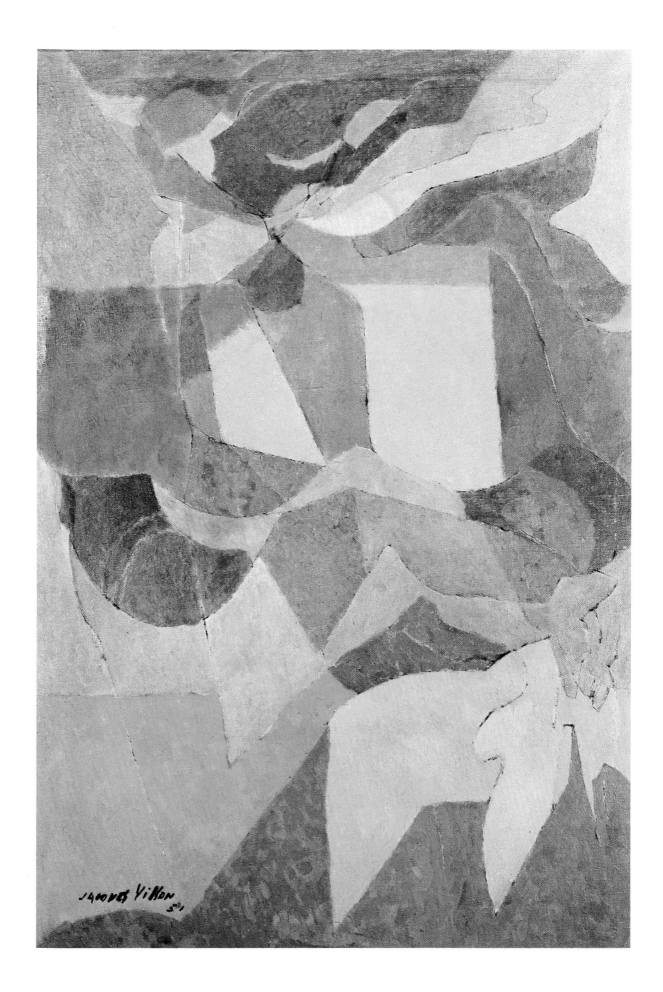

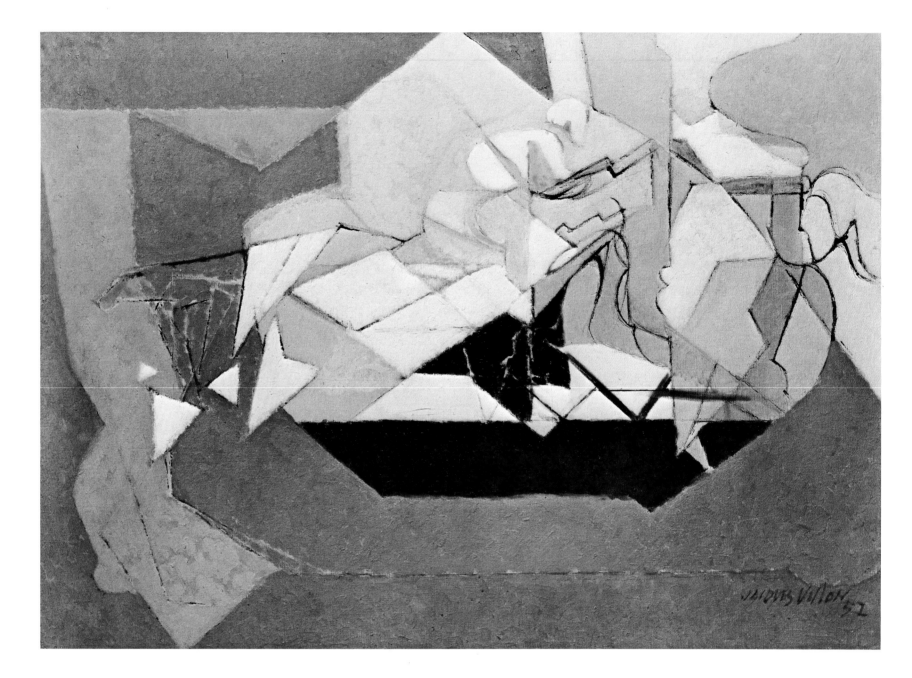

228

The artist's mastery of architectural rhythm and the play of light and shade was confirmed by his later etchings, sometimes based on old themes, which always preceded or followed a painting. As in his paintings, Villon's inspiration was diversified, going from geometry to a free rendering of a figure, from portraits to self-portraits. *Mon Frère Marcel*,[153] painted in 1951, inspired an etching of remarkable confidence and power two years later. The expressiveness of this face was one of Villon's highest achievements: Duchamp has his monument.

The Puteaux hermit had his revenge on the publishers who had hitherto ignored him. Only two sets of his works were published before the war: *Impressions*, a collection of ten coloured lithographs published by Sagot in 1907, and Pierre Corrard's *Poésies*, for which he did sixteen etchings. In 1945, Villon did five beautifully economical etchings for Racine's *Cantique Spirituel*, but he did his best work for Paul Valéry's translation of Virgil's *Bucolics* and Hesiod's *Works and Days*, twenty-seven coloured lithographs for the first, and nineteen double-page etchings, three in colour, for the latter.

Villon was perfectly at home with these classics. He was over eighty when he did these engravings, but his steadiness of hand is shown not only in the lightness of the lines and fractured rhythms, but in the confidence of his dazzling colours and in the light. His Greece has a limpid sky, cragged rocks standing out fantastically against the horizon, and figures as sturdy and powerful as stone; it is not the kingdom of the gods but a hard land where man has to work to live. At the same time, Villon's evocative lines alone create an impression of the immaterial; the eye has to finish the elusive line which never imprisons the shape but leaves it free.

When he assembled the scattered rhythms of this stony Greece within the fine meshes of his cross-hatching, he added his own appearance: the engraver sits alone at his table, working, as he did throughout his life. This thoughtful image of himself is the one he meant to bequeath to us.

Just as there is pure painting, there is pure engraving, and Jacques Villon was its incarnation.

He also engraved several frontispieces and illustrated André Frenaud's *Poèmes de Brandebourg* with six coloured etchings, Tristan Tzara's *Miennes* with seven etchings, and Robert Ganzo's *Œuvre Poétique* with eight etchings. In 1959, Villon did sixteen engravings, two in colour, for *Dents de Lait, Dents de Loup* by the young poet Henri Pichette. That was his last major set of illustrations.

"Drawing is writing. Painting is speech," he said. His drawings were neither rough drafts nor sketches, and they were not only studied preparations for a painting but contained its internal form, and crystallized the artist's feelings as well as the light which later would become colour.

He was very happy painting, living, being praised and seeing the young artists who came to visit him in Rue Lemaître. They were not all first-rate, but that did not bother him. They saw him as a wise guide and counsellor, which delighted and embarrassed him; he blushed like a girl at compliments. As a good craftsman, Villon was also pleased at fulfilling all his dealer's hopes and receiving fame and security in return for his work. Instead of ending his life in poverty and obscurity, he had a car to take him to and fro whenever he wanted it. He found it all overwhelming.

Such innocence might seem amusing, but the Puteaux sage defied irony as he was absolutely unaffected. He was the same at eighty as he had been at twenty or thirty: rather small, with a baby face, pink-cheeked, with mischievous blue-grey eyes, and thin lips. While we were talking, his face would suddenly light up and his eyes sparkle: "Ah, you've been in New York! Did you see Marcel?" Gaby fussed around discreetly, like a busy bee, as resigned to fame as she had been to poverty. Amused, sometimes anxious, she watched the beautiful women who came to see her famous husband.

In 1955 Villon painted *Un Atelier de Mécanique*[154] (Machine Shop), a subject he had been dissecting and analyzing in depth since 1914. The first painting on that theme is in an American collection; only the left side still survives. The second version, painted in the same year, is in the Columbus Gallery of Fine Arts. In 1946, he had painted *Le Petit Atelier de Mécanique*,[155] in 1947, *L'Atelier de Mécanique, Tintamarre*,[156] and *Mécaniques* in 1956. But he did other pictures on the same subject.

Aeroplanes too were mechanical, but offered a different scope. Villon had decorated the Pavillon de l'Air at the 1937 International Exhibition, and went round the Paris aerodromes with one of his best friends, Dr S.-H. Jurmand: he had painted portraits of Jurmand and his wife in 1949-1950. After 1934, Villon's aeronautic drawings and sketches led to several paintings opening a new perspective on his experiments in structure and space. He also gave a new dimension to his concept of time: not the neo-Cubists' solidified time, but time in motion, unifying subject and object, the undefined moment in which knowledge and the movements of life coalesce.

Before Jacques Villon, no one had dared represent aircraft and airports that way; Maximilien Vox said that in 1954 he was "the first painter to speak the language of the air." At Orly, Villacoublay and Le Bourget, he painted several series of pictures showing grounded aircraft as insects in repose (one of his paintings was called *L'Insecte*) and aircraft taking 229

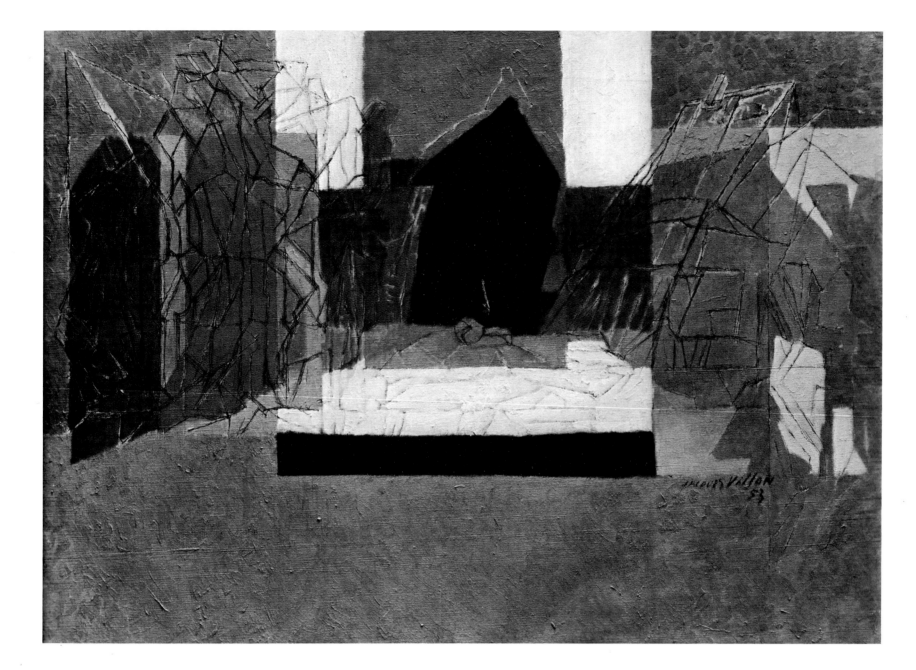

230 Jacques Villon *Le Pigeonnier Noir*, 1953. (Black Dovecote). Oil on canvas.

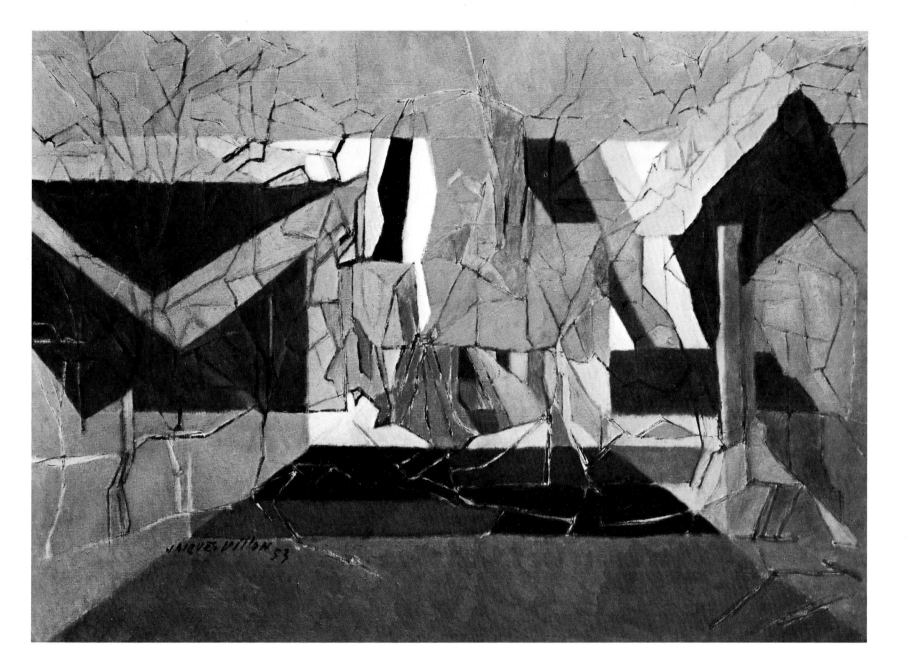

Jacques Villon *Le Four à Pain*, 1953. (Bread Oven). Oil on canvas.

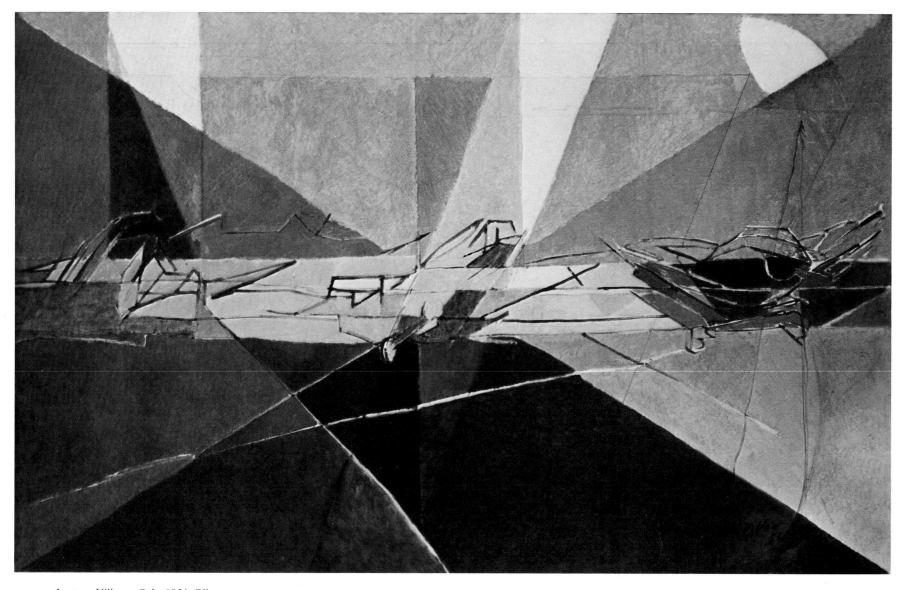

Jacques Villon *Orly*, 1954. Oil on canvas.

off and in flight. The horizontal body, parallel to the horizon, corresponds to the bristling wing-span, prolonged in space by wide diagonal rhythms. The air is divided into vital, oblique planes, contrasted or joining. Or Villon put large rectangles of light and shade, that is colour, in the centre of the painting to balance the aircraft's flight.

He was as much at home with aircraft, concrete-mixers, and harvesters as with the Norman dovecote. He examined faces because they contained life, and loved landscapes, which were air, light, and movement. Until he died, he played with what some critics senselessly call "abstract" or "figurative", and he combined his delight and restraint in

Comme il vous Plaira: Ascension (As You Like It: Ascent), one of his most uncompromising post-war paintings.

Age and success helped Villon to accept the restrictions of an art that tried to be both intellectual and sensitive and, unlike Delaunay or Kupka, he was unable to take the side of either method or feeling.

Jacques Villon

D'Azur vorace, 1954. (Like a Bird of Prey). Oil on canvas. p.233

Les Avions, 1954. (Airplanes). Oil on canvas. p.234

Le Long du Parc, 1955. (Along the Park). Oil on canvas. p.235

232

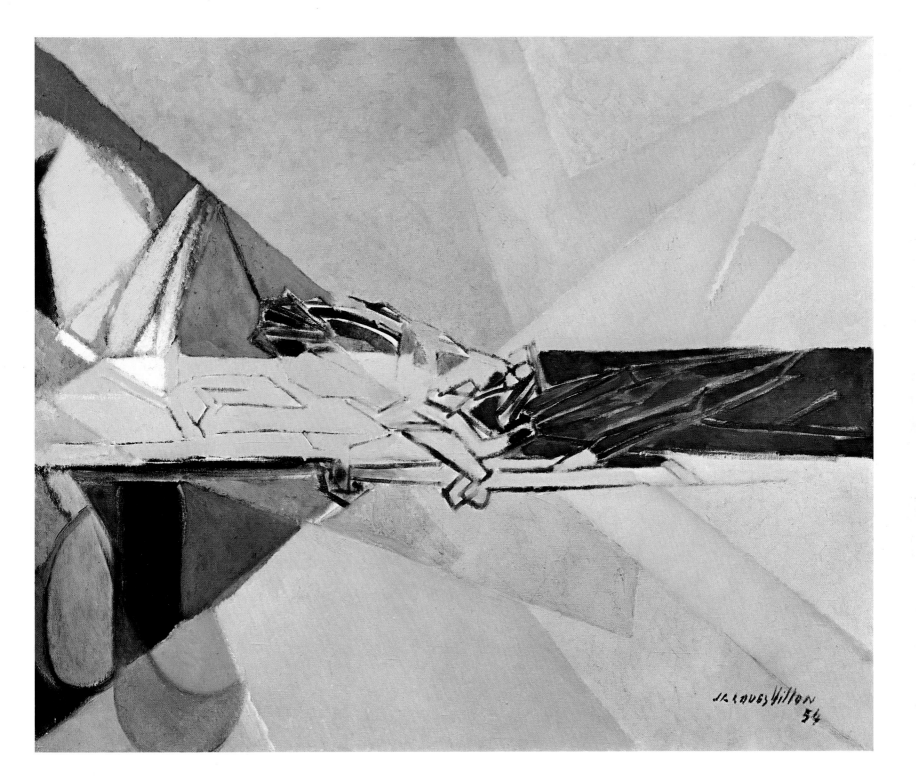

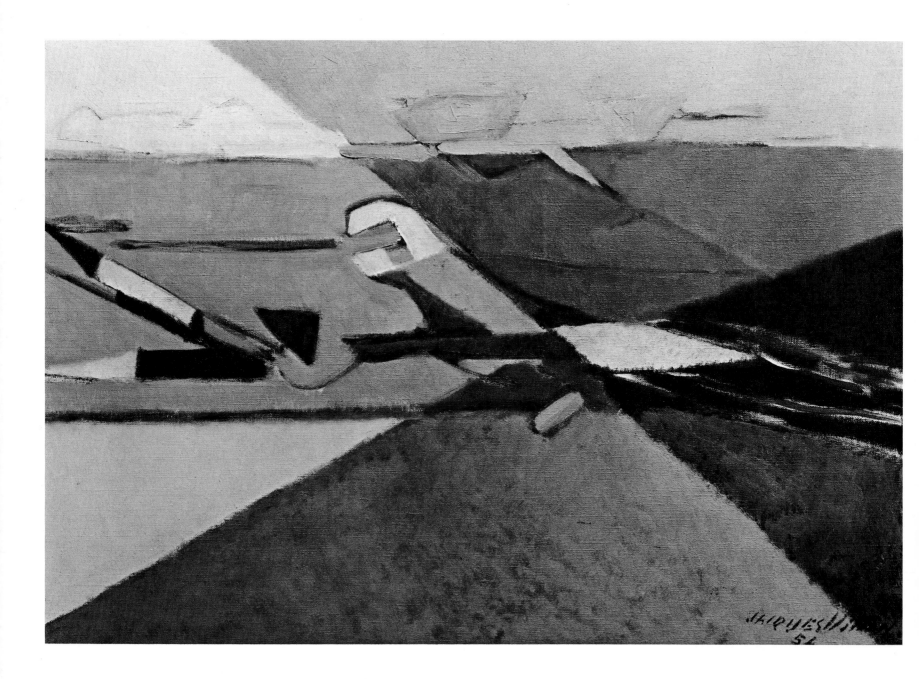

234

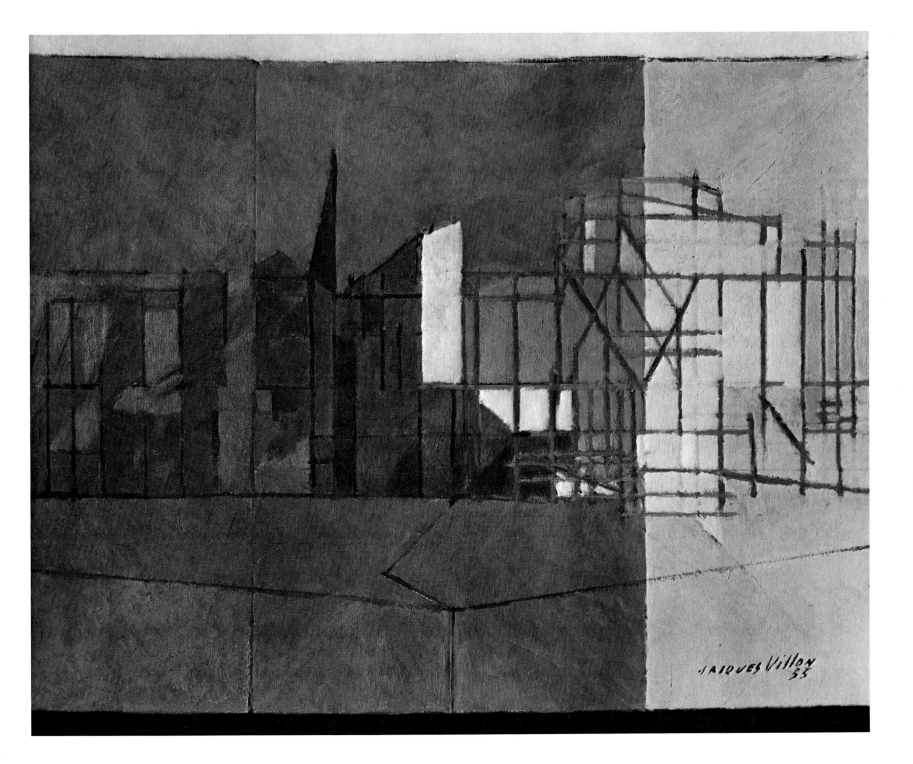

235

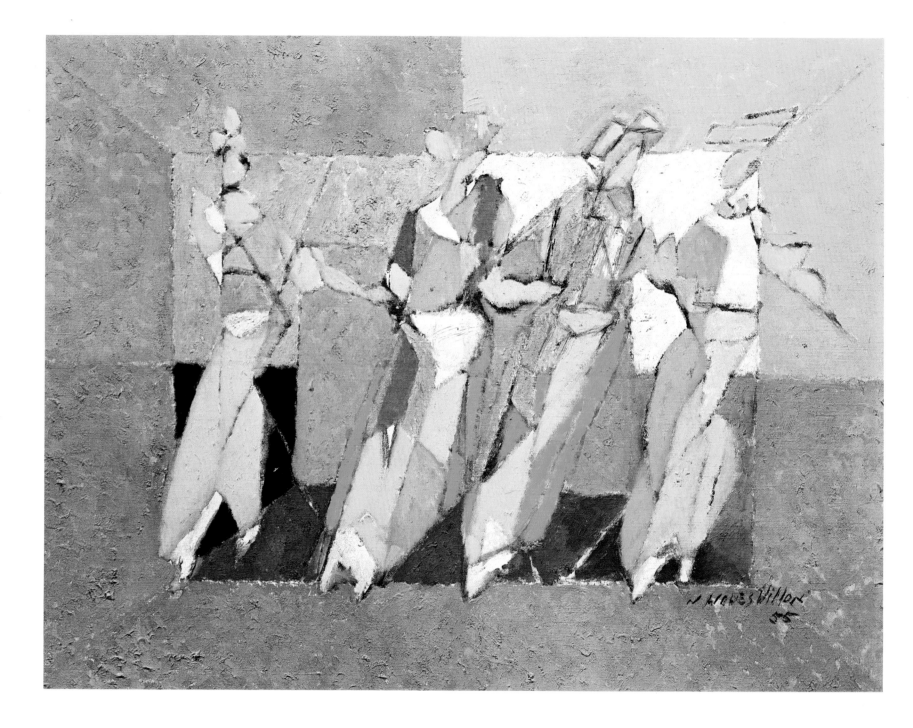

His cup ran over. He was Commander of the Legion of Honour, and a Commandeur des Arts et Lettres; a short while before his death he was created Grand Officier of the Légion d'Honneur. In 1961, he was elected an honorary member of the American Academy of Arts and Letters, and of the National Institute of Arts and Letters. In view of his style, he expected nothing from the Académie des Beaux-Arts, and those who hoped for something were doomed to disappointment. All the same, the old painter was on the jury of the nebulous Prix de Rome: he did not know how to refuse.

The exhibition organized by the Albi Museum in summer 1955 gave Villon a chance to rediscover the Tarn landscapes, which he had painted fifteen years earlier. He was reunited with his local friends, who teased him about his brand-new fame; among them Aymé Kunc, the composer, whom he had known in his young Rue Caulaincourt days. Villon felt awed at rubbing shoulders, figuratively, with Lautrec in the pink episcopal palace.

Villon exhibited thirty-eight canvases at the twenty-eighth Venice Biennale and was awarded the Grand Prix for painting. The "Mostra" had previously honoured such artists as Braque, Matisse, Dufy, Max Ernst, Henry Moore, Calder, and Arp, and some people were not too pleased at Villon's elevation to such heights. It was not the first time he had been attacked and considered unworthy of his position; on several occasions Louis Carré had been reproached for taking up such a minor artist, the "little master", whose charm was conceded, but who was not ranked among the great.

In October 1956, in reply to an enquiry by the weekly magazine *Arts*, Villon said that he was seeing less of the young artists. "They always hope they'll find some short-cut... I tell them that I don't know any more than they do. I've spent my life searching, and I'll go on, because I don't know what painting is exactly..."

"I advise the young to arrange their paintings around the golden section, for instance, or some other rule. In painting, it's not necessary to inflate oneself but to restrain oneself."

He once told Bazaine, with characteristic modesty: "I'm looking for the Philosopher's Stone"—that unique element or concentration of reality in which everything is expressed more and more simply and in greater depth.

Villon's detractors mainly criticized him for being a painter of happiness and not showing the drama of his time.

Matisse and Bonnard were similarly accused. Villon also had to bear criticism of his pyramidal theory, his use of squaring, his cyclical repetition of processes, including geometry, abstraction, and baroque realism. His golden section was considered out of date.

Villon took these accusations calmly. He painted *Icarus* in 1956, and its powerful use of Expressionist colour was enough to answer his detractors. He showed his energy by designing two big wall panels for the entrance hall of the Ecole Technique in Cachan: *L'Aigle Quitte Prométhée* (The Eagle Leaves Prometheus) and *Prométhée Délivré* (Prometheus Delivered). The splendid colours save these works from stereotyping and heaviness; Villon's mauves, pinks, greens, yellows and faded blues, in flat-tints or stippling, create a delicate harmony.

It was rather late for a painter to be asked at eighty-one to paint such large surfaces. Although the panels were not so large in themselves, they had to be incorporated into the architecture. He was more fortunate in the commission of five stained glass windows, each ten metres high, for a chapel in Metz Cathedral; he was able to make full use of light, his greatest ally.

He was commissioned to do five subjects: the Crucifixion, the wedding at Canaa, the Last Supper, the rock of Horeb, and the Paschal Lamb. With his usual conscientiousness, he started to undertake extensive research into the history of stained glass, read manuals, visited Chartres, Notre-Dame, the Sainte-Chapelle, and studied the windows of French Gothic cathedrals. He also went to Rheims a few times, not only to the cathedral, but to see the Simon workshop, where Charles and Brigitte Marq, who were carrying on the famous glazier's tradition, were to translate Villon's subtle, harmonious art into glass.

He made innumerable sketches of Bible scenes, then concentrated on distilling order from his outlines: he spread colour "in great sheets which flooded the outlines". "To my understanding of stained glass, I applied the line of the intuition of life through objects, winding through the areas of colour and expressed by outline, inscribing rather than describing the horrors of the Passion."

Villon added, "The right hand is line and accounts for the left hand: colour, light, and orchestration."[157]

The Metz stained glass windows were installed in 1957-1958, and some people were disappointed by their representational aspect, as they had expected the painter to be freer with plays of colour and light. He replied that definite themes had been commissioned, and if he were asked to do more stained glass windows, he would also use "large sheets of colour, but perhaps they'd be rather more deliberately influenced by strong values of light and shade. Line would 237

Jacques Villon *Harmony*, 1955. Oil on canvas.

be simplified too: a rhythmic line would run across the colours instead of a detailed line defining certain scenes."[158]

At eighty-two, Villon was able to criticize himself; what a lesson for young artists, and for less young, more confident ones!

He was not at all bitter about the delay his work as a painter had suffered through the circumstances of his life.

"Things come in their own good time, when they're meant to," he said, adding humorously, "I'm nearly a young painter; I've been able to concentrate on my own creative work for only twenty-five years."

Several of his pictures were inspired by a trip to Rouen and walks by the Seine; he also used some old drawings on the same theme, because he always depended on notes and studies. "I hardly ever work from memory," he told me one day, "I sketch to have something to do with my hands, and it comes in useful at some stage. You have to garner."

"There's a whole army of cranes near Rouen. I drew them last year," he told Yvon Taillandier in 1959.[159] "One tends to reduce an upright crane to just a line. That line tells you that the crane rises vertically. It's not an outline, it's a direction.

"To find this direction, you have to make a rapid choice between all the possible lines. It's important to be quick about it...

"The artist identifies himself with his subject by extremely fast waves. He draws from inside himself. He translates what Bergson called the line of intuition of life through objects.

"That line is expressed by drawing rather than colour."

The man analyzing himself was eighty-five years old. This was how he went about painting this picture:[160] "This landscape has several planes: there are buffers in the foreground, cranes in the middle ground, hills in the background. Each of these planes has a colour; the buffers are grey, the cranes greenish, the hills bluish. Now, each of these colours is affected by the colour of its corresponding plane in my structure. So the grey buffers in the foreground will be affected by the red which is the colour of the foreground in my structure. And that influence will not only affect the red square but the whole painting.

"I build it up bit by bit...," added Villon.

He also used other methods. Working from his sketches, he placed his chosen theme in a strict linear network. "I tend to give the drawing a sort of importance which brings it closer to the painting itself, which adapts it to the method of composition I've chosen, that is, the structure," he said. "That structure dominates the third phase, it corresponds to the permanent laws of nature, which we sense without seeing them."[161]

As if to reassure himself, Villon became more and more involved with geometrical constraints, which only bound him lightly, for his sparkle, the dynamic thrust of his shapes, and his subtle disorder of colour helped to mask his weaknesses. But his preciosity, and the excess of fractured, twig-like linear detail became increasingly irritating. Villon was repetitive, even self-parodying: after about 1960 his style ceased to evolve and seemed to suffer from his tired eyesight. The crystal structure of his paintings lost its cohesion and vigour; it might have been because the old painter's powers were also weakening in their turn.

Nevertheless, these last paintings were also "Villons". Those rather fluid faces floating on the geometrical framework that his brother-in-law, Jacques Bon, built to Villon's specifications, are enhanced by pinks and light transparent purples like an Indian summer. There is a sort of grace in them, sprung from the mysterious workings of instinct and love. Villon also took up a few old paintings, to which he could now add only a new heaviness.

Nobody can tell what he saw through the panes of trembling light. I often watched the octogenarian put the colours he took delicately on the tip of his brush on to a canvas, one by one, like droplets, and suspend them on a fine network of lines, bring them closer together, and blend them into each other, marvelling with his usual humility at still being able to enjoy painting.

In 1960, Villon broke his leg and had to stay in hospital for several months. After that, he moved with great difficulty and rarely left his studio, where he continued to paint. He worked from memory and seemed to be repeating mechanically gestures he had learned a long time ago, which was both disconcerting and touching.

Jacques Villon

Never More, 1956. Oil on canvas. p.239

Jeunesse et Feu, 1957. (Youth and Fire). Oil on canvas. p.240

Comme il vous plaira: Ascension, 1957. (As you Like It: Ascent). Oil on canvas. p.241

Le Lion fabuleux, 1957. Oil on canvas. p.242

Promethée l'emporte, le Vautour s'enfuit, 1957. (Prometheus Victorious). Oil on canvas. p.243

La Seine au Val de La Haye, 1959. Oil on canvas. p.244

Paresse, 1960. (Laziness). Oil on canvas. p.246

Les Grues près de Rouen, 1960. (Cranes near Rouen). Oil on canvas. p.247

Guitar, 1961. Oil on canvas. p.248

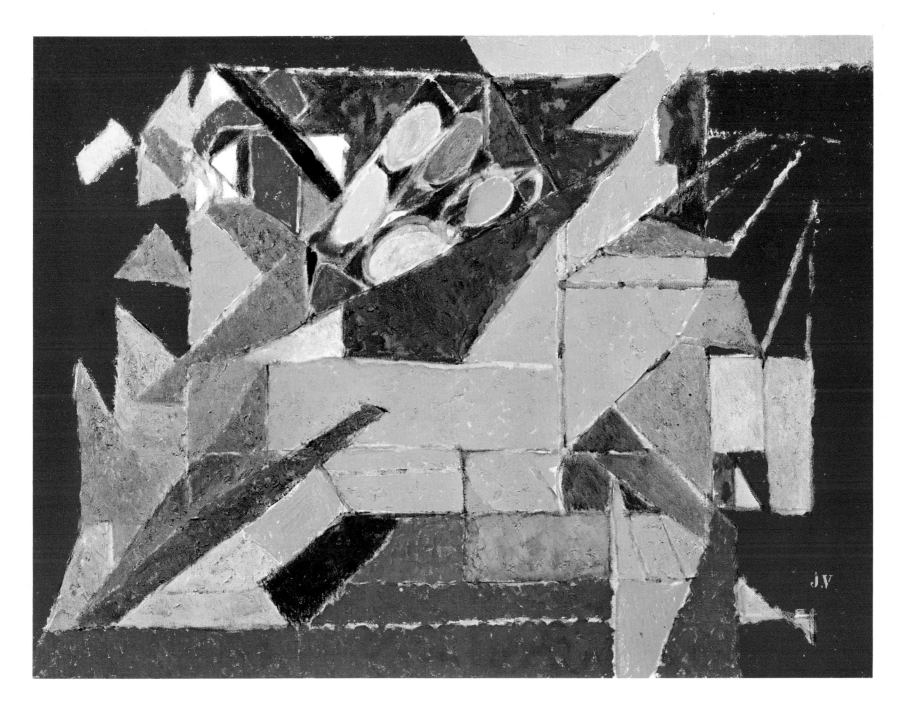

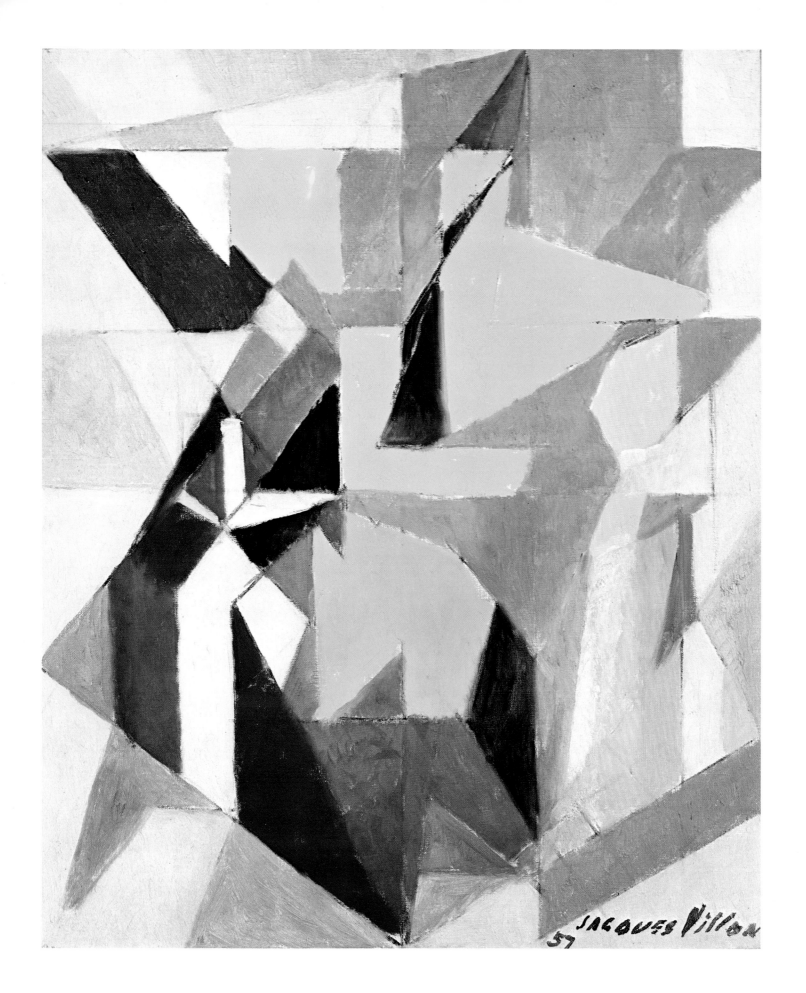

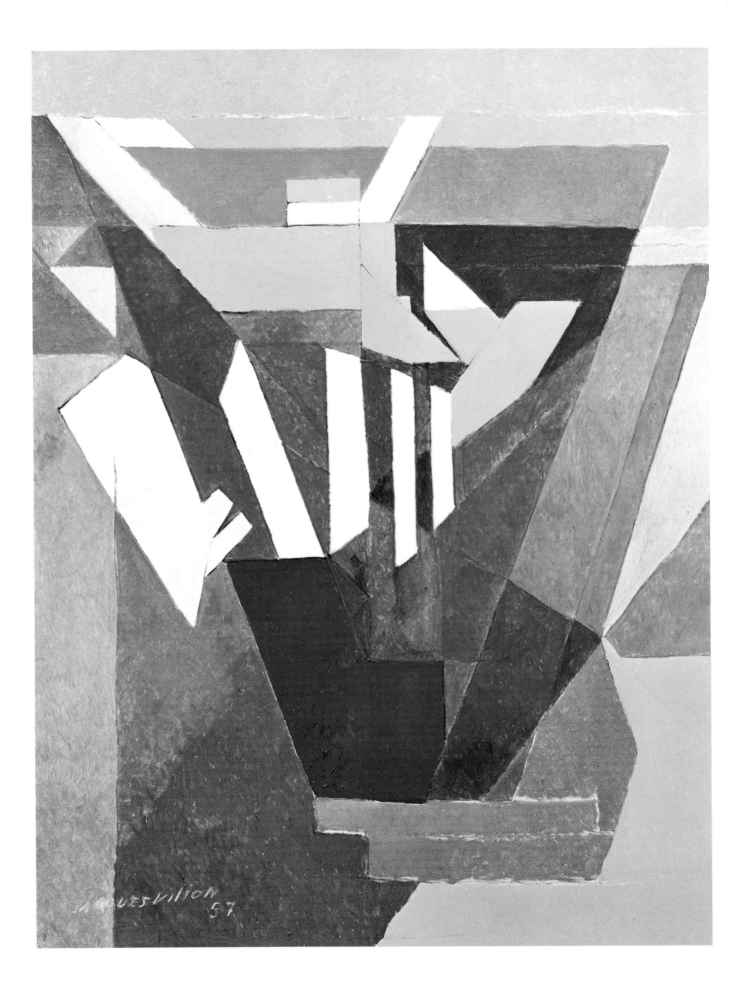

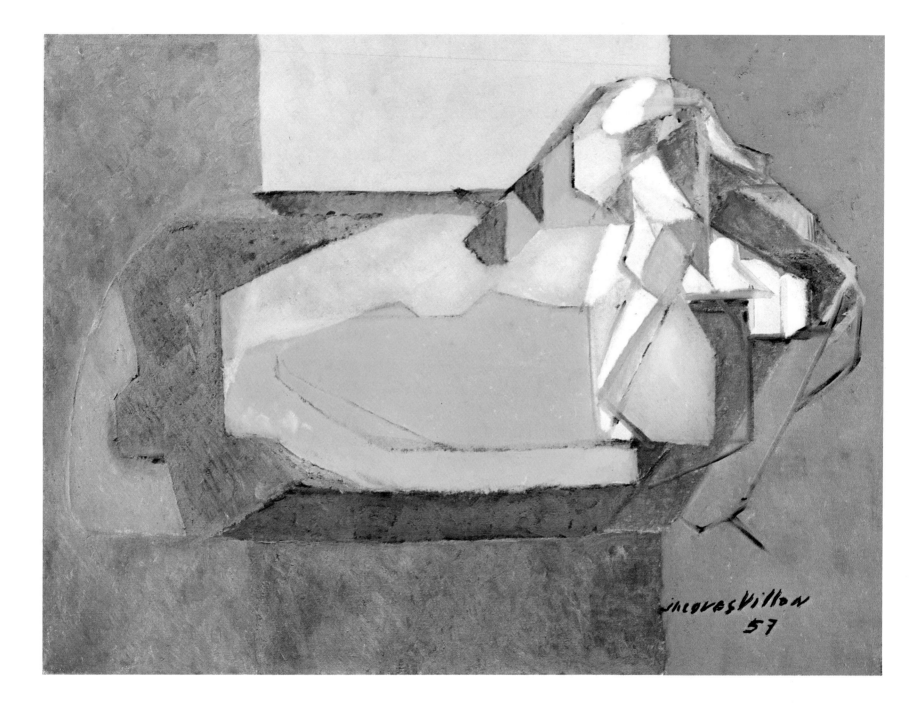

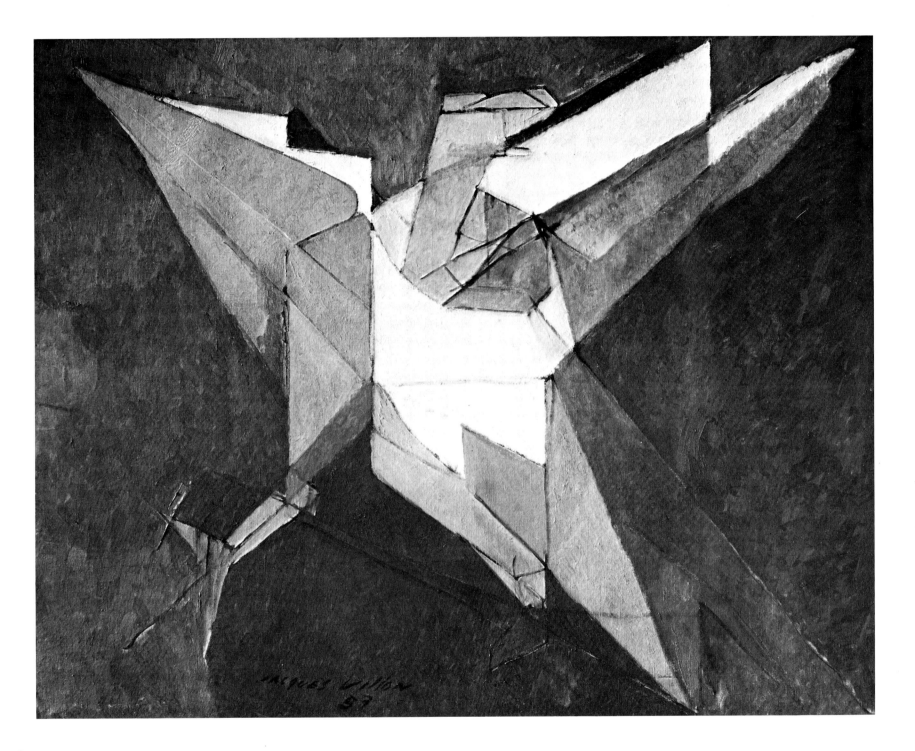

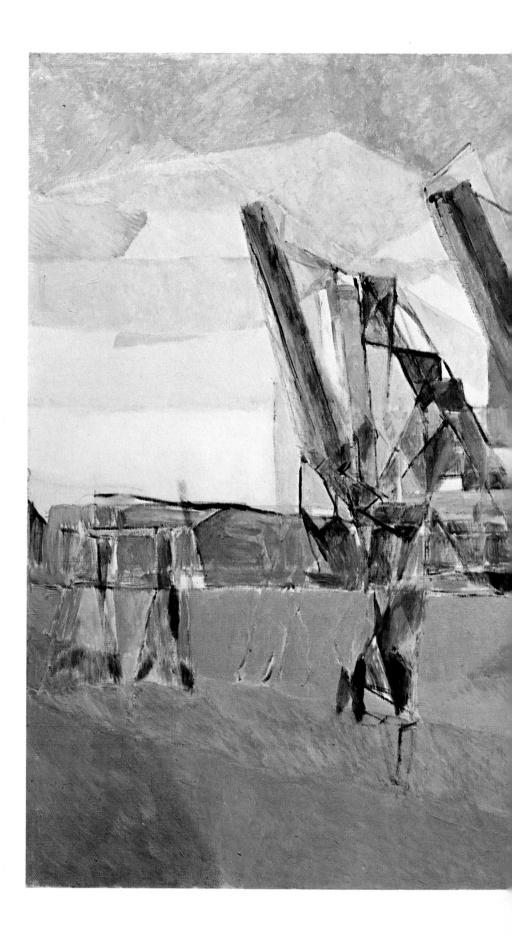

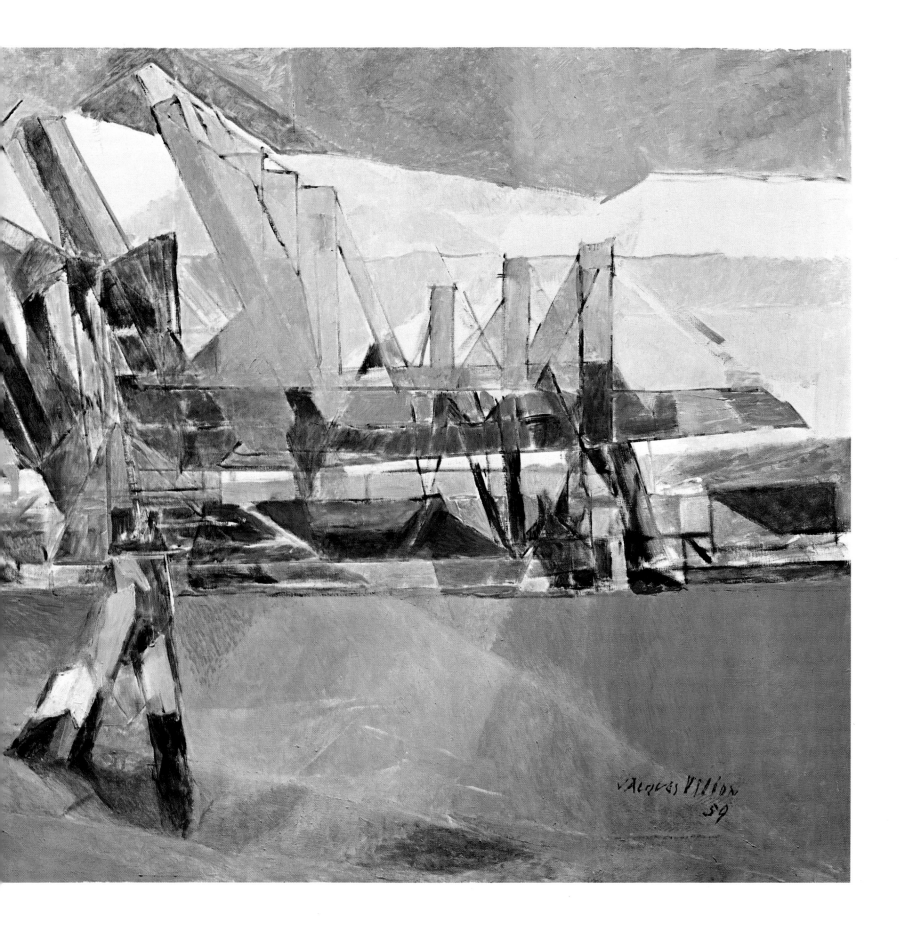

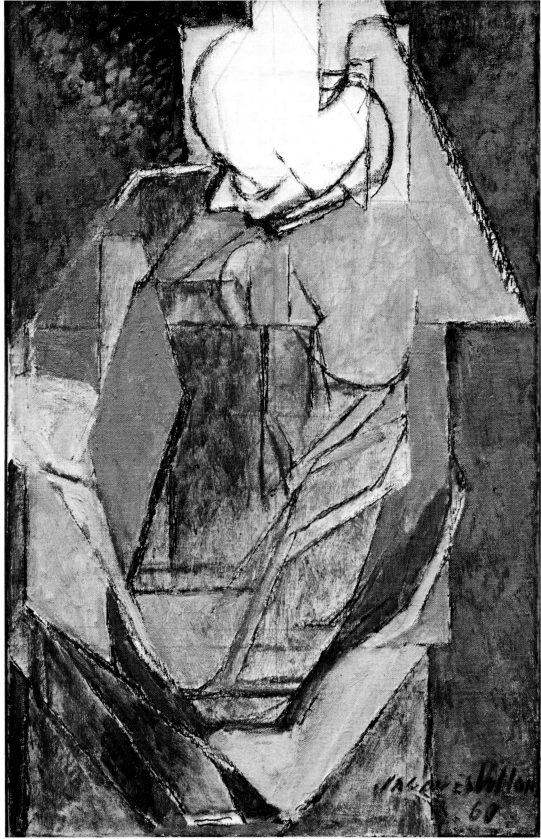

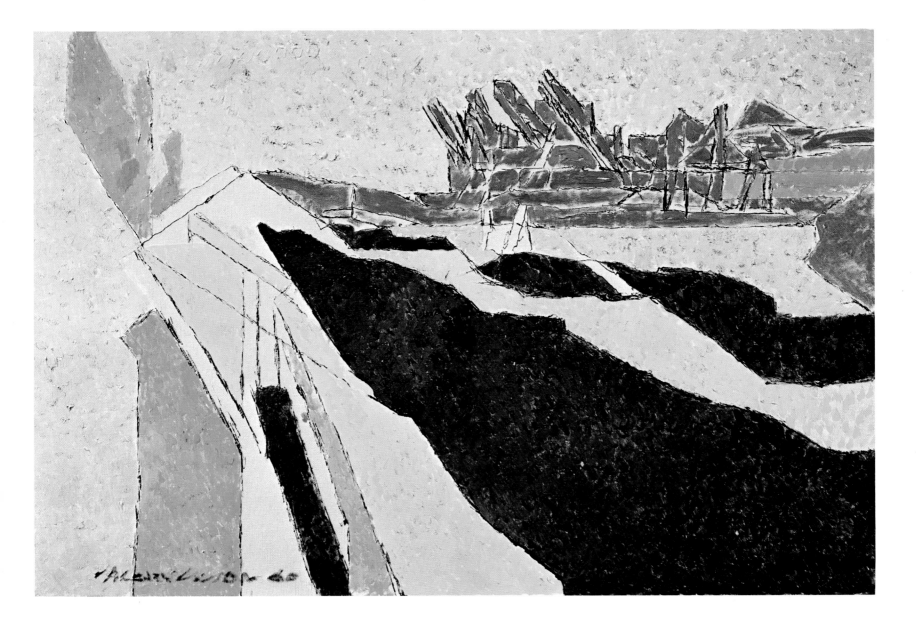

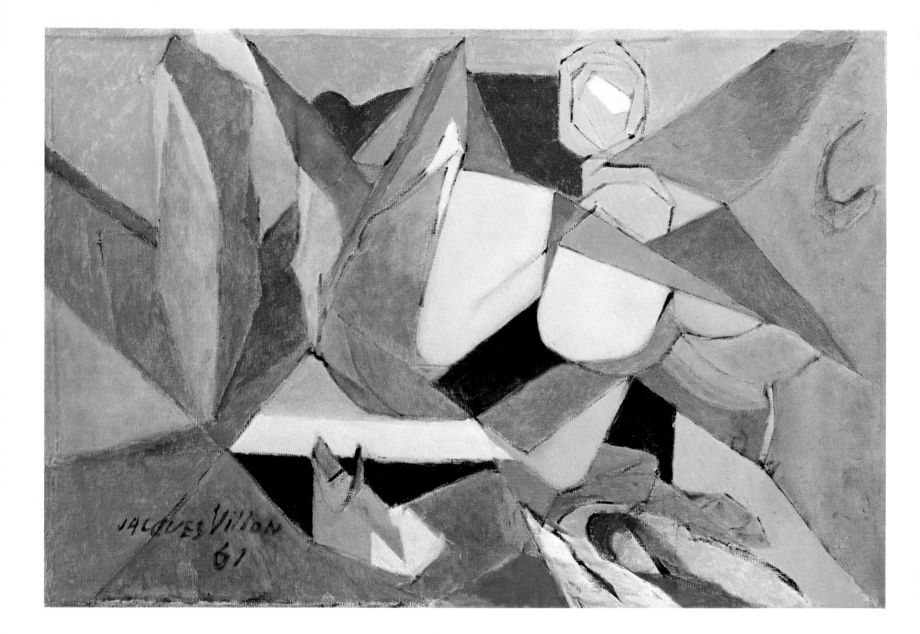

MARCEL DUCHAMP: PROTEST AND FAME

The three brothers have had joint exhibitions, but few historians or critics have studied them together, or found out their similarities and differences. Nicolas Calas was the first to do a serious analysis along these lines, entitled *The Brothers Duchamp All At Once*, in *Art News*, February 1957. The following April, Robert Rosenblum published an article called *The Duchamp Family* in *Arts*, on the occasion of the big Jacques Villon, Raymond Duchamp-Villon and Marcel Duchamp exhibition at the Solomon Guggenheim Museum, which was subsequently shown in Houston. The organizers offered it to the Musée d'Art Moderne in Paris, and were turned down. It was not until ten years later that the Rouen Museum, with its limited means, held a moving exhibition of the brothers' and Suzanne's work. Marcel was the only survivor of the four.

Arensberg had been collecting Marcel's work for forty years, and when he died in 1954 his whole collection went to the Philadelphia Museum. It was the first time that a living artist could see his almost complete works in a public gallery. Duchamp had never taken much trouble about publicizing his works and had only had one very limited personal exhibition, so this gave him a legitimate satisfaction. Arensberg had had some difficulty making this donation: he offered it first to the Art Institute of Chicago, who agreed to exhibit it for ten years, but did not guarantee anything after that. The New York Metropolitan Museum offered five years, then ten. Arensberg opted for the Philadelphia Museum of Art as it generously offered twenty-five years. This shilly-shallying shows that Marcel was not nearly so famous in America during the fifties as he was to become later.

In 1953 he helped in arranging and setting up Dada 1916-1923 at the Sidney Janis Gallery in New York, at which twelve of his works were exhibited, including several replicas from *Box in a Valise* and *Fountain*, in its natural size. Dada had been absorbed—but ill digested—by Surrealism, and now it was no longer seen as a Nihilist platform but, with time, was beginning to become an almost mythical point of reference for the new generation of anti-art protesters. The tidal wave of abstract art was slowly ebbing; around 1954, the English revival of popular art included not only painting but music, the cinema, philosophy. The term pop-art was coming into use to describe these new tendencies. In America around the same time, two young painters, Robert Rauschenberg and Jasper Johns, were trying to break with the aesthetic side of abstract Expressionism and turning to a figurative interpretation of commonplace forms and objects. In their wake, several other artists used symbols of modern life in their paintings and assemblages, including newspapers, television, comic strips, advertisements and household gadgets. In 1961, the movement inspired the Art of Assemblage exhibition at the Museum of Modern Art in New York, which set the seal of approval on "junk art" by citing Dada and Surrealism as its sources. The year before, Pierre Restany had created "new realism" at Yves Klein's house in Paris.

Marcel Duchamp had often said that a work of art matters only in relation to its existence in the world; the means used to distil this existence are the actual manifestations of the vital influx. New York pop artists, New Dadaists, and Paris new realists all relied on mass-produced products, which they incorporated in their creation and, by doing so, they stated their wish to give life to a whole area of the modern world—streets, factories, cities, and technology. The words art, work of art, and creation had new levels of meaning, blending with those that Duchamp had already iterated; and his Readymades were seen as the pioneers of this era of the object. "Like those long-distance runners who seem to have been outdistanced for ages and who suddenly forge ahead," wrote Robert Lebel.

For over forty years Duchamp had been the uncompromising yet nonchalant incarnation of the Dada spirit, and he was now becoming the philosophical leader of a whole generation. His anti-art activities, which had always been seen as purely negative, were suddenly transformed into the foundation of a new set of expressive media; and the Nihilist platform became the springboard for aesthetic novelty, in direct contact with the modern world. Marcel Duchamp, the isolated, detached iconoclast became part of a perfectly 249

organized and defined movement with its own masters, critics, dealers, and museums, which manifested itself noisily throughout America and Europe. The revolutionary without followers stumbled upon a heritage and innumerable offspring, who entered history through him and his past links with Cubism and Surrealism. Marcel Duchamp represented not only forty years of protest and humour but the whole twentieth century. Henceforth every single creator referred to him, and among the young painters even those furthest from his way of thinking joined the cult of the Readymade.

"I take that lightly and don't attach much importance to it or draw any conclusion," said Duchamp.

"Every new generation needs a model. I'm playing the part today. I'm delighted to do it. But it means nothing more than that. There's no glaring similarity between what I managed to do and what the Pop or Op are doing today... And, anyway, I did as little as possible. That's not how people think at the moment. On the contrary, right now people want to do as much as possible in order to make as much money as possible..."

On another occasion he told me, "You know, the object is very fine to begin with, but it's risky. It's becoming repetitive..."

The Duchamps moved to 28 West 10th Street in New York, where a succession of Marcel's followers flocked until his death, although he claimed he never had any visitors. In fact, there was not a single avant-garde American artist, or a European one staying in New York, who did not come to pay him homage; many went regularly to this meeting-place, and some of them played chess with Marcel, who was always very affable. In Paris, however, he rarely went out, saw a few friends and Teeny's children, visited no one, and claimed he led "the life of a waiter".[162] But a few minutes later he said, "I walk a lot because we always have some appointment." He also was annoyed that Breton, who was ten years younger than he, never made an effort to come and see him. "Not that I have anything special to say to him, but it would be a polite, friendly visit."[163] Duchamp could be disconcertingly conventional.

His more purist friends were disgusted when he gave permission to have copies made of some of his works. In May 1961, he allowed Ulf Linde and P. O. Ultvedt to make replicas of *Fresh Widow* and *Bicycle Wheel*, for an exhibition at a Stockholm bookshop. Richard Hamilton made another version in London, in 1963. There is also a copy of *Rotary Glass Plates* by Magnus Wibon, P. O. Ultvedt and K.C. Hulten, and *Door, 11 Rue Larrey* was redone by Hulten and Daniel Spoerri. Duchamp also approved two copies of the *Large Glass*, done with absolute fidelity. Ulf Linde did the first for the Art and Movement exhibition at the Moderna Museet in Stockholm in 1961, and Marcel collaborated, coming along to sign the work. The second, by Richard Hamilton, was done for the Duchamp retrospective at the Tate Gallery in 1966.

Duchamp was unruffled by protests and criticism and the sadness some people felt about his action. He told Robert Lebel, "As I've always been annoyed by the uniqueness people attribute to paintings, I saw a solution, suggested by others, a way out of this rut, and a way to give back to the Readymades the freedom of repetition they'd lost."[164]

A note in the *Green Box* showed his plan to "limit the number of Readymades per year", while another contradicted it by stressing the "exemplary side of the Readymade". The word "exemplary" was obviously chosen for its ambiguity. After all, Duchamp had, in the space of a few months, approved two different interpretations of the word, one by George Heard Hamilton in an American edition of Lebel's book,[165] the second in the Anglo-American version of the *Green Box*: "by way of an example" and "object of a common type forming a category".

Marcel Duchamp gave only dilatory answers to these questions, and finally admitted that he preferred "the specimen of something made", although both interpretations could hold true at different times, or simultaneously. In fact, he loved the ambiguity of it all, and derived great pleasure from his admirers' disappointment; he enjoyed both being contested and adulated.

Although Duchamp's fame started in America, the first study of him, by Robert Lebel,[166] was published in France, in 1959. In private Duchamp said that he had "hardly read" it, which was doubtless untrue as he helped with the page-setting and did two Readymades for the de luxe edition: a collage self-portrait silhouetted in profile, and an enamelled plate with *Eau & Gaz à Tous les Etages* (Water & Gas on Every Floor) in white letters on a blue background. This plate was very important: it was the basis of his use of *illuminating gas*, whose ultimate interpretation was in the posthumous *Given* (Etant donnés).

Duchamp had caught up with Villon on the road to fame; there was a succession of exhibitions, receptions, homages, various honours (non-academic, of course, like his entry to the "Pataphysical College") magazine and newspaper articles, commentaries and analyses, books, interviews, and catalogues. Duchamp the star loved the avant-garde cult he personified in America, but kept his clearsightedness and his irony, letting them escape in small doses during taped, radio, and televised interviews. All the same, when he was shown a copy, he carefully corrected it, deleted, and annotated it. This might have been due to age. In 1962, re-reading a taped interview with Jouffroy, the critic, in New York, he said he

Marcel Duchamp *Rrose Sélavy*, mannequin exhibited in the "Rue Sur-réaliste" at the Exposition Internationale du Surréalisme, Paris 1938.

was "in a state about it" and changed certain parts. Four years later, he was delighted with the long dialogues we had had in Paris and, when giving the go-ahead, wrote to me, "even I found them fun to read".

His few suppressions were mainly due to prudence and his wish not to shock certain people or lampoon certain institutions. Was that really a new departure for him? He, the pioneer of anti-art, went to his friends' exhibitions, because what he hated was the meanness and the vulgarity of certain kinds of imitative paintings, and money-grabbing. He saw exhibitions as "histrionic displays", yet he went to the big retrospectives at the Pasadena Art Museum in 1963, and at the Tate Gallery in 1966; he was even present, though fidgety, at the deplorable exhibition at the Musée National d'Art Moderne in Paris, where the organizers—misled by the presence of Raymond Duchamp-Villon's work beside his—stupidly lumped all Marcel's work together as Cubist.

In Rouen, a few weeks earlier, Duchamp had opened the exhibition comprising his works and those of his brothers and sister. It was a family occasion and Duchamp, flanked by the mayor and the Prefect, was in a charming mood; a local paper described him as the "survivor of a century of struggle", and he probably was pleased at this belated official recognition in France.

"Not really. I only play the part of a public man because I have to; it's the only job I do intermittently," he told Robert Lebel.

Nobody knows which was the real Duchamp. Every commentator saw and interpreted him differently. There were plenty of studies of him. He voluptuously accepted all the adulation. After refusing everything, he now accepted anything, though he sometimes flinched, as he did at the writings of his Milan dealer, Arturo Schwarz. "It's not about me, it's BY Schwarz," he said.

In spite of his sudden fame and his wide international following, Duchamp was not inspired to take up his artistic activity again. He had no reason to do so; Schwarz's "multiples" brought in plenty of money, and Schwarz himself bought anything Duchamp had to sell. His lectures and anything he wrote, however brief, fetched a good price.

He drew on both sides of a book jacket a front and back view of a dinner jacket, evoking the formal aspect of *Nine Malic Molds*[167]; a *Waistcoat* for Benjamin Péret, each of the five buttons containing a letter of his surname[168]; an imitated rectified Readymade, *Couple of Laundress' Aprons*[169]; a sculpture-drawing showing the artist's profile and called *With my Tongue in my Cheek*[170]; and *Torture-Morte*[171], the sole of a foot cast in plaster and crawling with flies. In 1958-1959, these were the "things" with which 251

Duchamp was occupied, along with a few other drawings and random objects.

On 9 June 1963, Jacques Villon died at Puteaux at the age of eighty-eight. Marcel and Teeny, in deep mourning, came to the state funeral decided by the government, probably more because the dead man was a Grand Officier of the Légion d'Honneur than because of his fame as a painter. Many people felt that such pomp was out of place for such a simple, reserved man.

It may have been due to his ill-contained indignation at all the fuss, and to all those pious orations that referred to Villon as a genius, that Marcel, talking about his brother on the radio, said some very hard things, which the late painter's friends could not easily forgive.

Suzanne Crotti died on 11 September, three months after her older brother.

In the years that followed, several major exhibitions set the seal on Marcel's fame. Jean-Marie Drot made a film, *Jeu d'Echec avec Marcel Duchamp*, for French television. In January-February 1965, the Cordier & Ekstrom Gallery in New York presented *Not Seen and/or Less Seen of/by Marcel Duchamp/Rrose Sélavy 1904-1964*. In Paris, on 15 May, the artist was present at a dinner given by the Association pour l'Etude du Mouvement Dada in honour of Rrose Sélavy.

To everyone's surprise, Marcel did nine engravings for the second volume of Arturo Schwarz's *The Large Glass and Related Works* during the summer at Cadaqués. These line engravings after Cranach's *Adam and Eve*, and the ballet *Relâche*, Rodin's *The Kiss*, Courbet and Ingres also included a Bride really stripped bare, kneeling on a prie-Dieu, and two equally naked personages lying next to each other head to toe. One of them, apparently a hermaphrodite, is holding a gas lamp. Later the public learned the significance of this engraving, which exists in two successive stages.

The Tate Gallery held the first of Duchamp's European retrospectives in June-July 1966: Marcel was present. "Everything brought back some memory; I wasn't at all embarrassed by things I didn't like, or that I was ashamed of, or would have liked to suppress," he said. "It's simply a gentle stripping bare, without shocks or regrets. It's rather nice." He gave several interviews to the BBC, and saw works about him proliferating on both sides of the Atlantic; he was pleased but relaxed about it. He knew that it would be a long time, if ever, before anyone captured his real personality, and that even the most perceptive interpretations would give his "things" a deliberately contrary set of meanings. However, he had helped to enable individuals to breathe more freely, at least those who saw the present as an appendage of the future and did not let prejudice or convention hinder them. Duchamp's "breathing" side is his most lasting legacy to us all: he devoted himself to breathing as some people devote themselves to seeing or hearing.

He was not attacked until his seventy-eighth year. In October 1965, three young painters exhibited a series of eight paintings at the Galerie Creuze in Paris, in the framework of La Figuration Narrative dans l'Art Contemporain. These paintings were entitled *Vivre et Laisser Mourir, ou la Fin Tragique de Marcel Duchamp* (Live and let die, or Marcel Duchamp's Tragic End). The artists, Gilles Aillaud, Recalcati and Arroyo had depicted themselves absolutely stylelessly in the process of carrying out a sort of ritual murder of Duchamp, who is then thrown naked down the stairs before being buried in a coffin draped with an American flag, carried by Rauschenberg, Oldenburg, Martial Raysse, Warhol, Pierre Restany, and Arman, all wearing naval uniform.

The text accompanying this series of paintings viciously attacked Duchamp's conduct: "Marcel Duchamp's sudden break with oil painting is not, in fact, accompanied by any reversal of perspective... If one wants to stop being individual, it's better to work without signing, than to sign without working. How can anyone fail to understand that 'the personality by choice preferred to the personality by profession' is just one more step towards the glorification of omnipotence and the idealization of the act of creation?... This Readymade has nothing to convey, no way to make in the tropical areas of life. He has been asepticized since birth and is destined to received the august and pallid light of the sanctuary where 'the annexation of the world by the individual' (Malraux) shall be celebrated. This sanctuary is the morgue, where the gods, well metamorphosized, are already sleeping scentlessly, where the urinal, well signed, won't smell any more..."

This attack on the most genuine representative of freedom and imagination scandalized nearly everyone. But in fact the corrosiveness of Duchamp's choices had lost a great deal of its power as time went on, and once Readymades were exhibited in museums and integrated into twentieth century art the whole perspective was altered.

Every work that breaks completely with whatever preceded it is finally caught up in the cycle again, because, willy-nilly, it springs from a culture. Being anti-art is just another way of being pro-art.

Aillaud, Recalcati and Arroyo claimed they had no intention of committing the "assassination of the father". "We try to betray our class in the same measure that Duchamp represents it obliquely," said Aillaud. "It isn't the father we want to kill, it's the order he stands for..."

The owner of the Galerie Creuze was worried about the reactions this attack might elicit and invited Duchamp to

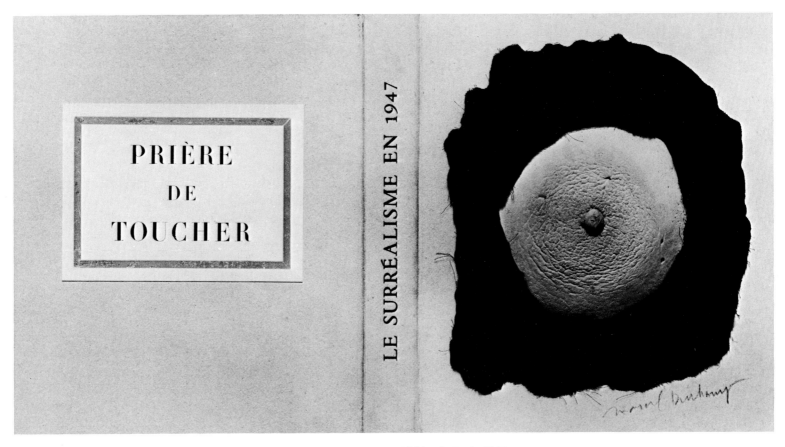

Marcel Duchamp Cover for the catalogue of the "Le Surréalisme en 1947" exhibition in Paris, 1947.

come and see it the day before the opening. He accepted and simply said, "The only thing to do is to ignore it: these people want to get noticed, that's all." And he advised his friends not to protest.

Duchamp's protest against the concept of art lay mainly in a re-evaluation of concepts existing at the time when he was creating something, while his followers protested more generally rather than against specific circumstances. When he produced his first Readymade, his protest was inseparable from its historical context, and it is in the light of history that his action has taken on the value of a precedent, outside any stylistic reference. To use this action for "making art" was to misrepresent it and invalidate it.

Nevertheless, Duchamp was used as a pretext for revolutions that were patently at opposite poles from his spirit and actions. The Readymades announced the death of art, but art did not die; the subsequent succession of avant-garde artists vied to surpass Marcel's absolute gesture, but they drew on other, less pure and less admissible sources, because they compromised with retinal painting, which Duchamp

detested, and with the humanist tradition, which he had finally absorbed. In 1966, he said of the young painters: "Nothing comes out that isn't old, dated... I'm sure that when people like Seurat wanted to do something, they suppressed the past completely. Even the Fauves and Cubists did that. It seems that today there are more links with the past than at any time this century. There's no daring or originality..."[172]

On 5 February 1968, in Toronto, Marcel and Teeny Duchamp went to see *Reunion*, a musical performance organized by John Cage, during which all three played chess on a chessboard electronically wired for sound. About a month later, the Merce Cunningham ballet presented *Walkaround Time* at the University College of Buffalo Arts Festival. Jasper Johns was in charge of the decor for the ballet, which was based on the *Large Glass*. At the end of the show, Duchamp, dressed in black, went onstage to take a curtain call between Merce Cunningham and Carolyn Brown.

The following summer he went to Cadaqués, as usual, where he designed, in red and blue pencil, an anaglyphic 253

fireplace for his summer apartment; perhaps that was why he ordered bricks. Back at Neuilly, he went on working on his projected fireplace, and was absorbed in trying to find stereoscopic glasses so he could finish his design. On 1 October he had dinner with Teeny, Juliette and Man Ray, and Robert Lebel; he was happy and relaxed. When his friends had left, he suddenly collapsed: his heart had stopped beating. It was five minutes past one in the morning on Tuesday, 2 October 1968.

Two days later, Marcel Duchamp was buried quietly in the family tomb at the Cimetière Monumental at Rouen. At his request, his tombstone was engraved, "D'ailleurs, c'est toujours les autres qui meurent" (Anyway, it's always other people who die).

Everyone thought that all Duchamp's works were known, and, besides, he had boasted for years of having no artistic activity; so that it was a complete surprise when it was discovered, a few months after his death, that he had been working in absolute secrecy from 1946 to 1966 on a work entitled *Given: 1.The Waterfall, 2.The Illuminating Gas*. Only two people knew about it, Teeny, and William N. Copley, Marcel's friend and executor, though probably neither had seen the finished work. Duchamp worked on it in a secluded studio in an office building at 80 East 11th Street, to which he went every day, as if to a clandestine assignment.

Once *Given* was finished he sold it to Copley and asked him to give it to the Philadelphia Museum after his death. A special room was arranged to house it, near Arensberg's collection. The installation took place according to Duchamp's instructions in February 1969, and it was opened to the public on 7 July.

Initially his friends and admirers saw this astounding, complex work, which was to inspire as many interpretations as the *Large Glass*, as a snub. The man they thought they knew had spent twenty years creating—behind their backs— a kind of illusionist show unlike anything he had done before, which challenged all the premises of his known works. There were two tiny holes at eye-level in an old, worm-eaten wooden door framed by bricks, through which one could see a half-concealed naked woman on a bed of branches, her legs amputated, her genitals atrophied, her head reduced to a temple covered with fair hair, in her hand an incandescent gas lamp. The banal landscape contributed to the uneasiness created by this flesh-coloured torso: a pond, a forest, small clouds crossing the sky, and a tiny waterfall activated by a luminous wheel; the whole is reminiscent of the 1914 Readymade print *Pharmacy*.

The bricks for the door frame came from Cadaqués (Marcel had not ordered them for his fireplace), the branches had been picked up during walks through Greenwich Village,

and the flesh colour of the reclining nude was due to a pigskin cover. As spectators had to look through both holes, they could not modify the angle of vision or step back from the scene.

Or course, the Bride is present in the androgynous body, which cannot been seen without uneasiness; the spectator is transformed into a voyeur, seeing the eroticism of a piece of flesh giving the illusion of "real" flesh, in the setting of some conventional postcard photograph.

Female Fig Leaf (1950), *Objet-Dard* (1951) and *Wedge of Chastity* (1954) sprang from the time when *Given* was being elaborated. Woman is treated purely as a fetish object: her head is cut off, her breasts are truncated, and her genitals are atrophied and hairless in the spreading of her amputated thighs. There is a homosexual undercurrent. As in the 1948-1949 sculpture, the woman has very marked masculine characteristics. In the etching *The Bec Auer* made for Schwarz in 1968, there is also some doubt as to the sex of the person holding the lamp at arm's length. With *Given* we go from sensitive to ethereal art.

Duchamp, who had said that he would not produce the smallest object, "even if they offered me 100,000 dollars", had worked for many years on an *œuvre* accompanied, like the *Glass*, by numerous drawings, studies, and manuscript notes. He was not "defrocked", as he claimed. He disdained neither creation nor reflection, and did not, as Breton wrote, find evasion in chess. Suddenly the Duchamp myth collapsed.

The anti-art revolutionary was really an "artist", who had patiently created his last work, finished and polished it with his own hands, signed it, and sold it, just like any of his colleagues. But Duchamp, by acting like that, remained loyal to the constant ambiguity of his personality. Each of his acts and works was contradicted by another.

Although there are many connections between the *Large Glass* and Marcel's last work—written notes, several features, and spiritual and physical similarities—the two works are diametrically opposed to each other. From any point of view, the Bride was naked, open to all comers, her freedom emphasized by the transparency of the glass, but *Given* is an enclosed work; the viewer can only enjoy it by himself, glued to two tiny peepholes in an irksome wooden door. After that he has to trust his memory as no one is allowed to photograph the interior; only photos of the door have been published. This has nothing to do with Duchamp but is due to the museum administration: either they do not wish to popularize the work or else it is a form of censorship, given

Marcel Duchamp with his first Readymade, *Bicycle Wheel*, at his home 5, Rue Parmentier, Neuilly, 1967.

254

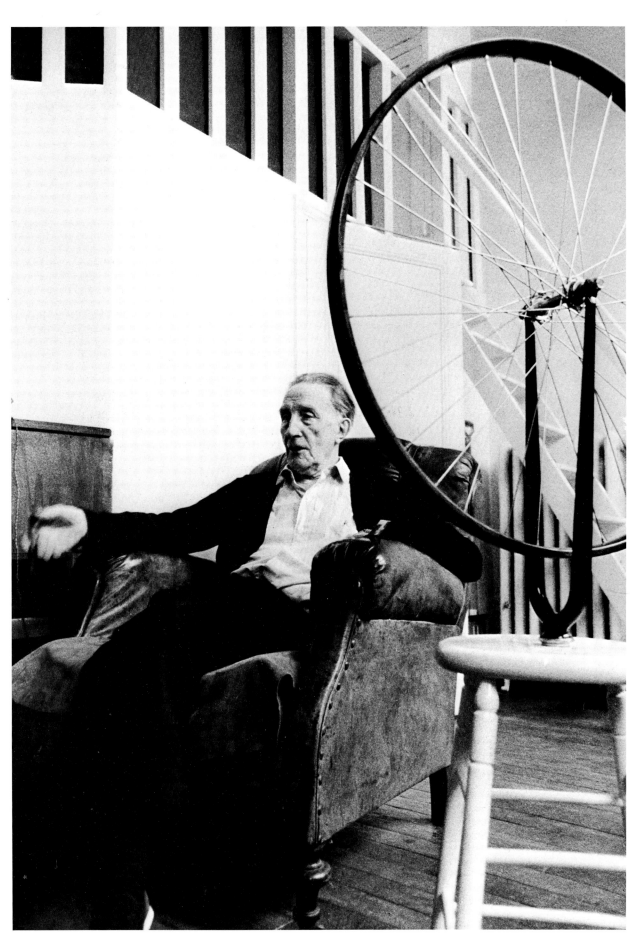

the erotic character of the reclining naked woman. [173] Of course, it is possible that the trustees of the Philadelphia Museum wanted to respond to Duchamp's oft reiterated dislike of retinal art and warn any "oculist witnesses" in advance to keep quiet.

As was to be expected, Duchamp's commentators threw themselves on to *Given* with their usual imaginative fervour. Duchamp would have been delighted, and he would doubtless have relished the dissimilar accounts of his naked woman and landscape, which everyone sees differently.

Octavio Paz wrote about Marcel Duchamp: "Although he has never set out to teach us anything, his attitude teaches us that the finality of an artistic activity does not lie in the finished work, but in freedom. The work is the path, and nothing else. This freedom is ambiguous, or rather conditional: we could lose it at any moment, particularly if we take our work and ourselves too seriously." [174]

Perhaps we shall understand *Given* better when the notes on it are published. These notes are crucial: they show Duchamp's painstaking elaboration of the work and of the way it was to be positioned; they also give instructions on how to dismantle it in the New York studio and put it together again in Philadelphia. *Given* is built on a linoleum surface with large black-and-white squares, reminiscent of a chessboard; the work hides this support, and only those present at its dismantling or reconstruction know it is there.

Many of Duchamp's friends and commentators were taken aback by this posthumous practical joke, the brutal full-stop to a myth to which everybody had already written the conclusion. They did not know Marcel very well. He taught us that no free being allows himself to be trapped in formulas and rules, even after his death.

Given has raised many questions, and will raise many more. After all, with humour and irony, Duchamp wanted to show his commentators and posterity that there is no truth, or that it is always bitter and incomprehensible. Marcel could not have died without leaving a mystery to the world and without breaking the links he had forged so carefully, because *Given* reveals a new Duchamp, and new paths opening to unknown destinations. His works, up to his very last, are signals pointing to our future.

In 1973, the Museum of Modern Art in New York and the Philadelphia Museum of Art organized the most complete Marcel Duchamp retrospective. There were a hundred and ninety works, and an exhaustive catalogue was published for the occasion, with remarkable commentaries on the man, his work, his ideas, and his influence in the world. This exhibition was refused by the Musée National d'Art Moderne in Paris on the grounds that there would be a homage to Duchamp to inaugurate the Pompidou Art Centre in 1978 or 1980. But it is doubtful whether it will be possible to assemble such a complete collection of his works again.

It is difficult to tell whether Duchamp is a dead man become important or someone alive who has remained crucial. When anyone talked to him about posterity, he said, "When I'm dead, I won't know it."

NOTES

1 Francis Jourdain, "Né en 1876", Paris 1951.
2 Dr Robert Jullien collection, Paris.
3 Dr Robert Jullien collection, Paris.
4 Dr Robert Jullien collection, Paris.
5 Former Jacques Bon collection, Puteaux.
6 Former Mme Duvernoy collection, Paris.
7 Dr Robert Jullien collection, Paris.
8 Former Mme Duvernoy collection, Paris.
9 Musée National d'Art Moderne, Paris.
10 Schwarz collection, Milan.
11 Arensberg collection, Philadelphia Museum of Art.
12 Frank Brookes Hubachek collection, Chicago.
13 Pierre Cabanne: *Entretiens avec Marcel Duchamp.* Paris 1967.
14 Ibid.
15 Ibid.
16 Dora Vallier: *Jacques Villon. Peintures de 1897 à 1956.* Paris 1958.
17 Pierre Cabanne: *Entretiens avec Marcel Duchamp.* Paris 1967 (*Dialogues with Marcel Duchamp.* New York 1971).
18 After Raymond Duchamp-Villon's death, Mme Lignères.
19 Pierre Cabanne: *Entretiens avec Marcel Duchamp.* Paris 1967.
20 Jacqueline Auberty and Charles Pérussaux: *Jacques Villon. Catalogue de son Œuvre gravé.* Paris 1950.
21 Arensberg collection, Philadelphia Museum of Art.
22 Do.
23 Mme Marcel Duchamp collection, Villiers-sous-Grez.
24 Arensberg collection, Philadelphia Museum of Art.
25 Do.
26 Do.
27 Do.
28 Do.
29 Do.
30 Do.
31 Dr S.H. Jurmand collection, Paris.
32 Schwarz collection, Milan.
33 Arturo Schwarz: *Duchamp.* Milan-Paris 1968.
34 Pierre Cabanne: *Entretiens avec Marcel Duchamp.* Paris 1967.
35 Conversation between the author and Jacques Villon, 1958.
36 Gabrielle Buffet-Picabia: *Aires abstraites.* Geneva 1958.
37 Quoted by Pierre Cabanne: *L'Epopée du cubisme.* Paris 1963.
38 Quoted by Bernard Dorival: *Les Etapes de la peinture française contemporaine.* Paris 1944.

39 Musée National d'Art Moderne, Paris.
40 Dora Vallier: *Jacques Villon. Peintures de 1897 à 1956.* Paris 1958.
41 Pierre Cabanne: *Entretiens avec Marcel Duchamp.* Paris 1967.
42 Ibid.
43 Ibid.
44 Arensberg collection, Philadelphia Museum of Art.
45 The Solomon Guggenheim Museum, New York.
46 Arensberg collection, Philadelphia Museum of Art.
47 Pierre Cabanne: *Entretiens avec Marcel Duchamp.* Paris 1967.
48 Ibid.
49 Ibid.
50 Ibid.
51 Peggy Guggenheim Foundation, Venice.
52 Arensberg collection, Philadelphia Museum of Art.
53 Marcel Jean: *Histoire de la peinture surréaliste.* Paris 1959.
54 Pierre Cabanne: *Entretiens avec Marcel Duchamp.* Paris 1967.
55 Ibid.
56 Mrs Robin Jones collection, Rio de Janeiro.
57 Pierre Cabanne: *Entretiens avec Marcel Duchamp.* Paris 1967.
58 Ibid.
59 Ibid.
60 Dora Vallier: *Jacques Villon. Peintures de 1897 à 1956.* Paris 1958.
61 Ibid.
62 Walter Pach: *Raymond Duchamp-Villon.* Paris 1924.
63 R. Duchamp-Villon: *L'Architecture et le fer* in *Poème et Drame,* January-March 1914.
64 *L'Intransigeant,* 7 February 1912.
65 Interview by J.J. Sweeney at the Philadelphia Museum of Art for a film produced by the National Broadcasting Company in 1955.
66 Robert Lebel: *Marcel Duchamp, maintenant, et ici,* in *L'Œil* No. 149, May 1967.
67 Dr René R. Held: *L'Œil du psychanalyste.* Paris 1973.
68 Museum of Modern Art, New York.
69 Cordier & Ekstrom Gallery, New York.
70 Pierre Cabanne: *Entretiens avec Marcel Duchamp.* Paris 1967.
71 Jacqueline Monnier collection, Paris.
72 Robert Lebel: *Marcel Duchamp.* Paris, New York and London 1959.
73 Pierre Cabanne: *Entretiens avec Marcel Duchamp.*
74 Dr René R. Held: *L'Œil du psychanalyste.* Paris 1973.

75 Jean Clair: *Marcel Duchamp ou le grand fictif.* Paris 1975.
76 Jean Suquet: *Miroir de la Mariée.* Correspondence between the author and Marcel Duchamp. Paris 1974.
77 Robert Lebel: *Marcel Duchamp.* Paris, New York and London 1959.
78 Jack Burnham: *La Signification du Grand verre,* in *V.H. 101,* No. 6, 1972.
79 Pierre Cabanne: *Entretiens avec Marcel Duchamp.* Paris 1967.
80 Reply to an enquiry on Carpeaux's *La Danse* at the Opera, in *Gil Blas,* 17 September 1912.
81 Do.
82 In *Montjoie,* November-December 1913.
83 Letter to Walter Pach of 16 January 1913, in *Duchamp-Villon* by Walter Pach. New York 1924.
84 G. Ribemont-Dessaignes: *Déjà jadis...* Paris 1958.
85 Preface to the *Duchamp-Villon, Le cheval majeur* exhibition, Galerie Carré, Paris 1966.
86 Several of Villon's works made at the Front are in the War Museum at Vincennes.
87 Pierre Cabanne: *Entretiens avec Marcel Duchamp.* Paris 1967.
88 Ibid.
89 Ibid.
90 Arensberg collection, Philadelphia Museum of Art.
91 Mme Marcel Duchamp collection, Villiers-sous-Grez.
92 Pierre Cabanne: *Entretiens avec Marcel Duchamp.* Paris 1967.
93 Ibid.
94 Ibid.
95 Ibid.
96 Third version in New York in 1952.
97 "Trébuchet" is a chess term, also used for a fixed object that trips one up.
98 Yale University Art Gallery, New Haven, Connecticut.
99 Pierre Cabanne: *Entretiens avec Marcel Duchamp.* Paris 1967.
100 Ibid.
101 Ibid.
102 Ibid.
103 Ibid.
104 In *L'Excelsior,* 6 February 1920.
105 In *Le Nouveau Spectateur,* March-April 1920.
106 Dora Vallier: *Jacques Villon. Peintures de 1897 à 1956.*
107 Louis Carré & Cie.
108 Jacques Lassaigne: *Développement de l'Œuvre de* 257

Jacques Villon in *Histoire de la Peinture moderne. De Picasso au Surréalisme*. Geneva-Paris 1950.

109 Dora Vallier: *Jacques Villon. Peintures de 1897 à 1956*. Paris 1958.

110 Told to the author by Jacques Villon, 1958.

111 In *L'Intransigeant*, 19 March 1920.

112 *Documents réunis par R.V. Gindertael*, in *Art d'Aujourd'hui*, August 1952.

113 Quoted by Dora Vallier in *Jacques Villon. Peintures de 1897 à 1956*. Paris 1958.

114 André Salmon: *L'Art vivant*. Paris 1920.

115 In *L'Intransigeant*, 21 June 1922.

116 Mr and Mrs Peter H. Deitsch collection, New York. Several of Villon's canvases executed at the same period, have the same title; we have chosen the most representative work or the best known one.

117 Dora Vallier: *Jacques Villon. Peintures de 1897 à 1956*. Paris 1958.

118 Yvon Taillandier: *Jacques Villon: de la pyramide au carré*, in *XXᵉ Siècle*, May-June 1959.

119 The original bottle and box are in a private collection in Paris. The collage, which belonged to André Breton, is in the C.F. Reutersward collection, in Lausanne.

120 Pierre Cabanne: *Entretiens avec Marcel Duchamp*. Paris 1967.

121 Ibid.

122 Ibid.

123 Alain Jouffroy: *Conversations avec Marcel Duchamp: Une Révolution du regard*. Paris 1964.

124 Ibid.

125 Solomon R. Guggenheim Museum, New York.

126 *Minotaure* No.6, Paris, winter 1935.

127 Robert Blay collection, Paris.

128 Louis Carré & Cie.

129 Quoted by Bernard Dorival: *Les Etapes de la Pein-* *ture française contemporaine*. Paris 1944.

130 Dr A.M. Boulard collection.

131 Cleveland Museum of Art, USA.

132 Musée National d'Art Moderne, Paris.

133 Ira Haupt collection, New York.

134 Private collections. Several canvases have that name.

135 Sonja Henie-Niels Onstad Foundation, Norway.

136 Louis Carré & Cie, Paris-New York.

137 Mr and Mrs Charles Zadok collection, New York, and private collection, Paris.

138 Mr and Mrs Francis Steegmuller collection, New York.

139 Musée National d'Art Moderne, Paris.

140 Pierre Cabanne: *Entretiens avec Marcel Duchamp*. Paris 1967.

141 Ibid.

142 Nora Martins Lobo collection, Sofia.

143 *Revue des Arts* Nos.4-5, 1960.

144 *Art de France* No.1, 1961.

145 Mr and Mrs Julien Levy collection, Bridgewater, Connecticut.

146 D.R.A. Wierdsma collection, New York.

147 Mme Marcel Duchamp collection, Villiers-sous-Grez.

148 Do.

149 L. Bradley collection, The Milwaukee Art Center.

150 Jean Grimar collection.

151 Richard Zeisler collection.

152 Svensk-Franska Konstgalleriet, Stockholm.

153 There are several versions of the 1951 portrait of Marcel Duchamp: Niels Onstad collection, Harry H. Rubin collection in New York, Columbus Gallery of Fine Arts, private Paris collection, etc. These paintings, and the 1953 etching, were preceded by a large number of drawings.

154 Scientific Design and Engineering Company Inc., New York.

155 Phillips Gallery, Washington.

156 Léon Duesberg collection, Verviers.

157 Jacques Villon: *J'attends le verdict d'octobre...*, in *Lettres françaises*, 1 August 1957.

158 Ibid.

159 Yvon Taillandier: *Jacques Villon: de la pyramide au carré* in *XXᵉ Siècle*, May-June 1959.

160 Ibid.

161 Ibid.

162 Pierre Cabanne: *Entretiens avec Marcel Duchamp*. Paris 1967.

163 Ibid.

164 Robert Lebel: *Marcel Duchamp maintenant et ici*, in *L'Œil*, May 1967.

165 Robert Lebel: *Marcel Duchamp*. Paris and New York 1959.

166 Ibid.

167 Drawn by Marcel Duchamp for Rudi Blesh's book: *Modern Art USA*. The publisher refused it. Private collection, New York.

168 Mme Marcel Duchamp collection, Villiers-sous-Grez.

169 Former Mary Sisler collection. Private collection, New York.

170 Robert Lebel collection, Paris.

171 Do.

172 Pierre Cabanne: *Entretiens avec Marcel Duchamp*.

173 Although photographing is forbidden, Les Levine was able to take a picture of the interior of *Given*; it was published in *The Art Gallery* of February 1970 as an offset lithograph. Robert Lebel said that "this document is a sacrilegious, but indispensable, substitute though it does not claim to replace the direct experience of the *voyeur*".

174 Octavio Paz: *Marcel Duchamp*. Mexico 1968.

THE BROTHERS DUCHAMP: CHRONOLOGY

1875 Gaston Duchamp, later Jacques Villon, is born at Damville (Eure) on July 31, to Justin-Isidore, known as Eugène Duchamp, notary, and Marie-Caroline-Lucie Nicolle.

1876 Raymond Duchamp, later Raymond Duchamp-Villon, is born at Damville on November 5.

1883-1894 Gaston and Raymond are educated at the Lycée Corneille at Rouen.

1887 Marcel Duchamp is born at Blainville (Seine-Maritime) on July 28.

1889 Suzanne Duchamp is born at Blainville.

1894-1898 Raymond Duchamp-Villon starts his medical studies in Paris; these are cut short when he gets rheumatic fever. During his enforced rest, he takes up sculpting.

1895 Jacques Villon moves to Paris. He works at the Atelier Corman for a while, and does cartoons for satirical magazines.

1895-1904 Marcel Duchamp is educated at the École Bossuet at Rouen.

1899 Jacques Villon does colour aquatints for the printer Delâtre. Until 1910, several of his engravings are published by Sagot, in Rue de Châteaudun.

1903 Raymond Duchamp-Villon gets married and moves to Neuilly.

1904 Jacques Villon exhibits at the Salon d'Automne, and Raymond Duchamp-Villon at the Nationale des Beaux-Arts. In October, Marcel Duchamp joins his brothers in Paris.

1905 The *Cage aux Fauves* at the Salon d'Automne. Marcel Duchamp enrolls at the Académie Jullian. Jacques Villon and Raymond Duchamp-Villon both exhibit at the Galerie Legrip at Rouen. Suzanne Duchamp starts to paint. In his turn, Marcel Duchamp contributes to satirical magazines. From 1905 to 1914, Jacques Villon and Raymond Duchamp-Villon exhibit at the Salon d'Automne. The Duchamp family moves from Blainville to Rue Jeanne-d'Arc in Rouen.

1906 Jacques Villon moves to 7 Rue Lemaître at Puteaux, where he lives until his death. He goes on contributing to satirical newspapers and doing lithographs and coloured aquatints. He marries Gabrielle Bœuf.

1907 Raymond Duchamp-Villon is on the jury of the sculpture section of the Salon d'Automne. He becomes its vice-president in 1910. He moves to Rue Lemaître, next door to Jacques Villon and Kupka.

The Duchamp family around 1900. Marcel is in the centre, between his mother and his paternal grandmother; at his feet, his sisters and his father.

Jacques Villon (left) and Raymond Duchamp-Villon, schoolboys at the Rouen Lycée.

Eugène Duchamp and two of his sons: Gaston (Jacques Villon) and Raymond (Duchamp-Villon).

Marcel Duchamp, Jacques Villon and Raymond Duchamp-Villon in the garden of Jacques Villon's studio at Puteaux, 1914.

260 Puteaux, Rue Lemaître and Jacques Villon's studio before their demolition.

1909 Marcel Duchamp exhibits at the Salon d'Automne and the Salon des Indépendants. He takes part in the former until 1911, and in the latter until 1912. He exhibits at the first Société Normande de Peinture Moderne exhibition at Rouen.

1910 Jacques Villon's studio become a meeting-place for many artists and writers, including Raymond Duchamp-Villon and Marcel Duchamp. Marcel Duchamp meets Picabia. *Le Figaro* publishes the *Futurist Manifesto*.

1911 Jacques Villon's engravings are published by Clovis Sagot, Rue Laffitte. Cubist rooms at the Salon des Indépendants and the Salon d'Automne.

1912 Marcel Duchamp's *Nude Descending a Staircase* is rejected by the Salon d'Automne; he resigns his position as "sociétaire". He takes part in a Cubist exhibition at the Dalmau Gallery in Barcelona, where *Nude Descending a Staircase* is exhibited for the first time. Marcel Duchamp, Raymond Duchamp-Villon and Jacques Villon take part in the Salon de la Section d'Or, founded by Jacques Villon. Futurist exhibition at the Galerie Bernheim-Jeune in Paris. Major Cubist participation at the Salon des Indépendants: at the City Council, M. Lampué protests about the "gang of ruffians" dishonouring the Grand Palais. In Parliament, Marcel Sembat replies that "you do not call the police" just because you do not like an artistic movement. Raymond Duchamp-Villon is a member of the Groupe des Artistes de Passy, founded by Henri-Martin Barzun; he exhibits the *Maison Cubiste* at the Salon d'Automne. Gleizes and Metzinger publish *Du Cubisme*.

1913 Jacques Villon, Raymond Duchamp-Villon and Marcel Duchamp take part in the Armory Show in New York, where *Nude Descending a Staircase* creates a furore. Jacques Villon exhibits nine paintings, Marcel Duchamp four, and Raymond Duchamp-Villon exhibits five sculptures. F.C. Torrey, an antique dealer from Chicago, buys *Nude Descending a Staircase*; a Chicago lawyer, A. J. Eddy, buys two of Marcel Duchamp's other paintings. Jacques Villon's nine canvases are all sold. Apollinaire's *Peintres Cubistes* is published. Marcel Duchamp produces his first Readymade, and does the first studies for the *Large Glass*.

1914 Germany declares war on France on August 3. Jacques Villon is mobilized in the 21st Infantry Regiment; there are battles at the Somme and in Artois. In 1916, he is moved to Camouflage. Marcel Duchamp and Raymond Duchamp-Villon are both exempted, but Duchamp-Villon enlists as a medical aide, and is posted to the military hospital at St-Germain-en-Laye. Marcel Duchamp produces several Readymades; Walter Pach, the American critic, invites him over to the States.

1915 Marcel Duchamp arrives in New York on June 15, and meets Louise and Walter Arensberg. He has his first interview in September, in *Arts and Decoration:* "A Complete Reversal of Art Opinions by Marcel Duchamp, Iconoclast." Marcel Duchamp gets involved with several American artists and writers; he begins the *Large Glass*. Raymond Duchamp-Villon is sent to the front at Champagne in September.

1916 Marcel Duchamp exhibits at the Montross Gallery in New York, with Jean Crotti, Metzinger and Gleizes. Raymond Duchamp-Villon catches typhoid fever in Champagne, and is evacuated to the Mourmelon hospital.

1917 Raymond Duchamp-Villon is seriously ill, and spends several months in various hospitals. Marcel Duchamp's *Fountain* is rejected by the Society of Independent Artists exhibition in New York, in which Jacques Villon takes part.

1918 Marcel Duchamp visits Buenos Aires. Raymond Duchamp-Villon dies on October 9, at Cannes. Jacques Villon is demobilized, and returns to his Puteaux studio. First Dada manifestos.

1919 Suzanne Duchamp marries Jean Crotti in April. Marcel Duchamp goes back to Europe in June, and gets involved with the Dada group in Paris. There is a Raymond Duchamp-Villon retrospective at the Salon d'Automne.

1920 Marcel Duchamp goes back to New York in January, and collaborates with Man Ray on optical precision objects. Katherine Dreier, Man Ray and Marcel Duchamp found the Société Anonyme, Museum of Modern Art 1920.

1921 Jacques Villon's first one-man exhibition, at the Société Anonyme headquarters in New York; he does thirty-four engravings for André Mare's *Architectures*. Marcel Duchamp returns to France in June, and refuses to take part in the Salon Dada. He signs Picabia's *L'Œil cacodylate*, along with many writers and artists. Rrose Sélavy, Marcel Duchamp's female counterpart, is born.

1922 From 1922 to 1930, Jacques Villon does forty-five coloured aquatints for the Galerie Bernheim-Jeune, after works by Cézanne, Van Gogh, Picasso, Matisse, the Douanier Rousseau, Bonnard, Dufy, Signac, Modigliani and others. André Breton publishes *Marcel Duchamp* in the October *Littérature*.

1923 Until 1927, Marcel Duchamp commutes between Paris and New York, where the *Large Glass* remains unfinished. He starts to enter chess tournaments. Suzanne Duchamp has an exhibition at the Galerie Paul Guillaume in Paris.

1924 Marcel Duchamp takes part in René Clair's *Entr'acte*, and *Relâche*, a ballet by Picabia and Satie. André Breton produces his *Manifeste du Surréalisme*.

1925 M. and Mme Eugène Duchamp die in Rouen, at a few days' interval. Jacques Villon takes part in the second Section d'Or exhibition in Paris.

1926 The *Large Glass* cracks after its exhibition at the International Exhibition in Brooklyn. The Salon des Indépendants holds a Raymond Duchamp-Villon retrospective.

1927 Marcel Duchamp settles in Paris until 1933. In June, he marries Lydie Sarazin-Levassor, whom he divorces a few months later.

1928 The Brummer Gallery in New York holds a Jacques Villon exhibition. André Breton publishes *Le Surréalisme et la* 261

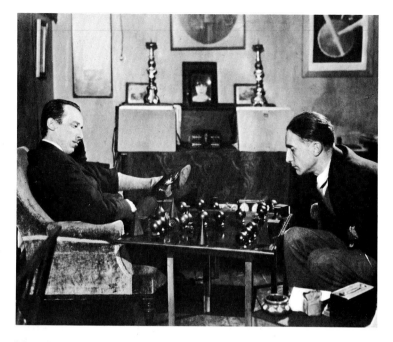

Marcel Duchamp playing chess with Denis de Rougemont, *ca.* 1925.

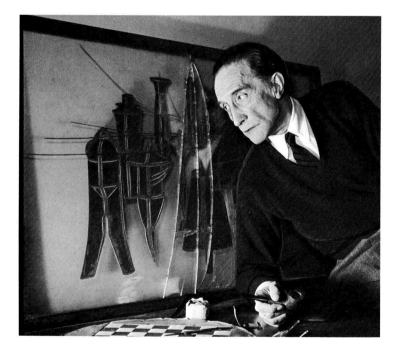

262 Marcel Duchamp with *Nine Malic Molds.*

Peinture.

1929 "Memorial Exhibition of the Works of Raymond Duchamp-Villon (1876-1918)" at the Brummer Gallery in New York; "Sculpture by Raymond Duchamp-Villon" at the Arts Club of Chicago.

1930 "La Peinture au Défi" at the Galerie Goemans in Paris, with Aragon's important text on collages. Marcel Duchamp contributes five works.

1931 First major exhibition of Raymond Duchamp-Villon's works at the Galerie Pierre in Paris, with a catalogue prefaced by André Salmon.

1932 Marcel Duchamp and Vitaly Halberstadt publish *L'Opposition et les cases conjuguées sont réconciliées*, a treatise on chess.

1934 Jacques Villon exhibitions at the Arts Club of Chicago and the Marie Harriman Gallery, New York.

1935 Marcel Duchamp starts *Box in a Valise.* André Breton publishes *Phare de la Mariée* (Lighthouse of the Bride) in *Minotaure.*

1936 Marcel Duchamp takes part in the "International Surrealist Exhibition" at the New Burlington Galleries in London and in "Fantastic Art, Dada, Surrealism" at the Museum of Modern Art in New York.

1937 Marcel Duchamp's first one-man exhibition, at the Arts Club of Chicago. The "Maîtres de l'Art Indépendant" exhibition at the Petit Palais includes works by Jacques Villon and Raymond Duchamp-Villon. Jacques Villon decorates the Pavillon de l'Aéronautique at the Exposition Internationale des Arts et Techniques in Paris, and receives two diplomas of honour and a gold medal.

1938 Marcel Duchamp is the "generator-arbitrator" of the "Exposition Internationale du Surréalisme" at the Galerie Beaux-Arts in Paris.

1939 Marcel Duchamp publishes *Rrose Sélavy, oculisme de précision, poils et coups de pieds en tous genres*, in Paris.

1940 Jacques Villon and his wife go to stay with Mme André Mare in Bernay before the Germans occupy Paris. They next stay with her daughter and her husband, Marc Vène, at La Brunié in Tarn. Marcel Duchamp spends the summer in Arcachon with the Crottis.

1941 Marcel Duchamp publishes *Box in a Valise*, and starts writing thirty-two critical studies for the catalogue of the Société Anonyme collection, which Katherine Dreier presents to Yale University Art Gallery, New Haven.

1942 Marcel Duchamp goes back to New York in June, and stays there until 1946. He meets John Cage at Peggy Guggenheim's. He publishes the magazine *VVV* with Max Ernst and Breton.

1944 First Jacques Villon exhibition at the Galerie Louis Carré in Paris, in December.

1946 Marcel Duchamp comes to Paris to help André Breton prepare the "Le Surréalisme en 1947" exhibition at the Galerie Maeght.

1947 Marcel Duchamp applies for United States citizenship.

1948 Second Jacques Villon exhibition at Louis Carré's gallery; from now on, Louis Carré organizes all his exhibitions, both in France and abroad.

1949 First Jacques Villon exhibition at the Louis Carré Gallery in New York. He gets the Grand Prix for engraving at the International Exhibition in Lugano.

1950 Jacques Villon gallery at the XXVth Venice Biennale. He is awarded the Carnegie First Prize at the International Art Exhibition, Pittsburgh.

1951 Jacques Villon retrospective at the Musée National d'Art Moderne in Paris, an exhibition of eighty-five canvases.

1952 Marcel Duchamp organizes the "Duchamp Frères et Sœur, Œuvres d'Art" exhibition at the Rose Fried Gallery, New York.

1953 Jacques Villon becomes a Commandeur de la Légion d'Honneur and a Commandeur des Arts et Lettres.

1954 Marcel Duchamp marries Alexina "Teeny" Sattler in New York in January, and they take up residence at 327 East 58th Street. The Musée National d'Art Moderne in Paris buys Marcel Duchamp's study for *Chess Players* (1911) from Jacques Villon. The permanent exhibition of Louise and Walter Arensberg's collection at the Philadelphia Museum of Art opens; this includes forty-three of Marcel Duchamp's works, the most complete collection of his output, and also features the *Large Glass*, bequeathed by Katherine Dreier. Exhibition of Jacques Villon's engravings at the Galerie Carré in Paris.

1955 Marcel Duchamp becomes a naturalized American.

1956 Jacques Villon gets the Grand Prix for painting at the XXVIIIth Venice Biennale.

1957 Homage to Jacques Villon at the Salon d'Automne.

1958 Michel Sanouillet publishes *Marchand de Sel. Ecrits de Marcel Duchamp* in Paris. Marcel Duchamp spends the summer at Cadaqués with Teeny, where they spend every summer from that time on. Jean Crotti dies.

1959 Marcel Duchamp and Teeny move to 28 West 10th Street in New York. Jacques Villon's engravings (115 works) are presented to the Bibliothèque Nationale in Paris. Robert Lebel publishes *Sur Marcel Duchamp* in Paris. Marcel Duchamp is admitted to the "Collège de Pataphysique" as a Maître de l'Ordre de la Grande Gidouille, with the rank of Transcendent Satrap. He organizes the Surrealist exhibition at the Galerie Cordier in Paris with Breton.

1960 Major Jacques Villon retrospective at the Moderna Museet in Stockholm (94 paintings and 58 engravings). Marcel Duchamp and Breton organize the "Surrealist Intrusion in the Enchanter's Domain" exhibition at the D'Arcy Galleries, New York. Duchamp is elected to the American National Institute of Arts and Letters.

1961 A hundred of Jacques Villon's paintings are exhibited at the Galerie Charpentier, Paris. Jacques Villon is made a member of the American Academy of Arts and Letters in New York. Marcel Duchamp receives an honorary degree of Doctor of Humanities from Wayne State University,

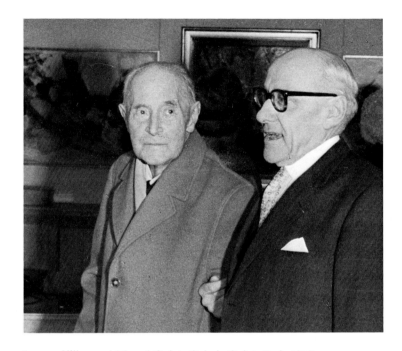

Jacques Villon and Marcel Guiot, Galerie Guiot, Paris 1960.

Invitation to the *Readymades et éditions de et sur Marcel Duchamp* exhibition, Galerie Givaudan, Paris, 7 June 1967.

263

Arturo Schwarz, Marcel Duchamp, and some Readymades.

Marcel Duchamp and Pierre Cabanne in Duchamp's studio at Neuilly in 1967.

Commemorative plaque on the Duchamp house, 71 Rue Jeanne-d'Arc at Rouen; put up in April 1967, it reads:
ICI A VÉCU / ENTRE 1905 ET 1925 / UNE FAMILLE / D'ARTISTES NORMANDS /
JACQUES VILLON / 1875-1963 / RAYMOND DUCHAMP-VILLON / 1876-1918 /
MARCEL DUCHAMP / 1887- / ET SUZANNE DUCHAMP / 1889-1963

Detroit. Jacques Villon is guest of honour at the VIth Sao Paulo Biennale, where a whole room is devoted to him.

1963 Major Jacques Villon retrospective at the Zurich Kunsthaus: 81 canvases, 23 drawings and 33 engravings. He is promoted to Grand Officier de la Légion d'Honneur. He dies at Puteaux on June 9. Marcel Duchamp attends his state funeral. Suzanne Duchamp dies three months later.

1964 "Omaggio a Marcel Duchamp" at the Galleria Schwarz in Milan. Jean-Marie Drot makes a film on Marcel Duchamp for French television.

1965 Gilles Aillaud, Arroyo and Recalcati exhibit *Vivre et laisser mourir, ou la mort tragique de Marcel Duchamp* at the Galerie Creuze in Paris, as part of "La Figuration Narrative dans l'Art Contemporain". Marcel Duchamp refuses to protest.

1966 First major European retrospective of Marcel Duchamp's work, at the Tate Gallery, London. Calvin Tomkins publishes *The World of Marcel Duchamp* in New York. Raymond Duchamp-Villon's *Cheval Majeur* is exhibited for the first time at the Galerie Louis Carré in Paris.

1967 Major Raymond Duchamp-Villon retrospective at the Knoedler & Co. Gallery in New York. An exhaustive account of the sculptor's life and work by George Heard Hamilton and William C. Agee is published for the occasion.

1968 Marcel Duchamp dies at Neuilly on October 2.

1969 On July 7, Marcel Duchamp's secret work *Given: 1.The Waterfall, 2.The Illuminating Gas* is revealed to the public at the Philadelphia Museum of Art.

MAIN EXHIBITIONS

JOINT DUCHAMP EXHIBITIONS

1905 *Duchamp-Villon et Villon.* Galerie Legrip, Rouen.

1942 *Jacques Villon, Peintures de 1909 à 1941; Duchamp-Villon, Sculptures.* Galerie de France, Paris. Preface by René Jean.

1945 *Duchamp, Duchamp-Villon, Villon.* Yale University Art Gallery, New Haven, Connecticut. Preface by George Heard Hamilton.

1945-1947 *Duchamp and Villon.* Itinerant exhibition. College of William and Mary, Williamsburg, Virginia, November 1945. Allegheny College, Meadville, Pennsylvania, May 1946. Saint Paul Gallery and School of Art, Saint Paul, Minnesota, September 1946. Carlton College, Northfield, Minnesota, October 1946. University of Maine, Orono, Maine, January 1947.

1952 *Duchamp Frères et Sœur. Œuvres d'Art.* Rose Fried Gallery, New York. Preface by Walter Pach.

1957 *Jacques Villon, Raymond Duchamp-Villon, Marcel Duchamp.* The Solomon R. Guggenheim Museum, New York, February. Museum of Fine Arts, Houston, March. Prefaces by James J. Sweeney and André Breton.

1967 *Les Duchamp. Jacques Villon, Raymond Duchamp-Villon, Marcel Duchamp, Suzanne Duchamp.* Musée des Beaux-Arts de Rouen. Texts by Olga Popovitch, Bernard Dorival, Jean Cassou, Katherine Dreier.
Raymond Duchamp-Villon—Marcel Duchamp. Musée National d'Art Moderne, Paris. Texts by Bernard Dorival and Jean Cassou.

MAIN EXHIBITIONS

The three Duchamps took part in many group exhibitions and Salons in France and all over the world. Only their individual exhibitions are listed here.

JACQUES VILLON

1921 Société Anonyme Galleries, New York.

1928 Brummer Gallery, New York.

1934 Arts Club of Chicago. Preface by Walter Pach.

1934 Marie Harriman Gallery, New York.

1944 Galerie Louis Carré, Paris. Preface by René Jean.

1948 Galerie Louis Carré, Paris.

1948 *Jacques Villon. Retrospektiv Udstilling.* Statens Museum for Kunst, Copenhagen.

1949 Louis Carré Gallery, New York. Preface by Jerome Mellquist.

1951 *Rétrospective Jacques Villon.* Musée National d'Art Moderne, Paris. Preface by Jean Cassou.

1952 Musée de Liège. Preface by Frank Elgar.

1952 Lefevre Gallery, London. Preface by Jerome Mellquist.

1952 Arts Club of Chicago.

1952 *Retrospektiv Udställning. Jacques Villon.* Svensk-Franska Konstgalleriet, Stockholm.

1953 *Jacques Villon. His Graphic Art.* Museum of Modern Art, New York. Preface by William S. Lieberman.

1954 *Jacques Villon. Œuvre Gravé.* Galerie Louis Carré. Preface by Jean Adhémar.

1955 Musée Toulouse-Lautrec, Albi. Texts by Edouard Julien and André Chastel.

1955 *Jacques Villon. Peintures.* Galerie Louis Carré, Paris.

1956 *Dessins de Jacques Villon.* Galerie Louis Carré, Paris. Preface by Pierre Mazars.

1957 *Jacques Villon. Grafiske Arbeider.* Nasjonal Galleriet, Oslo. Preface by Jan Askeland.

1957 Institut Français, Athens. Preface by P.M. Grand.

1959 *Jacques Villon. L'Œuvre Gravé.* Bibliothèque Nationale, Paris. Preface by Julien Cain. Texts by Jacques Villon, Jean Vallery-Radot and Jean Adhémar.

1959 Kunstnernes Hus, Oslo. Prefaces by Alf Jorgen Aas and Henning Gran.

1960 *Jacques Villon. Mäleri och Graphik 1902-1959.* Moderna Museet, Stockholm. Text by Carl Nordenfalk.

1961 *Cent Tableaux de Jacques Villon.* Galerie Charpentier, Paris. Introduction by Raymond Nacenta. Preface by Jean Tardieu.

1963 *La Figure dans l'œuvre graphique de Villon.* Galerie Louis Carré, Paris.

1963 *Rétrospective Jacques Villon.* Kunsthaus, Zurich. Prefaces by Eduard Hüttinger and Dora Vallier.

1964 *Jacques Villon. Master of Graphic Art.* Museum of Fine Arts, Boston. Preface by Jean Cassou. Introduction by Simone Frigerio. Text by Peter A. Wick.

1964 *Jacques Villon. 15 Paintings (1909-1960).* E.V. Thaw & Co., New York. Preface by William S. Lieberman.

1964 *Jacques Villon. Master Drawings and Watercolours (1908-1956).* Lucien Goldschmidt Gallery, New York.

1966 *Jacques Villon. Blick auf das Graphische Œuvre.* Kölnischer Kunstverein, Cologne. Preface by Jean Cassou.

1973 *Jacques Villon. Vingt-deux peintures 1939-1961.* Galerie Bonnier, Geneva.

1974 Galerie du Lion, Paris.

1975 Centenary retrospective (157 works). Musée des Beaux-Arts, Rouen, June-September. Grand Palais, Paris, October-December. Fogg Art Museum, Mass., January 1976.

RAYMOND DUCHAMP-VILLON

All one-man exhibitions of Raymond Duchamp-Villon's works were organized after his death.

1929 *Memorial Exhibition of the Works of Raymond Duchamp-Villon.* Brummer Gallery, New York.
Sculpture by Raymond Duchamp-Villon. Arts Club of Chicago. Preface by Walter Pach.

1931 *Sculptures de Duchamp-Villon 1876-1918.* Galerie Pierre, Paris. Preface by André Salmon.

1963 *Sculptures de Duchamp-Villon.* Galerie Carré, Paris. Preface by Simone Frigerio.

1966 *Duchamp-Villon: Le Cheval majeur.* Galerie Louis Carré, Paris. Preface by Jean Cassou. Introduction by R.V. Gindertaël. Selected texts by Walter Pach, Apollinaire, André Salmon, Anette Michelson, Carola Giedion-Welcker.

1967 *Raymond Duchamp-Villon 1876-1918.* Introduction by George Heard Hamilton. Notes by William C. Agee. Knoedler Gallery, New York.

Two group exhibitions must be mentioned:

1914 Sculptures by Raymond Duchamp-Villon, Watercolours by Albert Gleizes, Engravings by Jacques Villon, Drawings by Jean Metzinger. Galerie André Groult, Paris. Preface by André Salmon.

1919 Raymond Duchamp-Villon retrospective at the Salon d'Automne: 19 works exhibited. 265

MARCEL DUCHAMP

1937 First one-man exhibition (9 works), Arts Club of Chicago. Preface by Julien Levy.

1963 *Marcel Duchamp: A Retrospective Exhibition.* Pasadena Art Museum. Text by Walter Hopps. Dialogue between Marcel Duchamp and Richard Hamilton.

1965 *Marcel Duchamp: schilderijen, tekeningen, readymades, documenten.* Stedelijk van Abbe-Museum, Eindhoven, March-May. Gemeentemuseum, The Hague, February-March 1966.

1965 *Marcel Duchamp, même.* Kestner Gesellschaft, Hanover. Introduction by Wieland Schmied.

1965 *Not Seen and/or Less Seen of/by Marcel Duchamp/Rrose Sélavy. 1904-1964. Mary Sisler Collection.* Cordier & Ekstrom, New York, January-February. Introduction by Richard Hamilton. Art Center, Milwaukee, September-October.

1966 *The Almost Complete Works of Marcel Duchamp.* Tate Gallery, London. Text by Richard Hamilton; bibliography by Arturo Schwarz.

1972 *Marcel Duchamp: Drawings, Etchings for the Large Glass, Readymades.* Israël Museum, Jerusalem.

1972 Galleria Il Fauno, Turin.

1973 *66 Creative Years.* Galleria Schwarz, Milan.

1973 *Marcel Duchamp.* Museum of Modern Art, New York, and Philadelphia Museum of Art, Philadelphia. Texts by Anne d'Harnoncourt, Michel Sanouillet, R. Hamilton, Arturo Schwarz, Robert Lebel, Octavio Paz, etc.

BIBLIOGRAPHY

JACQUES VILLON

1914 A.J. Eddy. *Cubists and Post-Impressionism.* Chicago.

1924 Walter Pach. *The Masters of Modern Art.* New York.

1944 Jean Bazaine. *Jacques Villon* in *Poésie 44*, No. 21.

1944 Bernard Dorival. *Les Etapes de la peinture française contemporaine*, Volume II. Paris.

1945 René Jean. *Jacques Villon.* Paris.

1945 A. Frenaud, R. Mortimer. *Jacques Villon* in *Horizon* No. XII. London.

1948 Paul Eluard, René Jean. *Jacques Villon ou l'Art glorieux.* Paris.

1950 J. Auberty, Charles Pérussaux. *Jacques Villon. Catalogue de son œuvre gravé.* Paris.

1950 Jacques Lassaigne. *Jacques Villon.* Paris.

1955 Jacques Lassaigne. *Eloge de Jacques Villon.* Paris.

1957 Dora Vallier. *Jacques Villon. Œuvres de 1897 à 1956.* Paris.

1960 Jerome Mellquist. *Les Caricatures de Jacques Villon ou la Marge de l'Indulgence.* Geneva.

1961 André Chastel. *Jacques Villon ou la conquête de l'espace* in *Le Monde*, April 29.

1961 Simone Frigerio. *Jacques Villon* in *Aujourd'hui. Art et Architecture.* July.

1961 Jean Revol. *Braque et Villon, message vivant du cubisme* in *Nouvelle Revue Française.* August-September.

1962 Lionello Venturi. *Jacques Villon.* Paris.

1963 Raymond Cogniat. *Villon, Peintures.* Paris.

1963 Abbé Maurice Morel, Gaëtan Picon, Georges Dardel, Jean Cassou. *Souvenir de Jacques Villon.* Paris.

1970 *A Collection of Graphic Work 1896-1913 in rare or unique impressions by Jacques Villon.* New York.

RAYMOND DUCHAMP-VILLON

1924 Walter Pach. *Raymond Duchamp-Villon, sculpteur, 1876-1918.* Paris.

1931 Christian Zervos. *Raymond Duchamp-Villon* in *Cahiers d'Art*, No. 4.

1931 Walter Pach. *Raymond Duchamp-Villon* in *Formes*, May.

1949 Bernard Dorival. *Raymond Duchamp-Villon au Musée d'Art Moderne* in *Musées de France*, April.

1954 Jacques Villon. *Duchamp-Villon* in *Les Sculpteurs Célèbres.* Paris.

1955 A. M. Hammacher. *Raymond Duchamp-Villon (1876-1918) en de beeldhouwkunst Tussen 1910-1914* in *Museum Journal, Musée Kröller-Muller.* Otterlo, July.

1960 Marie-Noëlle Pradel. *Raymond Duchamp-Villon, la vie et l'œuvre.* Thesis for the Ecole du Louvre.

1960 Marie-Noëlle Pradel. *Dessins de Duchamp-Villon* in *La Revue des Arts*, Nos. 4-5.

1961 Marie-Noëlle Pradel. *La Maison Cubiste en 1912* in *Art de France.*

1964 R.V. Gindertaël. *L'Œuvre majeure de Duchamp-Villon* in *XXe Siècle*, May.

1967 A. Elsen. *The Sculpture of Duchamp-Villon* in *Artforum*, October.

1967 George Heard Hamilton. *Raymond Duchamp-Villon* in *L'Œil*, September.

1967 George Heard Hamilton, W.C. Agee. *Raymond Duchamp-Villon 1876-1918.* New York.

MARCEL DUCHAMP

1922 André Breton. *Marcel Duchamp* in *Littérature*, No. 5, Paris.

1924 André Breton. *Marcel Duchamp* in *Les Pas Perdus.* Paris.

1928 André Breton. *Phare de la Mariée* in *Le Surréalisme et la Peinture.* Paris. New York 1945.

1940 André Breton. *Marcel Duchamp* in *Anthologie de l'Humour noir.* Paris.

1946 Michel Leiris. *Arts et Métiers de Marcel Duchamp* in *Fontaine*, summer.

1959 Robert Lebel. *Sur Marcel Duchamp.* Paris.

1959 Robert Lebel. *Marcel Duchamp.* New York and London.

1960 Lawrence D. Steefel, Jr. *The Position of "La Mariée mise à nu par ses célibataires, même" (1915-1923) in the Stylistic and Iconographic Development of the Art of Marcel Duchamp.* Princeton.

1964 W. Hopps, Ulf Linde, Arturo Schwarz. *Marcel Duchamp. Ready-mades.* Paris.

1966 Calvin Tomkins. *The World of Marcel Duchamp.* New York.

1966 Shigeko Kubota. *Marcel Duchamp and John Cage.* Tokyo.

1967 Pierre Cabanne. *Entretiens avec Marcel Duchamp.* Paris. New York 1971.

1968 Takiguchi Shuzo. *To and from Rrose Sélavy.* Tokyo.

1968 Octavio Paz. *Marcel Duchamp.* Mexico City.

1968 Arturo Schwarz. *Marcel Duchamp.* Milan.

1969 Arturo Schwarz. *The Complete Works of Marcel Duchamp.* New York.

1970 Octavio Paz. *Marcel Duchamp or the Castle of Purity.* London-New York.

1970 Robert Lebel. *Le Chef-d'œuvre inconnu de Marcel Duchamp* in *L'Œil*, March.

1971 Pierre Cabanne. *Dialogues with Marcel Duchamp.* New York. Introduction by R. Motherwell, preface by Salvador Dali, appreciation by Jasper Johns.

1972 John Golding. *Duchamp: The Bride Stripped Bare by her Bachelors, Even.* London. New York 1973.

1972 Jack Burnham. *Marcel Duchamp. La Signification du Grand Verre* in *V.H. 101* No. 6.

1973 Dr. René R. Held. *L'Œil du Psychanalyste. Surréalisme et Surréalité.* Paris.

1974 Jean Suquet. *Miroir de la Mariée.* Paris.

1974 Jindrich Chalupecky. *Les Symboles chez Marcel Duchamp* in *Opus International* No. 49, March.

1974 Arturo Schwarz. *La Mariée mise à nu chez Marcel Duchamp, même.* Paris.

LIST OF ILLUSTRATIONS

JACQUES VILLON

8 *Portrait of Emile Nicolle*, 1891.
 (Villon's maternal grandfather).
 Etching, 17.6 × 12.8 cm

9 *Maggie Berck Poster*, 1904.

10 *La Boudeuse*, 1900. (Sulking).
 Etching and colour aquatint, 17.5 × 26.5 cm

11 *Portrait of Raymond Duchamp*, 1900.
 Oil on canvas, 93 × 65 cm
 Private collection.

12 *La Cigarette*, 1901.
 Etching and colour aquatint, 41.8 × 34.5 cm

13 Illustration for *L'Assiette au Beurre* No.1,
 1901.

14 Illustration for *L'Assiette au Beurre* No.9,
 30 May 1901.

15 *Maquis Caulaincourt*, 1901.
 Aquatint, 42 × 57.5 cm

16 *Premiers Beaux Jours*, 1902.
 (First Fine Days).
 Colour aquatint, 46.8 × 33.3 cm

19 *La Partie de Jacquet*, 1903.
 (Game of Backgammon).
 Etching and colour aquatint, 33.8 × 47.8 cm

20 *Portrait of Monsieur Pierre D.*, 1903.
 Oil on canvas, 92 × 73 cm
 Private collection, Paris.

21 *Femme Nue assise*, 1910. (Seated Nude).
 Oil on canvas, 38 × 46 cm
 Camille Renault collection, Paris.

22 *Les Haleurs*, 1908. (Haulers).
 Oil on canvas, 65 × 92 cm
 Private collection, USA.

25 *Suzanne au Piano*, 1908.
 Drypoint, 53.5 × 41.8 cm

26 *La Lecture sur l'Herbe*, 1910, second plate.
 (Reading Outdoors).
 Soft-ground etching and two-tone aquatint,
 30.5 × 39 cm

27 *La Lecture sur l'Herbe*, 1910, third plate.
 (Reading Outdoors).
 Drypoint and colour aquatint,
 30.3 × 40.1 cm

28 *Bal au Moulin Rouge*, 1910.
 Etching, second state, 23.3 × 30 cm

56 *Sancta Fortunata*, 1908.
 Oil on canvas, 55 × 38 cm
 Camille Renault collection, Paris.

58 *The Samourai*, 1909.
 Oil on canvas, 38 × 55 cm
 Camille Renault collection, Paris.

59 *Portrait of the Artist*, 1909.
 Oil on canvas, 41 × 33 cm
 Louis Carré & Cie.

60 *Petite Mulâtresse*, 1911.
 Etching, 27.8 × 19 cm

61 *Renée de face*, 1911, small plate.
 Etching, 27.8 × 19 cm

62 *Renée de trois quarts*, 1911.
 (Renée, three-quarter face).
 Drypoint, 54.5 × 40.7 cm

63 *Renée de trois quarts*, 1911.
 Oil on canvas, 60.5 × 49.5 cm
 Camille Renault collection, Paris.

64 *Musiciens chez le Bistro*, 1912.
 Etching, 27.1 × 23.7 cm

65 *Portrait of Raymond Duchamp-Villon*, 1911.
 Oil on wood panel, 35 × 26.5 cm
 Musée National d'Art Moderne, Paris.

75 *Portrait of E.D.*, 1913. (The artist's father).
 Drypoint, 23.5 × 16 cm

76 *Yvonne D. de profil*, 1913.
 (Yvonne Duchamp, the artist's sister).
 Drypoint, 55 × 41.5 cm

77 *Yvonne D. de face*, 1913.
 (Yvonne Duchamp, the artist's sister).
 Drypoint, 55 × 41.5 cm

78 *Portrait of Suzanne D.*, 1913.
 (Suzanne Duchamp, the artist's sister).
 Drypoint, 14 × 12.5 cm

79 *Portrait d'Acteur (Félix Barré)*, 1913.
 Drypoint, 40 × 31.5 cm

80 *L'Equilibriste*, 1913. (The Acrobat).
 Drypoint, 40 × 29.8 cm

81 *Soldats en Marche*, 1913. (Marching Soldiers).
 Oil on canvas, 65 × 92 cm
 Louis Carré & Cie.

82 *Portrait of Mlle Dubray*, 1914.
 Oil on canvas, 35 × 29 cm
 Camille Renault collection, Paris.

83 *La Table Servie*, 1913. (The Set Table).
 Drypoint, 28.5 × 38.5 cm

84 *Le Petit Atelier Mécanique*, 1914.
 (Small Workshop).
 Etching, 15.9 × 19.7 cm

85 *Le Petit Equilibriste*, 1914. (Small Acrobat).
 Drypoint, 22 × 16 cm

156 *La Table d'Echecs*, 1920. (Chess Table).
 Etching, 20 × 16 cm

157 *Jeu (La Table d'Echecs)*, 1919.
 Oil on canvas, 92 × 73 cm
 Louis Carré & Cie.

159 *Baudelaire au socle*, 1921, after the sculpture
 by Raymond Duchamp-Villon.
 Etching, 41.5 × 28.1 cm

160 *L'Oiseau*, 1921. (The Bird).
 Etching, 10.1 × 16.8 cm

161 *Gallop*, 1921.
 Oil on canvas, 45 × 81 cm
 Louis Carré & Cie.

163 *La Pipe (Silence)*, 1922.
 Oil on canvas, 81 × 69 cm
 Louis Carré & Cie.

165 *Femme Tête Penchée*, 1924.
 (Woman with Head Bent).
 Oil on canvas, 35 × 27 cm
 Louis Carré & Cie.

166 *Echecs sur une Table*, 1924. (Chess on a Table).
 Oil on canvas, 33 × 46 cm
 Galerie Bonnier, Geneva.

167 *Tabouret aux Papiers*, 1926.
 (Stool with Papers).
 Oil on canvas, 81 × 65 cm
 Camille Renault collection, Paris.

168 *Nature morte aux Noix*, 1929.
 (Still Life with Nuts).
 Etching and drypoint, 22.3 × 27.7 cm

169 *Parade*, 1931.
 Oil on canvas, 38 × 46 cm
 Galerie Bonnier, Geneva.

170 *L'Architecture*, 1931.

267

Oil on canvas, 55 × 46 cm
Private collection.

172 *L'Espace*, 1932.
Oil on canvas, 116 × 89 cm
Louis Carré & Cie.

173 *Les Fenêtres*, 1932–1933. (Windows).
Oil on canvas, 46 × 55 cm
Private collection.

186 *Le Philosophe*, 1930.
Etching, 21.3 × 15.3 cm

187 *Les Haleurs*, 1930.
Etching, 18.2 × 22.2 cm

188 *La Plaine entre Cannes et Mougins*, 1934.
Etching, 16.4 × 26.5 cm

189 *Mon vieux Luxembourg*, 1935.
Etching, second state, 25.5 × 39.7 cm

190 *L'Aventure*, 1935.
Etching, 32 × 21.2 cm

191 *Orpheus*, 1934.
Oil on canvas, 50 × 61 cm
Private collection, Paris.

192 *Homme dessinant*, 1935. (Man drawing).
Oil on canvas, 116 × 81 cm
Private collection.

193 *Le Petit Dessinateur*, 1935. (Self-portrait).
Ink on tracing paper, 17 × 13.4 cm
Louis Carré & Cie.

193 *Le petit dessinateur*, 1935.
Etching, 16.2 × 11.7 cm

195 *Pommiers à Canny*, 1936. (Apple Trees).
Oil on canvas, 70 × 92 cm
Milwaukee Art Center, Wisconsin.

197 *Arbres*, 1938. (Trees).
Oil on canvas, 50 × 43 cm
Private collection, Paris.

198 *L'Oiseau empaillé*, 1938. (Stuffed Bird).
Oil on canvas, 73 × 92 cm
Louis Carré & Cie.

199 *Le Joueur de Flageolet*, 1939.
(The Flageolet Player).
Oil on canvas, 162 × 130 cm
Louis Carré & Cie.

200 *L'Effort*, 1939.
Etching, 23.1 × 24.9 cm

201 *La Lutte*, 1939. (Wrestling).
Etching, 23.1 × 24.9 cm

204 *Potager à La Brunié*, 1941. (Vegetable Patch).
Oil on canvas, 65 × 92 cm
Cleveland Museum of Art, Ohio.

205 *Potager*, 1941.
Oil on canvas, 65 × 92 cm
Camille Renault collection, Paris.

206 *Madame de Bernay*, 1940.
Oil on canvas, 100 × 81 cm
Louis Carré & Cie.

207 *Portrait of the Artist*, 1942.
Oil on canvas, 92 × 65 cm
Private collection, New York.

208 *Portrait of Camille Renault*, 1944.
Pen drawing, 44 × 33 cm
Camille Renault collection, Paris.

209 *Portrait of Camille Renault*, 1944.
Pen drawing, 44 × 30 cm
Camille Renault collection, Paris.

210 *Portrait of Camille Renault*, 1944.
Pen drawing, 41 × 29 cm
Camille Renault collection, Paris.

211 *Portrait of Camille Renault*, 1944.
Oil on canvas, 54 × 46 cm
Camille Renault collection, Paris.

212 *Portrait of M.A.*, 1945.
Oil on canvas, 92 × 73 cm
Mme Louis Carré collection, Paris.

213 *Portrait of Mlle Colette Carré*, 1945.
Oil on canvas, 92 × 73 cm
Private collection.

214 *La Meule de Blé*, 1946. (Corn Stack).
Oil on canvas, 89 × 146 cm
Private collection, Oslo.

215 *L'Avare*, 1949. (The Miser).
Oil on canvas, 65 × 54 cm
Private collection, Paris.

216 *Nausicaa*, 1949.
Oil on canvas, 73 × 92 cm
Private collection, Sweden

217 *Les Grands Fonds*, 1945. (Broad Acres).
Oil on canvas, 46 × 65 cm
Private collection.

217 *Le Petit Atelier Mécanique*, 1946.
(Small Workshop).
Oil on canvas, 81 × 116 cm
Phillips Collection, Washington D.C.

218 *Portrait of Marcel Duchamp*, 1951.
Oil on canvas, 146 × 114 cm
Sonja Henie-Niels Onstad Foundation,
Norway.

221 *Faucheuse en Plaine*, 1950.
(Harvester in the Plain).
Oil on canvas, 66 × 82 cm
Private collection.

222 *L'Ecuyère au Cirque*, 1950. (Circus Rider).
Oil on canvas, 114 × 162 cm
Louis Carré & Cie.

223 *Portrait d'Homme aux Mains croisées*, 1950.
(Man with Hands Crossed).
Oil on canvas, 81 × 65 cm
Private collection.

224 *Portrait of Simone*, 1950.
Oil on canvas, 81 × 65 cm
Private collection.

225 *Gallop*, 1952.
Oil on canvas, 27 × 41 cm

Private collection, Sweden.

226 *Figure de Femme*, 1951. (Woman).
Oil on canvas, 61 × 46 cm
Private collection, Lausanne.

227 *Réflexion*, 1951.
Oil on canvas, 92 × 65 cm
Galerie Bonnier, Geneva.

228 *The Jockey*, 1952.
Oil on canvas, 66 × 93 cm
Private collection.

230 *Le Pigeonnier Noir*, 1953.
(Black Dovecote).
Oil on canvas, 65 × 92 cm
Private collection, New York.

231 *Le Four à Pain*, 1953. (Bread Oven).
Oil on canvas, 65 × 92 cm
Private collection, Sweden.

232 *Orly*, 1954.
Oil on canvas, 89 × 146 cm
Louis Carré & Cie.

233 *D'Azur vorace*, 1954. (Like a Bird of Prey).
Oil on canvas, 60 × 73 cm
Private collection, Blonay.

234 *Les Avions*, 1954. (Airplanes).
Oil on canvas, 39 × 56 cm
Private collection.

235 *Le Long du Parc*, 1955. (Along the Park).
Oil on canvas, 65 × 81 cm
Louis Carré & Cie.

236 *Harmony*, 1955.
Oil on canvas, 46 × 62 cm
Private collection.

239 *Never More*, 1956.
Oil on canvas, 60 × 81 cm
Louis Carré & Cie.

240 *Jeunesse et Feu*, 1957. (Youth and Fire).
Oil on canvas, 55 × 46 cm
Galerie Bonnier, Geneva.

241 *Comme il vous plaira: Ascension*, 1957.
(As you Like It: Ascent).
Oil on canvas, 146 × 114 cm
Louis Carré & Cie.

242 *Le Lion fabuleux*, 1957.
Oil on canvas, 60 × 81 cm
Galerie Bonnier, Geneva.

243 *Promethée l'emporte, le Vautour s'enfuit*, 1957.
(Prometheus Victorious).
Oil on canvas, 73 × 92 cm.
Louis Carré & Cie.

244-245 *La Seine au Val de La Haye*, 1959.
Oil on canvas, 97 × 162 cm
Louis Carré & Cie.

246 *Paresse*, 1960. (Laziness).
Oil on canvas, 41 × 27 cm
Musée des Beaux-Arts, Grenoble.

247 *Les Grues près de Rouen*, 1960.

(Cranes near Rouen).
Oil on canvas, 60 × 92 cm
Louis Carré & Cie.

248 *Guitar*, 1961.
Oil on canvas, 54 × 81 cm
Private collection, Geneva.

RAYMOND DUCHAMP-VILLON

89 Model of the façade of the *Maison Cubiste*,
Salon d'Automne, Paris 1912.

111 *Torso of a Young Man*, 1910.
Bronze, height 55 cm

112 *Torso of a Young Man*, 1910.

113 *Torso of a Young Man*, 1910.

114 *Decorative Basin*, 1911.
Bronze, height 58 cm

115 *Decorative Basin* (detail).

116 *Bust of Baudelaire*, 1911.
Bronze, height 40 cm

117 *Bust of Baudelaire*, 1911.

118 *Bust of Maggy*, 1912.
Bronze, height 72 cm

119 *Bust of Maggy*, 1912.

120 *The Small Dancers*, 1914.
Bronze, 18 × 47 cm

121 *The Small Dancers*, 1914 (details).

122 *The Lovers*, 1913.
Lead, 68 × 100 cm

123 *The Lovers*, 1913.
Lead, 68 × 100 cm

124 *Seated Woman*, 1914 (detail).

125 *Seated Woman*, 1914.
Bronze, height 69 cm

126 *Small Horse*, 1914.
Bronze, height 30 cm

127 *Small Horse*, 1914.

128 *Horse*, 1914.
Bronze, height 44 cm

129 *Horse*, 1914.

130 *Head of a Horse*, 1914.
Bronze, height 48 cm

131 *Large Horse*, 1914.
Bronze, height 100 cm

132 *Horse and Rider*, first state, 1914.
Bronze, height 21 cm

133 *Horse and Rider*, first state, 1914.

134 *Horse and Rider*, 1914.
Bronze, height 29 cm

135 *Horse and Rider*, 1914.

137 *Portrait of Professor Gosset*, 1917.
Bronze, height 29 cm

MARCEL DUCHAMP

29 *Fillette laçant sa chaussure*, 1902.
(Girl Lacing her Shoe).
Wash, 32 × 20 cm
Private collection, Paris.

30 *Suzanne Duchamp Seated*, 1902.
Watercolour, 31.4 × 32 cm
Private collection, Neuilly.

31 *Landscape at Blainville*, 1902.
Oil on canvas, 61 × 50 cm
Vera and Arturo Schwarz collection, Milan.

32 *Suzanne Duchamp Seated in an Armchair*,
1903.
Coloured pencils, 49.5 × 32 cm
Mme Marcel Duchamp collection, Villiers-
sous-Grez.

33 *Raymond Duchamp-Villon*, 1904-1905.
Pencil, 21 × 13 cm
Private collection, USA.

34 *Portrait of Yvonne Duchamp*, 1909.
Oil on canvas, 86.5 × 67.3 cm
Mary Sisler collection, New York.

35 *Portrait of the Artist's Father*, 1910.
Oil on canvas, 92 × 73 cm
Philadelphia Museum of Art,
Louise and Walter Arensberg Collection.

37 *Red Nude*, 1910.
Oil on canvas, 92 × 73 cm
National Gallery of Canada, Ottawa.

39 *Laundry Barge*, 1910.
Oil on cardboard, 66 × 74 cm
Mary Sisler collection, New York.

40 *The Chess Game*, 1910.
Oil on canvas, 114 × 146 cm
Philadelphia Museum of Art,
Louise and Walter Arensberg Collection.

41 *Portrait of Dr R. Dumouchel*, 1910.
Oil on canvas, 100 × 65 cm
Philadelphia Museum of Art,
Louise and Walter Arensberg Collection.

42 *Nude With Black Stockings*, 1910.
Oil on canvas, 116 × 89 cm
Private collection, New York.

43 *Baptism*, 1911.
Oil on canvas, 91.7 × 72.7 cm
Philadelphia Museum of Art,
Louise and Walter Arensberg Collection.

45 *Yvonne and Magdeleine Torn in Tatters*, 1911.
Oil on canvas, 60 × 73 cm
Philadelphia Museum of Art,
Louise and Walter Arensberg Collection.

46 *Draft on the Japanese Apple Tree*, 1911.
Oil on canvas, 61 × 50 cm
Private collection, Paris.

47 *Apropos of Little Sister*, 1911.
Oil on canvas, 73 × 60 cm
Solomon R. Guggenheim Museum,
New York.

48 *Sonata*, 1911.
Oil on canvas, 145 × 113 cm
Philadelphia Museum of Art,
Louise and Walter Arensberg Collection.

49 *Portrait (Dulcinea)*, 1911.
Oil on canvas, 146 × 114 cm
Philadelphia Museum of Art,
Louise and Walter Arensberg Collection.

50 *Young Man and Girl in Spring*, 1911.
Oil on canvas, 65.7 × 50.2 cm
Vera and Arturo Schwarz collection, Milan.

51 Study for *Portrait of Chess Players*, 1911.
Charcoal drawing, 43.1 × 58.4 cm
Private collection, Paris.

52 *For a Game of Chess*, 1911.
Ink and watercolour, 16.5 × 15.6 cm
Solomon R. Guggenheim Museum,
New York,
Katherine S. Dreier Collection.

53 *For a Game of Chess*, 1911.
Charcoal and India ink, 45 × 61.5 cm
Mme Marcel Duchamp collection,
Villiers-sous-Grez.

54 *The Chess Players*, 1911.
Oil on canvas, 50 × 61 cm
Musée National d'Art Moderne, Paris.

55 *Portrait of Chess Players*, 1911.
Oil on canvas, 108 × 101 cm
Philadelphia Museum of Art,
Louise and Walter Arensberg Collection.

69 *Sad Young Man in a Train*, 1911.
Oil on canvas, 100 × 73 cm
Peggy Guggenheim Foundation, Venice.

70 *Nude Descending a Staircase* No. 1, 1911.
Oil on cardboard, 96.7 × 60.5 cm
Philadelphia Museum of Art,
Louise and Walter Arensberg Collection.

71 *Nude Descending a Staircase* No. 2, 1912.
Oil on canvas, 146 × 89 cm
Philadelphia Museum of Art,
Louise and Walter Arensberg Collection.

72 *Coffee Mill*, 1911.
Oil on cardboard, 33 × 12.5 cm
Private collection, Rio de Janeiro.

93 *The King and Queen Traversed by Swift Nudes*,
1912.
Pencil, 27.3 × 39 cm
Philadelphia Museum of Art,
Louise and Walter Arensberg Collection.

94 *The King and Queen Traversed by Swift Nudes
at High Speed*, 1912.
Watercolour and gouache, 48.9 × 59.1 cm
Philadelphia Museum of Art,
Louise and Walter Arensberg Collection.

95 *The King and Queen Surrounded by Swift
Nudes*, 1912.
Oil on canvas, 114.5 × 128.5 cm
Philadelphia Museum of Art,
Louise and Walter Arensberg Collection.

96 *Virgin* No. 1, 1912.
Pencil, 33.6 × 25.2 cm
Philadelphia Museum of Art,
Louise and Walter Arensberg Collection.

97 *Virgin* No. 2, 1912.
Watercolour and pencil, 40 × 25.7 cm
Philadelphia Museum of Art,
Louise and Walter Arensberg Collection.

98 *The Passage from Virgin to Bride*, 1912.
Oil on canvas, 59.4 × 54 cm
Museum of Modern Art, New York.

99 *Bride*, 1912.
Oil on canvas, 89.5 × 55 cm
Philadelphia Museum of Art,
Louise and Walter Arensberg Collection.

100 *Nine Malic Molds*, 1913-1915.
Oil, lead wire and sheet lead on glass,
66 × 101.2 cm
Mme Marcel Duchamp collection,
Villiers-sous-Grez.

102 *Cemetery of Uniforms and Liveries* No. 1, 1913.
Pencil, 32 × 40.5 cm
Philadelphia Museum of Art,
Louise and Walter Arensberg Collection.

103 *Cemetery of Uniforms and Liveries* No. 2, 1914.
Pencil, ink and watercolour, 66 × 100 cm
Yale University Art Gallery, New Haven,
Société Anonyme Collection.
Gift of Katherine S. Dreier.

104 *Chocolate Grinder* No. 1, 1913.
Oil on canvas, 62 × 65 cm
Philadelphia Museum of Art,
Louise and Walter Arensberg Collection.

105 *Chocolate Grinder* No. 2, 1914.
Oil and thread on canvas, 65 × 54 cm
Philadelphia Museum of Art,
Louise and Walter Arensberg Collection.

141 *Bottle Rack*, 1914.
Readymade: galvanized-iron bottle dryer,
height 64.2 cm

142 *Pulled at Four Pins*, 1915.
Etching, 64 × 46.5 cm

143 *Apolinère Enameled*, 1916-1917.
Rectified Readymade: advertisement for
Sapolin enamel, partially modified by the
artist, 24.5 × 33.9 cm
Philadelphia Museum of Art,
Louise and Walter Arensberg Collection.

144-145 *You-Me (Tu m')*, 1918.
Oil and pencil on canvas, with bottle brush,
three safety pins, and a bolt, 69.8 × 313 cm
Yale University Art Gallery, New Haven,
Katherine S. Dreier Bequest, 1953.

146 *Hat Rack*, 1917.
Assisted Readymade: wooden hat rack hung
from ceiling, 23.5 × 14 cm

148 *To Be Looked at (from the Other Side of the
Glass) with One Eye, Close To, for Almost an
Hour*, 1918.
Glass, lead wire, oil paint, magnifying lens
and silver leaf, 51 × 41.2 × 3.7 cm
Museum of Modern Art, New York,
Katherine S. Dreier Bequest, 1953.

149 *L.H.O.O.Q.*, 1919.
Rectified Readymade: pencil on a reproduc-
tion of the *Mona Lisa*, 19.7 × 12.4 cm
Private collection, Paris.

150 *Unhappy Readymade*, 1919.
Geometry textbook exposed to the wind on
the balcony of his sister, Suzanne.
Original destroyed.

152 *Network of Stoppages*, 1914.
Oil and pencil on canvas, 148.9 × 197.7 cm
Museum of Modern Art, New York,
Gift of Mrs William Sisler, 1970.

153 *Why not Sneeze, Rose Sélavy?*, 1921.
Assisted Readymade: small painted cage,
marble sugar lumps, thermometer and cuttle-
bone, 12.4 × 22.2 × 16.2 cm
Philadelphia Museum of Art,
Louise and Walter Arensberg Collection.

177 *Rotary Glass Plates (Precision Optics)*, 1920.
Five painted glass plates of different lengths
mounted on a metal axis operated by elec-
tricity: in motion, the painted lines appear as
continuous concentric circles.
120.6 × 184.1 cm
Yale University Art Gallery, New Haven,
Gift of Société Anonyme, 1941.

178-179 *The Bride Stripped Bare by her Bachelors,
Even (Large Glass)*, 1915-1923.
Oil, varnish, lead wire and foil on glass
(cracked), mounted between two glass panels
in a wood and steel frame. 227.5 × 175.8 cm
Philadelphia Museum of Art,
Katherine S. Dreier Bequest, 1953.

180 *Glider Containing a Water Mill in Neigh-
bouring Metals*, 1913-1915.
Oil and lead wire on glass, 147 × 79 cm
Philadelphia Museum of Art,
Louise and Walter Arensberg Collection.

181 *Glider Containing a Water Mill*, 1965-1966.
Detail from the *Large Glass*, tempera on paper,
33.5 × 20 cm
Galleria Schwarz, Milan.

181 *The Bride*, 1965–1966.
Detail from the *Large Glass*, tempera on paper,
33.5 × 20 cm
Galleria Schwarz, Milan.

182 *Large Glass Completed*, 1965–1966.
Colour engraving, 50 × 33 cm
Galleria Schwarz, Milan.

183 *Nine Malic Molds*, 1965–1966.
Detail from the *Large Glass*, tempera on paper,
33.5 × 20 cm
Galleria Schwarz, Milan.

251 *Rrose Sélavy*, mannequin exhibited in the
"Rue Surréaliste" at the Exposition Interna-
tionale du Surréalisme, Paris 1938.

253 Cover for the catalogue of the "Le Surréalisme
en 1947" exhibition in Paris, 1947.
23.5 × 20.5 cm

255 Marcel Duchamp with his first Readymade,
Bicycle Wheel, at his home 5, Rue Parmentier,
Neuilly, 1967.

SUZANNE DUCHAMP

151 *Marcel's Unhappy Readymade*, 1920.
Oil on canvas, 81 × 60 cm, after her brother
Marcel Duchamp's *Unhappy Readymade*.
Private collection, Milan.

DOCUMENTS

9 Drawing by Grass-Mick, 1902.
In the centre, Jacques Villon.

88 Catalogue of André Mare's *Salon Bourgeois*,
Salon d'Automne, Paris 1912.

88 Catalogue of the *Boudoir* decorated by André
Mare and his group, with Raymond Duchamp-
Villon, Salon d'Automne, Paris 1913.

255-264 Photographs.

PHOTOGRAPHIC CREDITS

Bacci, Milan; Galerie Bonnier, Geneva; Louis
Carré & Cie, Paris; Cauvin, Paris; Walter Dräyer,
Zurich; Editions Ides et Calendes, Neuchâtel;
Georges Routhier, Studio Lourmel, Paris; Galerie
Sagot-Le Garrec, Paris; Galleria Arturo Schwarz,
Milan.

Produced by Editions Ides et Calendes, Neuchâtel
Technical direction and layout: André Rosselet
Printed in offset by Paul Attinger, Neuchâtel
Offset films: Atesa-Argraf, Geneva
Binding: Mayer et Soutter, Renens
Printed in Switzerland